DELINEATIONS

OF

THE NORTH WESTERN DIVISION

OF THE

COUNTY OF SOMERSET,

AND OF

THE MENDIP CAVERNS

JOHN RUTTER

With a new introduction by
ROBERT DUNNING

AMBERLEY

First published 1829
This facsimile edition published 2009

Amberley Publishing
Cirencester Road, Chalford,
Stroud, Gloucestershire, GL6 8PE

British Library Cataloguing in Publication Data.
A catalogue record for this book is available from the British Library.

ISBN 978-1-84868-211-5

Printed in Great Britain by Amberley Publishing

DELINEATIONS

OF

THE NORTH WESTERN DIVISION

OF THE

COUNTY OF SOMERSET,

AND OF ITS

ANTEDILUVIAN BONE CAVERNS,

WITH

A GEOLOGICAL SKETCH OF THE DISTRICT.

BY JOHN RUTTER,

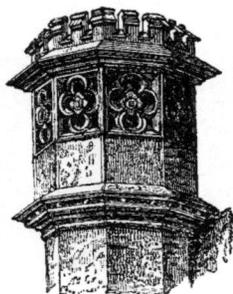

AUTHOR OF FONTHILL AND ITS ABBEY DELINEATED.

Plate 1.

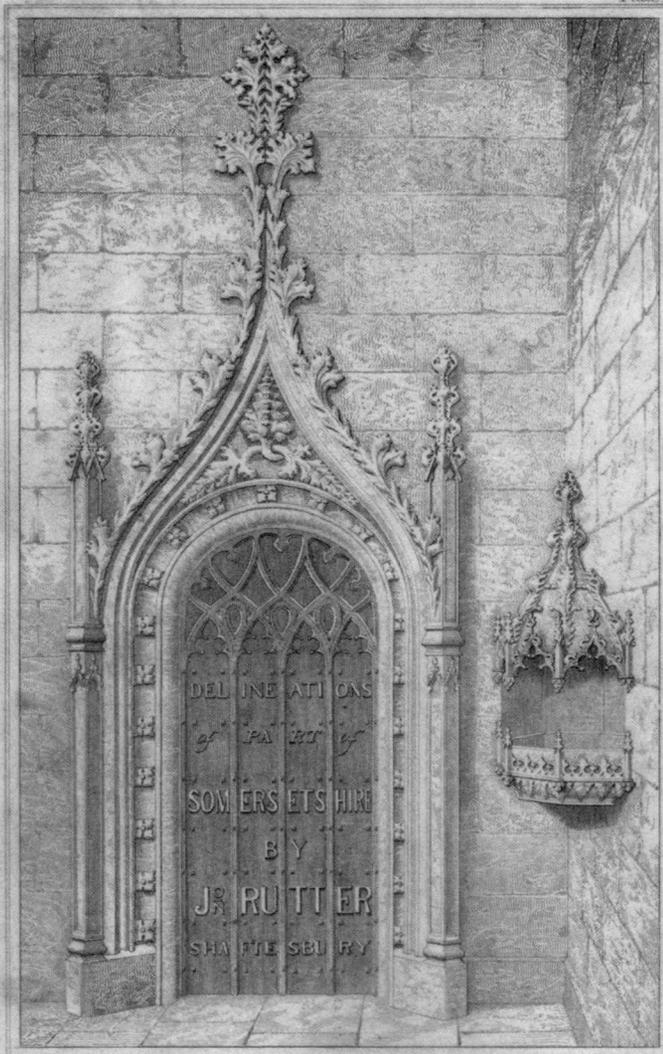

DEL INE ATI ONS

of PA RT of

SOM ERS ETS HIRE

BY

J.ᴿ RUTT ER

SHAF TE SBU RY

T. S. Biddulph, del.

J.ⁿᵒ Cleghorn, sculp.

THE DOOR-WAY & STOUP.

Formerly at the CHAPEL OF COURT DE WYCK, now at the
Interior entrance of CLEEVE COURT, the residence of the
Rev.ᵈ T. S. Biddulph, by whom this plate is obligingly presented.

Published by J.ⁿ Rutter Shaftesbury 1829.

INTRODUCTION

by Robert Dunning

John Rutter was, quite evidently, a remarkable man whose achievements have deservedly found a place in the *Oxford Dictionary of National Biography*, where he is described by Desmond Hawkins as a topographer and political agent. He was born in Bristol on 10 April 1796, the youngest of seven children of Thomas Rutter, a Quaker bellows- and brush-maker by his wife Hester Farley. The appearance of the coat of arms of the Rutter family of Cheshire, Gloucestershire and Stratford on Avon as the end-piece of his Delineations of North Western Somerset implies a claim of kinship, however distant. The family home was in the centre of the old city in Castle Street, but both his parents died while he was still a child; he was brought up by two elder sisters and was apprenticed to a linen draper of Shaftesbury, a connection perhaps made through the Society of Friends. It was evidently not a congenial move, for he later declared the trade only fit for women, and as soon as he was of age and could use his father's legacy he set up as a printer in the same Dorset town in 1817. In the following year, on 7 July 1818, he married the daughter of a Quaker draper from London.

How much business he did as a jobbing printer is not known, but the first work he both wrote and printed revealed his broad interests and his undoubted talents as a topographer, and also his understanding of what might sell. It came in the year of his marriage and was a pamphlet summarising the history of Cranborne Chase, a piece of countryside just south-east of Shaftesbury which was then the subject of local controversy.

Four years later he produced two more substantial works, both designed to appeal to the increasing number of gentlefolk of means who were becoming addicted to visiting country houses. Very near Shaftesbury was Fonthill Abbey, that fantastic product of the imagination of William Beckford. Rutters's first volume under the title *Fonthill and its Abbey Delineated* ran into six 'editions' in that single year of 1822, the last described as 'enlarged and very highly illustrated'. In 1823 came further 'editions' under slightly differing titles,

one *Delineations of Fonthill and its Abbey*, distributed by the author from Shaftesbury and by C. Knight in London, the other *A New Descriptive Guide to Fonthill Abbey and Demesne*, to be had in London from Longman, Hurst & Co., J. and A. Arch and Charles Knight, but also at the Abbey gates. It included a list of furnishings and curiosities in the house. The British Library holds two copies of the second title, one with proofs and etchings on India paper, a practice designed to widen the appeal of each volume that Rutter was to repeat with considerable success a few years later. As printer as well as publisher, Rutter evidently found he could revise and expand the title and content almost at will. Beckford's financial problems may have provided an impetus for popularising the house, but visitors could not save the situation; Beckford sold it in 1823 and the enormous tower collapsed in 1825.

The second country house guide of 1822 was his *Historical and Descriptive Sketch of Wardour Castle and Demesne*, the seat of Everard Arundell, Lord Arundell of Wardour. It was distributed by Longmans in London, named booksellers in Bath and Salisbury and 'all other booksellers'. A second edition seems to have followed in the following year.

Six years later came his fourth publishing enterprise, the result of two excursions made in 1828 and a 'more recent' personal visit. *Delineations of the North Western Division of the County of Somerset*, according to Emmanuel Green in his *Bibliotheca Somersetensis*, had also first appeared in 1822; the copy he possessed is listed as the second edition of 1829. No other copy of an 1822 edition has been found, and neither the prospectus nor any copies of the 1829 volume refer to an earlier edition.

North Western Somerset as delineated by Rutter had as its boundary the Bristol Channel coast between Burnham and the mouth of the Avon, the river Avon as far as Bedminster, the villages directly south including Chew Magna, Chew Stoke and Stowey, and thence in a line westwards to Cheddar, Axbridge, Weare, and East and South Brent, an area incorporating the ancient hundreds of Winterstoke, Brent with Wrington, Portbury, and Hartcliffe with Bedminster, and a few parishes in the hundreds of Bempstone and Chew. Geographically that was a logical and reasonable area; from a commercial point of view it was even more attractive, for it included in Burnham, Weston and Clevedon three places that were then

beginning to attract visitors in considerable numbers. Hotels were appearing where respectable people might lodge to enjoy both the antiquities of the neighbourhood, the attractive coastal scenery, sea bathing and 'the peculiar salubrity of the atmosphere'. To the outstanding antiquities of the region, among which the ruins of the priory at Woodspring and the many fine parish churches stood apart, were to be added the prehistoric standing stones at Stanton Drew and the even more amazing caverns at Banwell, Hutton and Uphill, the first recently discovered full of the bones of long-extinct animals. Add to those popular attractions Brockley Hall and Leigh Court, country houses full of fine paintings and owners happy to welcome genteel visitors, and Rutter the publisher saw a great opportunity.

The work was conceived from the outset as one to appeal to a wide market through its choice of quality and format, and after initial publication as a single volume might easily be divided for more slender pockets. Subscribers (for that was then the normal way for a publisher to minimise his risk) were offered in a *Prospectus* a choice of proofs on India Paper, attractively limited in number, at a price of 25 shillings, allowing them to have their volumes bound according to their own taste, or bound volumes on either 'large paper' (Royal 8vo) with early impressions of the plates, at 20 shillings or 'small paper' (Demy 8vo) at 15 shillings with illustrations or 10 shillings without. Green's *Bibliotheca Somersetensis* described the three sizes as quarto, royal octavo and octavo. The *Prospectus* promised that the work would be 'richly embellished with engravings on copper, wood, and stone' and declared that 'at the earnest request of several Subscribers and literary Men' the work would include 'a Map of the District, coloured geologically'. The list of plates already determined upon numbered 26, but Rutter promised that 'gentlemen may have their residences, or other favourite subjects, engraved for this work, at a very moderate expence [sic], on timely application to the editor; who has by him a numerous series of drawings of gentlemens' seats, &c., within the district'. In the event there were 14 plates including the geological map and 30 'vignettes'. Even after *Delineations* had appeared, Rutter's enterprise was not exhausted; he had ideas of printing extracts from the remarkable churchwardens' accounts of Banwell

together with facsimiles for the sum of 5 shillings should a sufficient number of subscribers present themselves.

The *Prospectus* instructed potential subscribers to give their names to the editor himself, to George Emery of Banwell, to booksellers in Bath, Bristol, Wells, Bridgwater, Taunton 'and other towns', to Mr R. Hill at the Library in Weston, to George Smith in Axbridge, and to three named London Booksellers, Messrs. Longman, Rees and Co. and J. and A. Arch, through whom he had already worked, and to a third whose name appears in striking bold print, Messrs. J. B. Nichols & Son, Parliament Street to whom, it may be assumed, members of the legislature went for their reading matter. The *Prospectus* contained the impressive list of those who had already been induced to subscribe, and anyone still thinking about ordering the expensive India Paper edition were warned that only 'a very few copies' remained. The completed volume lists the names of people who took 122 of the superior copies, 265 of the large paper edition, and 119 of the small paper edition and among them were booksellers in Bath, Blandford, Bridport, Bristol, Cirencester, Dorchester, Frome, London, Salisbury, Sherborne, Warminster, and Weymouth.

The individuals who supported Rutter's enterprise in such numbers included, of course, a substantial proportion of landowners and clergy from the immediate vicinity, and others who must already have subscribed to his earlier volumes; most had addresses in Somerset and Dorset, but the boundaries stretched to Torquay in one direction, Cirencester in another. Among those living further afield were William Buckland of Oxford, the country's leading geologist but with Somerset connections. One copy hopefully found its way to Thomas Weaver in Killarney, another geologist who worked on Somerset and Gloucestershire, another to Heberden Emery in Madras.

In an 'Advertisement' included in the completed work Rutter acknowledged the help of many people, two of whom remained anonymous and among them local naturalists, the antiquarian Sir Richard Colt Hoare, the rector of Shaftesbury for the final revision of the manuscript, the owners of several plates from whom his own were derived, and particularly to William Barnes, then of Chantry House, Mere, for providing seven charming vignettes. It was truly a cooperative enterprise, for most of those named in the 'Advertisement' were also subscribers.

The appearance of this reproduction of Rutter's *Delineations* is an eloquent acknowledgement of a valuable original work. John Collinson's *History and Antiquities of the County of Somerset* was not universally acclaimed when it appeared in 1791 and the comprehensive survey of the county by Edmund Rack, now among the Ashton Court Papers in Bristol Record Office, reveals how much better Collinson's work would have been had he included more of Rack's topographical information. Rutter, according to his 'Advertisement', produced his substantial volume from 'Notes taken in the summer of 1828, during two excursions through the North-western Division of Somersetshire... and by a more recent personal examination of the places described'. It is not absolutely clear that the 'Notes' were made by Rutter himself, but he obviously came in person later, and there is plenty of evidence of personal observation, such as the details of the surviving fabric of Worle rectorial barn or the swans and the weeping willow and the paper mill at the pond at Banwell. The comments on Weston beach can only have been made by one who had been there several times.

The record is patently careful: not simply the lists of shells, plants and sea birds or the furnishings and pictures at Brockley Hall and Leigh Court, but information, for instance, on parish churches which indicate recent work in some detail. Locking, had 'a few years since' been rebuilt and enlarged; Long Ashton 'thoroughly repaired' (though the imitation marble paint on the columns in the nave did not meet with approval); Bedminster 'totally inadequate to the present number of the parishioners' and about to be replaced by a new church 'erected in a central situation'; Portbury 'far too large for the population of the parish'; and, by contrast, Easton in Gordano relatively new and furnished 'so as to contain six hundred free seats for the lower classes'. The space occupied by material on the caves, notably that at Banwell, the careful plan of the stone circle at Stanton Drew, and the appendices on Wansdyke and Roman remains reflect the growing interest in such studies and, in the case of the Banwell bone cavern, the beginnings of speculation on the origins of life which were to be so crucial in the development of science and the questioning of traditional religious thought. The interpretation of the bone caverns continues to exercise the scientific world in the 21st century. Anyone studying the history of the parishes of this part of Somerset cannot afford to ignore Rutter.

Delineations is a substantial work of 350 pages, perhaps larger than many might care to carry with them. Smaller octavo volumes entitled respectively *Clevedon Guide*, *Weston Guide* and *The Banwell and Cheddar Guide*, published in the same year as *Delineations* offered more compact volumes and the latter was marketed through Rutter's usual channels but also at the cottage near the Banwell caves and at the Bath Arms in Cheddar. The subsequent popularity of Weston and its consequent expansion demanded revision of the work of 1829, and in 1840 Rutter published *A New Guide to Weston super Mare* as from the town, and sometime later republished it as from Bristol.

By that time the author's interests had moved from topography and publishing to local politics in Shaftesbury. The borough, which returned two members to Parliament, was notoriously corrupt, 'bought and sold but not represented for thirty years' it was said in 1802 and in 1819 sold for £60,000. The corporation which controlled the voters and the town was self-perpetuating and unrepresentative, and Rutter became the leader of those who in the heady days leading up to the Reform Bill opposed its power and acted as agent for John Poulter, the man who may be said to have represented the town after the 1832 Parliamentary election. Rutter continued his political activities by becoming a member of the newly-formed town council under the Municipal Corporations Act in 1835. His subsequent career has little bearing on the work here republished, but his political activities inspired him to turn to the law for a living and he qualified as a solicitor and later practised in the town. He was also secretary of the local branch of the Bible Society, and wrote and published *Letters in defense* [sic] *of the Bible Soc. to. L. Neville* in 1836. He held Bible-reading classes for working-class children in Shaftesbury, an activity disapproved of by his fellow Quakers, and he formally left the Society of Friends though continued to worship with them. He died on 2 April 1851 after being thrown from a coach and was buried in the Friends' burial ground in the town.

ADVERTISEMENT.

The plan of the following Treatise, which originated in Notes taken in the summer of 1828, during two excursions through the North-western Division of Somersetshire, has been considerably enlarged by reference to numerous authorities, and by a more recent personal examination of the places described.

The Author, in addition to his own labours, has gratefully to acknowledge the receipt of valuable communications from several literary characters, including a gentleman connected with the Bristol Institution; George Bennett, solicitor, of Rolston, near Banwell; a lady of Banwell; David Williams, M.A. F.G.S. rector of Bleadon; and F. Boucher Wright, F.L.S. of Hinton Blewett. To Sir Richard Colt Hoare, bart. F.R.S. F.S.A. he is also much indebted for the liberal permission of reference to his valuable topographical library at Stourhead; and to J. H. Smyth Pigott, of Brockley Hall, F.S.A. F.G.S. high sheriff of the county, for the use of numerous highly finished drawings, from which many of the plates that accompany the work were engraven; and for many other liberal efforts to render the work complete, and to aid him in his researches.

These observations cannot be closed without also acknowledging the kind and liberal attention which he received from the Clergy, and other Gentlemen of the district, during his excursions through it, and their subsequent perusal and correction

of his manuscript ; he must also gratefully advert to the exertions of GEORGE EMERY, of the Grange, Banwell, in forwarding the publication, by making its object known, and in directing him to numerous sources of interesting information.

He also feels much pleasure in noticing the readiness with which many respectable individuals in his own immediate neighbourhood, have encouraged his earliest efforts towards this publication; to WILLIAM PATTESON, rector of Shaftesbury, he is particularly indebted for the final revision of the manuscript; and to his friend WILLIAM WEST, of the same place, for much useful information respecting the parish of Yatton, and several other parts of the district.

The Author, together with his Subscribers, are also highly indebted for the following additional illustrations :—To WILLIAM LISLE BOWLES, canon of Salisbury, and his brother, CHARLES BOWLES, late recorder of Shaftesbury, for the view of Uphill church, of which parish their father was many years the rector ; to THOMAS SHRAPNEL BIDDULPH of Cleeve Court, rector of Brockley, for the appropriate Frontispiece ; to several gentlemen connected with Congresbury, for the View of its Church and Parsonage ; to J. A. STEPHENSON, rector of Lympsham, for the View of its elegant Parsonage ; and to WILLIAM BARNES of Chantry-House, Mere, for the Vignettes, executed by himself, at the head of the third, fourth, fifth, eighth, ninth, eleventh, and twelfth chapters.

Amongst the works of reference, may be enumerated, Collinson's Somersetshire, Seyer's Bristol, Sir Richard Colt Hoare's Ancient Wiltshire, Bowles's Hermes Britannicus, Transactions of the Geological Society, Buckland's Reliquiæ Diluvianæ, &c.

CONTENTS.

b

Window in Tickenham Court House.

CORRECTIONS AND ADDITIONS.

PAGE 3, ninth line, *for* westward, *read* eastward.
—— 3, fifteenth line, *for* eight, *read* five.
—— 4, thirteenth line, *for* Congresbury, *read* Wrington.
—— 4, last line, *add*, excepting to the Barons of the Exchequer.
—— 43, twenty-fifth line, *for* Hunter, *read* Winter.
—— 76, sixth line, *for* northern, *read* southern.
—— 88, sixth line, *for* 1000, *read* 500.

ADDITIONAL NOTES.

The parish of Congresbury contains 4400 acres; that of Yatton 5400; and Kenn 1000.

Flax Bourton has been detached from Wraxall by an Act of Parliament, and is now a Chapel to Nailsea. The manor of Bourton came by the Bampfylde family to that of the Smyths of Ashton Court.

Since the account of Yatton was printed, it has been suggested, that the etymology of its name, proves only that it was the site of a flood-gate, by which the further influx of the tide was stayed. It is also the same gentleman's opinion, that the waters of the Bristol Channel did not constantly extend, at any time, over the vallies of this district, since the flood of Noah.

The untimely death of the REV. F. BLACKBURNE, deprived the Author of one of his earliest supporters; to whom he had previously inscribed the Plate of Weston Super Mare, as a small acknowledgment of the friendly interest which its rector had felt in the success of the undertaking.

DESCRIPTION

OF THE

EMBELLISHMENTS.

PLATE I.—FRONTISPIECE.

Enriched Door-way and Stoup, formerly at the Chapel of Court
de Wyck, now at the interior entrance of Cleeve Court, the
residence of the Rev. T. S. Biddulph. These interesting
relics are protected by an exterior porch; the sculpture,
especially of the stoup, or consecrated water basin, is elabo-
rate, and delicately executed.

II.—PAGE 35.

Congresbury Church and Parsonage.—These are contiguous to
each other, but being difficult to group, are engraved as se-
parate subjects. The more ancient part of the parsonage is
an interesting specimen of its era, especially the projecting
porch. This leads to a spacious kitchen, which was, proba-
bly, the original hall. The modern part contains several
handsome apartments, and is shaded by a remarkably fine
beech tree.

The southern side of the church, with the eastern ends
of the aisles and chancel, are shewn in the view. The chan-
cel windows are good specimens of the perpendicular era, and
are shaded by an unusually fine yew tree. In front of the
porch are the remains of a fine old cross.

III.—PAGE 9.

Brockley Hall.—The seat of J. H. Smyth Pigott, Esq. This view
of the west front is taken from the north-eastern aspect.

IV.—PAGE 41.

Weston-Super-Mare.—This view is taken from Knightstone, and
gives a good idea of the general appearance of the town and
bay. The church, with its contiguous parsonage, shaded by

c

foliage, are the prominent objects on the left hand, the road from the beach occupies nearly the centre; Reeves's Hotel being conspicuous from its height and size. The view on the right is bounded by Mr. Price's pleasing residence; beyond which, the buildings extend as far towards the south as the large handsome edifice erected by Mr. Jacob.

V.—Page 58

Remains of Woodspring Priory; taken from the south-eastern aspect. The part shown in the drawing, was the conventual church. The arched walls on the left, formed the eastern boundary of the cloisters; on the southern side stands the refrectory; and on the western, was the principal entrance, formed by a handsome gateway, remaining nearly entire. The priory house stood on the eastern side of the church and cloisters; it was of considerable extent, the adjoining orchard being covered with its foundations.

VI.—Page 75.

Uphill Church.—This edifice stands on the apex of the hill, from which the name of the village is probably derived. It is supposed to occupy the site of a Roman post of observation; and from its elevated situation, is a well known land-mark. The arch of a Norman door-way is perceptible in the centre of the nave.

VII.—Page 85.

Lympsham Rectory; with the summit of the handsome tower of its church. This elegant parsonage is situated in the midst of extensive lawns, richly shaded with foliage. The part shewn contains the library, with its attached octagon tower.

VIII.—Page 112.

Mendip Lodge.—This delightfully situated residence has only its southern front shewn in the plate; the extensive offices, being detached, could not be exhibited. On the heights above, is the extensive fortification, called Doleberry Camp.

IX.—Page 137.

Banwell Church.—This View gives a correct idea of the south-eastern aspect of this fine parochial edifice. The general arrangement, together with the exterior architectural ornaments, may be distinctly traced in the plate.

X.—Page 147.

Ornamental Cottage on Banwell Hill.—The site of this building is romantic and commanding, overlooking a wide expanse of varied country, bounded on the west by the Bristol Channel. On the right hand of the path below the cottage, is the entrance to the Bone Cavern; and above the cottage is the door-way to the Stalactite Cavern. Still higher, nearly on the apex of the hill, is a summer house, whose elevated situation commands almost a panoramic view of the surrounding district; it has, however, been rebuilt in a different style, since the plate was engraven. The gate on the right leads towards Mr. Beard's residence at Wint Hill.

XI.—Page 235.

Clevedon and its Bay.—This view conveys a correct idea of the picturesque situation of this village, and of the undulations of its bay. The view was taken from the tree within the gate, which leads immediately to the eastern extremity of the village. The last house on the right hand is the hotel; the church is situated behind the high ground, called Clevedon Point, shewn on the left hand, which forms the southern extremity of the bay. Across the channel, the line of the Welch Coast may be distinctly traced.

XII.—Page 154.

Portrait of Mr. William Beard.—This may be considered an excellent likeness of the " *Genius Loci* " of the Banwell Caverns; and as such, cannot fail of proving acceptable to the subscribers and to the public.

XIII.—Page 277.

Map of the District, coloured geologically.—This has been carefully reduced from Mudge's Ordnance Survey, and corrected from personal observation. Though on a reduced scale, it correctly exhibits the situation of the places described, as well as the turnpike and cross roads ; the relative distances may be accurately ascertained by reference to the scale of miles. The geological divisions have been most carefully drawn and coloured ; and, with the shading of the principal hills, will correctly exhibit, at one view, the general geological features of the district. It will also serve as an essential Map of reference to the Geological Sketch, which forms Appendix A.

WOOD-CUT VIGNETTES.

VIGNETTE I.—TITLE-PAGE. Description p. 61.

Fragments from Woodspring; consisting of a summit of one of the turrets which ornament the western angles of the nave of the conventual church. The shield on the left hand is charged with a heart, between hands and feet pierced with nails, the usual emblem of the crucifixion. On the other is sculptured a chevron between two bugle horns. These shields were fixed on a pillar in a chapel attached to the south side of the conventual church of Woodspring.

II.—PAGE xv. Description p. 231.

Window in Tickenham Court House.—This window faces the south-east, and is an unusually fine specimen, tolerably preserved. It was formerly filled with painted glass.

III.—PAGE xxiv. Description p. 200.

Ancient Cross in the church-yard at Chew Magna.

IV.—PAGE 1. Description p. 57.

Norman Door-way in Kewstoke Church.—This fine arch forms the inner door-way of the porch. The whole of what is shewn in the plate, evidently remains on its original site, having had the walls of the present church attached to it.

V.—PAGE 9. Description p. 40.

Monastic Barn at Worle.—The part shewn, is the centre of the side nearest the road, looking through the window across the building, beyond the southern door-way. The original deserves protection from further decay.

VI.—PAGE 41. Description p. 45.

Weston Old Church.—This edifice, with the exception of the chancel, was taken down in 1824, and the present more capacious building erected on the site. The south front is shewn in the plate; the chancel remains without alteration.

VII.—PAGE 52. Description p. 65.

Ancient Tomb at Kingston Seymour.—This monument belongs to the Bulbeck family, and stands in the church-yard. There is a similar one, of equally large dimensions, at East Harptree, called the " Pay, or Money Table."

VIII.—Page 53. Description p. 54.

Vorlebury Castle or Camp.—This remarkable fortification occupies the western extremity of Worle Hill, immediately above Weston Super Mare. The ground falls somewhat precipitously on all sides, except the eastern, which is guarded by an unusual series of ditches and ramparts of loose stones. The waters of the channel flow round the termination of the hill, between which and the camp, is Mr. Pigott's new road to Kewstoke.

IX.—Page 74. Description p. 22.

Porch at Chelvy Court House.—This handsome entrance to the manorial residence of the Tyntes, remains nearly perfect; it communicated with a raised terrace, which enclosed the garden. Its roof forms a balcony, guarded by a stone parapet, of a light and elegant character.

X.—Page 75. Description p. 92

Brean Down and the Black Rock.—This sketch exhibits the eastern termination of Brean Down, which presents a rough perpendicular front of lime-stone; at its base is a farm house. In front is the Black Rock, within which is the mouth of the river Axe.

XI.—Page 78. Description p. 78.

Vertical Section of Uphill Cave.—This section is supposed to have separated the rock in a line from north to south; it exhibits the several fissures communicating with the cavern, the floor of which is nearly level with the beach.

XII.—Page 96. Description p. 76.

Uphill Parsonage.—This retired rectory is built in the cottage style; it is covered with foliage and trellis work, and is surrounded by lawns and shrubberies, laid out by the Rev. W. T. Bowles, the poet's father.

XIII.—Page 97. Description p. 128.

Cottage at Wrington in which Locke was born.—The gate on the left leads into the church-yard. The philosopher was born in the room lighted by the upper window on the right; it is a small, plain apartment, having few indications of former

respectability. It has been supposed that Locke was born here whilst his parents were accidentally detained in the town. This appears not to have been the case, for John Locke, the grandfather of the great John Locke, purchased an estate called Pilrow, at East Brent, of Sir John Whitmore, bart. in 1630, where he settled, and was succeeded by his second son, Christopher, who lies buried in East Brent church. Christopher had a son John, who possessed a farm at Mark, co. Somerset, now called Locke's Broad Farm. The first mentioned John Locke purchased another estate at Wrington, which he gave to his eldest son, also named John; he was father to the celebrated John Locke, who was born at Wrington, August 29, 1532.

XIV.—Page 100. Description p. 101.

Vertical Section of Hutton Cavern.—The insecure appearance of the floors between the caves, formed of masses of rock jammed between the strata, might well have produced the impression of being buried alive.

XV —Page 114. Description p. 115.

Doleberry Castle or Camp.—This entrenchment is situated on the highest point of the hill, above Burrington and Mendip Lodge.

XVI.—Page 131. Description p. 139,

Sculptured Stone Pulpit in Banwell Church.—This elegant piece of sculpture was long secreted by a thick coating of mortar; probably with a view of preserving it from injury, immediately subsequent to the revolution. It was accidentally discovered during the recent repairs, and is surmounted by a richly ornamented oak sounding board, which could not be conveniently shewn in the drawing.

XVII.—Page 145 Description p. 136.

Pond and Mills at Banwell.—This fine sheet of water is ornamented with a weeping willow and a pair of swans. It works an extensive writing paper manufactory and flour mill.

XVIII.—Page 146. Description p. 146.

Vertical Section of Banwell Caverns.—The one on the left hand is called the Stalactite Cavern, the other, the Bone Cavern.

XIX.—Page 160. Description p. 181.

Cheddar Cross.—This fine old hexagonal cross is correctly represented in its present dilapidated state.

XX.—Page 188. Description p. 199.

Ancient Parsonage House at Chew Stoke.—This curious old building is contiguous to the church, and is now used as a poor-house. The arms sculptured on the front, relate to the families of Loe, Fitzpaine, Ansell, Rivers, Ragland, Malet, and others.

XXI.—Page 201. Description p. 202.

Church Manor House at Chew Magna.—In this edifice the court-leets of the lord of the manor are continued to be held, though part is used as a school-room, and the remainder as a parish poor-house. The arms over the door are those of St. Loe.

XXII.—Page 208. Description p. 209.

Ground Plan of the Druidical Temple at Stanton Drew.—This plan, though on a small scale, is believed to be very correct, having been reduced from a survey by Mr. Crocker.

XXIII.—Page 222. Description p. 165.

Consecrated Water Drain in Compton Bishop Church.—This Piscina is in the south wall of the chancel, and has a small arched cupboard immediately over it, secured by a door, with an antique lock and key.

XXIV.—Page 223. Description p. 229.

Arches formed of Oak in Clapton Manor House.—This double archway is on the left hand of the entrance passage, beyond the porch, and communicated with antichambers leading to the baronial hall; no part of which now remains.

XXV.—Page 240. Description 231.

Window in Tickenham Court House, divided into two lights, having cinque-foiled heads, and a quartre-foiled circle above. The windows generally are of this pattern, but of various dimensions; they were originally filled with painted glass.

Ancient Cross at Chew Magna.

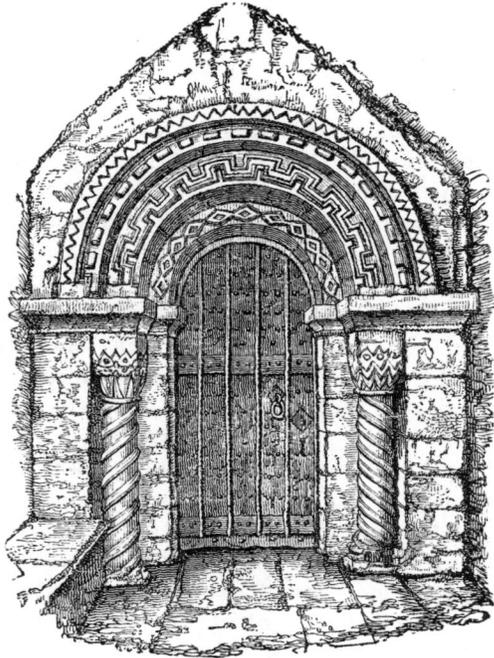

Norman Door-way in Kewstoke Church.

CHAP. I.

INTRODUCTORY.

General Summary—Boundaries—Coast—Levels or Vales—De-
rivations of Names—Mendip Hills—Agricultural Cultivation—
Public Drainage—-Parochial Churches—-Norman Vestiges—
Manor and Court Houses—-Antediluvian Relics—-Camps and
Ancient Roads.

THE following DESCRIPTIVE SKETCH embraces one of
the most interesting portions of the county of Somerset,
including the Hundreds of Winterstoke, Brent with Wring-
ton, Portbury, and Hartcliffe with Bedminster; together
with a few parishes in the Hundreds of Bempstone and

B

Chew. This district is equally gratifying to the lover of picturesque scenery, to the antiquary, and to the geologist; for within its bounds are situated the ANTEDILUVIAN BONE CAVERNS at Banwell, Hutton, and Uphill; Cheddar Cliffs, and Brockley Combe; the monastic remains at Woodspring Priory and Worle; together with numerous ancient manor and court houses, and some of the most remarkable parochial churches in the kingdom. All these are within a moderate distance of Bristol, and still nearer to Weston-Super-Mare; a very improving watering place on the Bristol Channel, which attracts numerous visitors.

The boundary of the BRISTOL CHANNEL, or Severn Sea, on the western side of this district, commences at Burnham opposite to Stert Island, at the influx of the river Parret, extending along the flat beach of Bridgewater bay, and its barrier of sand hills; thence by the village of Berrow to its northern point, where the coast is elevated into the lofty promontory of Brean Down, extending into the sea, and forming one of its most conspicuous headlands. Nearly opposite to Brean Down, west-ward, is the Steep Holm, and more to the north the Flat Holm; on the east are the remarkable hill and village of Uphill, at the conjunction of the river Axe with the Bristol Channel. Northward from Brean Down, is the Bay of Weston, with a fine sandy beach, two miles in length, to Anchor Head; and beyond Weston, at the western extremity of Worle Hill, is another vast rocky eminence, forming a most remarkable object by sea and land. Northward from this hill, is Kewstoke Bay, terminated by Sand Point and St. Thomas's Head, the lofty and conspicuous boundary of the demesne of the Priory of Woodspring.

From this point the coast is low as far as Clevedon, where it again exhibits rocks of considerable grandeur, which continue without much interruption to Portishead, the last promontory northward, and remarkable for its picturesque character. Hence the coast declines to King-Road, where the river Avon empties itself into the Bristol

channel; the course of this river forms the northern boundary of Somersetshire, as far as the city of Bristol; and few rivers can boast more beautiful scenery, than is to be seen on its woody banks.

Within the sand hills which now bound the waters on this coast, are the rich and extensive Levels of BRENT, WESTON, YATTON, and BANWELL, over the whole of which, in early ages, the waters of the channel flowed; extending, according to tradition, as far westward as Long Ashton, and to Glastonbury and Somerton on the south; some evident vestiges of which are left behind, not only in marine plants, shells, and fossils, but in the names of places : that of Banwell, for instance, being probably derived from its ancient British designation, *Banawelli,* compounded of *Bann* deep, and *Welgi* sea, though the town is now eight miles from the coast. Yatton is an equally striking instance; its old name of *Jatone,* from the Saxon, signifying the *Town port,* this place having formed an entrance or port to the channel, which then extended over these vallies.

The sea, from the formation of sand hills and other natural causes, gradually ceased to overflow these districts; but even at so late a period as the year 1304, the 33rd of Edward I. it was found necessary to check its destructive inroads by the formation of sea-walls, dykes, drains, &c. for the security and improvement of the several levels.*

These rich and extensive levels or vales are divided by portions of the MENDIP range of hills, which runs in a south-westerly direction across the county; this was formerly well covered with timber, and plentifully stocked with deer, but now presents a rocky barren aspect.— Several parts of this range abound in valuable minerals,

* Notwithstanding these precautions, the waters of the channel occasionally burst their bounds, especially in 1606, in which year was a remarkable flood, occasioned by a high spring tide, assisted by a strong wind. The waters of the channel broke over the sea-walls and inundated the flat lands to a wide extent.

the principal of which are lead, lapis calaminaris, manganese, and yellow ochre, which are found in veins, in banks, and in fissures of the rock.

The ascent on the north-eastern side of the Mendip hills is more gentle, and allows of more extensive cultivation; and the table-land of the interior has been many years inclosed, and much of it converted to arable land. The climate, however, is cold and moist, being subject to fogs and mists, which, in unfavourable seasons, impede a perfect ripening of the grain.

On the agricultural cultivation of this district of Somersetshire, we do not profess to enter into a minute detail. The low lands, mostly of alluvial soil, are noted for their richness and fertility.* But the principal attention in this division of the county, is paid to the management of the grass land. The meadows are generally laid out in ridges, a few yards wide, inclining to a convex form, with intervening narrow drains, the occasional cleaning out of which produces a valuable supply of rich manure, after being digested in heaps. The meadows are separated by wider and deeper ditches, which, ultimately communicating with the public drainage, prevent superfluous water from remaining on the surface of the ground, and in dry seasons, by shutting the flood gates, a sufficient supply is retained for the use of the cattle and moisture of the land.

The public drainage of the fertile and valuable Levels is subject to the direction of a body of commissioners, who hold their sessions of Water Sewers at stated periods, under the authority of an Act of Parliament, at Wells, Axbridge, and Congresbury. At these courts, reports are received from the juries of the several parishes connected with the districts, through which flow the rivers Brue, Axe, and Yeo. The commissioners are empowered to inflict heavy penalties on persons neglecting to perform their stated duty on the drainage, and from their sentence there is no appeal.

* In the parishes of Burnham, Hunts-pill, and Mark, are pieces of land which have borne crops of wheat, year after year, without any manure, for twenty years together, and produce, even now, remarkably heavy crops.

The expences attendant on this system are considerable, and the enclosure of nearly all the common lands, was felt as a serious hardship by many of the cottagers, who derived benefit from them; but when we regard the public advantage, especially if the land is of a valuable character, the improved salubrity of the district, and the increased facility of access to all parts of the levels, the advantages of the present system will be found to preponderate.*

The limits of this volume will not permit the author to enter so largely, as he might wish, into architectural detail; the parochial churches, will however, form a prominent feature in this sketch, not only as being generally attractive to strangers, but as claiming marked attention from their elegant architecture and stately towers. They are generally erected in well chosen and picturesque situations, either on the declivity of a hill, or on some rising ground above the ordinary level of the plains, and consequently out of the reach of the ancient inundations of the sea.

Many of the churches which the author visited, present a striking uniformity of general design with occasional variations, only to be accounted for by the probable supposition, that they were amongst those erected by Henry VII. when he came to the crown in 1485, as a reward for the attachment which the county of Somerset had evinced towards the Lancastrian party, during the civil wars.— Some others are of earlier date, and were probably erected or repaired by the Glastonbury or Keynsham monasteries. Similar causes may also account for the deficiency of Norman or Saxon vestiges. Excepting numerous instances of

* It must, however, be acknowledged, that enclosures considerably abridge the comforts of the poorer cottagers; who, however just in strictness the title of the landed proprietors may be to the whole benefit arising from an enclosure have in many instances been deprived of essential advantages, so long enjoyed whether by privilege, by sufferance, or by mere custom, that they naturally regarded them as a sort of right; and in some cases were reduced to the extreme of poverty from comparative comfort, or driven by despair to the commission of acts which rendered them amenable to the criminal laws. It would be well worth the consideration of those concerned in future enclosures, whether it might not be a judicious, as well as a humane measure, to appropriate small portions of them to the poor families accustomed to derive benefit from the commons.

Norman fonts, only a few arches of that era were remarked; one is in Kewstoke church, which has the appearance of remaining upon its original site, the present building having been erected over it, without much attention to regularity or uniformity. The other is a fine Norman door way in the church at Christon, and the two are good specimens of that kind of architecture; a third instance is a richly ornamented arched door way in Flax Bourton church, and the fourth is in the church at Compton Martin, the chancel of which, affords the most interesting remains of Norman architecture, that the author has noticed throughout the district which he visited.

The churches are generally built in the florid Gothic style, with lofty and enriched embattled towers, repeatedly presenting themselves to the eye of the traveller, emerging, as it were, from the surrounding foliage. In the interior of these edifices, are two striking peculiarities; first, the sculptured stone pulpits, like the churches, very similar in design, but varying in the profusion of their ornaments; and secondly, the richly adorned remains of the rood lofts; each having formerly on its centre, a large wooden cross, supported on the sides by rows of apostles; and in some instances, figures in ancient painted glass, are preserved in the rich compartments of the carved oak screens beneath these lofts or galleries.*

Many parishes have, or had a manor or court-house almost invariably contiguous to the church, and it is probable that large portions of many of the churches were built by the lords of manors. In some cases the chancel formed the original chapel, to which were added the nave and tower; probably, as is still the case in Italy, by individual benefaction, as were certainly the aisles; the east ends of which were retained and screened off as the erector's private

* W. L. Bowles very justly remarks in his "History of Bremhill," that nothing can equal the picturesque beauty of the towers and churches of Somersetshire, and that some of them present the most perfect specimens of parochial edifices in the kingdom.

chapels.* At all events, their situation plainly indicates a much more intimate connexion between the church and the manor, than exists at the present day.

The remains of ancient court and manor houses form a striking feature of this district of Somersetshire, and one which cannot fail to attract the notice of observant strangers. In some instances, these mansions are retained as the residence of the lord of the manor, and are consequently preserved in excellent repair, though occasionally much altered in many of their original features, if not in their total character. Others have been entirely demolished and made to give way to the spacious modern mansion, or buried in the centre of more recent erections. The greater number have been reduced in size, and converted into farm houses and agricultural offices; whilst too many others have been entirely demolished, or at best a few mouldering walls alone, permitted to remain as indications of a manorial residence.

H. Buckler remarks in his account of Eltham Palace, that the Court House at Clevedon, is unquestionably one of the most valuable relics of early domestic architecture in England; and the remains of those at Kingston Seymour, Tickenham, and Towerhead House near Banwell, together with Barrow and Nailsea Courts, may also be referred to, as interesting specimens, and as models of the style of architecture, which prevailed in their respective eras.

But quitting these subjects, and transferring our notice to more natural, though mysterious productions, of this district, the visitor may find ample room for research, and abundant matter for speculation, in the BONE CAVES at Banwell, Hutton, and Uphill; which are situated within elevated hills above the ordinary level of the waters, but evidently subject at some distant period to their operation. One of them was probably a den of hyenas; another contains the vestiges of the elephant and tiger; and a third apparently was tenanted by bears, wolves, and foxes, in succession.

* See Notes on Cambridgeshire Churches.

Nor will the antiquary find this portion of the county of Somerset destitute of interest; for, passing over the later vestiges of monastic establishments and manorial residences, he may discover, thickly scattered, remains of the BRITONS, ROMANS, SAXONS, and DANES; all of whom were anxious for the possession of a district, not only valuable in itself, but affording many strong positions for security and defence.

The most interesting of these remains will be found to consist in the camps at Worle or Weston Hill, Cadbury Hill near Yatton, Dolebury, Wint Hill and Dinhurst Camps near Banwell, the two Camps on Leigh Down, and that of Maes Knoll, with the remarkable sepulchral Barrow at Butcombe; together with the extensive Earth-Works at Bleadon; and the Roman Station at Uphill, from whence proceeded a Roman Road fifty-five miles in length, leading to the fortress of that nation, at Old Sarum in Wiltshire. This ancient road is traced by Sir R. C. Hoare in his splendid work on Ancient Wiltshire, as " *via Sorbiodunum ad Axium,* " from the ancient Roman name of Sarum, and from its opposite termination near the mouth of the river Axe. This road has been little noticed even by our more celebrated antiquaries; an account of it will be found in the appendix.

The very extraordinary boundary or military rampart, which still bears the name of Wansdike, is another curious work of ancient times, and being connected at its northwestern extremity, with the hundred of Portbury, a description of it will also be given in the appendix. It is supposed to have extended eastward to the banks of the Thames, and thus to have formed a communication between that river and the Severn, which it reached near the point where the Avon falls into it from Bristol.

The appendix will also contain an outline of the natural history of this division of the county, including botanical memoranda, and a geological sketch.

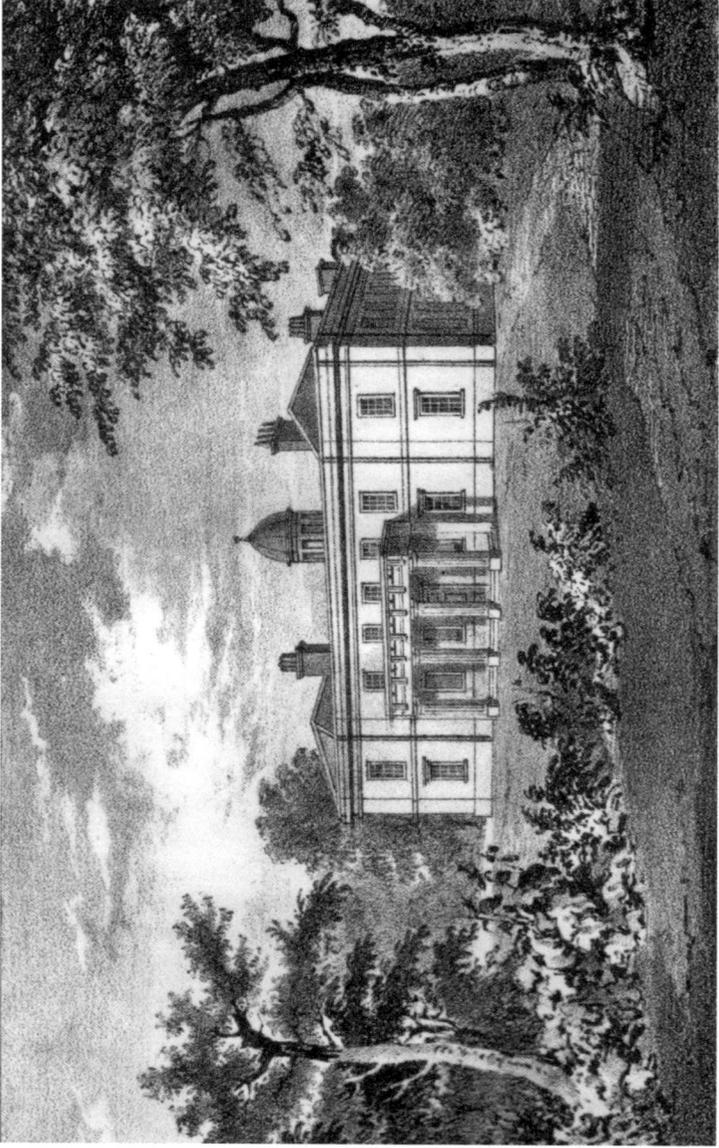

BROCKLEY HALL

The Seat of J.H. Smyth Pigott Esq. to whom this Plate is respectfully inscribed.

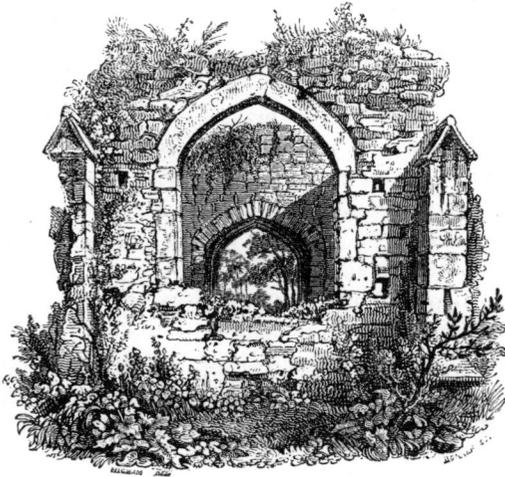

Part of a Monastic Barn at Worle.

CHAP. II.

LONG ASHTON

is a village of considerable extent, inhabited by many of the retired citizens of Bristol. It is pleasantly situated between two and three miles from that city, in a rich and wooded vale, having the lofty ridge of Dundry to the south, and a corresponding range of hills, commencing at the disjointed cliffs of St. Vincent, to screen it on the north. It

is celebrated for its extensive strawberry gardens, which are much frequented during the season by numerous parties from Bristol.

The turnpike road from Bristol to Weston runs through the whole length of this village, forming, in many places, a commanding terrace, overlooking a pleasing variety of hill and vale, finely wooded, and interspersed with gentlemen's seats. The upper road to Clevedon turns off towards the north near the turnpike, and passes on the south side of Rownham Lodge, till it reaches the summit of the hill, from which an extensive view is obtained of the city of Bristol, Clifton, Hotwells, the river Avon, and St. Vincent's Rocks, which lie considerably below it.

Ashton is a place of great antiquity, and was held in the time of Edward the Confessor by three Saxon Thanes, by whom it was called *Easton*, from its eastern situation from Portbury, which was then the most important place on this side of the river ; and that it was also known to the Romans, is probable, not only from their many stations in the vicinity, but also from the numerous coins of that nation occasionally dug up in the gardens, which are here cultivated to a wide extent.

LONG ASHTON MANOR

was given, at the conquest, to the bishop of Coutances. In the reign of Henry I. it was possessed by Adam de Heyron, or Herun, who bore on his seal the appropriate design of three herons; by his only daughter and heiress it came to the de Alno family, which becoming afterwards corrupted into Dando, gave name to a tithing in this parish still called Ashton Dando. It was subsequently possessed by a family named de Lyons, descended from a follower of William the Conqueror, who came originally from the city of Lyons in France, and gave name to the tithing of Ashton Lyons. From them it was conveyed in 1454, to Richard Choke of Stanton Drew, afterwards the eminent Lord Chief Justice of England. He removed to Long Ashton, where

he maintained a magnificent establishment, and on his death, in 1486, was buried in Long Ashton church, in which he founded a chantry, and endowed it with considerable lands, for the support of six priests. His grandson sold the manor in 1506, to Sir Giles Daubney, knt. having previously given the church house, now the Angel Inn, with lands, to feoffees, for the use of the parish, so long as a prayer should be offered up on every Sunday, in Long Ashton church, for his own soul and those of his deceased ancestors.

In 1541, this manor was conveyed by Henry Daubney, Earl of Bridgwater, to Sir Thomas Arundell, knt. of Wardour Castle, Wiltshire, who held other large possessions in Somersetshire, and who sold it in 1545, to John Smyth of Aylburton in Gloucestershire, esq. who was mayor and sheriff of Bristol; in whose family it still continues.

About two miles from Bristol, adjoining the road from that city to Weston, is a castellated lodge and entrance gateway, leading to

ASHTON COURT,

the seat of Sir John Smyth, bart. presenting an extensive front, pleasantly situated on a gentle eminence, in the centre of a luxuriantly wooded park, which was originally enclosed and planted by Thomas de Lyons, in 1391, under a licence granted by Richard II. and who from that time added the name of Ashton to the family appellation. The most ancient part of this building was erected by the Ashton Lyons, who resided in it, and whose arms and devices continue conspicuous on many parts of it. At the back part of the mansion still remains the ancient gateway leading from the park into the outer court, in which the Gothic windows, battlements, and projecting buttresses, are preserved, and it continues to be called the Castle Court. A low doorway, between two lofty turrets, forms the entrance into the second, or inner court, which contains the offices.

The front is one hundred and fifty feet in length, and contains several spacious apartments, which command a fine and pleasing prospect. This front was erected in 1634, by Inigo Jones, who was employed to modernize the ancient edifice, and to convert it into a regular quadrangular pile of building; but whose plan, from the unsettled state of public affairs, was never completed.

Within this mansion is a gallery of paintings, amongst which is the following series of family portraits :—John, first Lord Paulet and his wife.—Thomas Smyth, M. P. for Somerset, 1639; he was also returned twice for the town of Bridgewater. On the breaking out of the civil war, he joined the royal cause, and was at Sherborne with the Marquis of Hertford, whom he accompanied in his retreat into Wales, where he was taken ill, and died at Cardiff in 1642; he married Lord Paulet's daughter.—Hugh Smyth, M. P. for Somerset in 1660, who was made a baronet in 1661.—Sir John Smyth, bart. M. P. for Somerset in 1685. —Christopher Kenn, of Kenn, sheriff of Somerset in 1575. ——F. Rogers, sheriff of Somerset in 1604.——Sir Hugh Smyth, knt. sheriff of Somerset in 1613.—Sir John Smyth, bart. sheriff of Somerset in 1733.—Matthew Smyth, 1580, son of John Smyth, mayor of Bristol in 1544.—Thomas Tewther and wife, of Ludlow in Shropshire, whose eldest daughter and coheir was wife to Matthew Smyth.—Elizabeth Smyth, eldest daughter of Sir Thomas Gorges, knt. of Wraxall, 1627.—Thomas Smyth, M. P. for Bridgewater in 1627.—Florence, daughter of John, first Lord Paulett, wife to Thomas Smyth, M. P. for Somersetshire, and married secondly to Colonel Thomas Pigott of Brockley. —John Ashburnham, of Ashburnham, Sussex, groom of the bed-chamber to Charles I. and II.—Ann, wife to Hugh Smyth, K. B. and daughter of John Ashburnham.—Elizabeth Smyth, daughter of Sir Samuel Astry, knt. of Henbury, Gloucestershire.—Sir Jarrit Smyth, M. P. for Bristol in 1756.—Mrs. Pigott, who married secondly, Sir Jarrit

Smyth, M. P.—Sir John Hugh Smyth, sheriff of Somerset in 1773.—Sir Hugh Smyth, sheriff of Somerset in 1804.—Thomas Smyth.—Humphry Hook, mayor of Bristol in 1643.——-Helen Snachenberg, Marchioness Dowager of Northampton, maid of honour to Queen Elizabeth and wife of Sir Thomas Gorges, bart. of Longford Castle, Wiltshire, and Wraxall, Somersetshire, mother of Lady Smyth, 1627, buried in Salisbury Cathedral, &c.

On the hill immediately above the house, and now over-grown with trees and underwood, is

ASHTON CAMP,

occupying a large space, inclosed by a single ditch and rampart ; which, on the side towards the house, are gradu-ally levelled, or were never completed; affording almost uninterrupted access from it, and suggesting the probable idea, that the chieftain who inhabited the entrenched fort above, quitted it when the times became comparatively quiet and peaceable, for the more convenient site below ; though still preserving a communication with the stronger position.

Within the bounds of the present park, stood an ancient manor house, called

ASHTON THEYNES,

now entirely demolished, but long the residence of a family named de Theyne, probably descended from one of the three Saxon Thanes who held Ashton previous to the con-quest, and whose successors continued to hold the separate manor of Aston Theynes, till the reign of Edward III.

In the valley, south of the village, is an old mansion house, called

ASHTON LOWER COURT,

which was formerly surrounded by a smaller manor, called Ashton Philips, anciently held by a family of much note, who derived their name from the place. The man-sion was erected by Sir John de Æston, or Ashton, pre-

vious to the year 1265, at which time he had a dispute
with the rector of Ashton concerning a chantry which he
founded in the private chapel attached to this house, with-
out due ecclesiastical licence. It must originally have
been a large and handsome structure for the age in which
it was erected. After the lapse of nearly six centuries,
little remains, except the east wing, in which is a large
apartment wainscoted with gilt-edged panels. At the south
end stands the chapel, which is almost entire, the stone
altar remaining in its original state, with a *piscina* in the
south wall; and till within the last few years, the saints'
bell continued to hang in the niche over the entrance.

LONG ASHTON CHURCH

is a handsome structure founded by Thomas de Lyons, the
upper stone of whose monument is still remaining, and
whose arms are emblazoned on the ceiling of the nave, viz.
Argent, a chevron, *Sable*, between three lions dormant,
cowered, *Gules*, which are also cut in stone in the west end
of the tower. The church is chiefly of the perpendicular
English style, and was probably erected in the reign of
Richard II. about the year 1390, but has since undergone
various alterations. It consists of a nave, north and south
aisles, chancel, with a chapel on each side, and a tower at
the west end. The interior of this edifice is strikingly
handsome, and has recently been thoroughly repaired;
generally in good taste, with the slight exception of paint-
ing the clustered columns of the arches of the nave in
imitation of marble, rather than restoring the face of the
original stone. The Gothic oak screen is of superior
workmanship, and its elaborate carvings have been lately
re-gilt and painted. The ceilings of the aisles are di-
vided into square compartments with ornamented angles.
In the windows are the arms of Choke, Lyons de Ashton,
and others, together with the figure of an abbot, a cardinal,
and Edward the IV. with his queen, Elizabeth Woodville,
now much mutilated.

There are numerous elegant monuments within this church; the most striking are erected to the Smyth family of Ashton Court. In the north chapel, in the window of which are the figures above mentioned, is an elegant monument richly decorated with Gothic tracery of a superior character, to the memory of Sir Richard Choke, or Coke, and Margaret his wife, whose figures are placed beneath the canopy.

In the south chapel is a large uninscribed tomb to the memory of Hugh Brook, Esq. of Lower Court, who died in 1556, whose helmet, spurs, and gloves, are suspended. There are also monuments to the memory of individuals of the Sparrow, Mordaunt, Howell, and other families.

Within these few years there was a raised tomb in this church, enclosing the relics of Thomas de Lyons, its founder, surmounted by his effigy, and bearing this inscription:—

" Hic Jacet Thomas Lyons, miles, Xtus Benedictus Deus, Amen."

This curious and ancient tomb was lately removed, for the purpose of levelling the floor, and no part of it preserved, excepting the upper slab, which forms a paving stone in the passage between the chancel and belfry.

Under an arch in the south aisle was an ancient tomb of one of the Gatcombe family, who resided, as early as 1296, in the reign of Edward I. at a place about two miles west of the church, where formerly stood a gate leading from the hill into the combe or valley, and thence called Gatecombe; and from whom it has maternally descended to the present possessor, James Sparrow, esq.

In the church-yard are the stone figures of a male and female of the Lyon family, with the remnant of an ancient inscription:

" DE SALME EYT MERCI AMEN."

Near the church is the old hall of the ancient rectory house, in which the abbot's courts were held; and not far from it, is a fine old monastic farm house of considerable dimensions.

In 1821, Long Ashton contained 4000 acres of land, 202 houses, 227 families, and 1168 inhabitants.* The benefice is vicarial, in the deanery of Bedminster. The Smyth family are patrons of the living, by purchase in 1603.—Rev. Israel Lewis, incumbent.

FLAX BOURTON

is three miles from Long Ashton. It is so called from one large estate within the manor having formerly belonged to the Abbot of Flaxley. The road passes very near to the church, which consists of a nave and chancel, with a low tower; a saint's bell was, till lately, hanging in the small turret over the extreme point of the roof. Strangers passing through this place are sometimes amused by a story, that the minister occasionally preaches upon a pinnacle of the tower, because one, that was blown down a few years since, was cut into supports for the present pulpit. The door-way, leading from the porch into the church, is formed by a fine Norman arch.

This place was originally a part of the extensive manor of Wraxall; in subsequent records it is styled *Hamleta de Bourton*, and was successively possessed by the families of Wrockshall, Moreville, Gorges, Codrington, and by that of Bampfylde, in which it still continues.

Flax Bourton contains 31 inhabited houses, 36 families, and 192 inhabitants. The living is a perpetual curacy, in the deanery of Bedminster, and is a chapel to Wraxall.

North of Flax Bourton is

BELMONT,

the seat of the late G. P. Seymour, esq. now occupied by George Gibbs, esq. It is a handsome residence, seated

* Most of the population returns throughout this work, have been taken from the Parliamentary Census of 1821.

on the acclivity of the hill, with a fine wood in the back ground, above which, the bare summits of the heights rise in a picturesque manner. The plantations are intersected by delightful walks, with numerous openings, which command extensive views over the rich vale of Bourton.

BARROW GOURNAY.

South of Flax Bourton is Barrow Gournay, which was granted by William Rufus to Robert Fitz-Harding; by whose grand-daughter it came to the Harptrees, one of whom adopted the name of Gournay, and annexed it to this manor, in order to distinguish it from the many other Barrows in this county; from the Harptrees it descended to the Berkeleys, and it afterwards was possessed by the Compton family.

The chief ornament of this parish is

BARROW COURT,

a fine old manor house, not far from the church, and occasionally inhabited by Charles Gore, esq. the present proprietor. It was originally a Benedictine Nunnery, founded by one of the Fitz-Hardings, in the reign of Richard I. and was afterwards liberally supported by grants from the successive lords of the manor. On the suppression of this Priory by Henry VIII. in 1536, the house and demesne lands were granted to John Drew of Bristol, on lease for twenty-one years, at the rent of 5*l*. 1*s*. 8*d*. who converted the old building into a dwelling house.

This mansion is a remarkably fine specimen of the Elizabethan gabled style, having been preserved in its original state, both as regards its interior arrangement, and its exterior appearance; the spacious courts and straight avenues never having been modernized. The great hall is a handsome apartment, with some family portraits and other paintings, and a few coats of arms in the windows; at one end is a music gallery, at the other a library. In

c

the great dining room is a fine equestrian portrait of Charles I. passing under an arch. The ceilings are many of them richly decorated, especially that of the principal staircase, which is curiously groined, with a very deep and handsome pendant in the centre, and on its walls are several family portraits. In the small drawing-room is a curious mantel-piece, surmounted by figures of Innocence and Justice, with the arms of Gore in the centre. In one of the sleeping apartments are four ancient pieces of tapestry from scripture subjects, and the ceiling of another is most elaborately moulded, in a very curious and unusual style.

BARROW CHURCH

has been in a great measure rebuilt. It consists of a nave, chancel, and side aisle, extending the whole length, with a low tower at the north end.

The former building was of considerable antiquity ; but several monuments are preserved, and a few coats of arms remained till recently in the windows, relating chiefly to the Gores and their family connexions ; in memory of several of these, there is a handsome marble monument in the chancel. In the south aisle is a curious monument of white, grey, and Sienna marble, with the figures of Francis James, L.L.D. and four sons behind him ; at his side are his wife and five daughters kneeling ; the whole surmounted by the arms of James, and dated 1616.

Barrow Gournay contains 47 inhabited houses, as many families, and 285 inhabitants. The living is a donative, in the deanery of Redcliffe.—Rev. J. Sparrow, incumbent.

About half a mile west of Barrow, and south-west of the seventh mile stone from Bristol, on the Weston road is

BACKWELL,

a respectable, but scattered village, having several handsome residences. The manor is divided into two tithings, called Sores and Bayouse, from the *de Baiocis* or *de*

Baiose, and the *de Sor* or *de Sores*, two families of dis-
tinction, to whom these moieties were granted, more than
700 years ago, by William Rufus, on the death of the
previous possessor, the Bishop of Coutances.

Eastward from the church, but near the church yard,
was formerly a park of 140 acres, surrounding the manor
house, which was decorated with the arms of Churchill;
but little of this now remains excepting a portion of one
of the wings.

BACKWELL CHURCH

is an ornamental building, standing on a picturesque site
having high rocky eminences, with deep glens, partly
clothed with coppice wood and shrubs on the south and
east, and a fine rich valley, bounded by distant hills in
front. Its elegant, yet substantial tower is surmounted
by richly ornamented pinnacles, connected by an open bal-
lustrade, which being flung into deep relief by the back
ground of wood, produces a very pleasing and picturesque
effect when seen from the turnpike road.

The tower of this church is almost unrivalled, both in
its design and execution, and is evidently of two eras; the
lower stories partaking of the early English, the upper one
being of a more decorated character. It is traditionally
reported that a storm in 1603, greatly injured this, as well
as many others of the fine Somersetshire towers, and that
the upper story was afterwards rebuilt. The whole is of
excellent masonry, the buttresses terminating in an un-
usual manner, and the pinnacles highly finished. The
entrance door-way in the west front of the tower, is deeply
moulded, and near the window above, is the following in-
scription:

It has not been satisfactorily deciphered, but the first
three letters appear to stand for JESUS, and the conclusion

c 2

expresses the date, probably of the upper part of the tower, 1552.*

The turret over the saint s bell, is light and elegant; and in the church yard there is an ancient cross, remaining in almost its original state, mounted on four steps and a pedestal.

The interior of this church has recently been repaired, and is now in an excellent state. The windows are of various characters and periods; in the north aisle is a fine one of the lancet form, but with mullions of more recent insertion; likewise two fine specimens of the perpendicular era.* In the south wall of the chancel, are three canopied stalls, which are difficult to account for, but supposed to have been seats for the three ecclesiastical persons connected with the benefice; two rectors (one without cure of souls) and the vicar: or the rector, deacon, and subdeacon. Near these arches are evident vestiges of a *piscina,* or drain for the superfluous consecrated water.

Within the chancel is a Corinthian altar-piece, which blinds the east window. It was removed in 1771, from the

* This inscription has been suggested to stand for an abbreviation of " *In Jesu spes mea.*" " In Jesus is my hope," or more probably, the first three letters may be the initials of " *Jesus Hominum Conditor,*" and the last syllable an abbreviation of " *Supplicamus,*" meaning, " Jesus, we beseech thee, take this building under thy protection," and then follows the date, 1552.

* The architectural terms generally used in this treatise, coincide with those in Rickman's excellent " Essay on English Architecture;" in which he divides the styles into the following general divisions:—1. The *Norman* style; it prevailed for 124 years, from 1065 to 1189, during the reign of William I. to the end of that of Henry II. It is distinguished by its arches being *generally* semicircular, with bold and rude ornaments.—2. *Early English;* it prevailed about 118 years, from 1189 to 1307, in the reign of Richard I. to the end of Edward I. It is distinguished by pointed arches, and long narrow windows without mullions, and a peculiar embellishment, called the toothed ornament.—3. *Decorated English;* continued rather more than 170 years, from 1307 to 1377, in the reign of Edward II. to the end of Edward III. It is distinguished by its large windows, which have pointed arches, divided by mullions and tracery in flowing lines, forming circles, arches, and other figures, not running perpendicularly; its ornaments are numerous and very delicately carved.—4. *Perpendicular English;* prevailed about 169 years, in the reign of Richard II. to the end of Henry VIII. and partially much later. It is distinguished by the mullions of its windows and ornamented panellings, running in perpendicular lines, forming a complete distinction from the decorated style. Its ornaments are crowded, but delicately executed. *See " Rickman's Essay," for further particulars.*

old church of St. Leonard, in Corn street, Bristol. The
font is circular, and of the Norman era. It had been
deposited in the church yard, till the present incumbent had
it repaired and restored to its original station and use.

In the chancel is a large handsome tomb, surmounted
by a figure of one of the Rodney family, to whom the
adjoining chapel belonged. In the chapel is a monument
having the figures of a male and female with six chil-
dren, engraved on brass, which was once gilt, and bears
an inscription to the memory of Rice Davis, who mar-
ried a co-heiress of the Rodneys; date 1604 and 1638.

The chapel attached to the chancel is interesting and
curious, and was formerly open to the north aisle by an
arch now walled up. It has a stone roof with deep ribs
arched in an unusual manner. At its eastern end evi-
dently stood an altar, and the *piscina* attached to it remains;
on the floor are three ancient tomb-stones, apparently
removed from other parts of the building, with ancient
and mutilated inscriptions.

In the chancel is a large ancient tomb, enriched with
florid tracery and six coats of arms, above which, is a sculp-
tured entablature of a corresponding character. On the
tomb is the figure of one of the Rodney family clothed in
armour, to whom the adjoining chapel belonged; beneath
it was their family vault. Above this monument is a
Saxon inscription, and a modern translation engraved on
a brass plate, with the date of 1536. There are also a few
marble monuments on the walls of this edifice.

The rectorial house is a handsome residence and appears
to be of considerable antiquity, having several pointed
windows of three divisions, and ornamental character.

Backwell contains 131 houses, 156 families, and 863 in-
habitants. In this parish the tithes are divided into three
portions, severally belonging to the lay impropriators, a
rector (Lord John Thynne), and a vicar, the Rev. ——
Wake; the Rev. T. H. Biddulph; Fellow of Mag. Coll.

Oxford and vicar of Shoreham, is possessed of the next presentation, and is at present the curate.

CHELVY

is about a mile to the northwest of Backwell, and lies between that place and Brockley; it is for the most part rich pasture land interspersed with wood. The manor was anciently held by Matthew de Moretaine, and afterwards by the de Astons, from an heiress of which family it came to the Percevals, who possessed it for many generations. It was purchased in 1629 by Edward Tynte, Esq. whose wife Ann was daughter of Sir Edward Gorges, Knt. of Wraxall; and whose descendants successively married heiresses of the Halsewell, Fortescue, Kemys, and Walters' families; the united properties derived from these connexions are now possessed by Charles Kemys Kemys Tynte, Esq. M. P. for Bridgewater.

CHELVY COURT HOUSE

is a fine old mansion near the church, and was formerly surrounded by a park, with a warren and a swannery; all of which are now appropriated to the use of the farm, excepting a large portion of the mansion, which has been uninhabited for many years. It contains many handsome apartments, well wainscoted, with elegant gilt cornices and fine ceilings, all rapidly going to decay. It is in the later Elizabethan style, and the entrance on one side, was through an elegant porch, which remains nearly perfect.

THE CHURCH

is a small building of the decorated English style, consisting of a nave and chancel, a south aisle belonging to the Tynte family, and a square tower at the west end, surmounted by a band of open quatrefoils. There are some remains of painted glass in the windows, and several monuments of the Tyntes, whose manorial pew is enclosed by pannels of oak, elegantly carved In the church yard is a cross, consisting of three rows of steps with a pedestal

and a shaft; contiguous to it, is a noble old grange barn, supported by massy buttresses, and with a lofty entrance.

Chelvy contains nine houses, as many families, and 62 inhabitants. The living is in a rectory in the deanery of Bedminster.—William Shaw, D. D. is incumbent.

At the distance of three miles northward from Chelvy, and so far out of the direct road from Bristol towards Weston-Super-Mare, lies

NAILSEA,

a considerable village on the south western edge of what was once an extensive moor, to which it gives its name.

THE MANOR,

with that of Bourton, has always been annexed to the extensive royalty of Wraxall. It was formerly in possession of the de la More family, who probably derived their name of Bythemore, from the situation of their residence near the extensive moor of Nailsea. Subsequently this manor came to the lords of Hinton St. George, and from them, by an heiress, to the Percevals, by whom it was sold in 1582, to the Coles of Bristol, who disposed of the greater part of the lands in small portions.

THE HEATH

is to the eastward of the village, and was lately an extensive tract of rough land, thickly covered with timber and underwood, with the appearance of having formerly been a forest or chace; but it has been since enclosed and brought into cultivation. This tract, originally to all appearance poor and worthless, is extremely valuable in consequence of a bed of excellent coal which is found underneath its whole extent, and is worked in several places by shafts or pits, varying from fifty to seventy fathoms, and in some instances has been worked under ground to the distance of a quarter of a mile from the main shaft.

The firm of Lucas and Co. Bristol, have increased the importance and population of this district, by the establish-

ment of an extensive manufactory for crown glass; and the buildings connected with it are inhabited by a numerous colony of persons in their employ, forming a distinct village of considerable extent.

THE COURT HOUSE

is situated at some distance from the village, adjoining the parish of Chelvy. It is a fine and interesting specimen of the pure Elizabethan style, and must have been a handsome mansion when inhabited by the Cole family; but being now used as a farm house, it is much disfigured by incongruous buildings for the use of the tenant. It was erected probably in 1593, according to a date on a stone mantel-piece in one of the upper rooms, many of which are panelled with oak. The hall is in good preservation, with an ornamented door way, and a grand, or state chamber over it.

NAILSEA CHURCH

is a large building consisting of a nave, chancel, south aisle, and a stately tower surmounted by a band of open quatrefoils. The pulpit is of stone, richly ornamented with panelling, and is singularly constructed; the ascent for the minister, being up a narrow flight of steps in the wall, through a projecting aperture. In the chancel is a handsome old monument dated 1657, to the memory of Richard Cole, esq. his wife and three children, and a brother, William, who succeeded to his estates; above are the arms of Cole, quartered with others, and below, *Azure*, a lion rampant, *Gules*, impaling Cole. The windows, generally, are good specimens of the decorated English style, with one or two, of the later perpendicular era; some of them retaining portions of painted glass. The font is octagonal, and the sides ornamented with roses in quatrefoils; one of which contains a shield with arms. In a stone on the north side of the church is a brass tablet, about a century old, to the memory of Stephen Bennett and Mary his wife, with some curious latin verses, ex-

pressive of their mutual attachment. Another tablet commemorates Tobias Hort, gent. ob. 1722, with his arms, *Sable*, three bends wavy, *Or*.

Returning to the direct road from Bristol, the next place worth notice is

BROCKLEY,

a rural village, a few miles north east of Congresbury, pleasantly situated, and consisting of a diversified surface, with many delightful prospects from the higher grounds. Its ancient name was *Brochelie*, and it was held by a Saxon Thane in the time of Edward the Confessor, who continued to possess it under the Norman dynasty. In 1325, the 19th of Edward II. half a knight's fee within this parish was held by Peter de Sancta Cruce or St. Cross, at which time, other parts of the manor belonged to the family of de Ashton, who afterwards possessed the whole; for in 1367, the 41st of Edward III. Sir Robert de Ashton died proprietor of it. This manor afterwards came to the Berkeleys, and in 1528, the 20th of Henry VIII. it belonged to Richard Harvey, from whose family it was purchased by Col. Thomas Pigott, who married Florence, widow of Thomas Smyth, esq. of Long Ashton and daughter of John, first Lord Paulett.* It is now the property of John Hugh Smyth Pigott, esq. who has greatly enlarged and beautified the family mansion called

BROCKLEY HALL,

where he resides. This handsome seat combines comfort with elegance, and consists of a spacious entrance hall, surrounded with a numerous suite of apartments, richly furnished, and contains a series of paintings, consisting of choice specimens of the ancient masters, combined with a liberal selection from living artists; among the latter, are several from the pencil of Thomas Barker of Bath, well

* This lady lies buried in Long Ashton church, between her two husbands.

known as the painter of " The Woodman." The front of
the house is adorned with an elegant Grecian Portico,
with fluted columns; and in the centre of the roof is an
octagonal dome, fitted up as an observatory, with one of
Dolland's powerful telescopes.

The HALL is decorated with family portraits, chiefly of
the Mores of the Priory, Taunton; the Wadhams of Merri-
field; the Cowards of Sparkgrove; and the Pigotts; among
these are the following :—John, first Lord Paulett, by
Vandyke, and his lady, who was heiress of the Kenns—
of her grand children, by two marriages of her daughter,
Florence, already mentioned, first with Thomas Smyth,
Esq. of Long Ashton, and secondly with Colonel Thomas
Pigott of Brockley—of each husband—of Colonel John
Pigott, M.P. for Somerset in 1705—of his son John Pigott,
who died whilst sheriff of the county in 1730, by *Sir Peter
Lely*—of several of the Coward family, including Thomas
Coward, Esq. recorder of Winchester, by *Sir Peter Lely*
—a fine portrait of Thomas Coward, Esq. sheriff of Somer-
set in 1771, by *Gainsborough* *—Sir Hugh Smyth, sheriff
of the county in 1803, by *Hobday*—and of Mr. and Mrs.
Pigott, in water colours, by *Prince Hoare*—with their
daughter Mrs. Provost and her husband, by *Gainsborough*.
—There is also a fine painting by *Breughel*, the " Seven
Wonders of the World," from Mr. Beckford's collection.
The chairs in the Hall are interesting, having once be-
longed to Charles I.

In the BREAKFAST PARLOUR are a few choice Cabinet
Paintings by the old masters; amongst which are

1 A Cupid, leaning on a bow *Correggio*
This fine Painting was once in the Collection of James II. and is numbered
757 in Bushœs' Catalogue.

2 A Landscape *Creuse*

3 A Flemish Fair *Apshover*
Full of highly finished small figures.

* A grand daughter of Mrs. Coward, who was an heiress of the More family
of the Priory, Taunton, was married to John Pigott, Esq. of Brockley; by
this heiress, the Pigotts are descendants of Edward I. and of Sir Nicholas
Wadham, founder of Wadham College.

4 The Salutation *A. Carracci*
A fine cabinet Picture.

5 A Calm *Vandervelde*

6 The Wise Men's Offering *Old Franks*
A beautiful cabinet Painting

7 The Assumption *Corregio*

8 Boys blowing Bubbles *Le Nain*

9 The Saviour with Martha and Mary . . . *Raphael*

10 A Landscape *Gaspar Poussin*

11 A Flower Piece *Van Kessel*

12 St. John in the Wilderness *Andrea Sacchi*

13 The Saviour and Woman of Samaria *Pietro Cartona*

14 Virgin and Child *Schedoni*

15 The Duchess of Marlborough *Netscher*

16 Man blowing a Pipe - *M. A. Carravagio*
A fine spirited Picture in this Master's best manner.

17 St. John *Leonardo da Vinci*
This Painting was brought from Italy by Mr. Plunkett.

18 Angel and Child *Carlo Maratti*

19 A Cattle Piece *Van Opstael*

20 A Landscape *Gaspar Poussin*

21 Heron Bait *Hondius*

22 A Cattle Piece *Cuyp*

23 Cattle Market, or Campo Vaccino, at Rome *Claude*
From the Praslin Collection.

24 Queen Elizabeth, when a child *Holbein*
From the Collection of James II. and numbered 17 in Bushœ's Catalogue.

25 One of the Medici family *Titian*
A beautiful little Picture.

26 A Vessel on Fire *Vandervelde*

27 The Flight into Egypt *Poelembourg*
One of this celebrated Master's finest performances.

28 A Lady playing on the Piano-forte *Mieris*
A highly finished and perfect Cabinet gem.

29 Men playing at a game *Andrew Both*
From the Collection of William III. the Pictures of this Master are very scarce.

30 Bacchus, Jupiter, and Neptune *Titian*
An undoubted specimen of this admirable Painter.

31 Three Boys *Albano*
This Painting is admirably coloured.

32 Andromeda chained to the Rock ⎰ *Landscape by Claude*
 ⎱ *Figures by Poussin*

The female figure is most beautifully drawn and coloured; and the landscape is in Claude's best style.

The STAIR CASE is lighted by a window of painted glass by Eginton, each pane containing a coat of arms of the family, or some one of its connexions. Its sides are also ornamented with several fine paintings:

33 A Hunting Piece *T. Wyke*

A fine historical Picture from one of Racine's Tragedies.

34 Bear and Dogs *Hondius*
35 Portrait of Master Pigott *Hobday*
36 A Battle Piece *Vander Mulen*
37 An Italian Scene *T. Barker*
38 The Judgment of Paris *Breydel*
39 A Boy plucking a Thorn from his foot . *T. Barker*

This admirable performance may be justly ranked amongst the best works of this celebrated Master, and it reflects much credit on the discrimination of the late Mr. John Pigott, that he so liberally patronized an Artist, whose works already rival those of the best English Masters, and will hereafter be sought after with equal avidity.

In the DINING PARLOUR :—

40 The Charge of the Life Guards at Waterloo. *T. Barker*

" The handling of these conflicting masses, displays a disdainful rapidity, decision, and vigour, which I do not remember to have seen surpassed in the works of any ancient or modern painter. The strokes of the pencil appear as if they had been rained down upon the canvas, with all the noble heat of a soldier, letting drive with his sabre at an enemy in battle.—W. Carey, Author of " *The Fine Arts in England.* " See a review of this spirited picture, in " *Ackerman's Repository,* " for 1828.

41 The Falls of Ferni, near Rome *T. Shew*
42 Napoleon at Elba, from a sketch by SHEW *T. Barker*
43 " Up Guards, and at them," with Wellington's
 Staff, and the flight of Napoleon . . *T. Barker*
44 The Bay of Genoa, from a sketch by SHEW *T. Barker*
45 Boys Bird Nesting *T. Barker*
46 Hero and Leander, and companion . . . *Hobday*

The portraits are those of Lord Byron and Miss Foot.

47 King George IV. *Hobday*

The DRAWING ROOM is elegantly fitted up with ebony furniture, of which, the celebrated chairs on silver castors, that were in the palace at Esher, and belonged to the magnificent Cardinal Wolsey, form a part; also two superb

tables of Florentine mosaic, from Rome; a pair of re-
markably fine mirrors, and a splendid chandelier made by
Blades.—Some of the paintings are

48 The Lake of Guarda, in Italy, from a sketch by
 T. SHEW *Barker*
49 Judith *Guercino*
 This picture is beautifully coloured and has great force in its *chiaro oscuro.*
50 The Deluge *Loutherbourg*
 Bryan, in his Dictionary of Painters, says this is one of his best performances.
51 A Sybil *Dominichino*
52 A Landscape *Salvator Rosa*
53 Death of St. Jerome *Murillo*
 This is considered a very fine original sketch.
54 Old Woman Reading *Rembrandt*

 The LIBRARY is handsome, and fitted up with a well-
selected and valuable collection of nearly six thousand
volumes, including many rare editions of the classics. The
paintings are

55 The Lake of Avernus, in Italy, from a sketch
 by SHEW *T. Barker*
 A fine and much admired painting.
56 Portrait of the Duchess of Richmond . . *Vandyke*
57 A beautiful portrait of Master Pigott, in the
 costume of a Page of Charles I. *Barker*

 Numerous paintings are scattered through the remain-
ing appartments; these which follow, are selected as most
worthy of notice:

58 A Danaë *Vandyke*
59 A Nude *Rubens*
60 Temptation of St. Anthony *Breughel*
61 Ludlow Castle *Barker*
62 Italian Sun-set *Barker*
 The Bay of Baiæ, in Italy, with the Town of Puzzoli, and Caligula's Bridge,
 from a sketch by T. Shew
63 Portrait of Lady Smith *Hobday*
64 Chepstow Castle, by moon-light *Barker*
 A fine effective Picture.
65 The Tribute Money *Guercino*

66 St. Anthony *Murillo*
An admirably fine and forcible performance of this esteemed Master.

67 Richard Reynolds *Hobday*
A fine likeness of that excellent man, from which an engraving has been taken.

68 A Concert *Tintoret*
A fine boldly coloured Picture.

69 The Crowning of Bacchus *Jordæns*
A spirited and freely painted work.

70 The Astronomer *Rembrandt*

71 Cupid, (a fine sketch) *Vandyke*

72 A Head *Guido*

73 A Lady and Child *Leonardo da Vinci*

74 General Washington *Walker*
A good likeness of this great man.

75 A Stag Hunt *Snyders*

76 Hawking *P. Wouvermans*

77 Creation of Birds : . . *Roland Savury*
A curious picture of this master.

78 A Bear Hunt *Hondius*

79 Battle of the Boyne, and companion . . . *Wyke*

80 William Pitt, an excellent likeness . . . *Hoppner*

81 Two Battle Pieces *Vander Muler*

82 A Landscape *Paul Brill*

83 An ancient portrait of Petrarch's Laura . *S. Martini*

A fine bust of NAPOLEON, by Canova, and the emperor's chairs and couch from Mal-maison, are much admired.

Brockley Hall is surrounded by shrubberies and pleasure grounds, extending a considerable distance, including the romantic scenery of Brockley Coomb.

THE PARK,

as well as the rest of the grounds, is luxuriantly wooded; not a tree has been allowed to be cut for several generations; amongst these trees is a noble cypress, which in size and beauty, equals, if not surpasses, those of the luxuriant climate of Italy. It is also well stocked with deer, and contains an ancient HERONRY, an object now become rare, but formerly much coveted by English gen-

tlemen, for the sport afforded by these birds in the favorite amusement of hawking.

A CARRIAGE DRIVE,

extending more than three miles, has been formed through the grounds. It commences at the bottom of the glen, through which it pursues its way, turning to the right, to the high ground above, which has been extensively planted. It continues its winding course along the very edge of the cliffs, on a level with the tops of the trees, which grow on its precipitous sides, through which are caught some fine views of the opposite rocks, rearing their naked heads above the surrounding foliage.*

The road gradually inclines to the west, and after passing a picturesque keeper's lodge,† approaches the ruins of an old wind-mill, erected on the very apex of the down, commanding a panoramic view of the surrounding country, including Brean Down, Worle Hill, Cleeve Toot, Cadbury Hill, Yatton and its church, and the coast of Clevedon, crowned by the ruins of Walton Castle; beyond, are the waters of the Bristol channel, bounded by the coast of Wales.

> " From these towering heights we view
> All that can charm the wondering eye,
> The wide stretch'd valley, long pursue
> The bright sea, mingling with the sky."

The drive from the wind-mill proceeds down to the deer park, above the finely wooded heights containing the heronry; skirting which, a road leads across the entrance into the " Coomb," to another branch of the drive, through the woods on its opposite side, which commands some

* It is understood that Mr. Pigott intends to enrich its scenery by the erection of a *fac-simile* of the beautiful Temple of Vesta, at Tivoli, upon the highest point of the rocks. The model was brought from Italy, by Mr. T. Shew of Bath, under whose direction it will be built. Should this be carried into effect, it will not only harmonize with the mansion and its appointments, but will form a conspicuous land-mark from the Bristol channel, and from the coast of Wales.

† This lodge is inhabited by the Plumleys, as game-keepers; in which capacity they have served the Pigott family upwards of a century.

points of view equally fine with those already noticed. The
gardens are enclosed by high walls, containing from two to
three acres of ground, divided by cross walls into three
portions, the centre one being intended for the erection of
spacious conservatories.

BROCKLEY CHURCH

is a small but well proportioned structure near the court-
house. It has lately been covered with lead, and its ex-
terior completely restored in the style of the several parts
of the original building. Its interior has been also appro-
priately fitted up, and enriched with some beautiful efforts
of the chisel, in rich and delicate carvings both of oak
and stone ; and the whole has been executed with such good
taste, as to present an example worthy to be followed in the
restoration of other churches. The new work in the chan-
cel, in particular, displays great judgment, and the altar-
piece is a perfect model, being composed of a stone screen
of several compartments, surmounted by elaborate fineals
and tracery and a central canopy, under which is a fine paint-
ing of the descent from the cross, by Nicholas Poussin,
from the celebrated Fresco of David de Volterra, in the
church of la Trinitá del monte, in Rome. The altar and
the pulpit, which is ascended by steps leading out of the
vestry, with its canopy, are of richly sculptured stone.

For these, together with the sacramental plate, which
is classically designed, the communion cloth elaborately
worked by Flemish nuns, a fine toned and powerful organ,
and the elegantly fronted gallery, in which it stands, the
parish is indebted to the munificence of J. H. Smyth Pigott,
esq. of Brockley Hall. The whole of these works have
been executed from sketches by the present rector, and un-
der his immediate superintendance. An octagonal vestry
room has been added by him, in the same style and cha-
racter.

The south transept forms the Pigott aisle, which has
also been fitted up, by its owner, as a pew, in a handsome

manner. Within it are several family monuments,—of John Pigott, esq. who died in 1727—of his son John, who died in 1773—and his grandson John, who died in 1816—and also a very elegant monument, by Chantry, surmounted by a female figure, with the bust of the late Rev. Wadham Pigott, who died in 1823.

All the windows are of stained glass, in the old style, by Eginton; those in the south aisle, containing whole length figures of Nicholas Wadham, esq. and his wife, with that of Edward I. in armour, from both of whom the Pigotts trace their descent through the Cowards.

The church is kept in a neat manner, as is the church-yard, deeply shaded with ever-greens, and no graves are allowed to project above the level of the turf. Contiguous to the church is an ancient house, one of the former residences of the Pigott family, called Brockley Court.

Brockley contains 19 houses, as many families, and 173 inhabitants. The living is a rectory, in the gift of the Pigott family. The Rev. Thomas Shrapnel Biddulph, is the incumbent.

This village is celebrated for the romantic ravine, called

BROCKLEY COOMB,

situated on its south eastern side, and affording an avenue leading to the summit of the hill and the downs. It is a fine romantic glen, more than a mile in length, and very narrow, each side being a steep cliff of transcendent richness and beauty. The crags resemble ruins, and every fissure of the rocks affords an asylum for vegetation, which springs vigorously from them, and shades the surface covered with mosses of the richest tints. In the deepest parts, the trees are fine and lofty, and the rocks almost inaccessible to the height of nearly 300 feet, projecting in many places, and towering above the tops of the branches with rude grandeur.* The steep ascent and rugged surface of them on

* There is a small cave in the rocks on the eastern side, in which a hermit is said to have formerly dwelt.

D

each side, are rendered very romantic by the fantastically wreathed forms of the roots of many trees and shrubs which shoot out their branches across the glen. Along the bottom is a fine gravel road, and near the entrance of the Coomb, is a picturesque cottage, whither many parties of pleasure resort in the summer season, and where Dinah Swan, the guardian priestess of the glen, has resided for upwards of half a century.

Evans describes Brockley Coomb as an immense chasm in the mountain, winding upwards for a mile and a half, and terminating on a range of fine heathy downs. One principal charm of this delightful glen, is the circumstance of its being abundantly enriched with wood. He calls it a kind of paradise, which sylvan deities would be pleased to own. Trees of all shapes and characters are here scattered in the most interesting confusion; the young aspiring ash, mixes its elegant foliage with that of the oak; whilst the ivy, and the gayer flowering shrubs, wreathing their tendrils around the trunks and branches of the more naked trees, bestow an additional grace upon the whole.

One side of the Coomb is a lofty mass of limestone rock; yet the ledges of these rocks are so profusely ornamented with vegetation, as to resemble a garden fantastically suspended in the air. The rocks on the summit of the cliffs, are sometimes illuminated by the setting sun, so as to resemble, in detached portions, the fortifications of a city in the distance. Its rays, when breaking through the different openings between the trees, and resting upon the edges of the variegated foliage, on the broken lines of rock, or on whatever object they chance to illuminate, throw a beautifully transparent golden tinge, such as the painter delights to observe in nature, and aims to appropriate by his art.

A ramble over the summit of the rocks, to view the fine effects of light and shade on the woods, especially when enriched by the varied tints of autumn, will amply repay the visitor for his additional exertion.

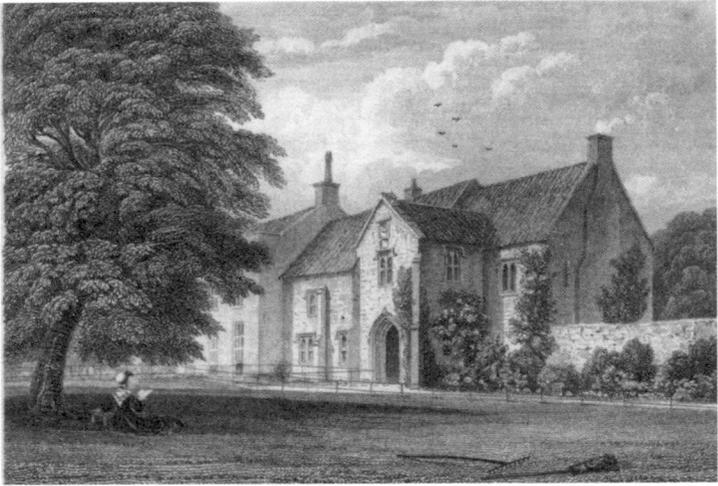

CONGRESBURY PARSONAGE
To the Rev^d Joseph Hawthorne, Rector of Congresbury & to the
other Gentlemen, who have obligingly presented this Plate, it is
respectfully inscribed.

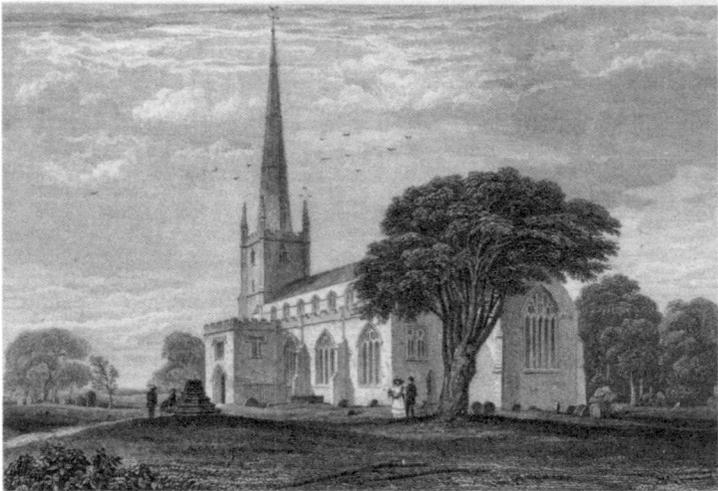

CONGRESBURY CHURCH

About a mile further is CLEEVE, which is described in Yatton parish, of which it forms a part. Here the Bristol and Weston coaches generally change horses, at a small inn and posting house, called the Nelson. Beyond Cleeve is

<center>RHODIATE HILL;</center>

descending which, towards Congresbury, a rich and commanding prospect is presented, bounded on the left by the mountainous range of Mendip hills; below may be distinctly seen the village of Banwell; more to the right is the valley of Yatton, with the Bristol channel and the Welch coast beyond it.

CONGRESBURY

is pleasantly situated a little above the neighbouring level. It is decently built, and has a large and lofty cross, probably on its original site in the centre of the street, consisting of five tiers of steps, surmounted by a tall shaft with arms.* The river Yeo runs through the village, over which is a stone bridge of two arches, the stream afterwards flowing through the level, and emptying itself into the Bristol channel below Wick St. Lawrence.

At the village of Congresbury commences an extensive flat, called the Marshes, which extends to the coast of the Bristol channel at Weston, several miles distant, possessing great depth and richness of soil. It is intersected by innumerable dykes and drains, which do not, however, prevent its being occasionally inundated by land floods.

According to ancient legends, this place derived its name from SAINT CONGAR, a religious hermit, son of one of the eastern emperors; who is stated by Cressy, in his Church History, to have stolen away privately, in a mean habit,

* The remains of crosses are interesting, as the common sign of the Christian faith, beneath which our converted ancestors performed divine worship previously to the erection of churches. They were usually set up in cross ways, or in the most frequented part of any town. Some of these were probably removed afterwards into church-yards, and new ones erected in the like situations, for the purpose, as is supposed, of putting the passers by in mind of offering up their prayers for the dead, whose remains were therein deposited.

<center>D 2</center>

from the imperial court of Constantinople, in order to avoid a matrimonial connection enjoined by his parents. After travelling through Italy and France, he came into Britain, and finding this spot, which then belonged to the Saxon King Ina, very suitable to his wishes, being surrounded by water, reeds, and woods, he settled upon it; built himself an habitation, and afterwards an oratory to the honor of the Holy Trinity. King Ina bestowed on him the little territory around his cell, wherein he instituted twelve canons, and after settling his priory, he went on a pilgrimage to Jerusalem, where he died, and his body was brought back to Congresbury and buried.

In this parish and the contiguous one of Puxton, were two large pieces of common land called East and West Dolemoors, * which were occupied till within these few years in the following remarkable manner. The land was divided into single acres, each bearing a peculiar mark, cut in the turf, such as a horn, an ox, a horse, a cross, an oven, &c. On the Saturday before old midsummer day, the several proprietors of contiguous estates, or their tenants, assembled on these commons, with a number of apples, marked with similar figures, which were distributed by a boy to each of the commoners from a bag. At the close of the distribution, each person repaired to the allotment with the figure corresponding to the one upon his apple, and took possession of that piece of land for the ensuing year. Four acres were reserved to pay the expences of an entertainment at the house of the overseer of the Dolemoors, where the evening was spent in festivity.

CONGRESBURY CHURCH

is a handsome structure, consisting of a nave, chancel, side aisles, and tower surmounted by a lofty spire, which is a conspicuous object for many miles around. The roof of the nave is ribbed, with large square bosses at the inter-

* From the Saxon *Dol,* share or portion.

sections, and is very neatly ornamented with a deep cornice of carved oak trellis work, on both sides. An oak screen separates the chancel from the nave. The font appears to be truly Norman, and remains upon its original pedestal, in its first situation in one corner, with the ancient stone seat around it.

Some of the windows of this church, are good specimens of the perpendicular English style; the upper compartments have been filled with painted glass, but only a few of the figures in them are in tolerable preservation. In the chancel is a *piscina*, beneath a double pointed arch, with elaborate ornaments; and above the arches of the nave, are two rows of clerestorial windows.

CHARITABLE BEQUESTS.—The corporation of Bristol, as governors of Queen Elizabeth's Hospital in that city, have granted, in obedience to a decree of chancery, an annuity of 10*l.* out of their manor of Congresbury, in lieu of certain rights, possessed by the parishioners of that place, of taking spars and stretchers out of a wood, which is parcel of the manor of Kingswood. This 10*l.* continues to be paid to the churchwardens of Congresbury; one third is applied to the repairs of the church, one third to the reparation of the highways, and the remainder is added to the poors' stock.

Congresbury contains 211 houses, 221 families, and 1202 inhabitants. The advowson of the church, together with the manor, was given by John Carr, esq. of Bristol, to the mayor and corporation of that city, in 1583, *in trust*, for the use of the Orphan's Hospital, which he founded there. The living is a vicarage, in the deanery of Axbridge.—The Rev. Joseph Haythorne, incumbent.

PUXTON

is a small parish, two miles west of Congresbury, and was anciently a portion of the great manor of Banwell, being held of the Bishop of Bath and Wells, as superior lord. Its chief possessors were the families of St. Loe, who held

it till the reign of Elizabeth, when Sir William St. Loe
gave it to Ralph Jennings, esq. of Islington, whose son
sold it to Wadham Windham, esq. and from him it came by
marriage to the grandfather of the hon. James Everard
Arundell, now Lord Arundell of Wardour Castle; but
on his death it reverted to the Windham family, and now
belongs to William Windham, esq. of Dinton, Wilts.

<div align="center">PUXTON CHURCH</div>

is a small edifice in the style of various ages, having a
lancet window on the north side, with a good perpendicu-
lar one on the south and others of various date. The
porch was re-built in the year 1557, as appears by that
date beneath a coat of arms, above the door. The tower
overhangs the base considerably, towards the west, and has
been in that situation from time immemorial. It contains
only two bells out of the original five, on one of which is
this inscription: *JOHANNES VODA BROVR*, " he shall be
called John. "

The original oak seats are retained and are of the rudest
and most massy workmanship; on the right of the pulpit
is the old iron frame for the hour glass, by which, sermons
were formerly regulated, as mentioned by Butler.

> " As gifted Brethren, preaching by
> A carnal hour glass, do imply. "

Not far from the church, are the remains of the parson-
age house, now only a cottage, with nothing to indicate
its former respectability, except an ornamental turretted
chimney, which has hitherto escaped what is miscalled
" repair. "

Puxton contains 27 houses, 30 families, and 137 inhabi-
tants. The church was formerly a chapel of ease to Ban-
well. It is now a perpetual curacy, a peculiar in the
deanery of Axbridge, and in the gift of the dean and chap-
ter of Bristol. The lay impropriation, which formerly
belonged to Bruton Abbey, was till lately, in possession

of John Lenthal, esq. of Burford, Oxfordshire, a descendant of the speaker to the long parliament, in 1650; it now belongs to John Francis, esq. as the lessee of the dean and chapter of Bristol.—Rev. Richard Davis, incumbent.

Three miles east of Weston is the singularly situated

VILLAGE OF WORLE,

sheltered from the sea wind, by its remarkable hill, crowned with a wind mill; and rich in mines of lapis calaminaris, and other ores.

The road from Worle to Weston, formerly led round the declivity of the hill, a little above the level of the vale; but the present road is an ascent over a portion of Worle hill, the fatigue of which is compensated only by the commanding view which presents itself, previous to the sudden descent to Weston. In front, is the broad expanse of the Bristol channel, bounded by the Welsh coast, and dispersed over it are the white sails of different vessels, occasionally contrasted with the lengthened cloud of smoke from the steam packets, and the dark rocks of the Steep and Flat Holms; on the right, ascends the cold, bleak-looking hill of Worle, with its rampart of stone, grey with age and exposure to the elements; behind, is the rich and level vale of Congresbury, beautifully ornamented with houses and churches partially visible above the trees; and immediately below, towards the left, is the village of Weston, with its smooth sandy beach terminated by Brean down, and sheltered by the hills from the keen winds, which blow from the north and east.

The village is scattered over a considerable extent, being pleasantly situated on the south east declivity of the hill, which extends full three miles from east to west. It bears a cheerful character and the dwellings have generally an appearance of neatness and comfort.

THE CHURCH

is a small antique building, plainly but appropriately ornamented. It has nothing peculiar except its sculptured

stone pulpit; and some ancient oak seats, which were pro-
bably brought from the contiguous Priory at Woodspring.
These seats are very solid, and turn up, so as to shew their
rough carvings below, which represent in one instance, a
dragon; in a second, two faces within a mask; in a third,
grapes, with vine leaves; and a fourth has a shield with
P B upon it.

At a short distance from the church, and nearly upon the
same level, are the ruins of a fine old building, having
much the appearance of a

RECTORIAL OR MONASTIC BARN,

built of superior masonry; probably in some way connected
with the adjacent priory of Woodspring, to which the
living of Worle, was attached. The walls of this building
are almost entire, forming a parallelogram, with gable ends
about 70 feet long by 30 feet wide. The height inside is
from 26 to 30 feet, and full 40 feet to the apex of the roof.
The north side is supported by eight well wrought chiselled
buttresses, and has an arched window in the centre, nearly
level with the road; there is an appearance of smaller ones
on each side, which have been filled up. The south side is
level with the lower ground, and has also eight buttresses,
more highly finished, whose copings are of an ancient charac-
ter. In the centre of this side only, is a door-way formed
by a plain obtuse arch, nine feet wide and twelve feet high
in the centre. At each end are three narrow lancet win-
dows, very much bevelled from the interior, so as to be
only three inches wide by two feet high on the exterior.
Three other buttresses support each end wall, which is
pierced with six rows of what appear to have been air
holes, formed by three thin stones placed in the form of a
triangle; corroborating the idea, that it was originally
intended for a barn, or agricultural store house.

The parish of Worle contains 130 houses, 140 families,
and 673 inhabitants. The living is a vicarage, in the
deanery of Axbridge, and in the gift of the crown, but
now vacant.—Rev. J. Price, late incumbent.

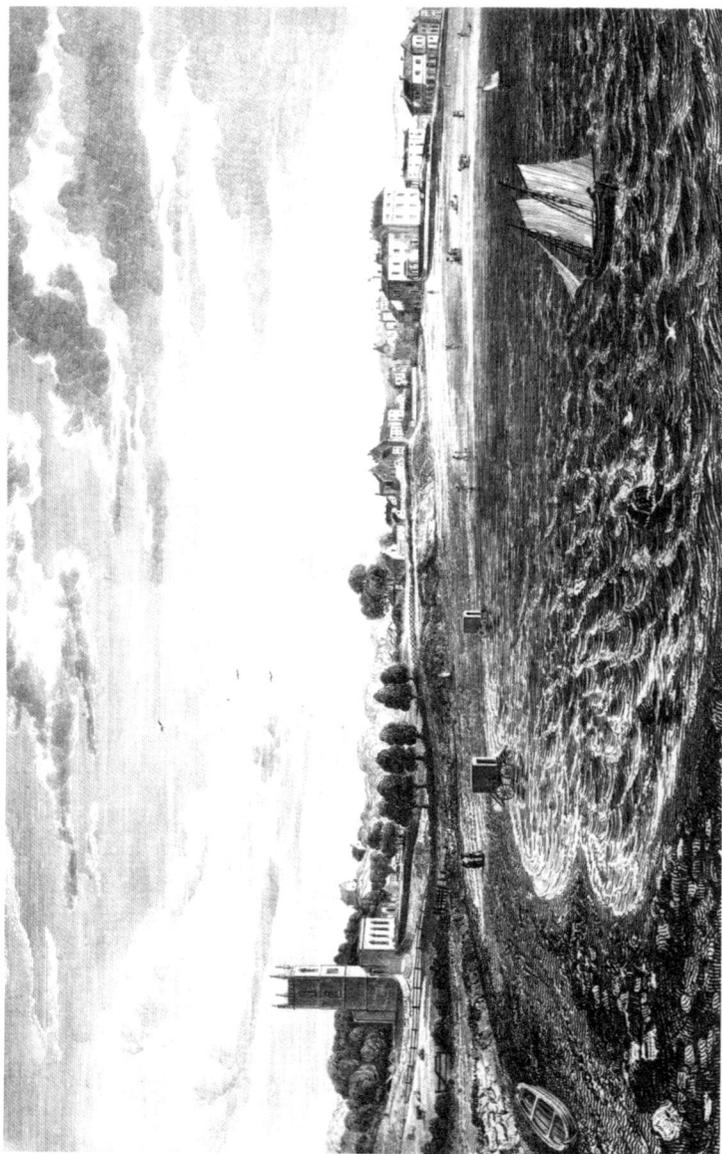

WESTON SUPER MARE

To the Rev^d Francis Blackburne. Rector of Weston. This Plate is respectfully inscribed.

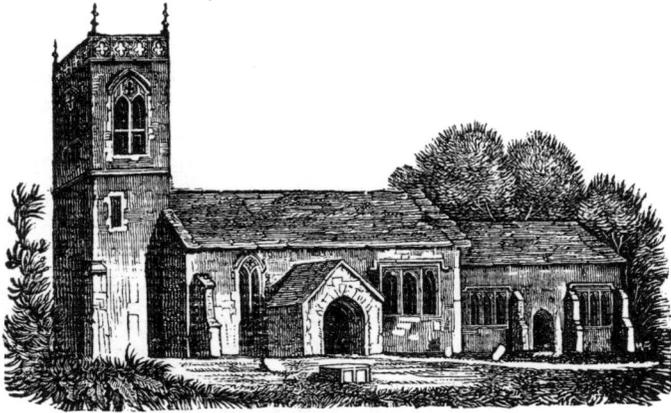

Weston Old Church.

CHAP. III.

WESTON SUPER MARE,

till within these few years, was a small retired village on
the Somersetshire coast of the Bristol channel, at the com-
mencement of that flat and marshy tract of land which ter-
minates at Congresbury, provincially called, the Normarsh
or Northmarsh. It was then inhabited by fishermen, and
contained only a few scattered huts; but the purity of its

air, combined with its smooth and extensive sand beach, added to its vicinity to Bath and Bristol, rendered it attractive to those who sought relaxation from business, or desired a change of scene within a moderate distance, and thus it was gradually raised to the rank of a watering place, supplied with accommodations for numerous visitors.

The fishermen's huts have almost disappeared, and the town now contains about two hundred and fifty houses; a large portion of which are respectable residences, and even some elegant mansions; but notwithstanding this, its general appearance is little inviting to the stranger, especially in gloomy weather, or when the ebb of the spring tides leaves open, large tracts of beach. But on a fine summer evening, when the tide is in, nothing can be more beautiful than the scene which it presents; numerous groups walking on its smooth and extensive sands, intermingled with a variety of carriages, horses, fishermen wading with nets, and the villagers enjoying the exhilerating breeze after the fatigues of the day; all these combine to render the scene interesting to the feelings, and cheering to the spirits.

To these is added the view of the town, lining the ample sweep of its capacious bay, and backed by the lofty hill, surmounted by its grey rampart of stones, with the picturesque church upon its lower declivity. In front, across the waters of the channel, is the distant coast of Wales, with a view of the vessels in the roads of Pennarth; and midway in the channel are the Steep and Flat Holms, appearing, as it were, to float upon its surface; while the setting sun frequently produces a beautiful effect as it catches the sails of the different vessels passing up and down the channel.

The town of Weston every year increases its accommodations, and consequently finds a fresh accession of visitors. From its situation it is calculated for an easy intercourse with Bath and Bristol; by which means it is enlivened by

a numerous influx of visitors during the season, which commences in the spring, and does not close until late in the year. The distance from Bristol is 21 miles, from Bath 33, from Wells 22, and from Bridgewater 20; several coaches run daily to and from the two former cities.

Though Weston is but recently become a place of any importance, yet we find the following notice of the state of the parish in the time of William the conqueror, as preserved in DOOMSDAY RECORD:—" William holds of the bishop, (of Coutances,) *Westone.* Alger held it in the time of king Edward, and it was assessed to the geld for three hides and one virgate of land; the arable is sufficient for three ploughs. In demesne there are two ploughs and two bordurers, and four villanes, and four bordars have two ploughs. There are seventeen acres of meadow, and twelve acres of coppice-wood. Pasture, twelve furlongs long, and two furlongs broad, and six furlongs of moor. It was, and is worth sixty shillings."

THE ANCIENT MANOR,

with a small hamlet to the eastward, called ASHCOMBE, was held for many generations, until the beginning of the last century, by the family of Arthur, of Clapton, originally under the honour of Gloucester, by knight's service. At the beginning of the last century, it passed into the family of Hunter, by the marriage of Mary, daughter and heiress of Edward Arthur, of Clapton, esq. to William Hunter, esq. whose family, in 1696, sold it to Col. John Pigott, from whom it descended to John Hugh Smyth Pigott, esq. of Brockley Hall, the present proprietor.

WESTON BAY

is on the south side of the Bristol channel, immediately opposite to Cardiff, on the Welch coast, and the islands called the Steep and Flat Holms. It is bounded on the southern side by the lofty ridge of Brean Down, which extends a considerable way into the sea, from which the bay makes a sweep of flat sandy beach to its northern ex-

tremity, where the western point of Weston hill juts into the channel, forming a head-land, named Anchor-head, beyond which, a disjointed mass of rock, called Birnbeck, is incessantly lashed by the waves, which in storms, rage against this shore with tremendous violence.

WESTON BEACH

is an unusually fine extent of compact sand, extending upwards of two miles, from the river Axe at Uphill, to Knightstone, beyond the town. The shore is so nearly level, that at ebb tide a stranger would suppose that the sea had abandoned the place; but at full tide the effect is fine; and was there a bridge, or even a passage boat for horses to cross the river Axe, the ride might be continued over the sand from Weston by Berrow to Burnham, a distance of full seven miles; unequalled along the coast of the Bristol channel. But without crossing the Axe, the sands are sufficiently extensive to allow persons, either on foot, or horseback, or in carriages, to enjoy the refreshing breeze from the sea, with perfect seclusion.

The beach is sometimes scattered over with various shells of the most common kind; but this shore affords but little to attract the attention, or to excite the curiosity of the professed conchologist; the most curious being the small land helix, and the viviparous snail; mixed with which are tellinas of various species, auger-wreaths, panamas, and the small olive shells, about the size of rice. On the rocks beyond Knightstone are nerites, limpets, and periwinkles.*

Above the beach is an extensive level moor, reaching in a north easterly direction to Congresbury; on it are various plants usually found on lands that have been covered with the sea, and which are enumerated in the appendix, under the head of "Botanical Memoranda."

HOTELS AND LODGING HOUSES.

The constant resort of genteel visitors for retirement or amusement, as well as for the advantages of sea bathing,

* For a more particular account of the shells of this coast, see Appendix.

soon rendered it necessary to increase the accommodations, and the erection of the Hotel, in 1812, led the way; since that time, the houses on the South Parade, Sea View, Belle Vue, and the row of houses fronting the beach, called Beach Parade, have all been erected, and the small fishermen's huts have given place to a considerable town of commodious and handsome lodging houses.

Reeves's Hotel is a large square house, pleasantly situated near the Esplanade, and commands a fine view of the bay and Bristol channel. It affords all the accommodations to be expected at an inn, united to an unusual degree of comfort.

There is also the Plough Hotel, situated at the other end of the town, at the bottom of West Street, near the Beach Parade, where visitors may be accommodated with comfort and economy.

WESTON CHURCH

is a neat modern structure, situated on a commanding spot, on the acclivity of the hill towards Worlebury, accessible to carriages, and within an easy distance of the town. It is large and commodious, consisting of a nave, 60 feet by 40, with a square tower, a chancel, and a projecting chapel on its northern side. The tower is divided into four stories, ornamented with a pinnacle at each corner, united by an open parapet; but it is rather too small in proportion to its height: within it are three small bells, and a clock with a conspicuous dial-face.

The present edifice, with the exception of the chancel, was re-built about the year 1824; the former church having become much out of repair, and by far too small for the increased population of the place.*

It is recorded, that in 1292, the church at Weston was valued at ten marks, charged with a pension of one hundred

* The late Rev. Wadham Pigott gave, in his life time, £1000 towards this object, and the remaining sum of about £800, was made up by the sale of pews. This gentleman also left £200, of which, the interest is to be given in bread and meat to the poor on Christmas-day and the following Sunday, for ever.

pounds of wax to the treasurer of Wells cathedral. In 1342, 16th Edward III. Walter de Rodney granted the advowson to the prior and convent of Woodspring; in whose possession it remained until the dissolution of monasteries by Henry VIII.

The interior is fitted up with pews, and a capacious gallery extends round three sides. The church is calculated to afford accommodation to a congregation of 1000 persons; many seats being provided for strangers, and most of the lodging houses have pews attached to them by purchase. It is lighted by four rather high and narrow Gothic windows on each side. The chancel has two windows and a centre door-way to the south. It is supported by three well-wrought buttresses, and attached to the south east angle of the new church, into which it opens by a large pointed arch. The ceiling of the chancel is ribbed, with ornamented bosses at the intersections alternately with a few shields, one charged with three clarions, and another with three roses.

The font is a Norman relic. It was for a long time neglected, and suffered to lie exposed in the contiguous paddock, but the present rector has had it cleaned and restored to its proper place in the church. It is of free-stone, (*Oolite,*) unusual in this part of the country.

This church has a small but handsome organ, said to have belonged to George III. The altar-piece is small, but beautiful, and represents the crucifixion. It was presented by John Hugh Smyth Pigott, esq.*

In the chancel are four marble tablets, one of them, surmounted by the family arms, to the memory of Joseph Rogers, esq. of Weston, who lost his life from a fever, caused by his exertions in attempting to recover the bodies of Mr. Elton's sons, who were drowned near Birnbeck. Underneath, is a tablet to the memory of his daughter

* The bust of the figure on the cross is exquisitely pourtrayed, but the lower part is evidently restored or added by an inferior artist.

Harriet. On a flat stone in the floor, is engraved a cross flory and a book, with a figure nearly obliterated; it is placed over a vault, but to whom it belonged is not known, though evidently to an ecclesiastic.

Over the door-way leading from the chancel into an ancient chapel now used as the vestry-room, is a tablet to the memory of Daniel Smith, esq. late of Mayfield Lodge, Derbyshire, and on the right of it, another to the memory of Robert Harvey Mallory, esq. of Woodcote, Warwickshire.

The present lord of the manor, and liberal patron of the place, has had a handsome pew erected, enclosed with oak panels, some of which were brought from the church at Brockley; the centre panel is richly ornamented with carvings of the Pigott arms and crest. Above it are two escutcheons, one of them is emblazoned with the arms of Captain John Pigott, sheriff of Somerset, who died in 1730, and the other with those of the late Rev. Wadham Pigott, who died in 1823.

The church yard is elevated, with a handsome flight of circular stone steps. It commands an extensive and pleasing view of the Town, Bay, Brean Down, Black Rock, Uphill, the Steep and Flat Holms, and Weston hill, with Worlebury camp; within it are the mouldering remains of an ancient cross. A similar cross was also to be seen in the flat grounds, half way to Uphill, which probably formed the ancient beach; the base now only remains, and is removed to a newly erected house, belonging to Mr. Richard Parsley, called White-Cross house.

In the field immediately west of the church, the present rector discovered a Roman coin of the reign of Vespasian, in excellent preservation.

The advowson is a rectory in the gift of the Bishop of Bath and Wells. The glebe-house is contiguous, and being almost buried in fine elms and other foliage, it presents a very pleasing object.—Rev. Francis Blackburne, rector.

PUBLIC AMUSEMENTS.

In fashionable and public amusements, Weston must be

acknowledged to be deficient; " health, not dissipation, "
is the lure it presents. Riding, walking, sailing, and read-
ing, generally have the effect of banishing care from the
mind; whilst the peculiar salubrity of the atmosphere,
expels disease from the body.

The beauty of its downs and neighbouring scenery, with
a firm level sandy beach of two miles in extent, to which
are now added, at the cost of the liberal proprietor, some
delightful drives and shady walks through occasional plan-
tations, combined with cheapness and retirement, form the
chief recommendations of Weston, and render it well
adapted for family parties, who seek retirement, and whose
enjoyments are chiefly confined to their own circle.

THE ASSEMBLY ROOMS

are situated on the beach, at the northern extremity of the
Beach Parade. They were erected in 1826, by the late
Mr. John Thorn, and consist of a handsome suite of rooms
on the first floor, the largest is 40 feet by 20, and com-
mands a fine view of the bay. On the ground floor are
other large and commodious apartments.

SEA BATHING.

As a sea bathing place, Weston has gradually risen high
in the estimation of the public. The strand is a fine level
sand, firm and gradually descending; and when the tides
are high, the bathing is not only pleasant but good, and
at all times it is so at the end of the bay towards Uphill.
This circumstance causes the sands to be much frequented
at the hour of bathing; this, of course, is regulated by the
tide, being about one hour and a half previous to, and
after, high water; which is about 45 minutes earlier here
than at Bristol dock gates.

The bathing machines are well built, and are kept clean
and neat; they are constantly in attendance, except at
very low tides, and may be driven to any requisite depth
into the tide; females being accompanied, if required, by
careful and experienced bathing women.

Near Anchor head, about a quarter of a mile from the hotel, is the original bathing place, on a narrow pebbly beach, formed by an opening of the rock. It is inaccessible to machines, but is romantic, secluded, and convenient at all tides, so that ladies frequently resort to it for bathing.* The accommodations consist of convenient dressing-rooms, and a careful and attentive guide lives in a turretted cottage at the upper end of the narrow beach.

HOT AND COLD BATHS.

On Knightstone are several hot and cold baths, plunging and shower baths of sea water, which were constructed at a considerable expence, and fitted up in a commodious manner, with every convenience ; each bath having a private dressing-room attached to it, and every attention paid to the accommodation of the bathers. An open cold bath, with dressing-rooms attached, has also been formed by enclosing a flat shelving portion of the rock with a breakwater, within which the sea flows at high tide.

Near the Post office, are other hot and cold plunging and shower baths, commodiously fitted up, under the superintendence of Mrs. Jane Gill, one of the original bathing women of the place.

Weston can also boast of its chalybeate springs, at Mr. Smyth Pigott's cottage, and at Tynning's, near Mr. Hogg's. That at Claremont is similar to No. 4 at Cheltenham.

In 1821 it contained 126 houses, 147 families, and 738 inhabitants; though in 1811 the population was only 163. In 1828 it was supposed to contain nearly twice the above number, and to consist of about 250 houses, 280 families and nearly 1500 resident inhabitants. The visitors are calculated to amount to not less than two thousand during the season.

* As this bathing place is appropriated exclusively to the ladies, gentlemen are considered as intruders, and will do well to avoid exciting the indignation of the priestess of the retreat, though it may not prove so fatal as that of Diana to Acteon.

E

KNIGHTSTONE

was a few years ago a solitary rock extending into Weston bay, and an island at high water, but joined the land at its retreat by a bank of loose pebbles thrown up by the sea. An enterprising individual lately purchased it, and raised a causeway above high water mark: it now forms a smaller or secondary bay, with Anchor-head for its other extremity. The present proprietor, the Rev. Thomas Pruen, has also erected a small pier on its eastern side, within which the fishing smacks lie at low water; here the fishermen land the produce of their nets, and here also parties generally embark.

It is said to have derived its name from having been the burial place of a Roman knight, who probably had been stationed, either at the settlement at Uphill, or at the camp above, on the summit of Worle hill. The tradition is in some measure confirmed, by some human bones of a gigantic size having been discovered, when the rocks were blown up, preparatory to the present buildings. *
The rock is composed of a veined limestone, and when polished for chimney pieces, is known by the name of Weston marble.

BIRNBECK ISLAND

is at a short distance beyond Knightstone, near Anchor-head; composed of an immense fragment of rock, apparently broken from the termination of Worle or Weston-hill. Its summit is now covered with a thin stratum of soil, on which is a spare growth of herbage; near the centre is a low hut, for the occasional protection of the fishermen, by whom it is much frequented. It is an island, except for about two hours at low water, at which time a causeway of pebbles is opened to the main land.

* The author has examined some of these bones, which are in the possession of a gentleman of Bristol, who carried them from the island, and can vouch for their gigantic dimensions.

During the sprat and herring season, this island exhibits a most animating scene; the fishermen of Weston, who rent the stands, go after every tide, to collect the produce of their nets, which is disposed of to dealers upon the spot; and then the children of the village are in the habit of gleaning into their baskets, the fishes that fall from them which, from time immemorial are considered to be their perquisite.

Visitors are frequently induced to ramble to the Island of Birnbeck, but the rapid rise of the tide over the causeway, by which alone it is connected with the land, renders it necessary to be careful in choosing the time for visiting it, as well as to guard against delaying the time of return. In the autumn of 1819, a melancholy and fatal accident occurred at this spot to two sons of C. A. Elton, esq. They were amusing themselves in searching for small fish and shells on the rock, until their retreat was cut off by the rapid rise of the tide, over the causeway. Not aware of the danger, they attempted to wade to the shore, but the youngest being carried away by the force of the current, the eldest rushed to rescue him, and both were swept away; the body of one was afterwards taken up in the Newport river, and that of the other at Clevedon. They were accomplished youths, and constant companions; the agonized feelings of their father, may be more easily imagined than described.

The rocks above the shore, beyond the island of Birnbeck, and beneath the lofty promontory of Worle-hill, are of considerable height, against which, in stormy weather, the waves beat with great violence, and to a person standing on the summit of the cliffs, produce a scene of terrific grandeur, beautifully described in the following lines, by Falconer.

" With boundless involution, bursting o'er
The marble cliffs, loud-dashing surges roar;
Hoarse through each winding creek, the tempest raves,
And hollow rocks repeat the groan of waves."

Ancient Tomb at Kingston Seymour.

CHAP. IV.

Worle Hill, Camp.—Kewstoke, Church.—Woodspring, Priory, Ruins. — Wyck St. Lawrence. — Kingston Seymour, Manor-House, Church.—Kenn.—Yatton, Cleeve Toot, Yatton Church, Ancient Sepulchre, Court de Wyck, Claverham, Charitable Bequests, Cadbury Camp.

WORLE HILL AND CAMP.

The road from Weston to Kewstoke, and thence to Woodspring, is by a new and delightful ascent over the western declivity of Worle hill, for which the public are indebted to the liberality of John Hugh Smyth Pigott, esq. lord of the manor. This road commences at the new lodge near Claremont, and gradually winding up the hill,

passes almost close to the north eastern angle of the camp, and commands a very fine view of Weston and Kewstoke bays, which are separated by the rocky promontory called Birnbeck. This view of the two contiguous bays, is remarkably fine at high water, and during the fishing season, is rendered interesting at its ebb, by the activity of the fishermen engaged in their occupations.

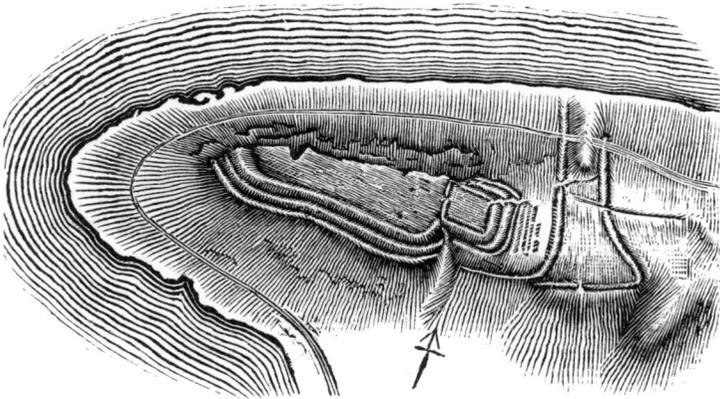

Worlebury Camp.

Worle-hill is an insulated ridge, about three miles long, but not more than a furlong in breadth, and includes a view of not less than 30 churches from its elevated summit. The western end projects into the Bristol channel, above the town of Weston, and is formed into one of the most remarkable fortifications in England. The length of the space inclosed from the inner rampart on the east, to the point of the hill on the west, is about a quarter of a mile, and the medium breadth is about 80 yards; making an area, as supposed, of 15 or 20 acres. On approaching the

camp, from the east, about a quarter of a mile distant from it, is a barrow of loose stones, five feet high, and 15 feet in diameter, which appears not to have been disturbed since its formation. Before arriving at the outer rampart, seven ditches are sunk across the ridge of the hill, out of which it is probable that the stones were drawn, which formed the ramparts; besides which, the whole ground, for a considerable distance in front of the camp, is still covered with loose stones. There are two ramparts, about 15 feet high from the bottom of the ditch, composed entirely of stones loosely placed, without a blade of grass or plant of any kind; these ramparts, with their corresponding ditches, cross the hill in a part where it is about 100 yards broad, and then, turning westward, are continued as far as the security of the station required; those on the north are soon rendered unnecessary by the rock, which is there precipitous; those on the south are gradually blended into the natural declivity of the hill, which is nearly as steep as the rampart itself, and, like it, is composed of loose stones. There is no indication of any building in the area, except a square excavation, about five feet deep, and seven feet square; the sides of which are built with loose stones without mortar; it has nearly the appearance of the mouth of a large square well, which might have been filled up when the place was abandoned.*

Within the area of this camp, are several curious circles, difficult to explain, about 28 or 30 feet in diameter, principally towards the western point; but one is nearly in the centre, composed of separate stones, surrounded by a slight shallow excavation or ditch. On the north side of the camp, there is a subterranean passage from the top, through the rock to the lower part of the hill, but which is now almost filled up with stones.

* This idea seems confirmed by the consideration, that without some internal supply of water, this camp, which was calculated to contain from 40,000 to 50,000 men, would have been by no means calculated for defence, if deficient in an article so essential as water.

This fortress is certainly of an extraordinary kind, and if the Danes ever constructed such places, it might well be supposed that this was a Danish camp; for the Danes much harrassed the shores of the Bristol channel in the 9th and 10th centuries; but it is much doubted whether the roving banditti, who were called by the general name of Danes, formed any of those fortresses, which are so common on the hills of England and Wales. That they occupied this, and others in the same neighbourhood, at the period above-mentioned, there can be little reason to doubt; but the original formation belongs to the Britons. Some chieftain of the Hædui seems to have employed the whole strength of his clan, in fortifying this retreat for himself, his subjects, and their cattle, against the invasion of their enemies, by sea or land; and here he might have dwelt occasionally, with some of the principal of his dependant neighbours.

Some time in the reign of Alfred, the Danes landed near Brent in Somersetshire, but were put to flight by him; great numbers were drowned or slain, whilst others escaped and fled to Worle-hill, where they fortified themselves for a time.*

This remarkable fortification † was occupied, and probably enlarged and strengthened by the Romans, as one of their *Castra Æstiva*, or summer camps; and it is supposed to have been their last retreat in this western district: if not the strongest, it certainly was the most convenient they possessed in all these parts, for surveying the motions of the enemy; and, most probably, was held by them in connexion with their station on Uphill, and their corresponding strong hold on Brean down.

* Seyer's Bristol.

† In the Saxon chronicle it is related that the Danes, in 998 issued from this encampment and advanced into the plain' as far as Biddesham, where they were completely overthrown by the Saxons; and their camp at Worlebury subsequently taken and burnt.

The range of prospect from this camp, is unusually extensive and varied. On the north side is Sandy Bay, terminated by Sand Point; at the inland extremity of which is Woodspring Priory, with its conspicuous tower rising above the surrounding foliage. Beyond this, is the bay and village of Clevedon, with the Severn Sea, and a long line of Welsh coast on its opposite side. More to the east are the glass works at Nailsea and Wyck St. Lawrence. On the west side are the waters of the channel, often profusely scattered over with vessels; nearer in the foreground are the Holms, Brean Down, and the Town and Bay of Weston, which at high tides, appear to great advantage from this commanding eminence.

On the north, as before remarked, the camp is guarded by its natural barrier of perpendicular rocks, which are from 30 to 40 feet deep; beneath their base, at the edge of the water, is a narrow terrace, along which, is Mr. Pigott's new road to Kewstoke.

The ground to the west, at the brow of the hill, above Devonshire cottage, is covered with evident vestiges of extensive earth-works, one of which is a somewhat irregular figure, approaching to the form of a parallelogram, from which there was a broad and gradual descent to the beach. Another embanked enclosure, though small, is in the form of an amphitheatre, and at the western extremity, beyond Claremont, is a tumulus, surrounded by a low ditch, curiously excavated from the sides of the shallow channel in which it is situated.

KEWSTOKE.

A neat lodge has been built at the termination of the new road on the further side of the hill, immediately below which, is the village of Kewstoke, two miles distant from Weston, containing a few farm houses and cottages, at some of which, retired lodgings are occasionally procured.

The ancient name was Stoke, but it afterwards obtained an additional appellation from a saint who had his dwelling

in the hollow of the mountain above the village. The narrow craggy track, with full two hundred natural and artificial steps, by which he went to his daily devotions, still preserve his memory and name, being to this day called, *the pass of St. Kew.* It is now used as the church way from the hamlet of Milton, on the opposite side of the hill, and its summit commands a most extensive prospect.

KEWSTOKE CHURCH

stands immediately below this pass, and retains evident traces of having been a much larger and more ornamented edifice ; some of the walled up arches are still visible, as are also the figured corbels, from which, probably, sprung the arched ribs of a more lofty roof. The inner door-way, leading from the porch into the church, is formed by a fine old ornamented arch, which has decided characteristics of the Saxon, or more properly, the Norman era. It is semi-circular, supported by rather clumsy columns, with grooves winding spirally round them. The mouldings of the arch are charged with various sculpture, the lower moulding being ornamented with a triangular *frette*, forming a series of lozenge figures, filled up with the nail-head ornament. The second, or chief division, has the embattled *frette*, or moulding, in deep relief, formed by a single round, traversing the face of the arch, making its returns and crossings always at right angles, so as to form the intermediate spaces into squares, alternately open above and below. The upper division has the billeted moulding formed by lengths of a cylinder, fastened on alternately round the face of the arch, which is finished at the top by a deep vandyke moulding.

Kewstoke contains 54 houses, 87 familes, and 429 inhabitants. The living is a vicarage, in the deanery of Axbridge, and in the gift of the crown. The Rev. Thomas Hume, incumbent. The great tithes, both of Kewstoke and Worle, are vested in twelve feoffees, in trust for Mrs. Alice Cole's charity in the city of Bristol, for the mainten-

ance of poor persons, apprenticing poor lads, and other charitable purposes.

From Kewstoke, a delightful ride of two miles over the sands, and about a mile through the fields, leads to

WOODSPRING.

Woodspring is a considerable manor in the parish of Kewstoke, situated on the Bristol channel, about ten miles north west from Axbridge, five from Weston Super Mare, and twenty south west from Bristol. It appears to have been of considerable extent, even so early as the conquest, and is recorded in the Doomsday Survey as having been held by a Saxon, named *Euroac*, in the time of Edward the Confessor; but his lands sharing the common fate of confiscation, this manor was granted by William the Conqueror to *Serlo de Burci*, who, with the king's consent, gave it as a dowry with his daughter to *William de Faleise*. It was taxed for six hides, and the arable land was sufficient for twelve ploughs, besides ten acres of coppice and ten acres of pasture, with servants, &c. held in demesne, exclusive of several hundred acres which were at that time added to this manor. It is now celebrated for containing the site and ruins of

WOODSPRING PRIORY,

which was founded for regular canons of the order of St. Augustine, by William de Courteneye, in 1210, the 12th year of King John. It owes its foundation to the murder of Thomas á Becket; to the honour of whom, united with that of the Holy Trinity and of the Virgin Mary, this monastery was dedicated, its founder having been a descendant from William de Tracy, and nearly allied to the three other assassins of the archbishop ; and as all the descendants of these families became benefactors to this institution, it was richly endowed, as the following list will testify.

The founder, William de Courteneye, gave thereto all his lands at Woodspring, and a fardel, (a fourth part of a

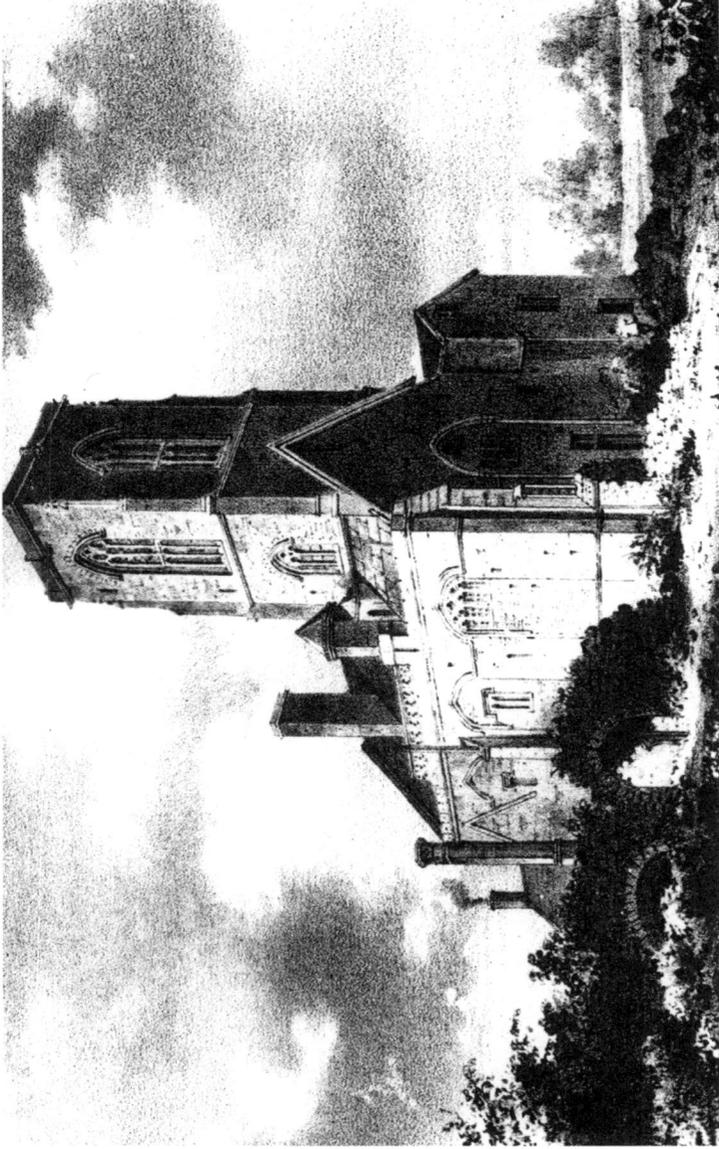

Remains of
WOODSPRING PRIORY
The property of L. H. Smith Pigott Esq. of Brockley Hall.

yard-land,) in Northamnies.—Geoffrey Gilbewyn gave the
manor of Locking.—Hugh de Newton * gave two messu-
ages and 89 acres of arable land in Norton, nine acres of
meadow, &c. in Woodspring, with licence to have a free
and spacious road along the grounds of the said Hugh,
towards Wampulleper.—Henry and John Engayne † gave
the manor of Worle, and various homages and services.—
Robert Offre, or *de Ouvre*, gave seven acres, and Maud
his wife, all her lands in Chandfeld, and several parcels of
land in Sandford, Bicknoller, and other places.—Alice, the
daughter of the said. Maud, and Robert de Ouvre, con-
firmed their mother's grants, and gave four acres in Sules-
worth, one acre in Sulfbrodacre, three acres in le Heye,
half an acre in Estre-dolmore, and half an acre in Westre-
dolmore.—John, son of Robert de Eston, gave the homage
of Martin de la Cume, in Milton.—Henry, son of Henry
Pendeney, gave certain messuages and curtillages at Pen-
deney, and lands in Locking and Locking Croft.—Henry
Limeshest gave the service of Robert Wrench for lands in
Sandford and Woodborough.—Richard Hordwell ‡ gave
lands in Locking; all of which several donations were
ratified and confirmed by King Edward the II. ¶

The name of the earliest recorded prior who presided
over this house, was John, who was living in 1266, 50th

* This person possessed the estate called *Newton's* near Worle, where he re-
sided, and from whom it probably took its name.

† This John Engayne was lord of Colam, in this parish, in the reign of
Edward I. and was one of the 100 gentlemen who signed the Lincoln decla-
ration of 1381.

‡ Many poor persons of this name, and probably his descendants, now live
at Locking and Banwell.

¶ These extensive estates were valued by the king's commissioners at the
dissolution, at 87*l*. 2*s*. 10½*d*. according to Dugdale, or at 110*l*. 18*s*. 4½*d*. accord-
ing to Speed; very trifling sums when compared with their present value.—
Vide Monasticon Anglicanæ.

of Henry III.—Reginald was prior in 1317, 10th of Edward
II. when he purchased 40 acres of land in Woodborough
of Henry Loveshate, for the use of this monastery.—Thomas
lived in 1383, 6th of Richard II.—Thomas de Banwell died
in 1414, 2nd of Henry V.—Peter Loviare was elected in
the same year.—William Lustre died in 1457, 35th of
Henry VI.—John Turman was elected in the presence of
six canons, in 1458, 36th of Henry VI.—Richard Spryng
was prior in 1498, 13th of Henry VII. and resigned in
1525, 16th of Henry VIII.—The last prior was Roger
Tormenton, who was elected when five canons were present,
September 24th, 1525, but on the 21st day of August, 1534,
he, together with John Berche, sub-prior, and five canons,
subscribed to King Henry's supremacy, by which the fra-
ternity became dissolved, and the extensive manors were
granted to Sir William St. Loe, knt. who, in the 8th of
Elizabeth, sold that of Woodspring to William Carre,
from whom it descended by a collateral heiress to William
Yonge, esq. of Ogborne St. George, and is now possessed
by John Hugh Smyth Pigott, esq. of Brockley Hall.

THE PRIORY RUINS

are in a secluded situation, well calculated for religious
retirement, being sheltered from the channel by a narrow
shelf of rocks, called Swallow Cliff,* having on the land
side a dreary insulated flat, closed in by the high ridge of
Worle Hill.

The principal entrance to the priory was in the west
front, where still remains a wide arched gateway, with a
contiguous one of smaller dimensions.

A considerable part of this building, which was, in its
original state, an extensive and handsome pile, is still stand-
ing. The conventual church is almost entire, but con-
verted into a farm house, the nave of which is the parlour

* Swallow Cliff terminates in Sandy Point, on the summit of which is a
large mound of earth and stones, called Castle Batch, and which is supposed
to have been the site of a small castle or battery.

and other apartments, surrounded by offices for the use of the farm; to which purpose the premises have for many years been applied. Little, as Maton observes, did the original tenants imagine, that their whole premises were one day to be occupied by a farmer; that their refectory was to be converted into a cart-house, and the church itself into a cellar.

Modern windows have been substituted for the original ones, of which there were three with broad obtuse arches on the south side of the nave, and one of much larger dimensions at the western end, below which was an entrance door-way which formerly had crockets and fineals. On the summit of the nave walls is an open parapet, pierced with quatrefoils, and at the western angles are octagonal towers, terminated by embattled turrets, the panels of which are also pierced with quatrefoils.

At the eastern end is the tower, a handsome structure 65 feet in height, the walls of which are in excellent preservation, and partially clothed with ivy. It is divided into three portions, and is supported by diagonal set buttresses, terminating below the parapet in crockets and fineals. The upper story is pierced with four large excellent windows of three lights, and a transom with trefoiled head. The tower was originally surmounted by a pierced parapet, with ornamented pinnacles at the angles, and smaller ones in the centre, none of which remain. The interior has been completely extracted, and the shell of this beautiful tower left even without a roof, until the present proprietor had it leaded, to preserve it from further decay.

On the north side of the nave, was a chapel, in which, on one of the pillars which support the tower, was a cherub holding a shield, whereon was sculptured a chevron between three bugle horns; and on the opposite wall was another shield sustained in a similar manner, and charged with a heart between hands and feet pierced with nails, the

usual emblems of the crucifixion.* The cloisters were on
the south side of the church, but only the outer walls are
now standing, the area being converted into a garden; at
the south east angle of which, stands

THE FRIAR'S HALL OR REFECTORY,

an elegant structure, 44 feet long by 20 feet in width, the
walls and roof of which remain tolerably entire. It was
lighted by well formed equilateral arched windows of two
lights, with cinque-foiled heads, and transomed with good
tracery of the earliest perpendicular era filling the head of
the arch. The roof is lofty, and is formed of oak ribs
open to the tiling, with arched principals springing from
ornamental corbels below the cornice. On the south side,
are the ruins of a low round tower, built so as to project
on the outside of the wall, the summit of which formed a
sort of raised gallery or pulpit.

At a short distance on the north west side, is the Mo-
nastic Barn or Grange, a long and lofty cruciform pile,
built in the most substantial manner, with massive but-
tresses, which, together with the window and door frames,
are of freestone, and evidently wrought with much care.
On the south west of the priory are the remains of ex-
tensive fish ponds, which supplied the prior's table with
carp and other fresh water fish.

The buildings, which are now remaining, occupy a large
space of ground, but the priory house, and the several offices,
as they originally stood, extended much further, their foun-
dations being spread over the adjoining orchard and field
to a considerable distance. Notwithstanding this extent
of the premises, the utmost number of the regular canons
resident in the convent does not appear to have amounted
to more than ten at any period, though the lay brethren
and servants, were probably much more numerous.

* These were the original and earliest emblems of christianity, which may
also be observed in the churches at Cheddar, Rodneystoke, Chewton Mendip,
and, probably, in other places.

WYCK ST. LAWRENCE.

The road from Woodspring to Wyck St. Lawrence is somewhat intricate, being a path-way or horse-road through the meadows. It is a rural village, without any thing worthy of remark, except the remains of a fine old cross near the church-yard, and the stone pulpit in the church, which is of very delicate workmanship.

Wyck St. Lawrence formed one of the Roman guard stations on the coast of the Severn and Bristol channel, a series of which commenced at Portishead Point, and were continued at intervals down the coast at Clevedon, Wyck Saint Lawrence, Worlebury, Brean Down, Stert Point, Watchet, Minehead, and Porlock.

This place gave a name to its ancient and respectable possessors, the de Wyck family, who resided at Court de Wyck, near Yatton. They are mentioned as holding two knight's fees in this county, so early as 1166, the 12th of Henry II. in the returns which were made for levying the aid for marrying the king's daughter to the duke of Saxony. To this Thomas de Wyck, succeeded John de Wyck, who was living in the reign of king John, and whose son was a commander in the army of Edward I. against the Scots.

Wyck contains 48 houses, 52 families, and 267 inhabitants. The living is a rectory, but annexed to Congresbury, in the deanery of Axbridge. It is in the gift of the mayor and corporation of Bristol, as appendant to the manor of Congresbury, and therefore included in the endowment of the orphan's hospital by John Carr.—Rev. J. Haythorne, incumbent.

KINGSTON SEYMOUR.

This is a large parish, extending to the border of the Bristol channel, and consists mostly of rich grass land, which being low, and bounded on the north and south, by

small rivers or main drains, is occasionally subject to in-
undations. It is defended from the waters of the channel,
by high banks of earth, through which the spring tides
have sometimes made breaches, and overflowed the ad-
jacent meadows. These occur but rarely, and are gene-
rally stopped during the ebb of the tide, by the country
people, who flock to the spot for that purpose. The lands
on this part of the coast, gain considerably from the water,
by the gradual deposit of mud from the channel, and seve-
ral portions have been occasionally banked off from the
salt water, much to the advantage of the adjacent land-
holders. *

KINGSTON MANOR HOUSE

is an interesting old mansion, attached to the rectory;
erected in the reign of Edward IV. whose favorite badge,
a *Rose en Soleil,* appears in the front. It was built in the
form of a roman H and though greatly modernized, still
retains the old banquetting hall, with its open ribbed roof
and fine projecting porches; the interior of one of which,
contained the entrance to the chief apartments of the man-
sion. In the wall, over the high place within the hall, is
a small aperture, a substitute for a window, sheltered by
a canopy, and directed into the apartment above the with-
drawing room, by which means the host and his family
could command a view of the banquet.

The manor of Kingston Seymour was granted by Wil-
liam the Conqueror to the Bishop of Coutances, together
with many others. † In the time of Henry II. it belonged

* The occasional inundations to which these lands are subject, render the
herbage unpalatable to cattle, for a year or two afterwards, and they produce
offensive exhalations; the inhabitants, though generally robust and healthy,
are subject to attacks of the ague, especially the younger part of them.

† This famous Bishop of Coutances, and monopolizer of manors, lived at
Bristol, where he was entrusted by William I. with the chief government of
the castle. He was an especial favourite with the Conqueror, who made him
immense grants of land, but only for his life, probably because he was an
ecclesiastic, and therefore unable to leave any legal successors. Many of
these lands were in the vicinity of Bristol, and he kept in demesne, or in his
own hands, no less than six large manors in the hundred of Portbury alone.

to the family of Malherbe, who were lords of many other manors in this vicinity, and one of whom, in 1197, the 9th of Richard I. made a grant of this lordship to *Milo de Sancto Mauro*, or Seymour, from whom the place derived its additional designation; it now belongs to John Hugh Smyth Pigott, esq. of Brockley Hall.

A few years since, in a field within this parish, were found an immense quantity of fragments of pottery, some of which had evidently been baked, whilst others appeared to have been only in part subjected to the effect of heat.

consists of a nave, chancel, and aisle, with a tower at the west end, surmounted by two deep bands of open trefoiled mullion work, and a spire. In the church yard is an old tomb of the Bulbeck family. In the chancel is an altarpiece, presented by J. H. Smyth Pigott, esq. of Brockley Hall. It represents the Transfiguration, painted by Smirke, which was engraved for Macklin's magnificent edition of the bible. Within the church is a tablet in commemoration of a destructive inundation, which occurred January 20th 1606, owing to the sea banks breaking down and letting in the waters of the channel, for ten successive days. Another inscription states, that a similar catastrophe happened in 1703, when a violent tempest again broke down the sea banks, and a great number of cattle and sheep, as well as a quantity of corn and hay, were swept away by the violence of the waves.

Kingston Seymour contains 43 houses, 55 families, and 320 inhabitants. The living is a rectory in the deanery of Bedminster, and in the patronage of J. H. Smyth Pigott, esq.—Rev. David Williams, incumbent.

KENN

is a small parish nearly north of Yatton and Kingston; adjoining which is an extensive flat, called Kenn Moor, containing a decoy pool, much frequented by wild fowl

F

during the winter season. This common was enclosed about 20 years since, and, though still liable to injury from occasional floods, is extensively cultivated, and, as is usually the case with alluvial soil, very productive.

This manor was also granted by the Norman William to the Bishop of Coutances; but, about the year 1150, it came to a family named Kenn, who resided for many generations at Kenn Court. Of this family was Thomas Kenn, who, in 1684, was made Bishop of Bath and Wells by Charles II. He was one of the seven bishops, who were committed to the Tower for opposing the reading of the declaration of indulgence issued by James II. On the accession of William and Mary, he refused, however, to transfer his allegiance, and having relinquished his preferment, he retired to Longleat, where he lived in privacy for many years. During his abode there he composed several works, some of which have been published. He lies buried in the church of Frome Selwood, at the east end of the chancel.

This manor passed by an intermarriage of the heiress of the Kenns to the Paulett family, who have lately sold it in parcels.

KENN COURT

was a fine old manor house, but nearly the whole was modernized about fifteen years since.

KENN CHURCH

is a small fabric, having a turret with a pyramidal top at the west end. In the east wall of the chancel is an old monument, containing within a recess, the figures of a man in armour, and a woman with two daughters kneeling, in the dress of the time of Queen Elizabeth. On the base of the monument is a lady leaning on her arm, holding an infant in one hand and a book in the other. Above is an inscription to Christopher Kenn, esq. who died Jan. 21st 1593, and to Dame Florence, his widow, who erected the monument.

On the right side of the communion table is the monument of " Sir Nicholas Stalling, knt. gentleman usher and dayly waiter of our late sovereign, of famous memory, Queen Elizabeth; and afterwards to our dread sovereign lord, King James." dated 1605.

Kenn contains 47 houses, 49 families, and 276 inhabitants. The living is a perpetual curacy, in the deanery of Bedminster, and is annexed to Yatton.

YATTON

is an extensive parish, celebrated for the fertility of its grass lands. The village is about a mile north from Congresbury; consisting mostly of one very long street with many respectable houses. Its most ancient name was *Jatone*, which signifies the *Town-port*, it having in early ages formed an entrance or passage to the channel when its waters overspread the valley; the extensive ridge or batch, on which the greater part of the houses and cottages are erected, is supposed to have been, in remote antiquity, a sand bank, which extended into the Bristol channel. This remarkable bank or ridge, is of a mixed loamy soil, rising a few yards above the level of the adjacent meadows, which join it on each side throughout its whole length of more than two miles. Its breadth is various, being generally from a quarter to half a mile.*

The higher or eastern parts of the parish are of a very diversified character, rising into rocky eminences, partly clothed with woods and intersected by deep ravines or combes; one of which, the Goblin Combe, presents the same features of wild and romantic interest, with mimic battlement, buttress, and pinnacle of native grey rock, intermingled with tufts and sprays of evergreen foliage springing out of the interstices, which we have fully de-

† On the dry or barren pastures south of Yatton, the lesser Centory or Centaury, (*Chironia Centaurium*,) grows somewhat abundantly. A variety of this plant, with white blossoms, occurs near Donhead St. Mary, in Wiltshire.

scribed in its neighbour and rival, of Brockley Combe.
After pursuing its deep windings for upwards of a mile, its
cliffs terminate in a lofty and somewhat insulated eminence
called

<div align="center">CLEEVE TOOT,</div>

which rears its rugged and naked head to a considerable
height above its base, so as to produce a very striking
effect from the rich vale which it overhangs. Its summit
is capped by a mass of rock, which, from below, has all the
appearance of an altar, and if we adopt the theory of Mr.
Bowles in his recent History of Bremhill, that the name
of *Toot* for elevated points, has been derived from their
consecration to *Thoth*, the Celtic Mercury, we may easily
suppose this to have been one of the "high places" on
which the bloody sacrifices of a cruel superstition have
been offered. In a little hollow, just beneath the summit,
is what bears the traditionary title of, "the king's chair,"
being somewhat in the shape of a stone stall or throne,
seated on which the adventurous visitant overhangs a giddy
precipice of near 300 feet. On a high level platform im-
mediately below the Toot, is a rude circular encampment,
which was, probably, the strong hold of some Danish
chieftain,* as we find in Doomsday that his descendant,
"John the Dane," held this manor of Yatton in the time
of Edward the confessor.

The Conqueror conferred it on Giso, the bishop of Wells,
in whose successor, it continued until, in the troublesome
times that ensued on the Reformation, the see was despoiled
of this, and the adjoining great manor of Congresbury by
the rapacity of the courtiers.

The manor of Yatton, having been granted out by the
crown, soon afterwards became the property of the Lords
Poulett, by marriage with the heiress of Kenn, in whom

* But here also the Roman has been. A coin of Antonine was, not long
since, found in the neighbouring glen, and is now in the possession of the Rev.
T: S. Biddulph at Cleeve Court.

it continued until a few years since, when it was purchased
by the Rev. Thomas Shrapnel Biddulph. The above pictu-
resque scenery is included in the grounds of the mansion
house of CLEEVE COURT, which is built in the old style,
many parts of the original mansions of the Newtons and
Pouletts having been judiciously introduced.

YATTON CHURCH
is a large handsome cruciform pile of building, having over
the intersection of the aisles a large well-built tower,
crowned with the base of a spire, the top of which was
many years since thrown down. The belfry contains eight
fine bells, one of which is very ancient, and has this in-
scription round it :

" Misericordias Domini in Eternum cantabo."
" The mercies of the Lord for ever I will sing."

In the church-yard are the remains of a very large and
lofty cross, the steps and base of which are alone existing.
The exterior of the church is much ornamented, and if
the spire were again restored, it would be strikingly
handsome. The west and north fronts are of a superior
character, and present a pleasing subject for the artist.
The west front is formed by the termination of the nave,
having the appearance of a centre and two wings, separated
by octagon towers with low spires, which are repeated on
a smaller scale at the exterior angles. In the centre of
the west front is a deeply arched door-way, with a fine
well proportioned window above; in a niche over it, is
the figure of a bishop wearing a mitre, and holding a
crucifix before him. On the south side is a porch with a
groined roof, containing much exterior ornament; over
which, on a shield, are sculptured three fusils in fesse,
impaling a chevron between three escallop shells.

The interior has been thoroughly repaired; it is lofty
and spacious, with ornamented oak roofs to the side aisles,
having a deep and curious hanging cornice. The roof of

the belfry beneath the tower is deeply groined. The lofty arches of the nave are supported by clustered columns, above which are two rows of five clerestory windows. The font is circular and ancient.

In the wall of the south transept, which is the de Wyck aisle, are two elliptic arches over two ancient effigies of an old man and woman, much mutilated, supposed to represent some of the de Wyck family. In front of these figures stands an altar tomb of white marble, the sides of which are richly sculptured, and charged with fourteen shields, which once bore the arms of Newton and Sherborne impaled with Perrot. On the top are two aged figures, a male and female, representing Judge Newton and his lady.

On the eastern side of this aisle is a small chapel enriched with highly decorated niches, which formerly contained images and much tracery. On an altar tomb within, are the figures of Sir John Newton, knt. in armour, and his lady. This chapel has been completely repaired, and the arms of the successive lords restored, by the Rev. T. S. Biddulph, now lord of this manor, to which it belongs.

Without the church-yard is a fine old rectorial house, held by James Tucker, esq. by lease, from the prebendary of Yatton, together with the rectorial tithes, which have been thus granted out to lay impropriators from the time of Henry the VIII. being one of the earliest instances on record.

An ANCIENT SEPULCHRE was discovered in 1828, on the property of J. H. Smyth Pigott, esq. in a field called great Wemberham, within the parish of Yatton, and about a mile and a half north-west of the church towards Kingston Seymour. About a foot below the surface, was a freestone coffin with a lid, shaped to the body, and fractured; it was of uncommon thickness and had been excavated from a solid block. It contained, besides the principal bones of a skeleton of middle stature, some parts of a lead coffin. The local situation of this interment, is extraordinary,

having, in former times, been a wild, lonely, spot, far distant from human habitation, and over which the waters of the channel frequently flowed, previously to the modern embankments. The head of the coffin pointed to the north west, a strong proof of its great antiquity, and it is conjectured that it was originally covered by a tumulus, which was levelled for agricultural purposes; this will account for its lying so near the surface, and for the absence of large portions of the lead coffin.

At a short distance eastward from Yatton street, were the remains of the ancient mansion of

COURT DE WYCK,

so named from the family de Wyck, its ancient founders and possessors, who obtained their name from their early settlement at Wyck St. Lawrence. The ruins were extensive till very lately; a few aged yews and elms alone remained of a noble avenue of trees, which led to a large gateway formed by two Doric columns, on which were the arms of Paulett and Popham impaled, opening to the grand court; on the left of it, towards the garden, stood the great hall. Beyond, on the same side, were ruins of the great parlour, with the ancient chimney piece, and its compartments of grotesque figures and scrolls. The chapel occupied the north-west angle of the court, the entrance to which was beneath a deep pointed arch, and in the porch were receptacles for consecrated water. * The chapel was small, and had only one large and lofty window to light it from the court. Over the entrance was a small apartment with a window looking into the chapel, for the purpose of hearing mass. On the north was a gallery, and beneath it in the wall, was an elliptic arch, on the back of which, were the arms of Newton, impaled with a lion rampant, billetted, and at the north corner the arms of Chedder.

* One of these, a relic of most beautiful and delicate sculpture, has been rescued from destruction, and now occupies a similar situation in the porch of Cleeve Court, to which the highly wrought door-way of the chapel, has also been transferred.—See the Frontispiece.

On this structure stood a small quadrangular open turret, which formerly contained a bell; in the court was the foundation of a cross, and a little to the west stood a much older and more massive one, called Stalling's cross.

On the 15th of October 1333, this mansion was the scene of great festivity, in consequence of Agnes, the daughter of John de Wyck, being married in this chapel or oratory, by special licence of Ralph, bishop of Shrewsbury, to Sir Theobald de Gorges, of the adjacent lordship of Wraxall.

This estate has recently been purchased of the Paulett family, by Stephen Cox, esq. who has entirely taken down the ancient mansion, and erected a handsome modern edifice near its scite. The noble barn alone remains in its pristine state.

CLAVERHAM

lies about a mile north-east of Yatton, and at a short distance from Court de Wyck. It formerly possessed a free chapel, endowed with lands, the advowson having been held by the lords of the manor. It stood near the present old court house, where ruins of a large building, and grave stones have been dug up. There is here a substantial meeting house belonging to the Society of Friends, who are numerous in this vicinity. This building has an interesting exterior, and is of some antiquity, though rebuilt, this having been one of the original stations frequented by William Penn, the colonizer of Pennsylvania.

CHARITABLE BEQUESTS.—JOHN LANE left by will 100 l. the income to be paid to a schoolmaster in Yatton, for instructing such poor children of the same place as the minister and inhabitants should think fit; also 20 l. the interest to be laid out in bread for the poor not receiving alms of the parish; also half an acre of pasture land for the same use. In 1742, about six acres of land in Kingston Seymour were purchased with this 120 l. and invested in trustees. The rent was lately 10 l. 10 s. and is received by

the churchwarden, who pays it to a schoolmaster in the parish, for teaching eight boys and girls to read, write, and cast accounts. The rent from the half acre is 15s. which is annually distributed, with other funds, amongst the second poor ; the sexton receiving 2s. for keeping the graves of the donor's family " well turfed and briered."

ROBERT DAVIS gave the rent of six acres of ground to the poor inhabitants of Yatton ; this land, with about nine acres of enclosed land, was let for 35l. per annum. In 1787, Mr. H. Turner gave 100l. In 1793, Mr. Christopher Battiscombe gave 40l. In 1797, Mrs. Sarah Plenty gave 40l. In 1779, Mr. John Butcher gave 20l. and in 1797, Mary his wife gave 10l. These four last bequests were for the benefit of the poor of Yatton, and in 1805 were expended in the purchase of five acres of land called Monkland, and about one acre and a half called Long Leg, in Congresbury parish, which were lately let for 10l. 16s. per annum. The income derived from these, and a few other donations, is annually expended in bread and money to the second poor of this parish.

Yatton, in 1821, contained 225 houses, 271 families, and 1516 inhabitants. The living is a vicarage and a peculiar, belonging to the prebend of Yatton, in the cathedral church of Wells.—Rev. Thomas Wickham, incumbent.

To the south-west of the ridge of hills separating the vale of Ashton from the vale of Wrington, which terminates between Congresbury and Yatton, is a pointed hill, on the top of which is an ancient fortress, called

CADBURY CAMP.

It occupies the whole summit of the hill, and extends about 400 yards from east to west. It may be about 150 yards broad, though the breadth varies considerably, being much less towards the west. The area is from thirteen to twenty acres. The fortification is very rude and irregular, consisting in many places of little more than the steepness of the hill, assisted by a slight ditch wrought out of the

rocky soil. Toward the eastern side is an oblique entrance, and further on toward the south is another strait; the south side is precipitous and rocky, and near this side toward the west, is a circular depression in the earth, having the appearance of a well, filled up.

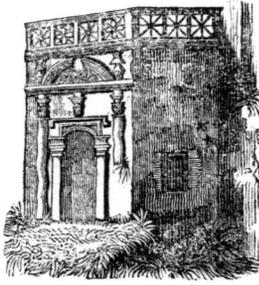

Porch at Chelvy Court House.

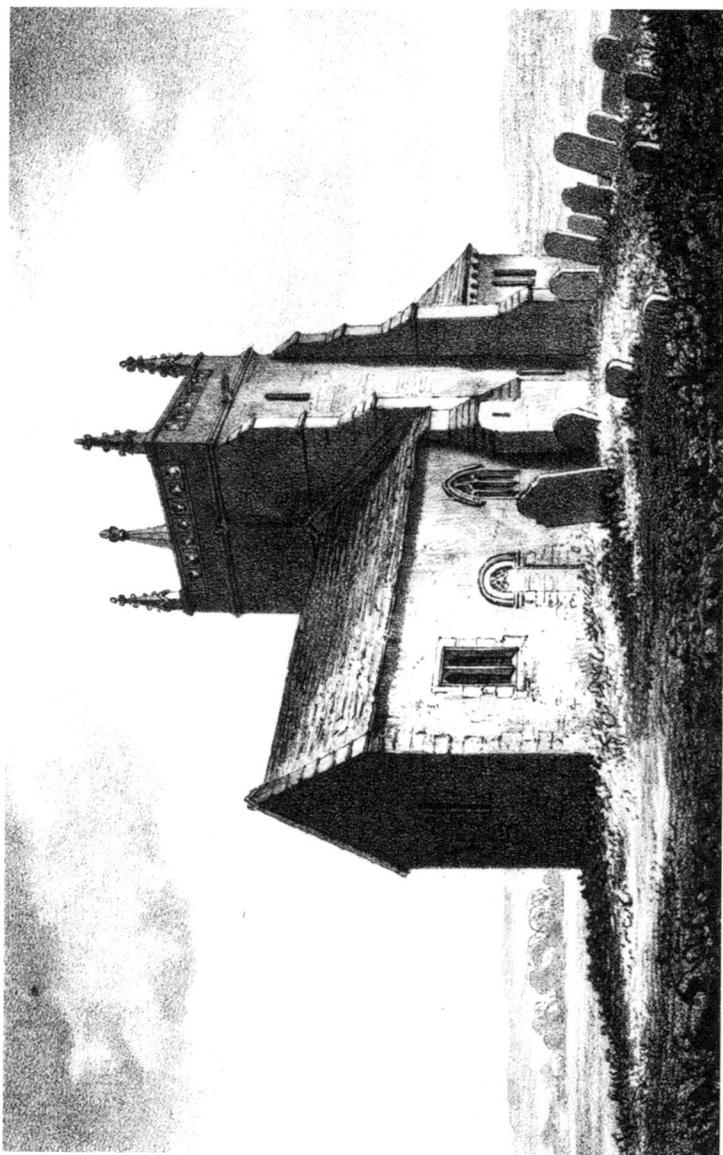

UPHILL CHURCH

The Plate is obligingly presented to the Work by the Rev^d W. Lisle Bowles and Cha^s Bowles Esq^r whose Father was many years Rector of the Parish.

Brean Down and the Black Rock.

CHAP. V.

*Uphill, Infirmary, Parsonage, Church, Earth Works—Uphill
Cave, Explanation of the Section, Bones of the Hyæna, Roof,
Fissures, Description of Bones—Bleadon, British Earth Works,
Church—Lympsham, Church, Parsonage—East Brent, Church
—Brent Knoll—South Brent, Church—Burnham, Church
—Berrow, Church—Parish of Brean—Brean Down—
Steep Holm, Gildas Bardonicus—Flat Holm, Light House.*

UPHILL

is two miles from **Weston**, sheltered by a considerable num-
ber of fine timber trees, with an abrupt hill rising on its
northern side, on the summit of which, stands the parish
church ; the side of the hill towards the village is covered
with smooth turf, but the opposite side terminates in pre-
cipitous rocks, reaching nearly to the beach. The ride over
the sands from **Weston** is very pleasant at spring tides

and may be continued to the banks of the river Axe, which empties itself into the channel between Black Rock and Brean Down.

The situation is remarkably good, and being contiguous to the northern extremity of the fine sandy beach of Weston Bay, a gentleman of the place some time since commenced an extensive range of buildings immediately opposite to the beach; but his affairs becoming embarrassed, the undertaking was relinquished. Had this plan been carried into effect, it would have greatly improved this part of the coast, and possibly led to the erection of houses on the whole line from Weston to Uphill.

At Uphill, between the village and the beach, is the Somerset Sea-bathing Infirmary, established a few years since, and supported by voluntary contributions, for the purpose of extending the advantages of sea-bathing to the poor, who suffer from scrofulous diseases. Its finances are not at present in a very flourishing condition; but it is to be hoped that the wealthy inhabitants of the county will more generally extend their support to so benevolent and excellent a design. Near the village is a coal wharf on the river Axe, where vessels from 60 to 80 tons may conveniently unload.

Uphill parsonage is much admired; its surrounding shrubberies were planted and laid out by the Rev. W. T. Bowles, who was rector of Uphill and Brean from 1796 to 1786. His son, the Rev. W. L. Bowles, the well known author of many beautiful poetical works, revisited this spot in 1828, forty-five years after he had witnessed the planting of every tree; and he remarks, in his History of Bremhill, that, although so many years had passed away, he found the garden precisely as it was when he left it as a child, excepting the additional beauty that time had given it.

UPHILL CHURCH

is a small structure with a low tower, dedicated to Saint Nicholas, but, from its commanding situation on the very

apex of the hill above the village, is a well known land-mark for sailors, being frequently white-washed,* and is a conspicuous object for many miles round the inland country. It is surrounded by an extensive church-yard enclosed from the down, which commands almost a panoramic view of great extent. Towards the east are Locking and Banwell, and the broad vale of the North Marsh, bounded by the hills beyond Congresbury and Yatton ; south-east is Worle, and nearly north is Weston, appearing to much advantage, with its sweeping bay ; immediately below to the south, is the river Axe, winding its course toward Bleadon ; and be-yond, is Bridgewater bay, with Brent spire and knoll, and the Quantock range in the distance.

Uphill contains 39 houses, 51 families, and 270 inhabi-tants. The living is a rectory, in the deanery of Axbridge.— Rev. Thomas Deacle, incumbent.

Beyond the church, on the downs towards Bleadon, are the walls of a windmill, near to which are some extensive

EARTH WORKS,

with two solitary tumuli ; the former have been too long subjected to the plough, to be very readily traced. But they are decidedly indicative of a Roman station, from whence commenced the Roman road, which has been traced by Sir Richard Colt Hoare, for 55 miles, to the important fortress of Old Sarum in Wiltshire ; and, from the two re-maining barrows, in connection with the extensive remains of earth works on Brean Down, we may conjecture that it was previously a station of the Britons. Beyond these works, is the mansion fo the Paynes, situated on the centre of the eminence.

* The white-washing of public and private edifices is a common practice in this part of the country. To a stranger arriving at the edge of the lofty Men-dip hills above Blagdon and Burrington, the whiteness of the distant buildings below him, affords a pleasant mixture with the more natural objects of the vale ; but, on approaching the several edifices, the fine effect of strong masonry is quite destroyed by the unmeaning uniformity of the white-wash.

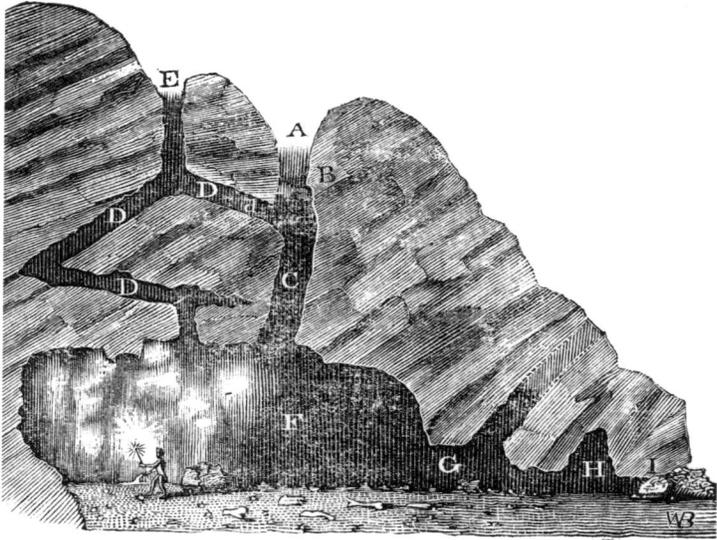

UPHILL CAVERN.

EXPLANATION OF THE VERTICAL SECTION.

A.—High portion of the main fissure, where the bones and teeth of the hyæna, rhinoceros, &c. were found. The dotted line shows its direction before the rocks were blasted.

B.—Two large blocks of stone, that lay like a portcullis in the avenue, forming a midway basement for the diluvium and bones above.

C.—Lower part of the large fissure, containing a wet tenacious loam full of birds' bones only.

D.—A second fissure, which, branching off to the north-west from A. and C. by an ascent of twelve feet, then dips away to the north by a descent of twenty feet, makes an acute angle back to the south, and descends vertically through the roof into F. it was almost filled with sand of a high ferruginous colour, most probably stained by the oxyd of iron, which the water precipitated from the lime-stone.

E.—A small vertical fissure, opening in the face of the quarry, ascending from D. through this, the sand was probably washed in, for there was none in A. B. C. or Dd.

F.—The Cavern; the floor of which was covered with the same coloured sand as D. on the surface was a thin deposit of mud, on which were partial mammillary spots of stalagmite, none of which were more than two or three inches thick; on it were also a great many bones of sheep; about a foot deep was found a coin of the Emperor Julian, and a piece of old pottery.

G.—Is a small cave leading away from F. with a chimney ascending towards the south-east.

H.—Is another smaller cave forming a sort of anti-chamber to F. and G. Here was found a fine stalactite, and a curtain-like fringe of the same substance.

I.—Is the stone that projected on the fox's gangway, the angular surface of which was as highly polished as a marble chimney-piece.* The continuation of this adit, when cleared away, will unquestionably lead to an entrance from the level outside. The mouth appears to have been choked up by an irruption of the sea, which rolled in a quantity of loose stones and alluvial matter; over this, the detritus of the rocks above, had, probably, formed a talus, on which the grass, &c. grew, so as to prevent it being observed; it has not been opened, owing to the immense quantity of quarried stone lying outside.

* There is another rock in F. whose edges have been smoothed and rounded, apparently by sheep, but the wool could not effect the high polish of the fur.

About thirty feet from the base of the precipitous and rocky termination of Uphill Down, and almost immediately beneath the church, is the entrance to a CAVERN, which was accidentally discovered in 1826 As some workmen were quarrying stones in the hill, they crossed a fissure containing a quantity of bones, some of which were shewn to the Rev. David Williams of Bleadon, who recognised them as belonging to animals of a country and climate differing from our own.*

The men were shortly after discharged; but, hoping the discovery of other remains, and probably a Cavern, would repay for the labour of further research, Mr. Williams employed two of them to pursue the fissure, in the course of which, he discovered bones of the rhinoceros, hyæna, bear, ox, horse, hog, fox, polecat, water-rat, mouse, and bird.

The bones and teeth of the extinct species of the hyæna were very abundant, and all the bones of the animals of

* This account is chiefly extracted from the Rev. David Williams's description of the Cave, in a letter to the Rev. William Patteson at Shaftesbury.

the larger species were so gnawed and splintered, and
evidently of such ancient fracture, that no doubt can exist
of its having been a hyæna's den, similar to Kirkdale, and
Kent's Hole.

All the ancient bones were found in the upper region of
the fissure, and were so firmly imbedded in the detritus,
as not to be extracted without difficulty with a pickaxe;
but on removing the two huge fragments of rock, mentioned
in the explanation of the section, as blocking up the
avenue, there was a wet, tenacious loam, abounding with
an innumerable quantity of birds' bones only, which Pro-
fessor Buckland supposes to have been introduced by foxes.

After working six days, the cavern was discovered, ten
to twelve feet in height, extending about forty feet from
north to south, and varying from eight to twenty feet from
east to west. The roof is very irregular and full of hollows,
and partakes of the general character common to all lime-
stone formations. The half corroded fragments of coral,
shells, stems of encrini, spines of echini, and the irregular
ledges of the rock, with nodules of chert, projecting along
the sides and roof, are exactly similar to those described
by professor Buckland as characteristic of the Kirkdale
cavern, which is likewise in the limestone formation. The
floor was covered with bones of the sheep, and on digging
into the mud and sand, of which it consisted, several other
bones of sheep, birds, cuttle fish, and fox, were found.

The fissure was nearly vertical, and about fifty feet deep
from the surface to the mouth of the cave, being situated
at the very western extremity of Mendip, in a bold mural
front of limestone strata. There were some fine stalactites
depending from the roof, and partial spots of stalagmite
on the floor, but as the water does not appear to percolate
so much as in many other caves, and it having been ac-
cessible to the level within the last fifteen hundred years,
was neither so abundant, nor so brilliant, as is often
witnessed.

When Professor Buckland first visited this cave, his quick eye detected where the foxes, in their ingress and egress, had polished the irregular points of the rock, projecting on their gangway, as smooth as if they had been submitted to the lapidary's wheel. But this entrance from the level must have been long since closed up, probably by an irruption of the sea, as no tradition exists of such opening having ever been, and the floor of the cave is but a few feet above the level of the sea.

The Rev. Mr. Williams has recently cleared out another fissure, which branched away from the main entrance, ascending to the north-west, for about fifteen feet, whence it descended with a northern inclination for about thirty feet, then made an acute angle back to the south, and terminated in a vertical chimney, through the roof of the cave. The lower extremity of this fissure, as well as the floor of the cave, was full of sand, apparently the same as that on the sea shore, but of a high ferruginous colour.

In this sand and near the surface, was found a Roman piece of pottery, and a coin of the emperor Julian; deeper were found other bones of sheep, fox, cuttle-fish, and bird; and twelve feet through the sand was clayey loam, which has not yet been examined.

Mr. Williams considers that here are evidences of three distinct periods of time, when water was a powerful agent: first, in the higher fissure where the hyænas were found, with the quantity of gnawed and cracked bones, so firmly imbedded in the diluvial detritus. Here was *no sand*; but a stiff, red calcareous loam, forming almost a brecchia of bone, stone, and earth. This only can be attributed to that great and violent catastrophe, recorded by Moses.

Secondly, the period when the sand was deposited by the sea in the second fissure, and washed into the floor of the cave, through the vertical chimney before mentioned; and this may readily be supposed to have happened, by all who believe the whole valley up to Glastonbury and be-

G

yond was as much sub-marine, as the bed of the Severn is now.

Thirdly, it is probable that there has been, within these 1500 years, an unusual and violent irruption of the sea, which choked up the adit from the level, by which the sheep and foxes entered, filled the caves with water, and deposited the comparatively thin crust of mud, which covered the sand, when the cave was first discovered. The coin and pottery above-mentioned must have been introduced through this entrance from the level; for the high fissure had been undisturbed since the period when the hyænas found it their grave; and the entrance from the level was only closed up by the washing in of a quantity of loose stones.

Mr. Williams has liberally presented the greater part of the bones discovered at Uphill to the Bristol Institution; where, from its locality, they possess great interest. A few were sent to professor Buckland, and others to the Geological Society in London. Among these bones preserved in the museum of the Bristol Institution, is a fine left lower jaw of the hyæna, with three molar teeth and one canine tooth. There are also several large incisor, canine, and molar teeth, metatarsal bones, &c. which evidently belonged to full grown animals; the former being worn down and having the base coated with tartar; exclusive of others evidently belonging to young animals, by the perfect state of their crowns. Some of the splintered bones are of great size, and many of them retain visible signs of having been gnawed by the tusks of the hyæna, the outer surface being removed in ridges, just such as would be formed by an animal of the modern species.

The den of the hyænas was probably confined to the upper part of the fissure, where all the *ancient* bones were found, which are unquestionably antediluvian; the diluvian detritus having completely choked up the passage to the lower part. These bones, not having been aggregated

and carried down by the waters to the floor of the cave, can only be accounted for, by the immense fragments of rock, which, at some period, were accidentally thrown as a portcullis into the avenue, completely blocking up the fissure, and forming a midway basement for the superincumbent mass of bone, earth, and stone.

The sheep and bird bones are of ancient date, though recent, when compared with the hyænas. The bones of birds were so perfect and abundant, that it is difficult to suppose them to have been introduced by foxes, who, in the progress of mastication, could scarcely have avoided cracking them. It is possible that the birds retired to die in this dark and quiet recess, which had a lateral entrance communicating with it.

BLEADON.

The road to this village winds over Bleadon Hill, being part of a lofty ridge, running from the interior of the country to the coast of the channel by Uphill.

Bleadon * is a place of considerable antiquity, and it is recorded, that before the conquest in 1053, it belonged to Githa, the wife of the Saxon Earl Godwin, who gave it to the cathedral of Winchester. At the time of the Norman survey, it was applied to the use of the refectory of that monastery, and to this day it continues to be vested in the dean and chapter; a remarkable instance of ecclesiastical succession.

On the western side of Bleadon Hill, is an extensive

BRITISH EARTH WORK,

or camp, consisting of one deep vallum, enclosing a wide extent of ground. It was evidently an extensive British settlement, subsequently occupied by the Romans, and connected with the Roman road leading to Old Sarum in Wiltshire. The enclosure is beautifully situated, sloping down

* Celtice, *Blaen-dun*, the hill at the extremity of the (Mendip) range.

to the banks of the river Axe, in the form of a grand and spacious amphitheatre.

Hearne relates, that a bloody contest occurred on Bleadon Hill, in consequence of the Danes having landed at Uphill, where they left their fleet and pursued the inhabitants, who, with the solitary exception of one infirm woman, fled before them. This woman being pressed with hunger, sought provisions on board the Danish ships, which finding deserted, she cut from their moorings. The Danes returning from the pursuit, found their vessels adrift and borne to sea by the tide. The inhabitants recovering from their surprise, took courage, and fought an obstinate battle with their assailants on Bleadon Hill.

BLEADON CHURCH

has a good tower, but the body is inferior. It is an ancient edifice, for the chancel and high altar were dedicated in 1317, the 11th of Edward II. Without the bounds of the church-yard is a cross with a square fluted column, elevated on an octagonal flight of steps.

The river Axe flows near Bleadon, and is crossed by a bridge, over which the road proceeds to Lympsham. Vessels of small burthen come up to this bridge, chiefly laden with coal; beneath it are flood-gates to prevent the tide rising further up the level.

Bleadon contains 102 houses, 116 families, and 518 inhabitants. The living is a rectory in the deanery of Axbridge, in the gift of the Bishop of Winchester.—Rev. D. Williams, incumbent.

LYMPSHAM,
ANCIENTLY LYN-PILS-HAM.

Leaving Bleadon wharf and bridge, and proceeding in a southerly direction, the traveller soon arrives at the ancient channel of the Axe, the boundary of the parish of Lympsham. The site of this channel is now crossed by an elevated causeway passing by the little inn, whose sign, Hobb's Boat, records the ancient ferry over the Axe.

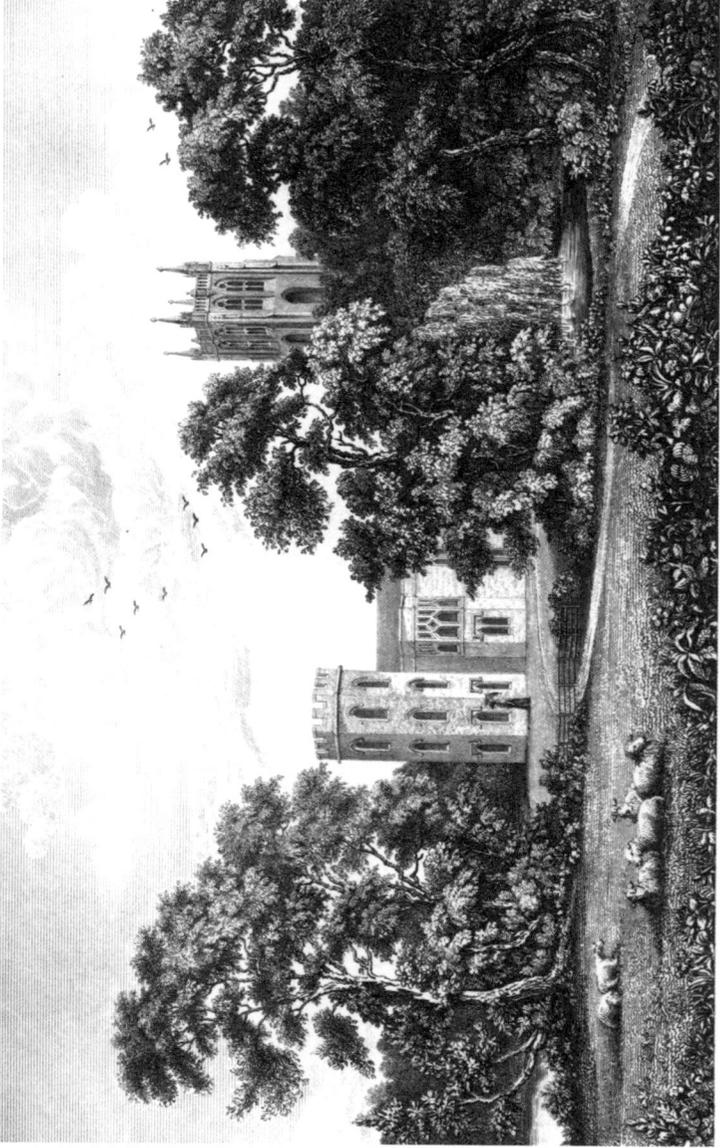

LYMPSHAM RECTORY

This Plate is obligingly presented to the Work by Revd P. A. Stephenson,
the Rector to whom it is respectfully inscribed.

A delightful walk of two miles leads to

LYMPSHAM CHURCH,

the turretted summit of its lofty tower rising gracefully
above the surrounding elms. A closer inspection of this
elevated structure discovers its deviation from the perpen-
dicular line, in defiance of the massy buttresses which run
up its angles; but the date of 1635 proves its declension to
have been arrested by the munificent hand of Charles I. the
then possessor of the manor. The interior of the fabric,
consisting of a nave, north aisle, and chancel, is distin-
guished by its general neatness, and ornamented by a richly
stained Gothic east window, the gift of the Rev. J. A.
Stephenson, the present incumbent, in whom the patron-
age of the rectory, long the property of the Powlett family,
is vested. A stall richly canopied, on the northern side of
the church, distinguishes the seat appropriated to the mitred
Abbots of Glastonbury, to whom the manor belonged,
from the reign of Ina, till it came into the possession of the
crown, on the execution of Abbot Whiting.* It was trans-
ferred to the Duke of Somerset, and subsequently formed
an appendage to the Dutchy of Cornwall. It is now the
property of Alexander Popham, esq. the worthy represen-
tative of an ancient Somersetshire family, distinguished for
its patriotism in the seventeenth century; but still continues
charged with a considerable chief rent to the Droits of the
Admiralty.

The parsonage house and its extensive lawns and offices,
closely contiguous to the church on the west, afford a plea-
sing specimen of the elegant neatness which so generally
characterize a clerical residence, and the western front is
ornamented by an unique elevation, adjoining a spacious
library.

The village of Lympsham consists principally of the habi-
tations of mechanics and shopkeepers, with the cottages of

* The living of Lympsham anciently paid an annual pension of 13s. 4d. to
the infirmary, and of five shillings to the mead-maker of Glastonbury Abbey.

the labouring poor; but the comfortable abodes of a sub-
stantial yeomanry are thickly scattered over the parish; and
the tithing of Eastertown, anciently *Austertown*, a name
descriptive of the tenure by which the property was held,
comprises a considerable groupe of tenements.

Lympsham contains, by the last census, 95 houses, 118
families, and 496 inhabitants; but the inhabitants are now
supposed to amount to 600, affording a striking illustration
of the present salubrity and comfort of the place, compared
with its quality previously to the operation of the drainage.

EAST BRENT

has been incorrectly supposed to have derived its name
from having been *brent* or burnt by the Danish invaders.
It is an ancient manor which Ina, king of the West Saxons,
is recorded to have bestowed on the abbey of Glastonbury
in the year 690, by which it was held until the dissolution
of that monastery.

Abbot Selwood built a noble mansion house at East
Brent, consisting of a chapel, hall, parlour, and other
sumptuous apartments, with a magnificent portico, the
whole of which was taken down in 1708. It is generally
supposed that this residence was used by the Abbots of
Glastonbury, as a place of occasional retirement in the
summer months. Many monumental effigies or figures of
monks and friars, originally entombed in the cloisters of
this edifice, were scattered in fragments about the church-
yard until within these few years.*

THE CHURCH

stands upon a rising ground, and is a handsome structure,
114 feet in length, and 50 in breadth; at the west end is
a quadrangular tower 80 feet high, whereon is a spire

* Mr. Harden has an old triangular chair, similar to the one engraved in
Warner's History of Glastonbury, which probably formed part of the furniture
of the Monk's mansion house at East Brent.

rising to the height of 60 feet. On the exterior are three niches, one above the other; in the upper one is an effigy of King Ina with a sceptre and mound, embraced by a monk; in the middle niche, is Queen Frithogitha; and in the lowest, her husband King Ethelard, the brother-in-law and successor of Ina on his retirement to Rome.

In the church windows are the remains of some excellent painted glass; in one, is the salutation, the nativity, and the wise men's offerings; in another, the Virgin with her infant son; in another, the scourging; and in others, the imprisonment and decollation of St. John the Baptist, and figures of St. John the Evangelist and St. James.

BRENT KNOLL *

is one of those insulated hills which rise suddenly out of the levels of Somersetshire; it separates the villages of East and South Brent, and its summit commands an extensive prospect. To the south-west, may be seen the hilly range of Quantock, extending from the neighbourhood of North Petherton, nearly to Watchet; to the south lies Bridgewater, distinguishable by its lofty spire; rather more to the west are the levels of Mark Moor, Godney, and Glastonbury, terminated by Glastonbury Tor, and the adjacent hills.† To the west lies the Bristol Channel, with the Welsh mountains on the opposite coast; while gradually turning towards the north, the eye takes in the

* Celtice, *Braint*, a name equivalent with " Law," the designation of similar hills in the north of England. The law having been anciently promulgated to the people from these heights.

† It appears probable from the etymology of Glastonbury, *Glastan-byrig*, " the Hill of Oaks," that this, and many other situations, anciently occupied by christian institutions, were originally the sites of Druidical worship. The oaken groves of superstition, being incapable of association with the religion of the cross, were felled and exterminated before it ; but the Druidical stone pillar, the object of religious attachment, around which our aboriginal forefathers congregated, and where the first christian missionaries courageously addressed them, still survives in various chisseled forms, in many of our towns and villages; monuments of the triumph of that cross, with the name of which, they have been now for ages invested.

Steep and Flat Holms, Brean Down, Bleadon Hill, and the fine range of Mendip; Crook Peak forming a prominent feature in the landscape; while to the west, are the town of Axbridge, Cheddar Cliffs, and many small villages and hamlets, which enliven and diversify the scene.

This hill is more than 1000 feet above the level of the sea, and is crowned by a large, double, irregular entrenchment, in which brass and silver coins of the Roman empire have been frequently found; and by digging at its base, heads of weapons, *fibulæ*, urns, and other remains, have been thrown up, most probably from the site of the numerous barrows or tumuli, which once were scattered over the low lands or flats, even as far as Cheddar Hill, until agriculture had worn them down to a level with the surrounding ground.

The west Saxons frequently occupied this important fortress, during their struggles with the Mercian forces, and King Alfred is supposed to have defended himself here against the Danes. A piece of ground south of the hill is called Battleborough, no doubt in commemoration of some engagement.*

SOUTH BRENT

is a neat small village immediately opposite to East Brent, on the other side of the Knoll. This manor also belonged to the Abbots of Glastonbury. Twelve tenements in this village were held of them by the service of drawing their metheglin or mead during their Christmas festivities at the mansion at East Brent.

THE CHURCH,

standing upon a picturesque acclivity, presents many vestiges of antiquity. The south door-way is formed by a Norman

* A few years since an ancient cuirass was dug up at East Brent, from a depth of five or six feet. It was in good preservation, and of unusual thickness and weight, and supposed by some antiquaries to have been of Roman workmanship. The immediate vicinity of the Knoll was the scene of warfare between the Belgæ and Britons, B. C. 300; the Romans and Belgians, A. D. 50; the Mercians and West Saxons, A. D. 500, and the Danes and Saxons, A. D. 880.

arch, and other Norman remains of a former structure may be observed intermixed with the present building. The arrangement of the massive oak sittings, bespeak their construction at a period in which the services at the high altar were more regarded than the ministrations from the pulpit; and the ludicrous subjects elaborately carved on the ends fronting the latter, refer the observer to the thirteenth century. The first of these remarkable specimens of ancient taste exhibits a fox hung by a goose, with two cubs yelping at the bottom of the gallows; the next, a monkey at prayers, with an owl perched on a branch over his head; and beneath this device, is another monkey holding a halbert. The following seat in the series, is decorated with a fox robed in canonicals, with a mitre on his head and a crosier in his hand; the superior compartment displaying a young fox in chains, a bag of money in his right paw, and chattering geese and cranes on each side, representing the crime, and the evidence, on which he had been detected and arrested. These caricature carvings were intended by the parochial clergy for a satire on the preaching orders, whose interference with their flocks gave rise to mutual antipathy and revilings.

The font is of considerable antiquity, and from its more than usual depth and capacity, was calculated to admit of baptism by immersion, if required.

BURNHAM,

deriving its name from the Brue which here falls into the Channel, is a considerable village about two miles below Berrow on the coast; the beach at this place is not of so firm a consistence as that of the latter.

Burnham is resorted to by many families in the summer season, for whose accommodation, an hotel and several new houses have been erected near the beach. The situation of this village is rather bleak, being exposed to the north-westerly winds. The beach extends nearly half a mile in

breadth at low water, and occasionally affords the rare and
curious atmospheric phenomenon, called the Mirage.

The dean and chapter of Wells have a manor in this
parish. A light house, with an intermitting light to dis-
tinguish it from the one on the Flat Holm, has been erected
here, to enable Bridgewater-bound vessels to avoid the
dangerous sand, called the Gore, at the entrance of the
river Parret, on which Alfred the Great is related to have
been wrecked.* The vicarage house, nearly adjoining the
light house, was for many years the favorite retreat of Dr.
King, the late Bishop of Rochester, and the friend and
editor of Burke.

THE CHURCH

stands near the sea side, and is 140 feet in length, consist-
ing of a nave, chancel, and south aisle, with a large plain
tower at the west end. It is a substantial building, chiefly
remarkable for a handsome altar-piece presented by the
late Bishop of Rochester, when vicar of the parish. It is
composed of veined marble, and was designed and sculp-
tured by Inigo Jones, for the chapel of the palace intended
to have been built by King Charles the II. at Whitehall.
Subsequently placed in Westminster Abbey by Sir Christo-
pher Wren, it remained there until the coronation of
George the IV. and being on that occasion removed and
presented to the Bishop of Rochester, he here erected it at
his own expence, as a memorial of his regard to his parish-
ioners. Formed upon the prevailing taste of the age in
which it was originally constructed, it is in the Grecian
style. A frame of black marble in the centre encircles a
gilded glory, with the words, "Glory to God in the high-
est, and on earth peace, good will to men." On each side
are bas reliefs finely executed. The subjects are, two
angels with a glory; an angel with the thuribulum, or cen-
ser of incense, suspended by a chain ; two other angels, and

* See Pye's Alfred

an angel holding the paten or salver, with two sacramental cups. Above the centre tablet is a bas relief of ten cherubs surrounding a gilded glory, within which is the word " Jehovah," in Hebrew characters. The whole is surmounted by the figures of three boys supporting a bible. On each side, a little in front of the communion table, is an angel kneeling in an attitude of reverence. The figures are exquisitely chisseled, and attract general admiration.*

In the church-yard are several tombstones inscribed with the name of Locke, who are understood to have been members of the same family as the celebrated John Locke.

BERROW.

The road to this place from South Brent, is deep sand for a mile previous to reaching the village, the detached cottages of which extend for a considerable distance along the Bristol Channel. The beach is a fine, firm sand, occupying a space of five miles to the north, and two to the south.

The bathing here at high tides is excellent, but there are few houses adapted for lodgings, though the village can boast of a decent Inn. The place is difficult of approach except by the Brent road. Between the village and the beach is a natural barrier of very high and extensive sand hills, which give its name to the place, and which the highest tides never pass or break through. A multitude of rabbits find an asylum within them, and they are partially covered with the sea mat-weed, *Arundo Arenaria,* the growth of which is encouraged as much as possible, to prevent the sand from being blown by violent winds on the enclosures.

THE CHURCH

is a plain old structure, between the village and the beach, with a low tower, hidden from the sight on the Channel

* See an Account of the marble Altar-piece, 4to. Meyler, Bath.

side by the immense sand hills, or *totts*, as they are provincially called.

BREAN,

which derives its name from the British *Bryn*, a hill, is situated on the western side of the river Axe, at its junction with the Bristol Channel. The sea forms a smooth sandy beach on the western side of the parish, extending three miles southward to Berrow; on the land side of the beach are immense sand hills, which form a natural barrier against the force of the tide. On this beach are abundance of small shells of the venus and of the tellina genus, with some buccinum.

From this manor the family of *Brien* or *Brene* derived their name; and a deed dated 34th of Edward III. 1360, is still in existence, by which, one of their descendants, Robert Brene, lord of a certain parcel of Brene in Brent-Marsh, granted to Thomas Hege, all his rabbits in his parcel of Brene Down; and by another old deed, it is stated that Thomas Baret, bishop of Knachdune, in Ireland, and a suffragan bishop of Bath and Wells, about 1484, "hath a moytie of the lordship of Brean in Brent-Marsh, so long as he shall stand personal surety there, so that he, with the revenue, fortifie the sea walls and banks for the salvation of the said lordship."

BREAN DOWN,

is a bold and conspicuous promontory, running out considerably into the Channel, and forms the extremity of Weston Bay on one side, and of Bridgewater Bay on the other. The river Axe flows between its northern side and the Black Rock, and separates it from Uphill and Weston sands.

The sides of Brean Down consist of precipitous rocks; those at its extreme point forming a bold head land, rising abruptly out of the sea, in a direct line with the Steep Holm, from which it was probably severed by some convulsion of nature. Its summit is covered with turf with-

out trees or shrubs, and previously to its partial cultivation, was an ancient and extensive rabbit warren; but a considerable portion of the warren, has been of late years enclosed and cultivated.

This high neck of land is full of vestiges of EARTH WORKS, from one extremity to the other, and has evidently been strongly fortified at some very remote period; probably, from its remaining tumuli, by the Britons; and subsequently by the Romans, Saxons, and Danes, who are all supposed to have successively occupied it, from the various fragments of ancient pottery which are constantly turned up by the plough. The whole Down was divided into three parts, by two broad and deep trenches, which apparently formed an outer and an inner encampment, the latter occupying about one third of the surface at its western extremity. `

On the rocks are found whelks, nerita or sea snail, patella or limpet, and other shell fish; large quantities of samphire are gathered for pickling by the country people, who afterwards send it to the inland towns for sale.

About five miles from the north western termination of Brean Down, is the

STEEP HOLM,

whose summit rises 400 feet above the level of the Channel. It was called by the Saxons, *Steopan Reorie*, or " Reed Island." It is a rock of about a mile and a half in circumference, and in many places over-hangs the water; it is inaccessible, except by two narrow passages, very difficult of access, rising from the small pebbly beach on its north eastern and south western sides. The summit is a sandy unfruitful soil, bearing little grass or any other vegetables, except those which seem peculiar to such situations. The single peony is indeginous upon the rock, and there is a considerable quantity of privet, ivy, and some elder.

A few rabbits contrive to exist on the rock, whose fur is of a redder cast than rabbits usually have. The vast

number of sea birds, who resort to the ledges and crevices of the rocks, for the purpose of incubation, afford amusement to the fowler; the eggs being sometimes collected as a source of profit.

On the summit of this solitary island, a small tenement was erected in the year 1776, for the convenience of the fishermen, who, on attending their nets pitched here, have been detained for several days, in tempestuous weather. It is the point of division, between the counties of Somerset, Gloucester, and Bristol; and upon it, one of its former possessors, Maurice, the third Lord Berkeley, built a small endowed priory in 1320, but no remains of it are now visible.

This island has frequently formed a refuge, either from persecution or the arm of justice. It was on this solitary rock, that

GILDAS BARDONICUS,

the celebrated British historian and philosopher, found, for a time, an asylum during the desolating conflicts between the Picts, Scots, and Saxons; and here it was that he composed his querimonious treatise, " De Excidio Britanniæ." Here he hoped to enjoy uninterrupted retirement; but his hopes were disappointed, as he was frequently intruded on by pirates, who made this island the place of their retreat. For some time he endured their insolence with patience, but at length was compelled to take refuge in the abbey of Glastonbury, where he was well received, and where he ended his days.

Leland, in his curious account of Gildas, writes thus, " he preached every Sunday in a church by the sea shore, which stands in the country of Pebidiane, in the time of King Trifunus; an innumerable multitude hearing him. He always wished to be a faithful subject to King Arthur. His brothers, however, rebelled against that King, unwilling to endure a master. Hueil, the eldest, was a perpetual warrior and most famous soldier, who obeyed no king, not

even Arthur himself. The term of a year being ended,
and his scholars retiring from study, the Abbot St. Cadoc,
and the excellent Doctor Gildas, went to two islands, Ro-
muth and Echin ; Cadoc entered the one nearest to Wales,
(Flat Holm,) and Gildas the other nearest to England,
(Steep Holm.)"

In 1067, Githa, the mother of Harold, the last of the
Saxon Kings, retired to the Steep Holm, accompanied by
the wives of many Saxon noblemen, or thanes, soon after
the death of her son at the fatal battle of Hastings ; they
remained in security on the island, until a favorable oppor-
tunity offered for their departure to St. Omer's in Flanders.

Here also it was that the Danes, who frequently infested
these parts of the kingdom, took refuge, after they had
been signally defeated at Watchet ; and being reduced to
great misery, many of them were cut off by famine, and the
remainder sailed for Ireland.

THE FLAT HOLM

is about three miles to the northward of the Steep Holm.
This island is about a mile and a half in circumference,
with a good farm house and inn, nearly in the centre, sur-
rounded by a dairy farm of sixty acres, the land bearing
good crops, and abounding with burnet, wild thyme, and
other aromatic plants. The Flat Holm is a favorite place
of resort in summer, being in itself pleasing, and command-
ing a delightful prospect of the Bristol channel, and of the
coast on each side, for more than sixty miles in length.
The inn affords good accommodation, and is occasionally
honored by a visit from the corporation of Bristol, who
combine an agreeable aquatic excursion from the city, with
the exercise of their judicial rights, which extend as far
into the channel as this island.

There is good bathing upon the pebbly beach, which at
low water extends round the island, strewed with fragments
of rock that have fallen from the cliffs, covered with whelks
and limpets, and the common kelp-weed, which is in great

abundance in the little pools of water; great numbers of sea anemonies, of different kinds, are left by the falling of the tide on the beach, and on the south side are found large tubulated ones, which, when open, are six inches in diameter. In some places also the green and brown confervæ are met with. Also many species of fuci, and some of the corraline or serpularia.

On the highest point of this island, is a

LIGHT HOUSE,

eighty feet in height, standing within 50 yards of the south east edge of the cliffs; and having been, within these few years, fitted up as a revolving light, it presents a pleasing object in the evening from Weston, twinkling like a star, at the interval of a few seconds. At spring tides, the water rises full 36 feet at this island. There is a remarkable well of fresh water here, which, when the sea ebbs, is filled, but when it flows becomes empty; and there is a similar one at Weston, not far from the church.

Uphill Parsonage.

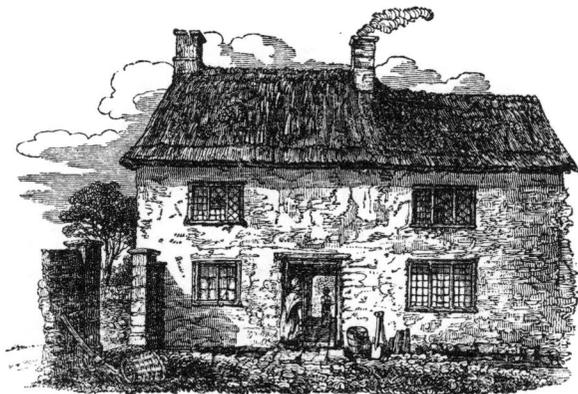

Cottage at Wrington in which Locke was born.

CHAP. VI.

OLDMIXON

is an ancient village between **Uphill** and **Hutton**. It gave the designation to a family of the same name; one member of which, **John Oldmixon**, is well known as the author of

H

a History of England, the Life of Queen Anne, and some poetical and dramatical works. Pope thus characterizes him in the Dunciad :

> " In naked majesty Oldmixon stands,
> And Milo-like, surveys his arms and hands;
> Then sighing thus, ' And am I now three score ?
> ' Ah, why, ye Gods ! should two and two make four ? '
> He said, and climb'd a stranded lighter's height,
> Shot to the black abyss, and plung'd down right ;
> The senior's judgment all the crowd admire,
> Who, but to sink the deeper, rose the higher."

HUTTON.

The road to Hutton winds along the base of Mendip, presenting a pleasing variety of surface, being in some spots partially covered with wood, and in others exposing the bare rock in projecting masses. On the left, is an extensive prospect across the level to Worle Hill, with an occasional glimpse at Weston and its conspicuous church, bounded by the waters of the Channel. The village of Hutton contains several respectable residences, and is pleasantly situated beneath the ridge of Bleadon Hill. It is an ancient manor, having been held by Saxon thanes, under the church of Glastonbury, previously to the Conquest ; and it afterwards was successively possessed by the Bishop of Coutances, and the families of Whaley, Payne, Still, and Brent ; a collateral descendant from the latter is now residing in the ancient

MANOR COURT HOUSE;

a curious building, well worthy the inspection of strangers and antiquarians, at a short distance from the church. The more ancient part consists of a manorial hall, with a fine old oak roof, having an unusual, large square tower attached to its side. In a parlour, within the more modern part of the building, is a fine portrait of Rubens, painted by himself; and another, apparently of inferior execution, said to be his wife, together with many family portraits of the Brents.

The ancestors of this family had great possessions at Cossington and South Brent, in the reign of Henry I. early in the twelfth century. Many of them served the kings of England in the wars of Gascony and Scotland, in the quality of knights, and they were great benefactors to the abbey of Glastonbury. The last of this ancient family who possessed the hereditary estate, was John Brent, who died at Cossington in 1693.

HUTTON CHURCH

is a small handsome building, consisting of a nave and chancel, with a porch on the south side, and a square embattled tower at the west end. The belfry contains five bells, and its roof is arched over with rich groined work, having bosses of foliage at the intersections, expanding from four spandrils, supported by a cherub in each corner. The roof of the nave is arched with oak ribs, also ornamented at the crossings, and a rich border of foliage running round, below the cornice. The pulpit is of stone, richly sculptured, with five projecting sides highly ornamented, and having the wall behind it hollowed out to receive the stair-case, and to give additional space.

In the windows still remain many armorial bearings stained in the glass, especially the Cheddar escallops, united with various other quarterings. In the chancel, under a low arched recess, is a curious old monument, with pieces of brass imbedded in cement, representing a male and female figure kneeling, with eight sons behind the father, and three daughters behind the mother, in regular gradation of height, surrounded by various coats of arms, chiefly of Cheddar and Payne. Beneath, is the following inscription, in old English characters:

" Pray for the soules of Thomas Payne, squier, and Elizabeth his wife, which departed the twelfth day of August, in the yere of our Lord 1528."

H 2

There is also a brass plate with this inscription :—" Hic jacet sub lapide Johannes Paine et Elizabetha, uxor. 1496."

In the chancel is a mural monument to Nathaniel Still, esq. of this parish, who died the 2nd day of February, 1628, surmounted by the arms of Still ; *sable*, gouttè de larmes, three roses, *argent*, barbed and seeded proper ; crest, a kingfisher. This gentleman was eldest son of John Still, Bishop of Bath and Wells. Thomas, a brother of Nathaniel, settled at Shaftesbury in Dorsetshire, and his descendants subsequently at East Knoyle, Wilts.

Hutton contains 44 houses, 58 families, and 325 inhabitants. The living is a rectory in the deanery of Axbridge. Rev. Alfred Harford, incumbent.

HUTTON CAVERN.

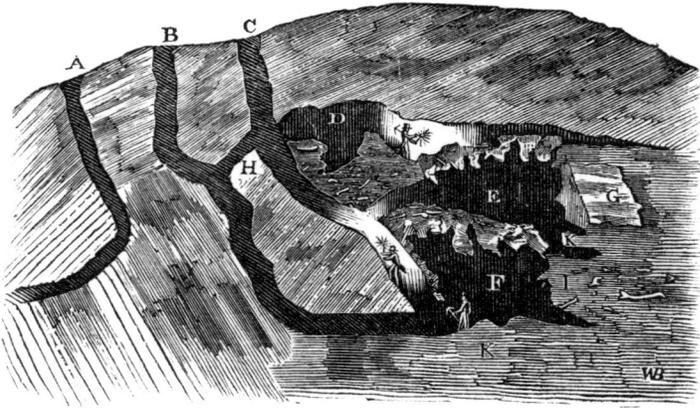

EXPLANATION OF THE VERTICAL SECTION.

A.—An old shaft, which was drawn, but which led away in a different direction from the great fissure.

B.—A second old shaft which was drawn, leading into F.

C.—The new shaft, which was sunk with the view of searching *above* the dangerous ground that hung over F.

D.—The upper chamber of the fissure; at the entrance of which, the two tusks, and most of the large bones were found.

E.—The middle chamber, where were found many bones of the horse and wolf, the young tiger, and a large furcula of a bird.

F.—The lower chamber; the roof of which consists of nothing but fragments of rock, ochreous rubble, bones, &c. jammed between the strata, and having no support but the precarious wedge they have formed in falling, it had a frightfully threatening look, and at first sight produced the impression of being buried alive. Here were horse bones chiefly. The strata dip at an angle of 65.

G.—Represents a huge mass of rock that has fallen away, and as yet prevents any further search in that direction.

H.—Is a small lateral crack connected with D. running behind the shaft C. into D. at whose confluent points were found the hyænas' bones, the album grœcum, and another large furcula of a bird.

I.—Loose ground and ochreous rubble running westward along the drift line of the strata, as yet unexplored.

K.—Are beds of ochre, in which no organic remains have been hitherto traced.

In the city library at Bristol, are preserved a collection of bones, which were presented by the Rev. Dr. Catcott, who was instrumental to their discovery, in a Cavern on the Mendip Range, south of the village of Hutton. The hill here rises to the elevation of three to four hundred feet above the level of the sea, and abounds with ochre, calamine and galena, which were worked to a considerable extent, about the middle of the last century.

The miners having opened an ochre pit, came to a fissure in the limestone rock, filled with good ochre, which being continued to the depth of eight yards, opened into a cavern, the floor of which consisted also of ochre; and strewed on its surface, were large quantities of white bones, which were found dispersed through the ochreous mass. In the centre of the chamber, a large stalactite depended from the roof; beneath which, a corresponding pillar of stalagmite arose from the floor.

In Dr. Catcott's learned and ingenious " Treatise on the Deluge," he mentions this discovery, and states that, in company with two or three friends, he descended into a cavern, about 90 feet deep, around whose sides, and from the roof, the bones projected, so as to represent the inside of a charnel house; that they extracted a great many

bones of different land animals, until the roof and sides beginning to yield, they ascended, purposing to return when it should be properly secured by wood work. That on his expressing his intention, a few weeks after, of visiting it again, he was informed the whole had fallen in, and was inaccessible.

These remarks first directed the attention of the Rev. David Williams of Bleadon to the discovery of elephants' and other animal bones on Hutton Hill; but, as the occurrence happened 70 years since, he despaired of recovering the fissure, especially as the number of ochre pits on the hill, all in nearly a similar state, made the chances great against opening the right one.

Mr. Williams was at length encouraged to make the attempt, from having discovered fragments of ancient bone, amongst the rubbish near one of the old pits; and from the information of an old miner, who told him that his father had pointed out this as the spot. At this crisis of hope and uncertainty, Mr. Williams received from his friend, the Rev. Mr. Richardson of Farley, a copy of an unpublished manuscript by Dr. Catcott, which further assisted him in identifying the place. Mr. Good, the lord of the manor, having readily granted permission, Mr. Williams began the work, in conjunction with Mr. Beard, whose zeal and ardour in such pursuits every one knows and respects, who has visited Banwell Cave, where he is the " *genius loci.*"

The following extracts from a letter, addressed by the Rev. Mr. Williams to the Rev. Mr. Patteson, descriptive of the several Caverns at Uphill, Hutton, Banwell, Sandford, and Burrington; which, though printed for private circulation, has not as yet been published, will be found highly interesting to the scientific reader.

" The first shaft was drawn to the depth of 70 feet, but proved quite a failure, and is marked A on the section. The next was more successful, and the third completely so. After working some time, they opened into what may

be termed three chambers in the fissure, the floor of the one above, forming the roof of the one below, and consisting of huge fragments of the rock, which have sunk away and jammed themselves between the strata; their intersections being filled with ochreous rubble and bones. The strata on each side, dip about north, with a variation of about ten degrees in their inclination; the south cliff dipping at an angle of about 75 degrees, and the northern about 65°. though in the shaft first drawn, which is not more than 10 yards distant, and in other places near, still more irregularly. The whole of this part of the hill, appears more like the tremendous ecroulement of an adjacent mountain, than the conformable super-position of stratified rocks. It is difficult to imagine a scene evincing greater disturbances; the whole region appears to have been displaced and shattered by the convulsing efforts of some mighty agent, elevating some strata, and depressing others, thereby creating chasms and fissures through the whole.

These rocks are mostly filled with ochre and ochreous rubble, throughout which, the bones are generally disposed; the principal of these are, elephant, tiger, hyæna, boar, wolf, horse, hare, rabbit, fox, rat, mouse, and bird. There has been found no more trace of the ox tribe here, than there is of the horse in Banwell; although the ox is as abundant there, as the horse is here.

Among the many curious and interesting specimens, which have been discovered, the following deserve particular notice; viz. the milk teeth and bones of a calf elephant; the molares and bones of another young one, about a size larger; of the full grown animal are two humeri, two femora, two tusks,* and five molares; so that in-

* These tusks are much curved, and have suffered a very extensive fracture, probably from the collision of two rocks. Of the fragments which are preserved, one is two feet four inches long, and sixteen inches in circumference ; the other is about four feet and a half long One of the molar teeth is three inches across, and five inches deep, from the grinding surface to the fang. It is broken and several of the centre laminæ are gone, but its proportions are altogether much larger than a full-sized molar tooth, in possession of Mr. Beard, taken from a recent animal.—D. W.

dependent of the young ones, we have the principal remains of at least one animal of this class. Dr. Catcott obtained from this hill, six molares, four femora, one head, three ribs, and a tusk; making altogether, found here, eleven molares, six femora, two humeri, one head, three ribs, and three tusks. Thus, the number of molares and femora, prove that three large animals were deposited here.

There are also specimens of two hyænas of the extinct species, with the jaw and bones of a young tiger, which was just shedding his teeth, when fate arrested him. The young tusks may now be seen in the act of replacing the milk teeth. There is no appearance of gnawed bone, and only two specimens have been discovered of *album græcum.* There are the remains of several wolves, and of the horse of different ages and sizes, from the little Shetland, up to the great London dray-horse. Also of the fox, hare, rabbit, rat, and mouse. Besides these are also the furculæ of two birds of a large species, probably of the pelican tribe; judging from the knobs on each side, to which some very strong tendons had been attached, it appears to have been provided with great powers of running, or of sustaining itself on the wing.

Dr. Catcott says, he found a great many bones in the ochre; hitherto none have been found in the recent research, though it has, as yet, been but imperfectly examined.* The bones hitherto procured have been extracted at different depths, varying from 15 to 50 feet; the elephant and tiger lay about 18 feet deep. There are some good specimens of bony brecchia, but no pebbles have yet been discovered."

* " When the short space of time is considered, that has been taken up in these researches, scarcely more than six weeks, and the success we have met with, it will be allowed that we have every reason to be satisfied with the report of our progress, which we are enabled to make. It is impossible to say how much of the fissure is as yet unexplored."—*Note to Mr. Williams's Letter.*

A short distance north of Hutton, is the village of

LOCKING,

pleasantly situated on a gentle eminence, having a neat church with a conspicuous tower, surrounded by fine trees. The manor was granted by Geffrey Gibwyne, to the monastery of Woodspring, in the year 1214. At the dissolution it was given to Sir William St. Loe, knt. It afterwards was in the possession of John Plumley, esq.* who, joining in the Duke of Monmouth's insurrection, forfeited the estate, which was purchased by the well known philanthropist, Edward Colston of Bristol, who, in 1708, founded a free school in Bristol, and endowed it with this manor.

LOCKING CHURCH

having become dilapidated, the nave and porch were, a few years since, rebuilt and enlarged at an expence of 700*l.* the greater part of which was defrayed by the corporation of merchant venturers of Bristol, (the trustees of Colston's charity,) and the remainder by voluntary contributions of the inhabitants of the parish. In this church is a very ancient and curious font, and a beautiful stone pulpit, somewhat resembling that at Banwell. A framed wooden panel bears the name of Cooke, a former incumbent of this church, and of his wife, dated 1618, 16th of James I.

Locking contains 26 houses, 35 families, and 198 inhabitants. The living is a vicarage, in the deanery of Axbridge, in the presentation of the merchant venturers of Bristol, who are also impropriators of the great tithes of the parish. In Bacon's new edition of Ecton's Thesaurus, it is said, that William Plumley, esq. presented Anno Domini 1671.—Present incumbent, the Rev. A. Harford.

* On one of the large oak timbers of the bell cage in the tower, is the following inscription cut deeply in the wood:—" John Plumley, esq. lord of the manor, 1631." This was, probably, the father of John Plumley, who unfortunately became a partisan of the Duke of Monmouth.

CHURCHILL

is a straggling village containing some neat residences, a little south of Congresbury, four miles from Axbridge, and three from Banwell. It is situated in a pleasant valley, screened by the steep ascent of Sandford Hill, partially wooded, and occasionally shewing the rugged surface of the rock. It is written in old records, Curichill, Cheuchil, Cherchile, &c. and is supposed to have imparted its name to Roger de Courcil or Curcelle, a famous chieftain, who came over at the Conquest; who, amongst other rewards for his services, had the grant of the lordship of Churchill, where he took up his abode, and assumed the name of Courcil, instead of the Norman surname of de Leon. His descendants held it for several generations, and his grandson, Sir Bartholomew de Cherchill, also resided on this lordship. He was a famous warrior, and actively espoused the cause of King Stephen in his civil war with the Empress Maud, and was appointed by him governor of Bristol Castle, which he bravely defended, and ultimately lost his life in the king's cause. His grandson, Roger de Cherchile, also lived here, and is recorded as having had free warren granted him in his lands in Churchill, in the reign of Edward I. His son, Elias de Churchell, also held this lordship, but his eldest son John, leaving two only daughters, who were co-heiresses, by their marriage the estate was alienated, and held subsequently by the families of Cogan, Fitzwarren, St. Loe, and Jennyns.

From William, the youngest son of the before-mentioned Elias Churchill, who by default of male issue in the elder branch, became the head of the family, descended through his eldest son, John Churchill, the great Duke of Marlborough; and through his second son Jasper, descended Sir John Churchill, an eminent lawyer, in the reign of Charles II. who purchased the family estate at Churchill of Richard Jennyns; but as he left an only daughter, the estate was

again alienated from the male line.* It is now possessed by the Rev. G. Pelican Cosserat, of Bramford Speke, near Exeter.

CHURCHILL COURT

is contiguous to the church, and the remains indicate its having been an extensive mansion. It was enclosed by grounds which still retain the name of Churchill Park. The only part of the mansion now remaining, is used as a farm house; but the gables are still surmounted by small ornamental turrets. It is supposed to have been erected about the year 1650, by Sir John Churchill, who was strongly attached to the royal cause at the time of the great rebellion. As an accommodation to a troop of horse which he is supposed to have commanded, he erected an extensive building, now used as part of the farm offices. The exertions of the Churchill family in favour of Charles, were heavily punished by the parliament; the uncle of Sir John Churchill being fined 440l. and his first cousin, Sir Winston Churchill, (father to the Duke of Marlborough,) to the amount of 4446l.

CHURCHILL CHURCH

is a handsome structure at a small distance from the village, and has an embattled tower, a nave, a chancel, and two side aisles, with a handsome porch on the south side. At the north-east angle of the tower is a turret, running up to its summit, with an exterior entrance; and at each of the other angles of the tower, is an ornamented pinnacle, connected by an open parapet of good workmanship. A similar one surmounts the walls of the side aisles and of the porch, which are supported by buttresses, terminating in

* John Churchill, the grandfather of the Duke of Marlborough, and uncle to the above Sir John, was also a celebrated lawyer, and consequently they are sometimes mistaken for each other. The above account of the Churchills is founded on Jacob's Peerage, (article " Spencer," &c.) Collinson's Somersetshire, and Hutchins's Dorset, (articles " Minterne and Wotton Glanville," &c.) It differs from some other accounts in tracing Sir John Churchill up to Elias de Churchill; no such name as Elias being found in some of the pedigrees of the Marlborough family.

pinnacles. The western entrance, beneath the tower, has been converted into a vestry-room, and the door-way has been formed into a window, over which is a canopied niche, with a plain shield below. The roof of the belfry is groined, and the other roofs are supported by ribs of oak springing from figures bearing shields, with the emblazonry totally hidden by repeated coats of white-wash.

The altar-piece is a fine painting of "the Lord's Supper." On the north side of the chancel is a handsome monumental effigy of Sir John Latch, (1644,) in a recumbent posture, singularly dressed in a coat of buff, and red stiff boots and spurs, looking on a female figure in a shroud; beneath are seven boys and four girls kneeling on cushions, also curiously attired. Some portions of the armour of this Sir John Latch, including his casque and leg pieces, were, until lately, in the old chest of the church, but are now removed to the neighbouring court house. Against one of the walls are also the effigies of one of the early Churchill family and his lady, but disfigured by white-wash. He is habited as a knight templar, having a coat of mail, his legs crossed, and a shield on his left arm. On the wall of the south aisle, above where these effigies formerly lay, and, probably, within the ancient manorial or family chapel, are sculptured the Churchill arms, viz. a lion rampant, *argent*, with a bend, *gules;* and also those of Prideaux, probably in consequence of Sir John Churchill having married Sarah, daughter of Edward Prideaux.

On a blue stone on the floor, are the figures of a man and woman, with eight children, in brass, with an inscription stating them to represent Ralph Jenyns, his wife Joane, and their family, dated 1572. These brasses are in a beautiful state of preservation; he is habited as a knight in armour, with a curious head-piece, giving him a very singular appearance; above, are three coats of arms. This Ralph was father to Richard Jennyns, who sold the estate to Sir John Churchill.

CHARITABLE BEQUESTS. — JAMES SYMONS, ESQ. of Langford, in 1820, left by will, a piece of land called Middle Common, in Churchill parish, measuring about three acres; the rent to be applied in teaching eight poor children to read the bible.—JOHN LATCH, esq. in 1696, left certain monies, with which a piece of land called Five Acres, in the parish of Hutton, was purchased; the rent, about 10*l*. 10*s*. to be distributed in shillings and twelve penny loaves to the poor of Churchill. — MRS. MARY PLUMLEY also left monies, with which about fourteen acres of land were purchased in Churchill parish, and lately let for 13*l*. 10*s*.; 40*s*. for a sermon, and the rest for the deserving poor.—THOMAS WATTS gave, in 1710, a yearly rent of 2*l*. 10*s*. to be distributed in bread and money to 25 poor householders. The funds from these charities are received by the churchwardens, and distributed by them as directed by the donors.

Churchill contains 153 houses, 179 families, and 842 inhabitants. The living is a perpetual curacy in the deanery of Axbridge, and a peculiar, belonging to the dean and chapter of Bristol.—Rev. Richard Davis, incumbent.

SANDFORD CAVES,

like those at Hutton and Banwell, lie in the northern escarpment of the Mendip Range, immediately south of Churchill. The mouth of the largest, which the miners call " the gulf," lies, they say, 80 fathoms, or 480 feet below the plane of Sandford Hill; they also affirm, that they have let down a man, with a line 240 feet deep, without his being able to discover top, sides, or bottom. Miners, like other men, are very superstitious and wonder working, when they meet with any thing extraordinary, which they cannot fathom. Some may consider it one of the Hutchinsonian swallet holes, made to carry off the waters of the deluge, to supply their internal ocean, and put out the central fire of the Huttonians. There is another extensive cave further to the westward, in this hill, near which, the

skeleton of an elephant was found, in 1770, four fathoms deep, amongst loose rubble."*

The success attending the examination of the caves at Banwell, Hutton, &c. will, probably, induce some active and public spirited individual to make further researches into these caverns, of which so little appears at present to be known.

UPPER AND LOWER LANGFORD

are two hamlets pleasantly situated within the parishes of Churchill and Burrington, and separated by a stream, over which is a substantial bridge, from which they derived their name. The village of Langford lies on the turnpike road from Bristol to Bridgewater, and contains about 500 inhabitants, and many respectable residences. Amongst these, is the pleasantly situated seat of John Fisher, esq. who has lately erected a large and comfortable inn, called the Churchill Arms. South of the village, is

LANGFORD COURT,

a large mansion, originally a hunting seat of the Capels, Earls of Essex. It was probably built in the style of that age, but was greatly modernized by the late Dr. Whalley, and is now thrown open to a well wooded park and pleasure grounds. The manor, after the dissolution of Glastonbury monastery, was granted, together with the adjoining manors of Wrington and Burrington, to Sir John Capel, in whose family it continued for several generations, until it was sold by his descendant, the Earl of Essex, to J. Creswick, a merchant of Bristol, by whose family it came, by marriage, to John Jones, esq. His only son, Edward Jones, esq. left an heiress, Elizabeth, by whose first marriage it came to John W. Sherwood, esq. and by her second marriage, to T. S. Whalley, D. D. who, in 1804, sold it to the Right Honourable John Hiley Addington, brother

* See Mr. Williams's Letter, &c.

of Viscount Sidmouth. It is now the property of his widow, who resides at the manor house, called Langford Court.

Within the hamlet of Upper Langford, on the right hand of the road from Churchill to Burrington, is a FARM HOUSE, the seat of the Latch family for several generations, many of whom are buried in Churchill church; in the chancel of which, is a large curious monument of Sir John Latch. This house bears the stamp of antiquity, both within and without, and has an old entrance porch, formed of three obtuse arches, supported by fluted columns with ornamented capitals, surmounted by an entablature.

ROWBERROW

is a small secluded village, about three miles from Wrington, and the same distance from Axbridge, and is delightfully situated in a hollow between the hills of Mendip, commanding an extensive prospect towards the Bristol Channel. It is watered by a clear rivulet issuing from the sides of the cliff, and running through a deep winding dell. This manor was part of the ancient possessions of the abbey of St. Augustine in Bristol; and upon the erection of the bishoprick of Bristol, on the dissolution of that richly endowed abbey, this manor, together with the patronage of the benefice, was granted by King Henry VIII. to Paul Bush, the first bishop of that see. The manor was detached during the Interregnum, and was sold in 1650. It now belongs to John Leacroft, esq. who holds it as Lord Farmer, under the Bishop of Bristol, who has the patronage of the living, which is a rectory.

This parish, with the adjoining one of Shipham, are situated in the centre of the Mendip mining district; and by far the greater part of their population are miners, whose sole occupation is in searching for and raising lapis calaminaris * and lead ore. The former is a carbonate of

* Calamine, from *calamus*, a reed, from the form in which it adheres to the base of the furnace in fusion.

zinc, combined with silicious earth, and when purified, is mostly used in the composition of brass. It is frequently found within a yard of the surface, and is seldom worked to a greater depth than 30 fathoms. The seams of ore lie in fissures in the solid rock, the situation and direction of which, are still supposed to be discovered by the divining rod, vulgarly called "Josing."

ROWBERROW CHURCH

is a small building of considerable antiquity, built on the edge of a deep dell; it stands detached from the village, and is surrounded by trees.

Near the church is a handsome OLD MANOR HOUSE, some years since the residence of Robert Burland, esq. brother of the judge of that name. This mansion, and the contiguous church, form picturesque objects in the view from the valley below.

SHIPHAM

is an adjoining parish south of Rowberrow, and is situated on the same side of the Mendip Hills, having a fine opening to the west, which commands an extensive prospect towards the Bristol Channel. The manor belonged, at the conquest, to Roger de Curcelle, and afterwards to the family of Malherbe, for many generations; it was successively possessed by the families of Courteney, St Loe, Botreaux, and Hungerford. In later times it came, by gift, to the dean and chapter of Wells, in whom it still continues, together with the advowson of the church.

Westward from Shipham, is the small, but ancient, hamlet of WINTERHEAD, which is described in the Norman survey as belonging to the Bishop of Coutances, and was afterwards attached to the honor or earldom of Gloucester.

MENDIP LODGE

is in the Italian style, situated nearly a mile west of Burrington, and was built, about 40 years since, by the late Rev. Thomas Sedgwick Whalley, D. D. on so steep a

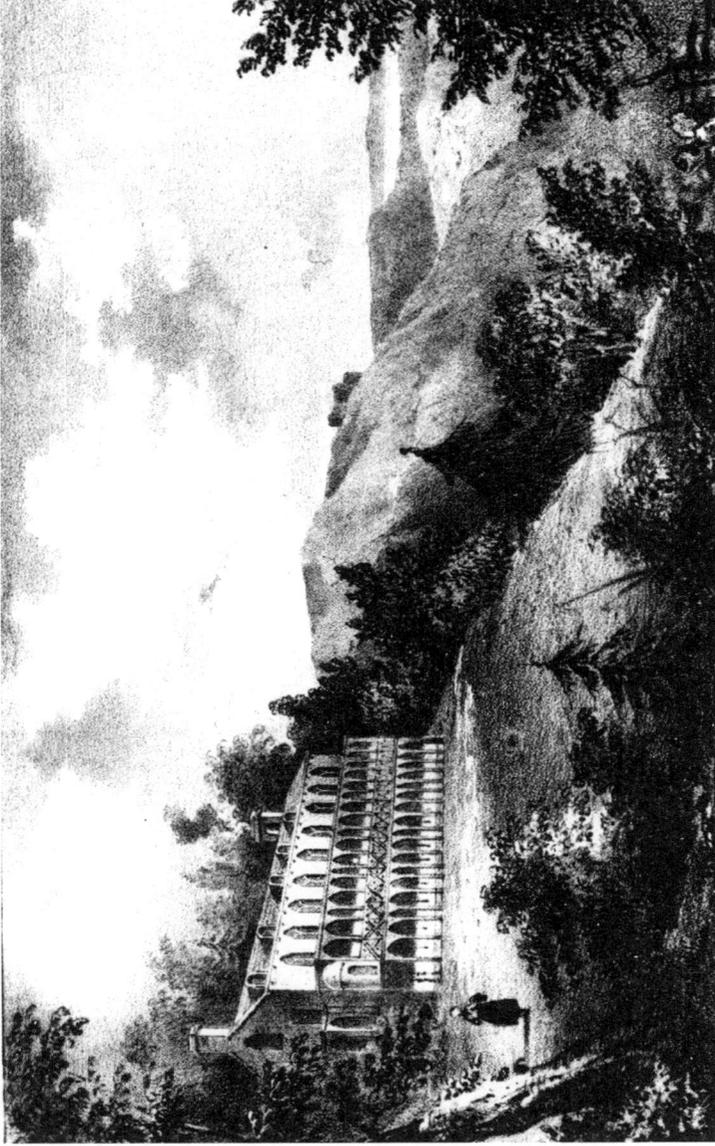

MENDIP LODGE

The Seat of the late D^r Whalley now the property of
James Anthony Wickham Esq of North Hill near Frome.

part of the hill, as to appear almost inaccessible ; but the
ascent is now perfectly gradual and easy, by a new winding
road cut through the woods. The latter are intersected in
almost every direction by foot paths ; one of which forms a
terrace a mile in length, leading to Burrington church,
through a thriving plantation of fir, larch, oak, elm, ash,
laurel, and a great variety of other trees and shrubs ; and
commanding magnificent views of the varied country below.
Another winding path leads to a plantation of magnolias,
azaleas, rhododendrons, and other American flowering
shrubs.

The interior of the lodge is handsomely fitted up, with
much taste ; the principal rooms, some of which are in the
back front, are of considerable size, and contain some good
paintings. In front of the whole, is a veranda, 84 feet long,
affording, as may be supposed, from its elevated situation,
a very extensive and varied prospect ; bounded in front and
on the west by the Bristol Channel, with the Welsh moun-
tains in the distance. The state bed-room was fitted up
with much magnificence, in expectation of its being occu-
pied by the late Duchess of York, on an intended visit to
this spot. In one of the rooms is a curious old map of
" Mynedeep Forest, with circumjacent villages, (36)
churches, and laws," but without any date. Most of the
offices are detached.

Mendip Lodge, though situated on an eminence which
overlooks the surrounding country, is well sheltered, both
by its surrounding plantations, which are of very consider-
able extent, and by the hill which rises far above it.

This hill is of great elevation, and is reported to be rich
in lead ore and lapis caliminaris, the specimens which are
shewn being of the finest quality. Its summit is one of the
highest points in the county, and is supposed to be the part
of Somersetshire seen from the tower of Windsor Castle.
The part called Doleberry, is wild and unplanted, forming
a striking contrast to the richness of the more ornamented
grounds.

I

This delightful residence, with its surrounding farms and manor, is now possessed by **J. A. Wickham**, esq. of North Hill, near Frome, a relative of the late possessor.

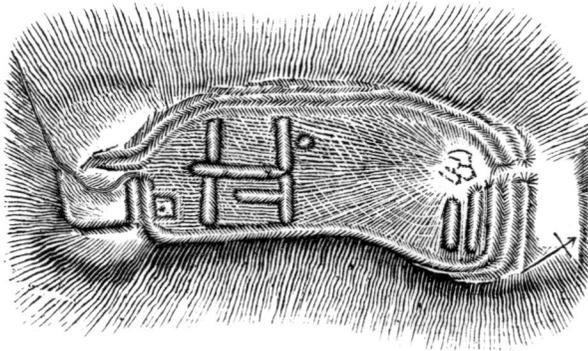

DOLEBERRY CASTLE OR CAMP,

is an ancient encampment at the western and highest extremity of the hill above Burrington and Mendip Lodge; the form of which is nearly a parallelogram, about 540 yards in length, and at a medium of 220 in breadth, containing, apparently, upwards of 20 acres. On the southeast side there is neither ditch nor lower rampart, as the steepness of the hill renders them unnecessary. On the other side, the ditch is, in different places, 16, 20, and even 30 feet deep, formed, for the most part, of loose stones. The whole was, undoubtedly, a fortress of great strength, and must have been a place of much importance. In Leland's time, the people had a suspicion that much treasure was here concealed, and thus

" If Dolbyri digged were,
Of gold should be the share."

An ancient path leads obliquely up to the south-west entrance. The inhabitants of the neighbourhood attribute

the formation of this camp to the *Redshanks*, *i. e.* to the Danes; * it is manifest, however, that it is a fortress of the same description as the others formed by the Britons ; and that it was afterwards occupied by the Romans, or Romanised Britons, the coins found here by Mr. Swymmer, sufficiently testify.

The ramparts of Doleberry Camp remain tolerably perfect through the whole circumference ; at the west end, is a winding road leading from the entrance on that side, to the foot of the hill. At the north-eastern corner, on the highest ground in the camp, are the ruins of a building, for many years tenanted as a place of shelter by a warrener, which is supposed to occupy the site of the original post of observation within the ramparts.

BURRINGTON

is a small village about two miles east of Churchill. It is situated beneath a beautiful ravine in the north eastern side of the Mendip Hills, called Burrington Combe. It forms a part of the manor of Wrington, at the Court Leets of which, suit and service is performed. It is divided into several Hamlets, the chief of which is Langford, which has been previously described.

THE MANOR OF BURRINGTON

is not distinctly mentioned in the early records, having been a portion of the manor of Wrington ; it was granted to Sir Henry Capel, and was sold with Wrington to the Pulteneys, from whom it passed by will to the Marquis of Cleveland, the present owner.

BURRINGTON CHURCH

is a small structure with a low embattled tower, having a handsome turret at the angle of the north aisle, rising

* So called, probably, from the red colour which their bare legs assumed from exposure. The Scots were commonly so called, from wearing buskins of the untanned hide of deer, with the hairy side outward.

above the roof and terminating in a light spire, crocheted and finealed. The interior has formerly been much decorated; and between the windows are circular columns with figured capitals, bearing variously charged shields; the arches of the nave are supported by clustered columns, some of which have capitals of foliage. On the interior walls, over the manorial pew, is a marble tablet to the memory of the Right Honourable John Hiley Addington, of Langford Court, who died June 11, 1818, after having served his country in parliament, and in other official situations. Around the chancel are monuments to the Sherwoods, Inmans, Jacksons, and several to the Jones', an heiress of whom married, first, John W. Sherwood, esq. to whose memory there is a handsome monument, and afterwards the late Rev. Thomas Sedgwick Whalley, D.D.

A monument to the memory of Albinia, daughter of the Rev. H. Wylde, the late incumbent of Burrington, and wife of —— Jackson, esq. who perished in the wreck of the Elizabeth, East Indiaman, off Dunkirk, Dec. 27, 1810, is deserving of notice, as the elegant epitaph which it bears, came from the pen of the celebrated Mrs. HANNAH MORE.

> " Fair, young, and happy, loved and beloved,
> A daughter cherish'd, and a wife approved.
> Such was Albinia! where could life display
> A fairer promise of a prosperous day ?
> Ah! treacherous calm! the sky was soon o'ercast,
> Loud was the surge and direful was the blast;
> Not fond affection's grasping arm could save
> The floating victim from her watery grave.
> Thou sad survivor! rescued from the deep,
> Improve the respite, cease at length to weep,
> Prepare to meet her on that blissful shore,
> Where storms shall beat, and friends shall part no more.
> Heaven calls, Hope leads, and Faith triumphant saves,
> Through the dear might of Him, who walk'd the waves. "

In some of the windows are fragments of painted glass, part of which, in the northern aisle relate to the arms of the Capels, Earls of Essex, who resided at Langford Court,

which they probably erected. * In the church yard are the remains of an ancient cross, and an old yew tree of large dimensions.

Burrington is a chapel of ease to the church at Wrington; the minister being nominated by a majority of the householders of Burrington, and approved by the rector of Wrington; but the latter appears to have no power of rejection, from a recent decision in a suit instituted in consequence of the refusal of the Bishop of the Diocese, to licence the Rev. J. W. Arnold to the perpetual curacy, he having been nominated by the parishioners, but rejected by the rector of Wrington, without the authority of a decision in a Court of Law.†

Burrington contains about 60 houses, 86 families, and 400 inhabitants.

Within this parish is

BURRINGTON COMBE,

presenting romantic scenery, similar to Cheddar Cliffs, but on a more contracted scale, though the rocks in one part rise to the perpendicular height of full 250 feet, having a bold and rugged front; through this Combe runs a road from Bristol to Wells, by the small inn called the Castle of Comfort. The Combe is also remarkable for two curious natural caverns, one of which was probably

AN ANCIENT CATACOMB.

This was accidentally discovered in the year 1795, and contained nearly fifty skeletons, surrounded by black mould,

* This church had, till within these few years, a fine and almost perfect window of painted glass, which was removed for the purpose of re-arrangement, but subsequently was lost, and has never been recovered.

† Since this was written, a Rule *Nisi* for a new trial has been obtained by the Defendants, on the ground that there was no evidence to support the custom of the inhabitants appointing the curate, and that the verdict found for the Plaintiff was wrong. But a second jury having confirmed the original verdict, the question may now be considered as finally settled, in favour of the householders of the parish.

placed regularly with their heads close under the north side of the rock, and their feet extending towards the centre. The mouth of the cavern was evidently secreted by a mound of loose stones and earth, mixed with bones of sheep and deer. Within the entrance, the cavern expands into a broad natural arch, below which, an inclined plane descends about one hundred yards; the floor afterwards extends horizontally for some distance, and in one place, some immense flat stones had been placed over a crack or fissure, which traversed the floor.

Professor Buckland describes this cave in the first volume of his " Reliquiæ Diluvianæ, " and he considers it to have been either a place of sepulture in early times, or a retreat into which, the individuals of whom the skeletons remained, had retired for protection during some military excursion; but the artificial bridge over the fissure, together with the bones of sheep and deer, which were found amongst the rubble at the entrance, indicate that at some distant period it was the habitation of man. At all events the state of the bones affords a presumption of high antiquity; some of which, were incrusted with a coating of stalagmite, particularly a skull, the inside of which had been so covered with this substance, as to form casts of the channels of the veins.* About half a mile distant, another of these curious places of sepulture was discovered, which was calculated to contain not less than one hundred skeletons; and higher up the combe, not far from Goatchurch, is

AN EXTENSIVE AND INTRICATE CAVERN,

but little known. Its entrance on the side of the hill

* Mr. Williams suggests, that the inhabitants of this cave may have retired into it from religious persecution, like the prophets of old, who " wandered in deserts and in mountains, and in dens, and caves of the earth." The persecution under Diocletian and Maximian, raged long and fiercely in Britain, in the beginning of the fourth century. Constantius Chlorus, who was their subordinate in the empire, and the minister of their cruel edicts in this country, died at York. St. Alban, who bequeathed his name to the town of St. Albans, was the first Martyr.—Mr. W. has since discovered a considerable quantity of flint knives, and some tesseræ, possibly used in a game; these were buried near the spot where the human skeletons were found.

is small, but on advancing, it is found more spacious, and presents magnificent masses of stalactite and of stalagmite. One of these is shaped like a throne, surmounted by a curiously formed canopy of fret work. A second descent of about twenty feet, leads to another portion of the cavern, which opens into numerous ramifications, so intricate that even the miners, who reside in the vicinity, find it requisite to use twine as a guide for their return; the terminations of these passages have never yet been thoroughly explored. A stream of water runs across the floor of one part of the cavern, forming a waterfall at a great distance from the entrance.*

Between Burrington and Blagdon, and partly in both of these parishes, is

RICKFORD COMBE,

a romantic spot, nearly surrounded by lofty eminences, covered with hanging wood, and traversed by a beautifully transparent spring, which expands into a wide shallow stream very near its source, and unites with the river Yeo at Perry Bridge. There was a mill on this stream at the time of the Norman survey; and there is now a paper mill, delightfully situated in the centre of the Combe; the house is of the age of James I. and was for some time inhabited by the Sheppards of Redcliff Hill in Bristol, who had large possessions in these parts.

BLAGDON

is situated on the northern side of Mendip, at a short distance west of Burrington, and on the skirts of a beautifully

* Since the slight sketch of this cavern was written, Mr. Williams has explored it, and discovered several fine specimens of bones of the bear, deer, &c. on and beneath the coatings of stalagmite, and intermingled with immense quantities of pebbles, diluvium, &c. Several lateral fissures branch off from the main one, and again expand into a labyrinth of collateral cracks and chambers; many of the latter being of great height, and hung with fine stalactites, which in some instances, are united into pillars reaching from the floor to the roof. The researches are continuing, and the result, will, at some future day, be made public.

rich valley, through which flows a branch of the river Yeo. It derives its original name of *Blachdone*, from its elevated situation, exposed to the northern blast; *Blac* and *Blœc*, being the Saxon for cold or bleak, and *Dun*, for a down or hill.

The manor of Blagdon was possessed, in the time of Henry I. (1100,) by Robert Fitz-Martin, of the Compton-Martin family, who made it the head of their large baronry, being held by them of the king in capite, and by the service of one knight's fee; in their possession it continued until the 18th of Edward II. (1324,) when, by the death of William Martin without heirs, it passed, by the marriage of his two sisters, to the families of Columbers and Audley. It subsequently was held in succession by the families of Vere, Earls of Oxford; Holland, Earls of Huntingdon; and Stanley, Earls of Derby; one of the latter of whom sold it about 1600. The court house, which is an antique gabled edifice, together with a portion of the ancient manor is now possessed by H. Seymour, esq. of Clouds, Wilts, M. P. for Taunton.

On the heights above the village, is

COMBE LODGE,

the delightful seat of Thomas Roworth, esq. commanding, on one side, the extensive vale of Wrington, and over-looking the romantic scenery of Rickford Combe on the other. It is surrounded with thriving plantations, through which are extensive terrace drives.

BLAGDON CHURCH

is, with the exception of the tower, a modern edifice, having been rebuilt in the year 1822. The ancient tower is remarkably fine, and well merits preservation. It is supported by substantial square set buttresses at the angles, of an unusual character; on the south side, is a curious square stone, of which the sculpture is difficult to comprehend; and in a canopied niche, there still remains an image of its patron saint

The former church was an ancient structure, the chancel and high altar having been consecrated in the year 1317, in the reign of Edward II. The present edifice has not a very elegant exterior, but the interior is spacious, light, and strikingly handsome. It is composed of a nave, with side aisles, separated by obtusely pointed arches, resting on tall slender piers, producing a light and elegant effect. It is neatly pewed, has a capacious gallery, and can accommodate nearly 1000 persons. The lofty ceiling of the nave is richly ornamented; on each side are six well proportioned pointed windows, and at the east end of the chancel is one of painted glass, rich and elegant in its design, in which are emblazoned the arms of Wait, the rector; of Seymour, the lord of the manor; and of Baker and Hall, the churchwardens; below them are the arms of the diocese.

In the chancel is a monument, dated 1768, to the memory of the wife of the Rev. J. Langhorne, editor of Plutarch's Lives, who was for some years incumbent of this parish : as was also the learned divine, Merick Casaubon, son of the celebrated critic, Isaac Casaubon, both natives of Geneva. He was deprived of his preferments during the civil wars, but regained them at the Restoration. The present rector is Daniel Guilford Wait, L. L. D.

Within the old church were two ancient effigies of the Martins, lords of this baronry; one of whom, named Robert Fitz-Harding, granted the church of Blagdon with its temporalities, to the Cistertian Abbey of Stanley, in the county of Wilts; at the dissolution of which, they were given, together with part of the manor, to the Cathedral of Winchester; the Dean and Chapter of which, are the present patrons of the benefice.

CHARITABLE BEQUESTS.—THOMAS BAYNARD gave, by deed, in 1687, eight acres and a half of land, called Croft, &c. in Blagdon, for finding a proper schoolmaster or schoolmistress to teach eight poor children of that parish to read the Holy Scriptures in their native tongue; the charity

to be managed by the churchwardens, overseers, and lord of the manor of Blagdon, for the time being, according to the donor's written instructions. The rent of this property lately amounted to 17*l.* 10*s.* which is received by a schoolmaster who teaches about seventeen poor children to read and write.

JOHN LEMAN left by will 100*l.* to be invested in land, the rent to be employed in apprenticing to trades, poor legitimate children of the parish of Blagdon. This property is now vested in the parish officers for the time being, and consists of various tenements and pieces of land, now let for about 13*l.* 4*s.* per annum, which formerly was distributed amongst the poor of the parish, but is now applied as directed by the will of the donor.

MRS. PRIEST left one acre of land, called the Poor Acre, which lets for 1*l.* 15*s.*—JOHN PLUMER gave an acre of land lying on the north side of Holt.—TIMOTHY PARKER left a rent charge of 2*l.* 12*s.*—MRS. FROWD gave 10*l.* The income from these bequests is distributed to the poor of Blagdon, as directed by the donors.

Blagdon contained in 1821, 211 houses, 231 families, and 1068 inhabitants, all of which are now considerably increased. Near the church is a Sunday school for boys, and another for girls.

BUTCOMBE

is a small secluded village, immediately north of Blagdon. The parish is extensive, and comprehends several ancient manors, the chief of which belonged, in 1100, to a family who took their surname from its original appellation of Budecombe.

BUTCOMBE MANOR HOUSE,

the seat of Charles Gordon Ashley, esq. is supposed to stand on the same site, as a house which belonged to the monks of the Cistertian Abbey of Thame, in Oxfordshire; towards rebuilding of which, John de Perceval, one of the

subsequent lords of this manor, granted by a deed, one yard of land, " in pure and perpetual alms, for the welfare of King Henry, and that of all his predecessors and successors, that he and they might be partakers of all the alms which had been, or should be made, from the days of the Apostles to the end of time; willingly and firmly enjoining, that the said benefit of alms should be free from all secular services whatever."

Within this parish was also another old residence, called

THRUBWELL MANOR HOUSE,

which was nearly destroyed during the great rebellion. It was situated on the borders of Broadfield Down, and was attached to the manor, which extended into the adjoining parish of Nempnet, and derived its name from a spring called Thrub-well, formerly of some notoriety. This manor was the residence, for several generations, of a family who came originally from Flanders, named Bretesche; one of whom, Richard de Bretesche, lord of the manor, was fined ten marks for trespassing in the king's adjacent forest of Cheddar, or Winford, in 1177, the 24th Henry II. This manor afterwards came, by marriage of the heiress, into the possession of Roger Lord Perceval of Butcombe, progenitor of the present Earl of Egmont.

The manor of Aldwick is partly in this parish, and partly in that of Blagdon, and its court house is still in existence. There were several other ancient manors within this extensive parish; one was held by the Abbot and Monastery of Flaxley, in Gloucestershire; and another by the Hospital of St. John, in Bristol; this latter also held the advowson of the living of Butcombe, which continues vested in the lord of the same manor to this day.

BUTCOMBE CHURCH

is a small building with a tower on its south side; contiguous to which, is an ancient chapel, where are monuments to the memory of Richard Plaister, gent. and several of

his family. The chancel is ancient, and still retains in its windows, several good figures in painted glass.

Butcombe contains a population of 213. The living is a rectory in the deanery of Redcliff.—The Rev. R. P. Hassell, incumbent.

A short distance from the village church, in a field, from time immemorial called Fairy's Field, is a remarkable tumulus, called

BUTCOMBE BARROW,

or Fairy's Tout. It was opened in 1788, by the Rev. T. Bere, rector of the parish, from whose account the following is extracted. The Barrow from north to south is 150 feet, and from east to west 75 feet; it is of an oval shape, its greatest elevation being about 40 feet. It is composed of small whitish stones, abounding in the neighbourhood, covered over with a stratum of earth and grass; the summit being overgrown with ash trees and underwood. In this singularly sequestered situation, far removed from any modern public road, 15 miles distant from the sea, in the ancient forest of Selwood, this barrow remained for two thousand years, unknown to any but the immediate neighbours, who regarded it with awe and reverence, as a place frequented by ghosts and faries.

In 1788, the proprietor, having occasion for materials to repair the roads, began to open it at the northern extremity. Here an entrance stone was soon found, square, but very rough, behind which was an introductory avenue 13 feet long, formed by a wall on each side, 14 inches thick, and somewhat more than four feet high, built of selected small flat stones, laid very true, and every joint locking with great exactness; but without earth, clay, lime, or any other cement. At the end of this avenue, was another large flat stone, which formed the immediate door way of the sepulchre, whose centre has not hitherto been thoroughly explored.

It appears that an avenue or passage goes through the middle, four feet high, constructed of large fragments of rock, and consisting of triplets of stones, two perpendicular and one horizontal. On each side of this avenue are cells, four feet high, two feet three inches broad, and nine feet long, where the bodies were deposited north and south; and there being many skulls in each cell, they were, perhaps, family repositories.

Many of the stones of which the cells are composed, weigh two or three tons each, and are in the very state in which nature formed them. The cells are conjectured to amount to about ten or eleven on each side of the avenue.

In the southernmost cell, on the eastern side of the avenue, was found a perfect human skull, the teeth entire, all sound, and of the most delicate whiteness; and the body, to which it belonged, must have been deposited in the cell, north and south. Besides human bones, there were the thigh bone of a large ox, and some teeth, probably of the red deer.

This sepulchre must have been constructed before the Roman conquest, as is proved by the extraordinary rudeness of the stones ; and at a time when the use of iron was unknown, and therefore prior to the Julian æra. The absence of mortar, is an additional proof of its construction, prior to the time of the Romans, and the position of the bodies, north and south, indicates it to have been also prior to the introduction of the christian mode of burial, with the head towards the west. There was neither urn, ashes, coin, nor inscription found, nor the trace or mark of any workman's tool.

It was perhaps a burial place formed by the early Britons, and possibly connected with the great Druidical settlement at Stanton Drew, four miles distant; at all events, it is one of the most interesting monuments in the kingdom, and was a most commodious place of sepulture, furnishing a good model of a family vault, even at the present day.

WRINGTON

is an ancient market town, irregularly built, but pleasantly situated in a fruitful vale, about three miles west of Butcombe, and twelve miles south west of Bristol, between the high lands of Broadfield Down to the north, and the Mendip Hills to the south.

The charter for the market on Tuesday, as well as for the annual fair, on the 9th day of September, was originally obtained by Adam de Sodbury, Abbot of Glastonbury, in the reign of Edward II. and they have now been regularly continued for upwards of five centuries.

The Manor of Wrington was originally very extensive, including the tithings of Broadfield and Burrington, both of which continue to do service at the Lord's Court Leet. Previously to the Norman Conquest, these vast possessions belonged to the Saxon King, Athelstan, who, in 926, gave it to the duke of the same name, who, assuming the habit of a monk, conferred it upon the Abbey of Glastonbury. This grant was afterwards confirmed by several kings, especially by Henry III. and Edward III. who not only ratified all former grants, but exempted the abbots of Glastonbury, as lords of this manor, from the expeditation of forest dogs, * inquisitions on the death of the beasts, agistments of all kinds, and the assize and custom of the forest.

At the dissolution of Glastonbury Abbey, this manor was granted to Sir Henry Capel, which grant was confirmed by Philip and Mary. In the year 1726, his descendant, the Earl of Essex, sold it together with the Burrington and Ubley manors to William Pulteney, esq. afterwards created Earl of Bath, from whom it descended to the late William Pulteney, esq. On the death of the Countess of

* Cutting out the balls of the feet of all dogs above a certain size, for the preservation of the King's game; and whoever kept any great dog, not thus expeditated, was liable to a fine of 3s. 4d.

Bath in 1808, it passed by will to the present Marquis of Cleveland, in whom it is now vested.

Wrington is mentioned in the Norman survey, under the title of *Weritone*. It is described as having been then held by the church of Glastonbury; it was an extensive lordship, containing thirty two carucates of arable land, and in demesne (royal) eleven hides, or six carucates. It also had 44 acres of meadow and 200 acres of pasture land, besides a wood, two miles square. The same church also had seven servants, forty one villaines or villagers, not immediately maintained by the lord of the manor, and twelve cottagers, or small cultivators, and twenty ploughs. It also appears that one Roger, possibly Roger de Curcelle, held of the Abbot of Glastonbury, three carucates, two villagers, and six cottagers, which a Saxon Thane had previously held; also Saulf, probably a Saxon, as he held the same in the time of Edward the Confessor, was possessed of one carucate and a half, one villager with four cottagers, who had one plough between them.

In the roll of the estates of the Glastonbury Abbey, drawn up soon after its suppression, is the following curious and interesting survey of this manor, which also explains some part of the above-mentioned Norman survey.

" THE MANOUR OF WRINGTON."

" The rentes of assise and customarye tenauntes there, with theire workes whiche they are bounde unto by tenure of theire landes, are of the yerely valewe of 85*l*. 6*s*. 4¼*d*.

" The profites comyng of the perquysites of the courtes holden there, with the 11 greate lawe dayes and fynes of landes at this audite was answered to the king, come to the sum of 48*l*. 8*s*. 7*d*.

" Alsoe within the sayd manour there are dyverse woodes growing of dyverse ages, as in the particular boke of this survey fully it doth appere, whiche are nowe worthe, to be

sold, 179*l*. 7*s*. 7*d*. whiche alwayes have ben used to be sold every 18 yeres, out of whiche there may a yerely wood sale be made of 100*s*.

" Alsoe within the sayde lordship there be able men, beying in all a rednes to do the king servyce when so ever they shall be called upon, to the nombre of 40.

" Alsoe there are within the circuite of the sayde lordship, certayne bond men, beying at the king's highnes pleasure in subjection and bondage, both bodyes and goodes, to the nombre of 2.

"Alsoe a common there, called Blackmoore and Warmeshawe, whereof the king ys chief lorde, and hath the profitts of the dryving thereof, and conteyneth 1 mile and a half."

In this village, and in a cottage close to the north gate leading into the church-yard, was born the celebrated John Locke. The house is now divided into tenements, one of which is used as a school for young children ; the whole having a mean and insignificant appearance.

BARLEY WOOD, long the residence of the highly respected and talented Mrs. Hannah More, is half a mile north-east of Wrington, and within the parish. It is built in the cottage style, pleasantly situated, with a verandah running along the front. It has lately been sold, and Mrs. More has removed to Clifton, where she now resides.

In allusion to these circumstances, and to the birthplace of Locke being now used as a school, the following lines were written.

> " Perhaps some village LOCKE is here,
> And o'er his horn-book drops the tear ;
> Who may fair learning's path pursue,
> And Wrington's classic fame renew.
> Perhaps some MORE her needle plies,
> Who may in future days arise,
> In virtue's cause the pen to wield,
> And as her champion, take the field."

In the garden at Barley Wood, stands an *Urn*, commemorative of Locke, the gift of Mrs. Elizabeth Montague, with the following inscription :

TO

JOHN LOCKE,

BORN IN THIS VILLAGE,

THIS MEMORIAL IS ERECTED,

BY

MRS. MONTAGUE,

AND PRESENTED TO

HANNAH MORE.

WRINGTON CHURCH

is a stately edifice, 120 feet long by 52 wide, consisting of a nave, chancel, side aisles, and an embattled porch with richly ornamented pinnacles. At the west end is a very fine tower, 160 feet high, with battlements, ornamented with four corner turrets, and sixteen elegant pinnacles 15 feet high. The terminating point of the ridge of the roof is finished by a small elegant turret, surmounted by a cross, with a small opening below; in this once hung the bell which was formerly rung to call the parishioners to morning and evening prayers.

The ceiling of the belfry is domed and groined, and the west window is fine. The nave is lofty, and the columns of the arches are clustered, the exterior one being continued up in an unusual manner to the moulding of the clerestery windows, which light the nave, there terminating in figures bearing blank shields. A light and elegant oak screen separates the chancel and the corresponding ends of the side aisles.

In the chancel are still remaining the old reading desks fastened to the walls, on which are copies of several works; especially Fox's Martyrs, and the *Clavis Bibliorum* of F.

K.

Roberts, who was rector of this parish in 1675. There are several mural monuments, especially one dated 1779, with a long inscription to Henry Waterland, prebendary of Bristol, who was rector of this place for fifty years; and a curious ancient stone monument to Samuel Crooke, dated 1649.

CHARITABLE BEQUESTS.—GEORGE LEGG, by will, 1704, gave a close of land in Congresbury parish, on the borders of that of Wrington, containing nine acres, called the Poors' Ground, for the purpose of keeping, successively, six boys and six girls of Wrington at school, to be taught to read the Holy Bible, perfectly, throughout. This land is let for 17l. per annum, 8l. of which is paid to the master of the boys' school at Wrington, for eight boys, who are particularly taught to read the Bible; the remainder of the income is applied to the School of Industry, for promoting the same object.

MR. SMITH, in 1794, left 33l. towards the support of the School of Industry in Wrington; the Rev. William Leeves has invested this money in the Funds, and applies the income of 1l. 13s. to the purpose intended.

MRS. ANN WEBB gave 50l. the interest to be applied to the support of a sunday school at Wrington, or in purchasing religious tracts, &c. The interest is regularly applied towards supporting the School of Industry, where the boys are taught to read; and the girls to read, sew, and knit. The average number is from 30 to 40. There are also several benefactions for supplying bread, &c. to the poor of Wrington, as stated at length on a tablet in the church.

Wrington contains 215 houses, 263 families, and a population of 1349 persons. The living is a rectory in the deanery of Redcliffe, and in the patronage of the lord of the manor.—The Rev. J. Vane, incumbent.

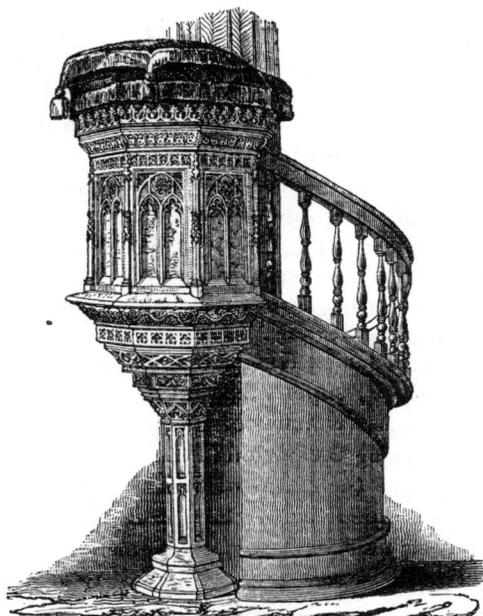

Sculptured Stone Pulpit in Banwell Church.

CHAP. VII.

*BANWELL, Derivation, Manor, Rolston, Yerbury, Banwell Ab-
bey, Bishop's Palace, Towerhead House, Bishop Godwyn, Mi-
neral Spring, Church, Extracts from Churchwarden's Accounts,
Parish School and Charitable Bequests, Park, Camp, Rampart
of Earth.—BANWELL CAVERNS, Explanation of Section, Orna-
mental Cottage, BONE CAVERN, STALACTITE CAVERN, Mr.
Beard's House, the Bones of the Bear, Wolf, Ox, Deer, &c.
Concluding Observations, the Rev. William Lisle Bowles's Lines
on Banwell Cave.*

BANWELL

is of considerable extent and population, pleasantly situated
on the north side of Wint, or Banwell Hill, with a rich
valley to the north, which is generally supposed to have

been once covered by the waters of the channel, as is pro-
bably indicated by its ancient name of *Banawelli*, from the
British word *Bann*, deep, and *Weilgi*, sea.* It is in the
hundred of Winterstoke, in the diocese of Bath and Wells,
fourteen miles from the latter place, sixteen from Bristol,
and about five from Weston Super Mare. The parish is
sixteen miles in circumference, and contains about 5000
acres of land, and 1500 inhabitants.

Banwell is a place of great antiquity, and from records
now extant, its history may be traced from the time of
Alfred. It was, at one time, of considerable importance,
and contained a monastery, founded by one of the West
Saxon Kings, over which King Alfred afterwards appointed
his favourrite Asser, superintendant or abbot; to whom he
also gave the extensive manor of Banwell. The monastery
was destroyed during the period of the Danish wars, but the
manor passed into the hands of Harold, Earl of Wessex,
who refusing to appear before the great council, convened
by King Edward the Confessor, was banished the kingdom,
and the lordship seized and given as temporalities to
Dudoco the Lombardic Bishop of Wells, whose successor,
Giso, enjoyed it at the time of the Norman survey.

This manor continued attached to the see of Wells,
until the time of Edward VI. when bishop Barlow sold it
to the Duke of Somerset; upon whose attainder, in 1552,
part of it was granted, for twenty-one years, to Sir William
St. Loe, knt. who also held the office of park keeper
until his death, in 1556, when Queen Mary granted the
whole of the manor, with lands at Axbridge, Worle, and
Churchill, to Bishop Bourne, thus restoring it to the see
of Bath and Wells, under which it still remains.

* Since this was written, it has been suggested by a neighbouring gentleman
and scholar, that *Ban*, is mountainous or hill-side, and *Gwely*, a bed or couch, or
form, on which animals lie down; and that the name was probably formed in
allusion to the Banwell Hills being the resort and resting place of the numerous
herds of animals, whose bones have been found in the lime-stone caverns.

Within this parish, and to the north of the village, are the two hamlets of

EAST AND WEST ROLSTON,

which were formerly united under the name of Worlston, and formed the head of an extensive barony, being for some time in the family of Perceval, but more recently in that of Wyndham ; from whom it passed, by marriage, to the Hon. James Everard Arundell, whose son is now Lord Arundell of Wardour ; but it again reverted to the Wyndhams, who are its present possessors.

YARBURY OR YERBURY

is an ancient hamlet within this parish, on the southern side of Banwell Hill. It contains a few houses, one of them retaining vestiges of former respectability, having been successively occupied by the families of Hill, and James, in which the principal estate has descended to the present time.

BANWELL ABBEY

was founded by one of the Saxon Kings, and probably enriched by Alfred. In Asser's life of that king, it is stated, that on the morning of Christmas Eve, when the author was about " to visit Wales, Alfred gave him the monasteries of Ambresbury in Wiltshire, and Banwell in Somersetshire, with all that they contained, together with a silk pall, very precious, and as much incense as a strong man could carry."

The monastery was destroyed by the Danes, who over-ran the whole of this part of the country, contiguous to the Channel ; it was afterwards re-established, but never recovered its former magnificence ; and had fallen into ruin, some centuries previous to the general dissolution of monasteries.

The original establishment is supposed to have been situated in the hamlet of Winthill, on the southern side of the hill ; where is a piece of ground, from time immemorial called Chapel Leaze, in which have been discovered nu-

merous skeletons, lying regularly east and west; and in an adjoining field are the foundations of extensive buildings, supposed to have been the site of the monastery and chapel. Several coins have been dug up on this spot; two of which, the most remarkable, are now in the possession of Mr. George Bennett, solicitor of Rolston; one of silver, representing Julian the apostate, the other copper, of the Emperor Alexander.* It is supposed that this monastery was the one destroyed by the Danes; and that on its re-establishment, it was built within the village; probably on the site of the bishop's palace, on which now stands the Court House.

The late Doctor H. Gresley Emery, some years since, met with an ancient manuscript at Rome, mentioning the number of monks supported at Banwell; and as it contained other information upon the subject, it is to be regretted that he had no opportunity of taking a copy of so interesting and valuable a document.

THE BISHOP'S PALACE.

It appears that Banwell was a favourite retreat of the bishops of the diocese, as early as the reign of Edward I. but the episcopal palace was erected by Bishop Beckington, who flourished during the middle of the fifteenth century, and who constructed it, not only on the site of the ancient monastery just mentioned, but partly from its remains. Early in the next century, the palace was repaired and ornamented by Bishop Montague; but it had long been neglected and fallen into decay, until at the beginning of the last century, the ancient hall was converted into the present dwelling, called BANWELL COURT; and the other parts of the palace were demolished, with the exception of the chapel, a handsome gateway, porter's lodge, granaries, and other detached offices. The whole of these have been

* This gentleman has also two bronze coins of the Emperor Constantine, which were found in Lloyd's Field, on the north side of Banwell Hill.

within a few years past taken down by the present occupier, Mr. John Blackburrow, except the chapel, now converted into a cellar, and retaining but small indications of its original beauty.*

In connexion with this palace, was a fine PARK, eastward from the village, on the declivity of the hill, which will be hereafter mentioned at the extremity of which stands

TOWERHEAD HOUSE,

supposed to have been erected by Bishop Godwyn, as a summer residence, about the year 1584. It is a large substantial structure, in the Elizabethan style, and retains much of its original character, including the front porch, over which is the Bishop's arms, impaling Bath and Wells, with the singular motto, " *Godwyn—wyn God wyn all.* "

This prelate resided chiefly at the palace at Wells, in the winter, and at his mansion at Towerhead during the summer months; having had a raised causeway, about a mile in length, formed from his country residence, to the church, for the more convenient attendance there of his family.

Whilst the bishop resided here, he married a third wife, when upwards of seventy years of age and very infirm. A noted courtier † of Elizabeth's reign coveting the manor, palace, and park of Banwell, always considered as the most valuable appendage to the See of Bath and Wells, and being well aware of the queen's dislike to the marriages of her clergy, represented it to her Majesty as a heinous offence, that the bishop had married a girl of twenty, with a large portion, to whom he had conveyed half the bishopric, although he was at the time of his marriage, gouty and unable to stand ; the courtier finally begged that the bishop

* It appears by the register, that marriages were celebrated in this chapel so late as the year 1730.

† The gallant but unfortunate Sir Walter Raleigh.

might be deprived of his possessions at Banwell, and that they might be granted to himself by lease for one hundred years. The queen's favourite, the Earl of Leicester, defended the character of the prelate; and the Earl of Bedford assured the queen that, " though he knew not how much the woman was above twenty, yet he did know that her son was near forty." This rather irritated than soothed the queen, who replied, " *Majus peccatum habet*," he hath the greater sin. There are three kinds of marriage: first, of God's making, when two young folks are coupled; second, of man's making, when one is young and the other is old; and third, of the devil's making, when two old folks are married, not for comfort, but for covetousness, and such is this of the bishop's."

The good prelate was much perplexed by this sudden tempest, and withstood several severe messages from the queen; * and fearing that he should lose his favourite manor of Banwell, relinquished that of Wiveliscombe for 99 years, and by this means purchased his peace.†

A few years since, there stood, in the centre of the village, an ancient market cross; but as it was considered an obstruction to the thoroughfare, it was entirely demolished.

Collinson notices a mineral spring as formerly being in much repute for its medicinal properties; it took its rise near the large sheet of water in the middle of the village,

* Probably similar to the one she sent to Bishop Heaton of Ely, viz.

" Proud Prelate,

 " I understand you are backward in complying with our agreement; but I would have you know, that I, who made you what you are, can unmake you; and if you do not forthwith fulfil your engagement, by —— I will immediately unfrock you.

 " Yours, as you demean yourself,

 " ELIZABETH."

† See Sir John Harrington's Life of Dr. Thomas Godwin, and Park's Nugæ Antiquæ.

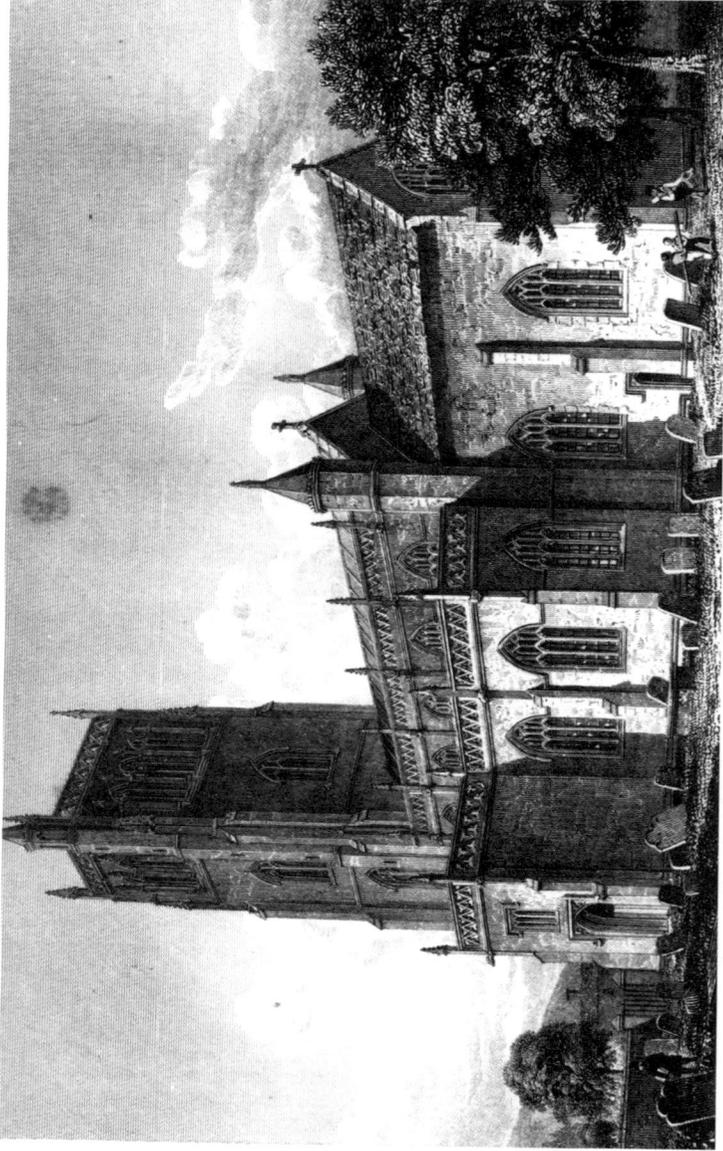

BANWELL CHURCH

To the Revd Francis Randolph D.D. Vicar of Banwell
this plate is respectfully inscribed.

which is now ornamented by a graceful weeping willow on a small island in the centre, and a pair of handsome swans. It is the property of Mr. Emery, and forms a pleasing object from the street. This beautiful spring of water, which is said never to be frozen, works an extensive writing paper manufactory and flour mill; from thence it flows through a rich vale of fine pasture land to Wick St. Laurence, falling into the Bristol Channel near Woodspring Priory.

BANWELL CHURCH

is a fine, well proportioned, and lofty edifice, in the elegant pointed style of the reign of Henry VI. and has been pronounced by an able judge, to be one of the most complete parochial edifices in the kingdom.

It was, probably, erected by Bishop Beckington,* about the middle of the fifteenth century; his arms were formerly in the east window of the north aisle; but it has evidently undergone several extensive repairs; one of them was effected in the reign of Edward VI. after the destruction of the altars and ornaments at the Reformation; and a much later one in 1813, when many very judicious improvements were made. It consists of a lofty nave, 80 feet in length, with side aisles, a chancel, and a vestry room. There is a large projecting porch on the south side, over which was formerly a rood loft; the remains of the niche, in which the crucifix stood, may still be seen, with a canopy elaborately carved in stone; and at the west end is a stately tower, one hundred feet in height, supported by double buttresses, terminating in handsome crocheted pinnacles.

The interior of the church is not only capacious, but strikingly handsome; the centre aisle having a groined arched roof, springing from a row of small ornamental

* Fuller says, "Thomas de Beckington was a good statesman, a good churchman, a good townsman, a good kinsman, a good master, and a good man," and we may add, a good architect. He was born at Beckington, near Frome, in this county.

pointed arches, with a richly sculptured cornice below.
Five lofty gothic arches, with clustered columns, having
grotesquely carved capitals, open into the side aisles; these
are lighted by five well proportioned windows, correspond-
ing on each side; and separated on the exterior by but-
tresses terminating like those on the tower, in ornamental
pinnacles connected by an open balustrade.

The belfry has six bells, and its roof is handsome, being
formed of stone, like the one at Hutton, with moulded ribs,
springing from a corbel in each corner, and expanding into
open fan-work groins, which form a vaulted ceiling richly
ornamented with bosses of foliage at the intersections.

An unusually rich and ornamental oak screen, separates
the chancel from the body of the church and comprises a
centre arch with four smaller ones on each side, filled with
stained glass, a great part of which is evidently of ancient
date.* Between these elegant arches, are small clustered
columns, expanding into richly gilt fan-work groins, which
support the projecting gallery or rood-loft; in front of
which, towards the nave, is an elaborately carved cornice
or border richly gilt, surmounted by an oak panelling and
railing, the whole producing a combined effect, strikingly
rich, light, and elegant.+ Upon this gallery, in the centre,
was formerly placed the rood or large crucifix, with the

* The stained glass is of more ancient date than the screen, and was taken
from the church windows and placed in its present situation in the year 1813.
The screen was supposed to have been brought, either from Glastonbury or
Bruton monasteries, at their dissolution; but this supposition is proved to be
erroneous by the churchwardens accounts, in which successive charges are
made for its carving and erection, dated twenty years prior to the dissolution
of either of those houses.

+ This rood loft was subsequently used as an organ gallery, no vestige now
remains of the instrument, but endeavours are making, and hopes entertained
that it will again be re-placed. It was upon the tie-beam that the crucifix was
put, and over it a canopy of crimson silk or velvet; nothing could be worse in
point of taste, but it is curious as exhibiting the probable origin of rood-lofts
in our cathedrals.

figures of Mary and John, one on each side, probably with other figures of saints, as thus mentioned in an old ballad:

" Oh ! hold thy peace, I pray thee,
The house was passing trim,
To hear the fryars' singing,
As we did enter in,
And then to see the rood-loft
So bravely set with saints. "

The octagon pulpit is of sculptured stone, supported on an octagon stone pillar; above it hangs a richly ornamented oak sounding board, erected in the reign of James I. This pulpit and its appurtenances, have been most judiciously restored, being unusually rich and handsome; *and are said* to have tempted an antiquary to offer one thousand pounds for them.

The centre of this beautiful church is still fitted up with the old substantial oak seats, though such seats in other churches have been generally superseded by the modern innovation of pews. The ancient font is of large dimensions, and embossed with very roughly sculptured foliage and other devices; on the floor are several slabs, with well preserved figures and inscriptions in brass. One is dated 1503, to the memory of " Master John Martock, Physician," and another, dated 1554, with the effigies of John Blandon and Elizabeth his wife," and some others.* There are some modern tablets, in the interior of this edifice, several of which, relate to deceased members of the Gresley, Emery, and Hill, families. A Gothic altar-piece of beautiful workmanship, in correct unison with the building, has been lately erected by Mr. R. H. Trickey of Bristol; also a communion table enclosed by rails, in the same style, designed and executed by an inhabitant of the village. The painted glass in the windows, has been taken out and

* Mr. George Bennett, solicitor, of Rolston, has kindly sent the author some admirable drawings of the brasses, and also of the figures in the glass, but the limited price of this work, would not admit of their being engraved —ED.

restored, and placed in the arches of the truly elegant screen, at the cost of the respected vicar of the parish. The figures are about 18 inches high, and unusually curious; two of them represent bearded and hooded priests, with their hands joined in prayer, and covered with mantles; three others are figures of bishops, with richly jewelled mitres and crosiers; two of them being in the attitude of giving the benediction; a seventh figure represents a priest reading a book to a noviciate standing behind him; and the subject of the eighth, refers to the seventh chapter of the second book of Maccabees.

THE CHURCHWARDENS' ACCOUNTS
of the parish of Banwell have been most carefully preserved, and contain an unusually regular series of entries, commencing at the 7th of Henry VIII. 1516, down to the present period. The writing is peculiar to the different eras; but the most interesting specimens are those of the reigns of Henry VIII. Edward VI. Elizabeth, and Philip and Mary. Mr. G. Bennett, of Rolston, has made beautiful *fac-similes* of each, and has also written out copious extracts from the accounts, with explanatory notes; which together, would form a most interesting antiquarian publication, but the limits of the present work will only permit the few following selections.*

A. D.

1516 Pd. for 58*lb.* of Wexe agen Crysmas, 1*l.* 11*s.* 3*d.*

—— Pd. for making of the High Cross light agen Crysmas, 1*s.* 5*d.*

A large taper stood before the holy rood, and wax lights were kept burning in the churches day and night during the great festivals.

—— Pd. for making of the 2 pocketts in the chancel, and the 4 pketts. at the syde Autrs, and the 5 pketts. afore the 5 *ownys*, agen the same, 5½*d.*

The pockets were intended to receive the contributions of the congregation; and the last alludes to the five wounds of our Saviour on the cross.

* If the author could obtain a sufficient number of subscribers at 5*s.* each, he would immediately undertake to print these most curious extracts with the *fac-similes.*

—— Pd. for the making of the Paschall agen Est[r]. 1*d*.

This was the wooden box, by means of which the resurrection of Christ was represented at Easter. "Making it," implied cleaning and getting it in readiness.

—— Pd. for Rychard Webbe, ys Dyryge, 1*s*.

The dirge was a solemn laudatory song to commemorate the dead.

1517 Pd. John Keyncote for his mete and drynke for 6 daies with the plomer, 1*s*.

—— Pd. for mendyng of the belys of ye orgons, 4*d*.

This organ stood on the rood loft, at the foot of the high cross, where it remained until its final removal in the last century. A new organ is about to be erected in its place.

1519 Pd. John Morse for mendyng of the poly of the clocke, 1*d*.

Pulley of the church clock, of which this is the first notice.

—— Pd. for a neu Banner, (for processions,) 10*s*.

1521 Rec[d]. of Robart Cabyll for the lyyng of his Wyffe in the *Porche*, 3*s*. 4*d*.

—— Rec[d]. of Robart Blandon for the lyyng of his Wyffe in the *Church*, 6*s*. 8*d*.

The fee was as much again for burying in the church, as in the porch.

—— Pd. for a paper for to draw the Draft of the Rode-lofte, 4*d*.

—— Pd. for the makyng of the Endentur and the Oblygacyon for the Kervar, 1*s*. 8*d*.

—— Pd. to John Sheppard of Walfarshill, 18*l*.

1522 Pd. to the Kervar att Willya Jervys howse, 23*l*.

These last four payments related to the rood loft and the screen.

—— Pd. John Wylde to helpe rede the boke of counts, 4*d*.

—— Pd. to Robart Cabell for a Kapon, 1*s*. 8*d*.

This entry *savours* of good parish feasting, even in those days.

—— Rec[d]. of Rychard Lockyar of Axbryg for the Anvell, 2*s*. 4*d*.

This man appears to have rented the parish anvil at 2*s*. 4*d*. per annum.

—— Pd. to John Welsche, our Ladyman, 2*s*.

This man's office was to collect the offerings to the virgin's or high altar.

—— Pd. for Brede and Ale for men to take downe the rodelofte, 9*d.*

Probably for repairing, as the Reformation had not commenced.

1523 Rec^d. of John Blandon for candyll of the trendyll, 4*d.*

" Trental," 30 masses for 30 days for the dead.

—— Rec^d. of John Ree for a boschell of Whete, 11*d.*

Wheat, in 1801, was 30*s.* and now, (1829,) is 10*s.* per bushel.

—— Pd. to John Wyld for makyng of the Sepulkar, 1*s.* 7*d.*

A tomb for the burial of Christ on Good Friday.

1525 Pd. to Rob^t. Hoptyn for gylting in the Rode lofte, and for steynyng of the clothe afore the Rode lofte, 5*l.*

This gilding appears to have remained perfect and bright until the year 1805, when it was new gilded, but the latter is already considerably faded.

1530 Pd. three Laberers for a weke, 4*s.* 6*d.*

Threepence a day each, when wheat was about 11*d.* a bushel;---they are paid only twice or thrice as much now, though the price of wheat has increased eleven fold.

—— Pd. for two men costs and their horsys to brystowe, (Bristol,) 1*s.*

—— Pd. for the custome of the Yeate, 1*d.*

This was the toll at Redcliff Gate, Bristol.

1531 Rec^d. for the Rode, (High Cross,) 3*l.*
—— Pd. for mete and drynke to tak doun ye Rode, 10*d.*
—— Pd. for Careg (carriage) of the Rode to Uphill, 1*s.*8*d.*
—— Pd. to the bote men, 1*s.*

These are strong symptons of the Reformation. It is probable, from the last entry, that the High Cross, (which was sold for the value of 65 bushels of wheat, now 32*l.*) was exported.

1559 Pd. for takyng doun of ye Aulters, and for carrynge out of same, 4*s.* 8*d.*
1560 Pd. for 2 Bowes, 5*s.* 6*d.*
—— Pd. for one Sheyffe of arowes with ye cace, 2*s.* 3*d.*
—— Pd. for one sworde and 2 capps, 5*s.* 8*d.*
—— Pd. for exspences at Brystowe, when we bought the Harnes (accoutrements,) 10½*d.*

Each parish was required to fit out a certain number of soldiers for the defence of the kingdom.

1568 Pd. John Payne for the *Hooken Stool*, 17s.

This curious entry refers to the legal punishment of " Communis Rixatrix,"
or common scold ; and of brewers and bakers who transgressed the laws.
The original name was the Cucking or Scolding Stool, now corrupted into
the Ducking Stool, from its occupant being plunged into the water.

THE PARISH SCHOOL.

This building was erected in 1824, at the cost of 400*l.*
raised by the subscriptions of the venerable vicar, Dr. Ran-
dolph; the curate ; and a few other persons. There is a
foundation for the education of ten boys, attached to the
establishment, but it is chiefly used as a Sunday School for
boys and girls.

CHARITABLE BEQUEST.—WILLIAM BURGIS, in 1676,
granted a rent charge out of a property at Cote, in the
parish of Westbury on Trim, Gloucestershire, towards ap-
prenticing poor boys of the parish of Banwell ; a sum not
exceeding 16*l.* to be paid as a premium, and 12*l.* to be
given to the boy, when out of his time, towards setting him
up in business. Boys educated at the Free School are
generally, and very properly, preferred in the selection.

Banwell contains 262 houses, 300 families, and 1500 in-
habitants. The living is a valuable vicarage and a peculiar,
in the deanery of Axbridge ; under the patronage of the
dean and chapter of Bristol.—The Rev. Francis Randolph,
D. D. is the present incumbent.

BANWELL PARK

lies eastward from the village, and was attached to the
Bishop's Palace. It continued in demesne until within a
few years past, when it was unfortunately leased out, like
the remainder of the manor, upon lives. It was formerly
well stocked with deer, but is now divided into small fields,
and grazed by cattle and sheep. On the upper side of the
park are the remains of a beautiful wood, which is much
reduced from its original extent. At the time of the
Doomsday Survey, it is recorded as having been two miles
and a half in length and breadth. This part of the manor is

exceedingly picturesque; and the present prelate, Doctor
Law, was so much struck with its beauty, that he most
liberally re-purchased the lives of a great part of the estate,
at a considerable personal sacrifice; and has had it thickly
planted, and laid out with delightful drives and walks,
with the view of increasing the comfort and attractions of
the village, and of accommodating those who might desire
to explore its romantic dells.

BANWELL CAMP

is situated on the summit of what is called the Great
Wood. It was originally an extensive British earth-work,
occupying the crown of a lofty knoll, with an area of about
twenty acres, having a Roman camp within. The exterior
line is of an irregular form, wide towards the west, and
narrower to the east; the rampart is formed out of the de-
clivity of the hill, and rises about two or three feet above
the level of the interior, its height varying from seven to
ten feet from the bottom of the ditch. On the highest point
of the interior area, is a small mound of earth, several
feet high, which was always considered to have been the
remains of the Pretorium; but on digging, a regular foun-
dation of bricks and mortar was found, and in the memory
of some now living, many cart loads of freestone were
carried away from this spot. There are two entrances to
this camp, the principal one facing the east, as usual; but
the other appears to have communicated with another rem-
nant of antiquity, not easily accounted for, which is situated
about a quarter of a mile to the eastward, in what is
called the Little Wood. It is a small plot of ground
nearly square, surrounded by a

RAMPART OF EARTH,

only three feet high, and a slight ditch; it is about fifty-
five yards from east to west, and forty-five yards from north
to south, with an entrance on the eastern side. Within
the area is a raised ridge of earth, about two feet high and

ten feet wide, formed in the shape of a cross, about thirty-five yards long, and about twenty yards broad, edged on all sides by a slight ditch or trench.

Although the square form of this enclosure, indicates it to be of Roman origin, its object is not easy to be comprehended; but it was probably an out-work, connected with the contiguous fortress of Banwell. At a later period, according to tradition, a severe battle was fought near this hill, between the Saxons and Danes; the memory of which is preserved by the appellation of Wint Hill, which, in the Saxon language implies the place of the tower, or hill of battle, and these camps confirm the supposition; at all events, these two rival nations had many encounters in this part of the country.

Within the larger camp on Banwell Hill, and on the mound of earth before mentioned, the Rev. Dr. Randolph has lately erected a gazebo or summer house, surrounded by a verandah. The situation is well adapted for the enjoyment of a rural repast, by any parties, who are induced to explore the varied scenery, which this elevated situation commands, and which the Rev. W. Lisle Bowles has celebrated in his recently published poem on Banwell Hill.

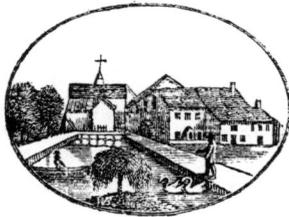

Pond and Mills at Banwell.

L

BANWELL CAVERNS.

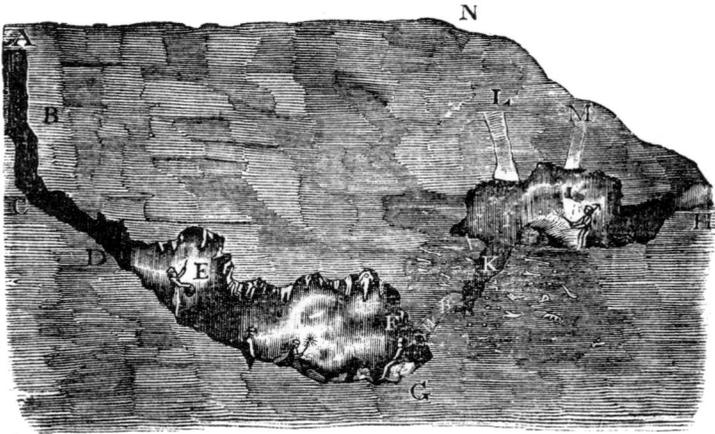

EXPLANATION OF THE VERTICAL SECTION.

A.—The entrance at the side of the hill to the stalactite cave leading to

B.—The original shaft, which was sunk about thirty years since. It was re-sunk under the direction of Mr. Beard.

C.—The second landing place, where was found a piece of candle incrusted with a coating of stalagmite.

D.—The continuation of the shaft, leading by a rough flight of slippery steps to

E.—The immediate entrance, or upper division of the cavern.

F.—The stalactite cave; being an immense vaulted apartment, about 150 feet in length and 35 feet in height. The arched roof is hung with stalactites, and the floor strewed with fragments of rock, partially covered with the same material.

G.—The Bishop's Chair, formed of a mass of rock, covered with stalagmite.

H.—The entrance to the bone cavern, leading to the almost horizontal shaft, originally sunk with the intention of making a more convenient entrance to the stalactite cave; but which unexpectedly led to the discovery of

I.—The bone cavern; the floor of which was covered to the depth of several feet with loose stones and fragments of rock, intermingled with a large quantity of bones, and smaller portions of mud, sand, and gravel.

K.—The descending fissure, in which the bones are left in their original state. It has not been thoroughly explored, but it evidently communicated at some early period with the stalactite cave.

L. M.—Two natural entrances to the cave, now filled up with a broken and rubbly mass.

N.—The relative situation of the Bishop's Cottage.

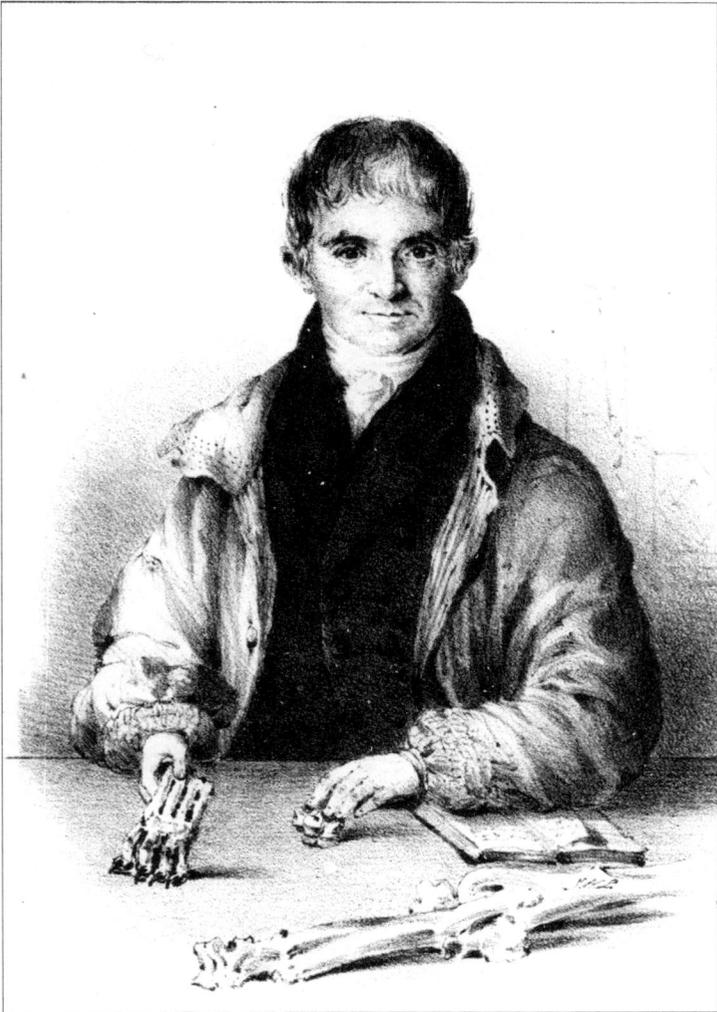

M^R WILLIAM BEARD
Of Wint Hill near the Banwell Caves.
Aetaitus LVII

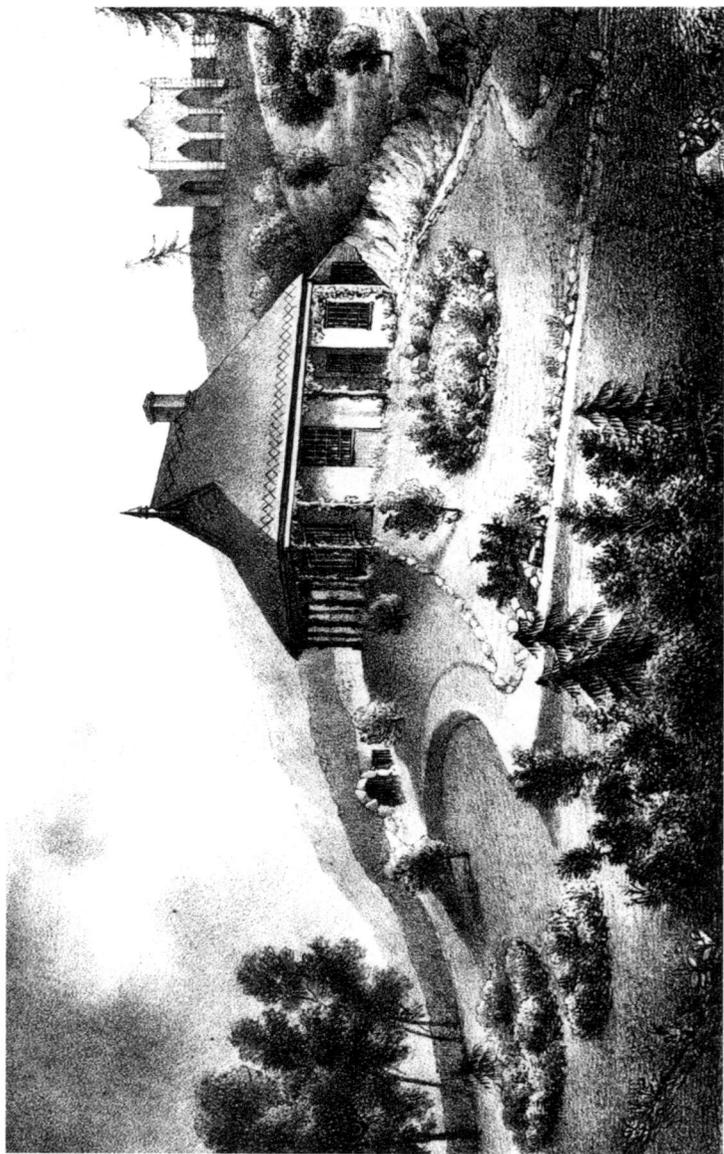

ORNAMENTAL COTTAGE ON BANWELL HILL

Erected by the Bishop of Diocese, who is Lord of the Manor, for the accommodation of Visitors to the Caves.

THE CAVERNS

are situated at the western extremity of Wint, or Banwell
Hill, immediately above the latter village. The road from
Weston turns off towards the south, at a hamlet called
Knightcott, two miles from Hutton, and one from Banwell.
It gradually winds up the steep ascent to an

ORNAMENTAL COTTAGE

built by the Bishop of Bath and Wells, in the summer of
1827, for his accommodation, and that of the numerous
visitors.*

Soon after the discovery of the caves, the Bishop, who
is lord of the manor, purchased from his tenant the lease
of the ground ; and with the laudable view of preserving
the remains in the caves from destruction, he enclosed the
ground, and laid it out with ornamental shrubs and plan-
tations. His lordship has evinced great interest in the dis-
covery, and has fitted up a handsome drawing and dining
room in the cottage ; which also contains apartments for
John Webb, who has the charge of the caverns under Mr.
Beard, and who assisted, as a miner, in their discovery.

The situation of this cottage is pleasant and commanding,
the drawing room windows over-looking the extensive
valley at the foot of the hill, bounded by the Severn. The
hill itself is a high ridge, from a quarter to half a mile in
length, and abounds with ochre, calamine and lead, which
have been worked for ages. Its summit commands an am-
ple prospect : towards the south, are Brent Knoll, the
white spire of East Brent church, and, through an opening
in the Mendip range of hills, Bridgewater spire may be
distinctly seen on a clear day. The tower of Banwell
church rises immediately in the fore-ground on the north-
east, with Congresbury spire and Yatton church more to
the north. To the north-west is the level, bounded by the

* A contiguous stable and shed have also been erected by him, for sheltering
horses and carriages.

Severn, with the Monmouthshire coast on its opposite shore; further to the west, is the village of Worle, with its conspicuous hill, and the town of Weston Super Mare; and a little southward is Brean Down; with the Holms in the distance.

The hill in which the caves exist, contains ochre, cala-mine, and lead, as before mentioned, which were obtained from the mines in considerable quantities; some of the shafts having been sunk to the depth of 80 fathoms, or 480 feet; but these proving less productive than other parts of the Mendip range, have not been worked during the present generation of miners. A tradition was prevalent amongst them, that about 30 years since, an immense cavern had been discovered in the north-western extremity of the hill; the entrance to which being difficult, it excited no further attention. But when the discoveries of Professor Buck-land opened a new era for research, a respectable farmer named Beard, who lives at Wint Hill, a village below the south side of the high ridge, remembered hearing of this cavern when a child, and happening to meet with John Webb the miner, who now lives at the Bishop's cottage, was directed to the supposed entrance, which Webb and another miner, named Colman, commenced clearing out. After re-sinking the shaft to the depth of about 100 feet, they came to the entrance, or first landing place of the cave, where they found two pieces of candles, evidently left there by the original discoverers, encrusted with a slight coating of carbonate of lime, giving them the appearance of stalactites.

The cave thus re-discovered is the one distinguished as the Stalactite Cave; and from its description by the mo-dern discoverers, attracted the attention of Dr. Randolph, the vicar of Banwell; who, conjointly with the Bishop of Bath and Wells, resolved to improve the access to it, for the convenience of visitors from Weston and other adjacent parts, whose donations on viewing it, might increase the funds of a charity school, just then opened at Banwell.

A horizontal opening was accordingly made lower down the western point of the hill, where a fissure about eight inches wide was observed in the rock, running in the direction of the cave. The workmen followed this fissure, until it gradually became wider, but filled up with a loose mass of stones and earth. About twenty feet from the surface of the rock, the fissure expanded into a small cavern, unconnected with that which they desired to approach, being of much less extent, though ultimately proving of far greater interest than the larger one.

This smaller cavern was nearly filled with sand, mud, loose stones, and fragments of mountain limestone fallen from the roof; intermingled with an immense quantity of bones of various animals, the living species of most of which, no longer exist in England.

This unexpected discovery of the smaller cavern, now became the subject of attentive research and intense curiosity. The Bishop of Bath and Wells, proprietor of the ground, and Dr. Randolph, together with some other gentlemen, set on foot a subscription for exploring its organic contents, and their exertions were most zealously aided by Mr. Beard, by whose unremitting attention, the bones were secured as they came into view, and preserved for future examination.

The workmen gradually enlarging the opening, cleared out a large portion of the sand, clay, and stones, leaving the bones in the cavern, where they were afterwards arranged, nearly as they now appear ; a large portion of the deposit remaining undisturbed, with the bones indiscriminately mingled with the rubble ; the former being completely disjointed and confusedly interspersed with only two exceptions, viz. some of the vertebræ of a deer, and the head and horns of an ox.

In proceeding from the cottage to examine the caves, visitors usually place themselves under the guidance of Mr. William Beard, who evidently appreciates the scien-

tific and interesting characteristics of the scenes of which he was in some measure, the discoverer. The first, into which he introduces the visitor, is the

BONE CAVERN,

where he explains the peculiarities of its contents, having previously caused it to be illuminated. The entrance is at a short distance below the cottage, over which, an appropriate arch has been thrown. A rough flight of stone steps, leads down about thirty feet to the cavern, which may be described as consisting of a centre, with three branches, something similar to the palm of the hand, with three expanded fingers.

The descent inclines to the south west, one branch being directly in front, and another towards the right hand, of considerable dimensions, but of trifling depth, both being level with the floor of the cave; but on the left hand, is another narrow descent of rough steps formed in the rock, leading down into the lower fissure or branch of the cave, from forty to fifty feet below the level of the other part of the cavern.

The body of the cave, together with the two horizontal branches, was, when first discovered, filled to the depth of eight or ten feet, with a confused mass of bones, stones, stiff loam or mud, and coarse gravel, with a small portion of sand. The stones, gravel, and mud, have been cleared out, and the bones arranged on the sides, being piled up into squares, and other more fantastic forms, similar to a charnel house; those found in the upper portion of the cave, being sufficient in quantity to fill several waggons.

Mr. Beard in his capacity of Cicerone, describes the course of the discovery, points out the bones of the various kinds of animals, chiefly of the ox or buffalo, deer, wolf, and bear, from the masses arranged around; and then superinduces his theory as to the best method of accounting for so large a deposit of them in such a situation.

Many of the most interesting specimens are very properly taken from the cavern by the " Professor," * that they may be preserved from the moisture, which in the course of a few years, would probably decompose them.

Immediately opposite to the termination of the passage into the cave, is a portion of it, by far the most interesting, being a fissure declining somewhat steeply, full forty feet below the floor or level of the principal cavern ; through which fissure, visitors descend by a flight of rough, uneven steps, with a low head-way. On the right hand, through nearly the whole descent, is a bank of stones, sand, and loam, left undisturbed, intermingled with bones lying in their original position. The upper part of this bank, contains a much larger portion of bones ; some of those on the surface, appearing as if they had been bleached, or whitened by the flow of water, which probably carried away the upper portion of the clay and sand. The bones project from the sides of this bank, and at the lower extremity, they are left confusedly mixed together, as they were discovered ; the different kinds appear to lie promiscuously ; and on the left, in descending, besides those already mentioned, bones of mice were observed ; Mr. Beard also exhibits a substance which he considers to be *album græcum*.

The body of the cave is about 30 feet in length, and the eastern branch extends about 30 feet further. There is every appearance of the previous existence of three natural entrances to this cavern ; one leading from the south-western branch, one in the roof, and the present entrance, each of which was filled up with a broken and rubbly mass ; all these were opened for the more convenient removal of the rubbish and soil, but two of them have been again closed ; the remaining one is arched over with rough masses of the limestone rock, evidently rounded by the action of water.

* A title which the Bishop of Bath and Wells conferred upon him, in consequence of the zeal and enthusiasm, which he evinced during the progress of the discoveries.

The roof of the cavern is very uneven and full of deep recesses, difficult to be accounted for, because the edges of many of them are sharp; but other appearances would induce the presumption that they were filled with softer portions of rock, which have been gradually washed away by the action of water.

From the bone cave, visitors are conducted to the

STALACTITE CAVERN,

the entrance to which is from a much higher level than that of the bone cavern, and the descent much greater, more perpendicular and difficult.

At the upper end of the enclosure, above the cottage, an archway, extending about twelve feet, leads to a ladder, by which an almost perpendicular shaft of about twenty feet is descended; at the bottom is a narrow landing place leading to a second descent, nearly of the same depth. At this point the fissure becomes rather more roomy, and a very rough flight of rocky and slippery steps leads down about 100 feet to the immediate entrance of the cavern, which here suddenly expands, unfolding the real character of the place.

The visitor looks down an immense vaulted apartment, from 100 to 150 feet deep, 35 feet high, and from 50 to 60 feet broad, which, on being lighted up, presents a grand and imposing appearance, amply repaying the fatigue and inconvenience of the descent.

The stalactites are fine, and their semi-transparent cha- rater is exhibited by the aid of the guide's candle, fastened to the end of a long pole.

The capacious arch of the roof, springs from a wall of solid rock on each side, from which it is separated by a narrow crack or fissure, extending the whole length of the cave. Huge masses of rock, detached from the sides and roof, lie scattered on the floor, covered with stalagmite incrustations, and having their forms flung in strong relief, by the glare of the lights.

A flight of broad rough steps leads about 100 feet towards the bottom ; at the further extremity is a rough seat, with a circular back, covered with mamillated carbonate of lime, the seat being formed of a large mass of stalagmite. It is called the " Bishop's Chair," not only in commemoration of the lord of the manor, and the patron of the caves, but from his having first applied it to its present use. This natural chair has considerable resemblance to the ancient stone crowning chair in Winchester cathedral. It appears to be a mass of rock separated from a corresponding portion in the roof immediately above it, which is ornamented in a similar manner, with stalactite incrustations.

The view from this seat upwards towards the second landing place, is strikingly grand. The arched roof rises majestically above, and displays itself to much advantage ; while the effect is heightened by the deep shades of its projections and recesses ; and the inclined plane of the ascent shews, that the cave has been partially filled with fallen fragments ; its original bed or base, having, probably, been level with the lowest portion.

The roof is curious and worthy of attention, presenting a very rugged and grotesque appearance, partaking of the general character common to all limestone formations, being perforated with irregular hollows, the causes of which have not been very satisfactorily ascertained by geologists ; but the spherical and oval cavities exhibit strong indications of their having been formed by the action of water. The " Professor " points out various stalactites, which have been noticed to bear fanciful resemblances to a lion, to the upper jaw of an alligator, and other natural objects.

Emerging from the caves, visitors usually repair to the cottage, where, after enjoying a short rest, they proceed by a very pleasant walk over the hills, to

MR. BEARD'S HOUSE,

which is about half a mile from the caves, on the south side of Wint or Banwell Hill ; the wall enclosing a small

court in front of his residence, being surmounted by pieces
of stalactite and stalagmite, brought from the larger cave.
Hither many of the finest bones were carefully conveyed,
and are now preserved in a curious old carved oak cabinet,
from which the specimens are produced for examination. *
In the cave, the " Professor " is extremely jealous, even of
a touch, by stranger hands; not only through fear of
damage, but lest the number of specimens should gra-
dually be diminished, by the eagerness of collectors over-
coming their sense of propriety.

In the parlour are arranged various curiosities of minor
interest, among which, is the book in which visitors gene-
rally enter their names, most of whom add a small gratuity,
which has hitherto been expended in increasing the accom-
modations at the caves, and improving the access to them;
the surplus will hereafter be appropriated to Banwell
Charity School.

The Bishop of Bath and Wells has presented Mr. Beard
with a handsome silver embossed tankard, having the
following inscription :—

GIVEN TO MR. BEARD, OF BANWELL, BY GEORGE HENRY
 LAW, LORD BISHOP OF BATH AND WELLS, AS A
 SMALL TOKEN OF ACKNOWLEDGMENT OF HIS CARE
 AND SKILL IN EXPLORING THE ANTEDILUVIAN RE-
 MAINS, DISCOVERED AT BANWELL.
 A. D. 1825.

The bones which have been discovered in Banwell Caves,
may be enumerated under six different heads in their rela-
tive proportions as regards quantity : first, the ox or buf-
falo; second, the deer tribe; third, the wolf; fourth, the
bear; fifth, the fox; and sixth, the mouse or bat. They

* Mr. Beard has also a collection of bones which were extracted from the re-
opened caverns on Hutton Hill; a description of them is given in the sixth
chapter.

consist chiefly, of more or less perfect skulls of quadru-
peds, amongst which are the heads of two very large bears,
and others are of a smaller species of wolf, deer, &c.
A number of teeth are also preserved, amongst which, the
canine teeth of the bear merit attention, from their ex-
traordinary size ; there are also teeth of wolves, deer, oxen,
and foxes; portions of the antlers of a kind of rein-deer
or stag, with the horns of a large species of ox. Nume-
rous bones of bears, wolves, &c. are occasionally fitted to-
gether by Mr. Beard : some specimens were clearly diseased,
particularly one or two of the bear and wolf; distinctly
proving that the bears of Banwell, were as much subject to
enlargement of the bones, as those which inhabited the
caverns of Kirkdale in Yorkshire, and those of several
places in Germany.

The following is a tolerably correct list of the bones,
with their peculiarities.

THE BONES OF THE BEAR,

claim the pre-eminence. They consist of both the superior
and inferior maxillæ, or upper and lower jaw, some with
molares or grinders, still retained in their sockets, others
with the recesses only. Some have the tusks remaining,
occasionally much worn down, and indicating the great
age of the animal. There are several portions of the ske-
leton of bears' heads, one of which, measures nineteen
inches and a half in length, and nine inches and a half
from ear to ear ; this head is tolerably perfect, the upper
and lower jaws, with the four tusks, remain, the mo-
lares or grinders, and incisors or front teeth, are wanting ;
the palatine or palate bone is also whole, together with
the orbit for the eyes, but the cranium or skull is gone.
From the appearance of the remaining cavity of another
skull, it must have been much larger than the foregoing,
and have belonged to an animal of extraordinary dimensions.

A claw of the bear is beautifully perfect, and is particu-
larly worthy of attention, the bones of which, including

the metacarpus and phalanges, have been carefully united
with cement, by Mr. Beard. It is five inches in length,
from the superior end of the metacarpal bones, to the
extremity of the claw, and about four inches across, pre-
senting a strong resemblance to a skeleton hand; a few
separate bones greatly exceed even these dimensions.

There are several bones of the bears' legs, especially
the humerus, or large bone of the fore leg; one of the
largest of which, measures seven inches in circumference
at the articulation, being greater than any known species
of the ox or horse. The ulna and radius, or the two bones
below the humerus, are of a corresponding size, and may
be completely fitted together at the elbow joint.

The tusks of the bear are numerous, and some are of an
immense size, being even too large for the jaw previously
mentioned, and must have belonged to an animal of gi-
gantic size.

BONES OF THE WOLF

are numerous, chiefly of the three bones of the fore and
hind leg, and claws complete, with some mutilated bones
of the cranium. There are several maxillæ or jaw bones
of this tribe; some with their grinders much worn, as well
as the tusks, which are so far destroyed by use, as to
expose the cavity where the nerve and vessels of the teeth
had passed.

BONES OF THE OX OR BUFFALO.

Of this tribe, there are a great number of the vertebræ,
some of large dimensions, and others with portions of the
ribs, but much broken; many of the molares, bones of
the legs, the humerus, ulna, and radius of immense size,
together with the scapula or blade bone, and a jaw with
the teeth remaining perfect. The porous, or interior por-
tion of the horn of the ox or buffalo, in some instances
measures twelve inches in circumference, and fourteen
inches in length, with fragments of the skull attached.

BONES OF THE DEER OR STAG.

The antlers are numerous, but three very fine ones are most remarkable, and appear to have belonged to three different species; one, similar to our red deer; another, much more palmated, like the elk, with antlers of an immense size; and a third fragment, attached to a small portion of the occipital bone, measures thirty-two inches in length, with another branch seventeen inches long.

OF THE FOX,

there are some skulls, leg bones, tusks, and teeth; but not many bones of this animal have yet been discovered.

One small head, appears to have belonged to the WILD CAT, together with some other bones of the same tribe; also of a few mice; and a fragment of a dorsal vertebra, about eighteen inches in length, which is at present a non-descript.

CONCLUDING OBSERVATIONS.

The author does not profess to enter deeply into the intricate and difficult question, how this amazing collection of bones became deposited in this and other similar caves. It will suffice for the purposes of a publication of this character, that he should briefly state those opinions which appear to him to carry with them the greater weight, both from reason and authority.

The position of the cave is at the western extremity of Banwell Hill, a portion of the Mendip range, where it gradually slopes to the valley. The hill is composed of carboniferous limestone, of a hard, compact character, varying in colour, from a yellowish brown to blue, and from a light to a dark grey.

Many causes may have contributed to the accumulation of the bones at Banwell, but their final indiscriminate admixture with pebbles, sand, and mud, can alone be referred

to that overwhelming catastrophe, when the waters of the deep broke their barriers, and consigned the living creation to one universal ruin.

The introduction of these bones must have been effected, either by beasts of prey, who were the natural tenants of the cave, or by the violent action of water, or they may have fallen in from upper fissures, or down an abrupt precipice. This latter conjecture is somewhat strengthened by the consideration, that we can scarcely form an opinion now, of what the features of any part of the world may have been before the deluge; for previous to the diluvial detritus having choked up the cave and filled the adjacent irregularities, there was, apparently, a precipitous chasm, which, in the course of centuries, might have collected, or at least aided in collecting, a large number of bones, which the rush of waters would disperse, and deposit in every nook and chamber of the cavern. The great mass of bones were certainly found accumulated at the furthest extremities of the cave, appearing as if they had been driven to them by the rush of waters from the entrance at the west. It may also be conjectured with some plausability, that the bones of the ox, deer, and other herbivorous tribes were gradually accumulated on the floor of the cave by the bears and wolves who successively tenanted it, and who returned into their den to die, as all carnivorous animals are known to do. The bones might thus gradually accumulate, till the waters of the deluge, carrying with them pebbles, sand, and mud, rushed in, and mixing the whole mass confusedly together, drove it, as before conjectured, into the lowest depths of the cave and fissures, where they remained undisturbed, until their recent discovery.

The elevated situation of the cave, is against the theory of any flood but that of the deluge; and discoveries of these antediluvian bones occur too rarely, in the numerous natural caverns which have been discovered in the limestone districts, to sanction the idea that the waters of the deluge conveyed them there; for had the carcasses of these animals

floated on the surface of the waters, they would have been too large to have been washed into their present situation, otherwise than by piece-meal; and if we allow the force of these waters to have washed in the bones, surely we should have found them in most caves of similar character.

Nor does it appear probable, that even in many successive ages, a vertical fissure would have entrapped such a vast number of animals, especially of the ox and bear tribes; neither of whom prefer the high, rocky, mountainous districts, but the richer pasture of the plains; besides which, the supposed vertical fissures must have been large indeed, to have permitted such immense bears, oxen, and deer to have fallen unwittingly into them.*

It appears to be the opinion of Dr. Buckland, the celebrated Professor of Geology at the University of Oxford, who has investigated the subject more narrowly than any other individual, " that the animals to whom these bones belonged, lived and died in the regions where their remains are found, in the period immediately preceding the deluge, and were not drifted thither by the diluvial waters from other latitudes." †

If this theory be correct, it follows, from the contents of the caverns at Banwell, Hutton, and Uphill, that the Mendip Hills of Somersetshire have been inhabited by elephants, tigers, hyænas, rhinoceros, and other races of

* Some parts of the Mendip Hills are full of calamine pits, especially above Winterhead, near Shipham; yet it is a rare occurrence for either horses, cattle, or sheep to fall into them, though constantly grazing on their brinks.

† It may be proper to state, that the Rev. Mr. Bugg, in his " Scripture Geology," denies that these caverns are antediluvian, but he admits that they might have been inhabited by wild beasts immediately subsequent to that catastrophe. He also acknowledges that the animals to which many of the bones belong, are much too large, either to go into the caves to die there, or to be drifted into them by the diluvial waters.

It may also be remarked, that as Hutton cavern contains, among the remains of numerous other animals, those of the hyæna and elephant; and as the bones of the former occur also at Uphill, yet as in the large bone deposit in Banwell cave, remains of these animals are missing, may it not be possible that those in Banwell cave belong to a later era? perhaps to a period when the hyæna and elephant were destroyed? The vicinity of the three places to each other, and the known habits of these animals, tend to strengthen this suggestion.

animals, now confined to distant countries, and much warmer climates.

These animals, together with "species supposed to be altogether extinct in the creation, probably lived and died in this region of the earth, at that period of the world's existence when the palm, the bamboo, and the large American fern, with other tropical plants, so abundant in our coal measure, were among the indigenous productions of our soil. The existence of these organic remains in caves and fissures, is comparatively a new feature in geology, and may be regarded as another ray of light to assist in guiding us to the source of truth."

We conclude our description of these most interesting caverns with the beautiful Lines of the Rev. W. Lisle Bowles, whose early days were spent at Uphill Parsonage.

SPIRIT and shadow of the ancient world,
Awake! Thou who hast slept four thousand years,
Arise! For who can gaze upon this vault,
Strewn with the fragments of a former world,
Swept to destruction, but must pause to think
Of the mutations of the Globe; of Time,
Hurrying to onward spoil; of his own life,
Swift passing as a summer-cloud away;
Of Him, who spoke and the dread storm went forth!
Since then, these bones that strew the inmost cave
Have lain, the records of that awful doom.

When now the black abyss had ceas'd to roar,
And waters, shrinking from the rocks and hills,
Slept in the solitary sunshine, Here
They lay; and when four thousand years had passed,
And the grey smoke went up from villages,
And cities, with their tow'rs and temples shone
Where Life's great hum was murmuring,
 Here they Lay !

The crow sail'd o'er the spot, the villager
Plodded to morning toil, yet, undisturb'd
They lay; when lo! as if but yesterday
The wave had left them, into light again
The shadowy spectacle of ages past
Seems to leap up, as the dim cave unfolds
Its mystery. Say! Christian, is it true?
This cavern's deep recess, these scatter'd bones,
Faint echo to thy Bible! O'er the cave
Pale Science ruminates.

 Meantime I gaze,
In silence on the scene below, and mark
The morning sunshine, on that very shore

Where once a child I wandered : Oh ! return,
(I sigh) " return a moment, days of youth,
" Of childhood,—oh, return ! " How vain the thought,
Vain as unworthy ! yet sad Poesy
Unblam'd may dally with imaginings.
For this wide view is like the shadowy scene,
Once travers'd o'er with carelessness and glee,
And we look back upon the vale of years,
And hear remembered voices, and behold,
In blended colours, images and shades
Long pass'd, now rising, as at Memory's call,
Again in softer light.

 There is the Church,
Crowning the high hill-top, which overlooks
Brean-Down, where in its lonelier amplitude
Stretches into grey mist the Severn Sea.
There, mingled with the clouds, old Cambria draws
Her line of mountains, fading far away ;
There sit the sister Holms, in the mid-tide
Secure and smiling, though its vasty sweep,
As it rides by, might almost seem to rive
The deep foundations of the Earth again,
Might seem to scorn its limits, and ascend
In tempest to these heights, to bury there
Fresh welt'ring carcasses, and leave their bones
A spectacle for ages yet unborn,
To teach its sternest moral to the heart.

———————

'Tis well we hear not the fleet wings of Time.
Enough, if while the summer day steals on,
We muse upon the wreck of ages past,
And own there is a God who rules the world.

Gents. Mag. May, 1828.

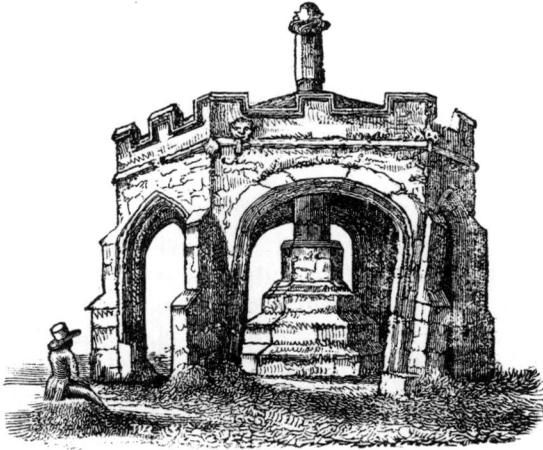

Cheddar Cross.

CHAP. VIII.

LOXTON

is a village situated under Crook Peak, a remarkable eminence at the western extremity of the hill It is romantically placed on the slope of a rocky projection, both

M

steep and lofty. The cottages are built promiscuously on the craggy eminences ; giving the place, at a distance, the appearance of a town in ruins.

Loxton contains 26 houses, 35 families, and 198 inhabitants. The living is a rectory, in the deanery of Axbridge. The Rev. D. S. Moncrieffe, incumbent. The rectory house is delightfully situated on the gentle slope of the hills, with extensive enclosed gardens, in which fuschias, myrtles, and other tender plants flourish throughout the year, in the open air.

LOXTON CHURCH

is a small irregular building, with evident marks of considerable antiquity. The pulpit is sculptured from one block of stone, into Gothic compartments of high relief. An antique oak screen, curiously carved, divides the chancel from the body of the building; the interior has recently been thoroughly repaired and neatly painted. Attached to the chancel is a vestry room, which was formerly a chapel, with a recess and drain for the consecrated water, still existing. On the floor are several very old tomb stones, two of them with crosses, and part of an ancient inscription in Saxon characters, that is not legible. In one corner of the porch is a curious recess, about eighteen inches square, guarded by an iron grating, and penetrating through the walls to the depth of six or eight feet; the use of which it is difficult to account for, unless it was intended to open a view of the altar to those who stood in the porch. The tower of this building is attached to the south side of the church, and the lower compartment of it forms the entrance. An old stone cross is remaining in the church yard, with an ascent of five rows of steps, leading to a shaft sixteen feet in height.

CHARITABLE BEQUEST.—MRS. ANN GADD, in 1765, gave by will 50*l.* to be lent out on the best security, the interest to be applied to teaching poor children of Loxton parish to read and knit. A poor woman is appointed, by

the present rector, to teach six or eight poor children to read and knit, for which she is paid 25s. half yearly, from the interest of this money.

LOXTON CAVE

lies about a mile to the south-east of Hutton, on the western flank of that fine gorge which separates Loxton Hill from Crook Peak ; but as it was sadly despoiled of its beauties soon after its first discovery, about 80 years since, a brief summary, extracted by Mr. Williams from Dr. Catcott's unpublished manuscript, will suffice. It appears to have consisted of three chambers, leading into each other, beautifully and abundantly adorned with stalactites of various lengths and colours, pendant from the roofs and sides. In some places the incrustations assumed a serpentine and wavy form, curiously entwined along the slope of the roof and sides, being more or less tinged with green, red, or yellow, as the copper, iron, or ochre, predominated in the solution by the water, which percolated through it. In a lateral fissure from the middle cavern, were seen beautiful efflorescences, and incrustations of stalagmitic matter.

CHRISTON

is a small retired village, situated a short distance north of the road from Loxton to Compton Bishop.

THE COURT HOUSE

was a fine old mansion, standing west of the church. The greater portion of the building was taken down in 1822, and the remaining part is completely altered, being converted into a farm house. The original name of the manor was *Chricheston*, and it was possessed in the time of Henry II. by a family of the same name. After being subdivided into four parts of a knight's fee, which were held by a long list of possessors, it became again united in the reign of Edward VI. and was held by Francis Vaughan, esq. who either re-built or greatly embellished the ancient court

M 2

house; for in one of the remaining rooms is a carved oak mantel-piece, surmounted by the arms of Vaughan, with the date of 1674, on one side of which is a figure of justice with her balance, and on the other, peace with her olive branch. In front of the former mansion was a richly decorated porch, and over it a similar coat of arms, sculptured in stone; this now lies neglected in the enclosed garden; the latter still retains its ancient gravelled terrace, 64 yards in length. From the Vaughans, the manor came, by purchase, to the Smyths of Ashton Court, and from Lady Anne, relict of Sir Hugh Smyth, bart. it passed to the Gores of Barrow Court, the present possessors.

CHRISTON CHURCH

is a small building, having a low ancient tower between the chancel and the nave, but without transepts. The nave and chancel arches beneath the tower, are of Norman structure, as is the interior door-way in the porch, the latter being richly ornamented with the chevron moulding, though now much disfigured with white-wash. The font is plain and circular, of the Norman character. The roof is formed of ribs of oak, open to the leads, with a row of ornamented bosses down the centre.

On the old walls in this parish are some curious mosses, and in the meadows the meadow saffron, or autumnal crocus, (*colchicum autumnale,*) grows plentifully.

Christon contains 13 houses, as many families, and 57 inhabitants. The living is a rectory, in the deanery of Axbridge, and appendant to the manor.—Rev. William Truman, incumbent.

COMPTON-BISHOP,

or *Compton-Magna*, is two miles from Axbridge, pleasantly situated in a hollow, under the southern side of the Mendip Hills, and open to the extensive moors, which reach to Glastonbury and Wells. Soon after the conquest, it was

possessed by the Bishop of Bath and Wells, from whom it derived its distinctive name. It was sequestered in the reign of Edward VI. and subsequently was possessed by the family of Prowse, of Axbridge. By the marriage of an heiress of that family, it came to Sir John Mordaunt, bart. the present proprietor.

Within this parish is an old manor house, now attached to a farm, which was inhabited for many generations, by the once wealthy and respectable family of Wickham, and of whom several portraits are remaining in some of the rooms.

COMPTON CHURCH

is a small structure, with a good tower surmounted by an open battlement. The exterior arch of the porch is an unusual specimen of the Norman style. The upper arch is plain and circular; below is a trefoiled semi-circular arch, supported on clustered columns, with the two points depending from above. The chancel arch is without shafts, but is sustained by two well wrought, sculptured corbels; the pulpit is of stone, with pointed tracery; the font is plain and circular. The chancel window was once adorned with stained glass, of which a few figures are remaining. In the south wall of the chancel, is a double water-drain, beneath two trefoiled arches, and immediately over them is a small arched cupboard with an antique lock and key.

On the south side of the nave, is a handsome monument to the memory of John Prowse, esq. who died in 1688, and also of several of his children. Amongst the benefactions to this place, is one worthy of notice; that of William Cray, who in 1728, gave seven acres of land in the parish of Badgworth, the rents to be applied to the " teaching poor children of this parish, in reading English, until they shall be perfected therein."

The parish of Compton-Bishop, including Cross, and Webbington, a small straggling hamlet which extends round the western base of Crook Peak, contains 99 houses and 105 families.

The living is a vicarage and peculiar, in the deanery of Axbridge, belonging to the prebendary of Wells. The vicarage house is pleasantly situated beneath Crook Peak, commanding an extensive prospect.—The Rev. Henry Watson Barnard, incumbent.

The rectory is a lay impropriation, held on three lives under the prebendary of Wells, by Mrs. Henning, in right of her late husband, who re-built the rectorial house. The former one was an ancient edifice, and on its destruction, several curious coins were found, but of what era is not known.

Immediately above the village of Compton-Bishop, rises the remarkable hill, called

CROOK PEAK,

the summit of which overlooks a wide extent of the surrounding country, on both sides of Mendip, and also commands a view of Bristol Channel, the Welsh Coast, Weston and Uphill Bays, and Bridgewater Bay. Below, is the village itself, lying in a hollow of the hill, having numerous trees intermingled with the houses; these, with the church, the tower, the arched porch, and the mutilated cross in the church yard, present a very picturesque landscape. On a high ridge of the hill to the south-west, is a large natural cave, the entrance to which, is nearly perpendicular; the roof expanding into a rough, but capacious archway, forms a kind of anti-chamber to one of infinitely greater extent. The interior apartment, which is of vast dimensions, was, when first explored, beautifully ornamented with stalactites, suspended from its roof and sides, and some of the incrustations presented the most fantastic forms. The access to the inner cave, is through a narrow, winding passage, very difficult and disagreeable; and having been completely rifled of its ornaments, by the country people, soon after it was discovered, it scarcely recompenses the trouble of accomplishing the descent.

CROSS

is a village pleasantly situated above the level, and imme-

diately beneath the heights of Mendip. It is within the parish of Compton-Bishop, half a mile west of Axbridge; and being on the great thoroughfare from Bristol to Exeter, about half way between the former place and Bridgewater, has been found a convenient situation for several considerable posting houses and inns; at which, the mail and several daily coaches stop, to change horses and afford refreshment to passengers.

WINSCOMBE.

On the north-eastern side of the hill, behind Compton-Bishop, lies the parish of Winscombe, which includes a large tract of land, and contains the hamlets of Woodborough, Barton, Sandford, and Sidcott.

THE MANOR

was originally granted by the Saxon Queen *Allswithe*, in 965, to the monks of Glastonbury, who retained it until about 1236, the twenty-first of Henry III. when, to prevent the union of their monastery with the bishopric of Bath and Wells, they resigned their manor to Joceline, bishop of that see, who in 1239, granted the whole to the Dean and chapter of his cathedral, " to hold to them and their successors in pure and perpetual alms," and upon these terms, they continue to retain possession of a property, which has been uninterruptedly held by the two ecclesiastical fraternities for 860 years.

Winscombe contains 255 houses, 314 families and 1428 inhabitants. The living is a vicarage, in the deanery of Axbridge, and in the gift of the Dean and Chapter of Wells. —The Rev. Charles James Cobley, incumbent. The rectory is a lay impropriation, held by Hyde Whalley, esq. who resides in the adjacent manor house.

WINSCOMBE CHURCH,

stands on the northern slope of Mendip. It is a large

handsome fabric, with an elegant tower, 100 feet high, sur-
mounted by a turret and pinnacles ; the whole of which was
built by Bishop Ralph de Salopia, about 1340. On the
western front of the tower, are canopied niches, and in
them formerly stood figures of the patron saint, and pro-
bably of the founder. In the blank window between these
niches, is a curious scuptured figure of a handled flower-
jug or vase, in the mouth of which, is a flower or branch,
and on one side the representation of a funnel.

The interior of this church is handsome ; the belfry has
a groined roof, and in the windows are considerable remains
of stained glass, chiefly of ecclesiastical figures, with a few
coats of arms. It also contains numerous monumental
tablets, chiefly relating to the families of Fry, Knolles,
Doolan, Athay, Palmer, and a more recent one to the
memory of Mary, relict of the Rev. Dr. Whalley. On
the floor is a large old stone, engraved with a cross flory.

The church-yard commands an extensive prospect, and
in it, is a most beautiful yew tree ; the vicarage house is
near, but it has dwindled into a mere cottage.

CHARITABLE BEQUEST.—SYMON CARDINBROOK, of
Sandford, left by will, in 1761, an estate in South Brent,
for the purpose of establishing a school for the poor chil-
dren of Winscombe, so soon as the parish should subscribe
200*l.* in addition towards the same object. This not hav-
ing been done, it appears that in 1776, Symon Cardin-
brook's executor, paid 100*l.* to the parish as a compromise,
which sum was placed out to accumulate at interest, small
portions of the interest having been occasionally applied to
the instruction of poor children. In 1813, the amount
had increased to 359*l.* 4*s.* 4*d.* of which, 59*l.* 4*s.* 4*d.* was
directed by the vestry to be appropriated towards defray-
ing the expense of erecting a school house on Woodborough
Green, the remainder having been provided by public sub-
scription. The 300*l.* balance is now out at interest, and
the income applied to the support of this school; it
was at first conducted on the Lancasterian system, but

now upon that of Dr. Bell, it being considered as an appendage to the church establishment. The poor children of the parish are all admitted; the boys being taught by a master, and the girls by a mistress, at different ends of the room. An annual subscription of about 30*l.* has also been raised for the more effectual support of this school.

SIDCOTT

is a small, scattered village within the parish of Winscombe, and is situated near the turnpike road from Bristol to Bridgewater, about mid-way between Cross and Churchill, and about two miles from Axbridge. At this place is a public school, partly supported by subscription, for the education of children, belonging to the society of Friends. There are a considerable number of that sect of christians residing in this palce and its vicinity, who have a spacious Meeting-House lately re-built.

WEARE

is situated two miles south-west from Axbridge, and contains two hamlets or tithings; Upper Weare and Lower Weare; the last of these was anciently a borough, and sent members to parliament in 1305–6, the 34th and 35th of Edward I. it was also honoured with several other privileges from Henry I. and Edward III. Here is a neat bridge, erected over the river Axe, and probably the name of this place was derived from some wear across the river in remote times. The church is an ancient and small building, of the time of Henry VII. having a handsome tower with pinnacles, and an open-work parapet. In the body of the church is an old brass plate, with an effigy, and the following inscription :

" 𝔒f youre charitie that passeth here by,
𝔓ray for the soule of 𝔍ohn 𝔅edberie,
𝔗hat here doth lye,
𝔒n whose soule Christ 𝔍hu. have mercie."

Weare contains 127 houses, 174 families, and 800 inhabitants. The living is an endowed vicarage, in the deanery of Axbridge, and in the patronage of the dean and chapter of Bristol.—The Rev. Henry Beeke, D. D. Dean of Bristol, incumbent.

AXBRIDGE

was a borough by prescription, and is now an irregularly built market-town, situated south of the Mendip Hills, and immediately under them ; it is supposed to have derived its name from the Celtic, *Acs-byrig*, the town near the river, though others have supposed it to have arisen from an ancient bridge over the river Axe, which is, however, too distant from the present town to render this derivation satisfactory, though its Saxon name of *Axbrigge*, is of the same signification. It is a place of antiquity, lying upon a line of the Roman road leading from Old Sarum to the Bristol Channel ; in later times it was in the centre of a royal hunting forest or chace, and was afterwards a demesne of the crown, the nominal royalty being now vested in the corporation. It sent members to parliament during the reigns of the three first Edwards; after which it was, by the desire of its inhabitants, deprived of its franchise.

Axbridge appears to have been a place of some importance to the Romans, as several of their public roads here intersected each other. Of these, the principal was the main road from Old Sarum to Uphill, from which branched one road to Bath, and another from Axbridge to the summer station at *Ischalis*, now Ilchester. This road passed through Wells, Glastonbury, and Somerton, near which latter place, at Pitney, have recently been discovered some tessellated pavements, belonging to a Roman villa.*

* The discovery of these interesting Roman antiquities at Pitney, have not been pursued to any considerable extent. The floor originally opened is about 18 feet by 20, in the highest state of preservation, and is considered to be the

Axbridge being sheltered from north and north-west winds by the lofty heights of Mendip, which rise immediately behind the town, the air is peculiarly soft and salubrious.*

The streets of Axbridge have an appearance of antiquity, and several houses of venerable exterior are remaining; especially one in the market-place, and another still more ancient, opposite the Lamb Inn, which, notwithstanding modern alterations, still retains several small windows, having ogee arches with quatre-foiled spandrils.

The old town hall is an ancient edifice near the Lamb Inn, but the corporation are on the point of erecting a handsome new one, with a market-place beneath, on the site of the Bear Inn; which will be a considerable improvement to the appearance of the town.

In the present hall are two curious old paintings, one of a large size and well executed, representing a lion hunt; and above it, a smaller one of a boar hunt; but there is no traditional account of the manner in which they came into their present situation. In the window of the Council-

finest specimen of tesselated pavement in the west of England. The centre is an octagon, in which is a perfect figure of Bacchus, with the usual emblems; the eight surrounding compartments of the floor contain figures of Minerva, Mars, Neptune, and other heathen deities, with a bust at the corners; each division being surrounded by a border, which also encloses the whole. The designs are admirably executed in tesseræ of four colours, and of small dimensions, scarcely half an inch square. About a mile south of these Roman remains, and about half a mile from Pitney church, other extensive ruins have been discovered, which are supposed to be two acres in extent. The walls are two feet thick and about the same in height. Both of these remains are conjectured to have belonged to Roman villas; the entire plans of which will probably be laid open and traced in the present summer.

* In Marsford's "Inquiry into the influence of *situation* on pulmonary consumption," Axbridge is particularly mentioned as one of the most desirable places of residence for patients of this class that our island affords, and the statistical tables given in that work, embracing returns from a variety of places, appear to justify the opinion.

Chamber, is a circular pane, representing the *eye* of Providence, with this legend around it :

> God, that's Lord of all,
> Save the Council of this Hall.

THE CORPORATION OF AXBRIDGE

have preserved a most extraordinary series of ancient grants, charters, and other documents, highly interesting to the antiquary. They chiefly relate to Axbridge, Cheddar, and Wedmore, all of which were intimately connected in former ages. Even the minute books of their own corporation proceedings, commence as early as the fourteenth century. Among the original grants, the following are remarkable for their excellent state of preservation, the writing being fresh and brilliant to an extraordinary degree. A grant from Henry I. dated 1113, attached to which, is the large official seal, with an equestrian impression of the king, armed as a knight, and an ecclesiastical figure on the reverse. Another, by Edward I. with a seal nearly similar, granted in 1279. Another, by Edward III. in 1351; and a fourth, by Henry VI. dated 1403.

The corporation also possess several Royal Charters, and an ancient MS. apparently written about the middle of the fifteenth century, purporting to have been compiled from the ancient charter, granted by Edward the Confessor, in consequence of his miraculous preservation, as he supposed, from being precipitated over Cheddar Cliffs, when hunting near them. Axbridge was previously a royal borough, with thirty-two burgesses, fourteen of whom were aldermen, with a portreeve; to whom the King granted the additional right of hunting and fishing from Cottle's Oak, near Frome, to the Black Rock at the mouth of the river Axe, at Uphill, a distance of upwards of thirty miles.

ANCIENT MANUSCRIPT.

"In the times of Athelstan, Edmund, Edred, Edgar, and Saint Edward, and of the other ancient Kings of England, this was the government of the kingdom, *to wit*, that it was ordained by the council of Saint Dunstan and Saint Alphage, and other eminent men of the kingdom, that there should be made boroughs, (that is, manors or royal mansions, for boróugh in English, is in **Latin**, *Burgus*, mansion or habitation; whence, we even now call the holes of foxes, boroughs,) which were constructed in divers places, in every part of the kingdom, as the time and local situation should best suit the pleasure and convenience of the King's Majesty. And that there should be wardens in every borough, who at that time were called wardmen, that is, portreeves, constables, and other officers, who in the King's name, should set apart, (for the King) victuals; *to wit*, corn, wine, and barley; sheep and oxen, and other cattle of the field; and fowls of the air, and fish of the sea; during the period in which the King should resolve to remain with his retinue in any fixed borough; inasmuch as by the King's council, there had been assigned to every borough, a certain period and space of time, during which the King should remain with his retinue in such place. But if it should happen that the King should not go thither, then all the victuals before set apart, ought to be sold in the market of the same borough, and the money received therefrom, should be brought into the King's treasury, by the aforesaid officers.

"Moreover, [it was ordained] by the said council, there should be villages adjacent, throughout the circuit of the said boroughs, wherein there should be villeins and bondmen, who should cultivate the land, and tend the cattle; and there should be other things necessary for such work, for the maintenance of the officers of the borough aforesaid. So that, in those times, the King lived from his own lord-

ships or manors, as other lords now do; and this wholly so, in order that the kingdom might not sustain any public injury.

" Sometimes, for the sake of hunting, the King spent the summer, about the forest of Mendip, wherein there were at that time, numerous stags, and several other kinds of wild beasts; for, as is read in the life of Saint Dunstan, King Edward, [A. D. 975] who sought retirement at Glastonbury, came to the said forest to hunt; Axbridge being then a Royal Borough. The King, three days previously, had dismissed Saint Dunstan from his court, with great indignation and lack of honour, which done, he proceeded to the wood to hunt, This wood covers a mountain of great height, which being separated at its summit, exhibits to the spectator an immense precipice and horrid gulph, called by the inhabitants Cheddre Clyff. When therefore, the King was chasing the flying stag here and there, on its coming to the craggy gulph, the stag rushed into it, and being dashed to atoms, perished. Similar ruin involved the pursuing dogs; and the horse, on which the King rode, having broken its reins, became unmanageable, and in an obstinate course, carries the King after the hounds, and the gulph lying open before him, threatens the King with certain death; he trembles, and is at his last shift. In the interval, his injustice recently offered to Saint Dunstan, occurs to his mind; he wails it, and instantly vows to God, that he would as speedily as possible, recompense such injustice, by a manifold amendment, if God would only for the moment avert the death which deservedly threatened him. God immediately hearing the preparation of his heart, took pity on him; inasmuch as the horse instantly stopped short, and to the glory of God, caused the King, thus snatched from the perils of death, most unfeignedly to give thanks unto God. Having returned thence to his house, that is, to the borough of Axbrigge, and being joined by his nobles, the King re-

counted to them the course of the adventure, which had
happened; and commanded Dunstan to be recalled with
honour and reverence; after which, he esteemed him in
all transactions, as his most sincere friend.

"And so there were in Axbrigge thirty-two burgesses, to
whom the above named king granted the right of hunting
and fishing in all places, (warrens excepted,) *to wit*, from
the place called Cotellis Ach, now Cottle's Oak, near the
town of Frome, as far as the rock called Blackstone, in the
western sea. And of the aforesaid thirty-two burgesses,
there were fourteen chief elders, called sockmen, that is,
wardmen or aldermen, out of whom they should themselves
every year elect a portreeve, who now, by royal charter, is
called mayor, and one bailiff, and two constables, and other
officers, who should be necessary for the governance of that
borough; so that on the coming of the king's steward at
the feast, *to wit*, of Saint Michael, they should do fealty
before him, to the king and kingdom for such governance,
and for the keeping of the peace. And thus the town of
Axebrigge, with the manor of Cheddre, was the king's
own demesne.

"And note—that the two manors, *to wit*, Somerton and
Cheddre, with their appurtenances, rendered the farm of
one night's entertainment in the times of St. Edward the
King, and of William the Conqueror, as appears in the
Book of Domesday, vol. ii. where it treats of the county
of Somerset, under the title of "the King's Land," in the
same book wherein it is thus contained. "The king holds
Cheddre. King Edward held it. It never paid tax, nor
is it known how many hides there are. The arable land is
20 carucates. In demesne there are three carucates and
two servi, and one colibert, and seventeen villeins, and
twenty bordars, with seven carucates, and seven gavelmen,*
paying seventeen shillings. In Alesbrigge, thirty-two bur-
gesses paying twenty shillings. There are two mills paying

* Gavelmen are tenants liable to tribute.

twelve shillings and sixpence, and three fisheries paying ten shillings, and fifteen acres of meadow and pasture, one mile in length, and as much in breadth, paying yearly twenty-one pounds and twopence half-penny. Of twenty moor-hayes; * the wood is two miles in length, and half a mile in breadth. Of this manor, Bishop Gise holds Weti-more (Wedmore,) as a member, which he held of King Edward; for which William the sheriff, accounts in the king's farm, twelve pounds every year. From this manor, half a yard-land is taken away, which was of the king's demesne farm; and Robert de Otburguile held it, and it is worth fifteen-pence. These two manors, Somerton and Cheddre, with their appurtenances, paid the farm of one night's entertainment in the time of King Edward."

" And so King William, and all the kings his successors, had the said town of Axbrigge, with the manor of Cheddre, in their own demesne, until the 5th year of King John, in which year the said King John granted the said manor of Cheddre, with the town of Axbrigge, and the hundreds of Wynterstoke and Cheddre, to Hugh, Archdeacon of Wells, for twenty pounds, payable at the terms of Michaelmas and Easter, as appears by a certain charter thereof made, &c.

AXBRIDGE CHARTERS.

The next document connected with the corporation, contains letters patent of *Inspeximus*, or inspection of char-ters, dated 26th October, in the sixth of Henry VI. 1427.

These letters patent refer to a charter which was granted by King Edward the Confessor, and another by King Henry I. at Woodstock, in the fifth year of his reign, which confirms the grant of the manor and lordship of Cheddre and Axebridge, with the hundreds of Winterstoke and Cheddre, &c. to Hugh de Wells and his heirs, at fee-farm rent to the crown of 20*l*. in tale, and the men of the said

* The moor-hayes are small enclosed gardens in the moor, and exist both in name and reality to this day.

manors were exempted from serving on juries, and were quit of suits of the shire, and aid of the sheriffs and their bailiffs, neither of whom were to intermeddle in these hundreds; which were also quit of fines for murder, with other privileges.

The next is a Charter of Incorporation, dated 1st Jan. 1556, in the third and fourth years of Philip and Mary. In this charter, Axbridge is again called an ancient borough, and reference is evidently made to the charter of King Edward the Confessor. This charter, of Philip and Mary, was evidently granted with the view of confirming and incorporating the privileges granted by the previous charters. It made it a borough corporate, in deed, fact, and name, by the title of one mayor and 32 burgesses, 14 of whom are aldermen, and other officers of the borough of Axbridge; it also granted a common seal, engraved with a lamb and flag—the right of perambulating the bounds—power to make ordinances and statutes for the public good of Axbridge—the assay of wine, bread, ale, &c.—all fines, redemptions, &c.—holding a court of frank pledge, &c.—a market on every Saturday—two fairs—court of *pie-poudre*—exemption from all county suits—a court of record every Monday for pleas of debts, trespasses, covenants, and contempts, with full powers; for all of which privileges the sum of 3*l*. 6*s*. 8*d*. was yearly to be paid to the crown.

The charter at present acted upon, is dated the 23rd of January 1558, the forty-first of Elizabeth. This charter appears to have been granted in consequence of " certain defects, ambiguities, and inconveniences existing in the charter of Philip and Mary; and thus to ratify, confirm, approve, make, reduce, constitute, or create anew the said mayor and burgesses of the said borough into one body corporate and politic, in manner as to us shall seem most expedient." This charter confirms the before enumerated privileges, with some few variations. It granted one

N

mayor * and one alderman only, and one recorder, who constitute the magisterial bench; the former were to be elected annually, and the others during the pleasure of the common council, which was to consist of—mayor, alderman, recorder, eight capital burgesses or councellors, exclusive of twenty-two free burgesses, not members of the council: but the number of free burgesses does not appear to be expressly limited. This charter also granted a bailiff, who is sheriff for the borough and keeper of the town prison, with inferior officers; and power to commit to the borough prison any one duly appointed to any corporate office, until he submit. The court of record is confirmed, and its powers enlarged, excepting as relates to treason, felony, or murder, amounting to loss of limb ; and two markets are granted instead of one.

On the back of the second skin of the before written charter, is indorsed, " The Abbuttolls of the Burrowe and Liberties of Axbridge ; " below which, the boundaries are specially enumerated, and stated to have been copied verbatim from the indorsement of another ancient charter.

James I. granted another charter in the twenty-first year of his reign, 1603, simply confirming the previous charter, and adding West-Street, towards Compton Bishop, to the bounds of the borough, which did not previously extend so far; with two serjeants at mace, and silver or gilt maces, engraved with the king's arms.

AXBRIDGE CHURCH

stands on a slight eminence, near the site of the old market house, and is a handsome cruciform building, with side aisles, and a chapel north and south of the chancel.

* The first mayor of Axbridge, under this charter of Queen Elizabeth, is called " our beloved John By-the-sey; " who derived his name from the circumstance of his forefather having been picked up when an infant, on the beach near Weston Super Mare. He was subsequently adopted by a gentleman, who gave him a good education, and had him christened. One of his descendants, named Thomas Bythesea, left a noble to the church of Axbridge, a noble to the poor, and a noble for a sermon on Christmas day.

It has a fine well built tower, supported by double buttresses at the angles, terminating in handsome crotchets and fineals. On the summit are four large pinnacles, connected by a richly pierced parapet. On the west side of the tower, in a canopied niche, is a crowned figure with a sceptre, and on the east side, is another, sustaining a globe and cross, supposed to represent King Henry VII. who probably, re-built the tower and the greater part of the church. The south side is rich; the windows are good specimens of the perpendicular era, and between each, is a well wrought buttress, terminating in pinnacles, crotcheted and finealed, and connected by pierced parapets similar to those on the tower.

The interior is spacious and handsome; the side aisles and transept arches are supported by clustered columns, with foliage capitals. The ceilings are lofty, and those of the nave and chancel are curiously divided into shallow compartments by projecting ribs, with *fleur de lis* at each angle, and a row of immense pendants along the centre of the arched roof; on one of them is the date of 1636, at which time considerable repairs were probably effected. The side aisles are ceiled with large panels of oak, and ornamented angles The roof of the belfry, as is usual in many of the Somersetshire churches, is supported by spandrils springing from the corners, and spreading into a boldly groined ceiling. The font is ancient and curious, but much disfigured with whitewash and colouring; it well deserves to be carefully restored to its original appearance. The organ is handsome, and said to be well toned; the splendid communion table cover is worthy of inspection, having been wrought with silk, by Mrs. Abigail Prowse, who was seven years in completing it; the selection of the subjects is good, their arrangement excellent; and the colours being brilliant, it has altogether the appearance of a rich piece of tapestry. The altar-piece, which was presented by the same lady, though rich and handsome in itself, yet

being Corinthian in its character, is inappropriate to the situation which it occupies. In a pew beneath the pulpit, is a very curious old painting on a piece of oak panelling, of the age of Edward III. representing the Saviour, with a pointed beard.

There are numerous costly monuments in this church, several of them are erected in memory of individuals of the Prowse family. One of white marble on the north wall, to the memory of Thomas Prowse, records that he had been five times knight of the shire, and though solicited, was too independent and unambitious to accept any office under the crown.

There is a fine old brass plate in the floor of the north aile, with the portraitures of a male and female kneeling, and this inscription underneath :

𝕳ic jacent
𝕽ogerus 𝕳arper, quonda mercator istius villae, et 𝕵ohanna uxor, ejus qui quidem 𝕽ogerus obiit. xxii. die mensis Augusti, et dicta 𝕵ohanna obiit eodem die ad mensem precedentem, Anno dni millimo rccc° lxxxr iij°.
Quorum aiabus micict Deus.
Amen.

TRANSLATION.
Here lie the remains of ROGER HARPER, formerly a merchant, or trader, of this town, and JOANNA his wife,—which Roger, indeed died on the twenty-second day of the month of August, and the said Joanna died on the same day in the preceding month, in the year of our Lord, MCCCCXCIII.
MAY GOD BE PROPITIOUS TO THE SOULS OF BOTH. —*Amen.*

CHARITABLE BEQUESTS. — WILLIAM SPEARING, in 1688, left a farm house, with several pieces of land in South and East Brent, about thirty-one acres, and let for nearly 78*l.* a year; of which 4*s.* is laid out weekly in bread for the poor of Axbridge, 13*s.* is paid for a sermon annually preached on Good Friday, and the remainder

distributed every year, among reduced householders, and other poor inhabitants of the town, in various sums under twenty shillings each.

Mrs. MARY DUNSTER and the Rev. ELIAS REBOTIER, in 1731, left certain monies to be invested in land for the poor of Axbridge. This property partly consists of a dwelling house, garden and paddock at Turnock, in the parish of Badgworth. The whole produces about 19*l*. 15*s*. per annum, which is applied precisely in the same manner as Spearing's Charity.

RICHARD DUBBEN, gave a noble to the church, a noble to the poor, and a noble for a sermon, on the fifth of November.

RICHARD GOLDWIRE gave 10*s*. for a sermon on the fifth of August.

Axbridge in 1821 contained 127 houses, 210 families, and 998 inhabitants. The living is a rectory in the deanery of Axbridge, the Bishop of Bath and Wells is the patron.— The Rev. George G. Beadon, incumbent.

The greater part of the tract of land lying between Axbridge and Cheddar, bears the appearance of a continued garden; being sheltered by the Mendip Hills on the north and east, it is chiefly occupied in the culture of vegetables, large quantities of which are obtained very early in the season, and forwarded to the distant market of Bristol.

CHEDDAR or CHEDDRE

is a large but straggling village, deriving its name from *Ced* a conspicuous brow or height, and *dwr* water. It consists of three or four irregular streets, in one of which stands an ancient hexagonal market cross.* The situation is rendered exceedingly fine by the contrast between the

* This fine old Cross, is lamentably neglected and out of repair; it amply deserves careful restoration.

lofty brow of the Cliffs on one hand, and the rich and extensive level on the other. The slopes of the hill, are every where diversified; being in some points excavated into deep recesses, and in others, swelling into bold projections, adorned with hanging woods, which in autumn, especially, exhibit the richest variety of tints.

The continuous flat, called the Cheddar Moor, was, until within these few years, studded over with British barrows or tumuli; but the plough and the harrow have entirely levelled them with the surrounding land, and every vestige of these ancient places of sepulture, entirely obliterated by enclosure and agriculture.

THE MANOR OF CHEDDAR

was anciently a royal demesne, even in the time of the Saxon monarchs; and so remained till it was granted with that of Axbridge and other possessions, by King John to Hugh de Welles, Archdeacon of Wells, who sold it in 1229 to the bishop; and to that See it was attached, until Bishop Barlow exchanged it in 1548, for other lands, with Edward VI. Its present possessor is the Marquis of Bath. A large portion of this extensive manor was held for a long series of years, by De Cheddar family, who also held many other domains in the vicinity; their arms, *Sable*, a chevron, Ermine between three escallops, *Argent*; frequently combined with other arms, are conspicuous in the windows of the church; one of the family founded a chantry at the altar of the Virgin Mary, and another to the Holy Trinity in this church.

There were several extensive subordinate manors in Cheddar, even at the time of the Norman Survey, one of which was held by Roger de Curcelle,* progenitor of the Marlborough family, and another called Lower Cheddar, by Roger Arundell, forefather of the Lanherne and Wardour Castle families.

* See Pages 106 and 107.

At the entrance to the village from Axbridge, is a farm house, which formed part of the manor house of John de Cheddar. The surrounding wall has been castellated, but the only part of the ancient building, remaining tolerably entire, is the Hall, now used as a stable and granary; the ornamented chimney turret, together with fragments of arches and mullions of windows, are lying about in the contiguous garden. In a field belonging to Mr. Richard Gilling, a little on the north-east of the road leading to Wells, about a quarter of a mile from the village of Cheddar, stood the mansion of Thomas de Cheddar,* where the foundations may be easily traced. These parts of the manor are now possessed by the Longs of Wiltshire, who are maternally descended from one of the co-heiresses of the above Thomas de Cheddar.

Another manor house is situated on the eastern side of the river, between the village and the Cliffs. This mansion has been externally modernised; but the old hall is retained in its original state; it is pleasantly situated in a small park, with fish ponds, and enclosed by a wooded eminence in front. The manor is called Cheddar Fitz-Walter, from its possessors, the Lords Fitz-Walters, whose predecessors came over with William the Conqueror. In 1467, seventh of Edward IV. Henry Roe resided here, and appears to have inherited this portion of the Cheddar manor from the eldest co-heiress of Thomas de Cheddar. The Roes continued here for several generations, until the estate came, by an heiress of the family, to that of Tillam, who sold it to the Birches, who now possess it.

CHEDDAR CHURCH

is a fine old building dedicated to St. Andrew. It is 120 feet long and 54 wide, consisting of a nave, with side aisles and a chancel; the former being continued, so as to

* This Thomas de Cheddar, had also the advowson of the family chantry in Cheddar church; the service of which, was performed by his private chaplain.

appear like two transepts, one on each side of the chancel. It has a porch on the north and south sides, together with a small chapel or chantry projecting from the north-east corner of the chancel. The tower is at the west end, and is 100 feet high, with double buttresses terminating in or-namented pinnacles, connected by a parapet of open work. The exterior of the nave and aisles are also highly adorned with smaller buttresses of a similar character, connected by pierced parapets. The belfry has a finely moulded vaulted ceiling, with ornamented intersections terminating in a circular opening; there is a peal of five well-toned bells.

The interior of the church is lofty and spacious, the nave being opened to the aisles by pointed arches on oc-tagonal columns, and lighted above, by six well formed clerestory windows on each side, with an oak ceiling divi-ded into deep compartments.

The aisles extend half the length of the chancel, but these projecting ends are divided by a handsome oak screen, which has been recently restored.* The windows are of various dates, generally in good taste, and well preserved; many of them are partially filled with stained glass, con-siderably mutilated, but the Cheddar arms are strikingly conspicuous. The pulpit is of richly sculptured stone, and is one of the finest in the county. The body of the church has recently been repaired, and as far as possible, restored to its original appearance; it is entirely fitted up with oak seats of the most substantial character, having carved ends.

In the chancel, beneath a richly sculptured arch,† is the

* These ends of the side aisles, were probably large private chapels, belong-ing to some of the families who possessed subordinate, yet very extensive manors, within the larger lordship or parish.

† The beautiful tracery of this arch has been most judiciously restored by the Rev. Charles J. Cobley, son of the vicar, who has also collected various fragments of the beautiful panelling of the ancient rood-loft, and formed them into an appropriate reading desk, and clerk's pew; with many other equally judicious repairs.

BRASS EFFIGY of Sir Thomas de Cheddar, in armour, with the Cheddar arms around it; and on a slab near it, is a corresponding figure in brass, of his lady, named Isabella, with the Cheddar arms, impaling three *fleur de lis*, in chief a label of three points; but the remaining parts of the inscription have been taken up, to secure their preservation.

On the south side is a chapel, opening from the aisle by a broad, handsome, obtuse arch, with a clustered shaft on one side, and a series of canopied niches on the other. This chapel was originally a chantry, and in its eastern window, is the arms of Roe, a *Roebuck*, impaling several others; among which, are those of Bishop Sharpe, and the Cheddar family; against the wall, is the front of the tomb of Edmund Roe, esq. who died in 1595, with the arms of Roe, and three others.

The vicarage house is situated near the church. Its southern wing has been completely re-built, and the other parts, comprising the old hall, have been considerably repaired in the original style, by the present vicar.

Cheddar, including the hamlet of Draycott, contains 314 houses, 393 families, and 1797 inhabitants. The living is a vicarage and peculiar, belonging to the Dean and Chapter of Wells.—The Rev. John Cobley, incumbent.

CHEDDAR CLIFFS,

are the sides of a stupendous chine or chasm, extending across or through one of the highest ridges of the Mendip Hills; and, as Collinson very justly remarks, presenting one of the most striking scenes of the kind, in Great Britain. " Here indeed, Nature, working with a gigantic hand, has displayed a scene of no common grandeur. In one of those moments, when she convulsed the world with the throes of an earthquake, she burst asunder the rocky ribs of Mendip, and tore a chasm across its diameter, of more than a mile in length. The vast opening yawns from the summit down

to the roots of the mountain, laying open to the sun, a sublime and tremendous scene; exhibiting a combination of precipices, rocks, and caverns, of terrifying descent, fantastic form, and gloomy vacuity."

The approach from the village, is extremely picturesque, and " at the entrance, all is gentle and beautiful; a brook, clear as crystal, leads its murmuring course by the side of the road on the left, backed by a shrubby wood; at the edge of which, are a few humble cottages, and on the opposite side, the ground swells into a steep, sufficiently covered, however, with verdure and vegetation, to form a soft feature in the scene; but as the visitor advances, the abyss suddenly expands, the rocks assume a more precipitous character, presenting bold and almost perpendicular points, with bare and rugged tops, towering many hundred feet above the level of the country."

The visitor is not, however, permitted to enjoy or contemplate the scene, without perpetual interruption from the resident females, who unremittingly persevere in offering for sale, small polished specimens of the rocks, or in recommending a visit to the several caves, few of which are either striking or capacious. From a ledge of rock in front of the entrance, to the cave above that, which has formed the comfortless habitation of a poor woman for upwards of twenty years, the view amply compensates for the roughness of the ascent; being considerably heightened by a bold insulated mass of rock, rising perpendicularly in front, on the opposite side of the chasm. One cave alone, is deserving of a visit, its entrance is nearly 100 feet above the valley, and it penetrates full 300 feet beneath the rocks. Its interior is rugged and uneven, branching into several spacious vaults, producing a fine echo. Its roofs and sides are covered with stalactites, whose fantastic shapes have been gradually named after such animate or inanimate things, as the lively imagination of the exhibitors or visitors, have fancied them to resemble.

A rough carriage road, winds for nearly two miles through the Cliff, until it reaches the summit of the hills, presenting various advantageous points for viewing the wild and tremendous magnificence of the scenery; the rocks alternately projecting on one side, and receding on the other, and on either hand, rising almost perpendicularly into the most wild and picturesque forms; sometimes resembling the " ruined battlements and solitary towers of a stupendous castle," having their perpendicular fronts, partially covered with ivy, and beautifully intersected by verdant ledges, scattered over with the mountain ash and darker yew, intermingled with the crimson mountain pink, and other flowering shrubs, peculiar to this romantic district.

Nine considerable springs,* pure as crystal, burst from the foot of the rocks, and almost immediately uniting together, form a beautiful stream, dashing over a rough bed of sand, mixed with shingles, and sprinkled with fragments of rock, over which the waters murmur, keeping in perpetual motion the curious aquatic plants,† with which its surface is covered; and these, mingling their deeper shades with the blue and amber coloured cone of the fresh-water limpet, that adheres to the rocks, scattered over its bed. This stream has thus been commemorated by Drayton in his " Polyolbion."

" And *Cheddar* for meere grief his teene he could not wreake,
 Gust forth so forceful streams, that he was like to breake
The greater banks of Axe, as from his mother's cave
 He wandered towards the sea."

* The water which forms the springs at Cheddar, is, probably, a stream which sinks into the chasms of the rock above, at Longwood, and in another place, on Charter-House farm.

† Particularly the *Polypodes, Asplenums,* and *Confervas.*

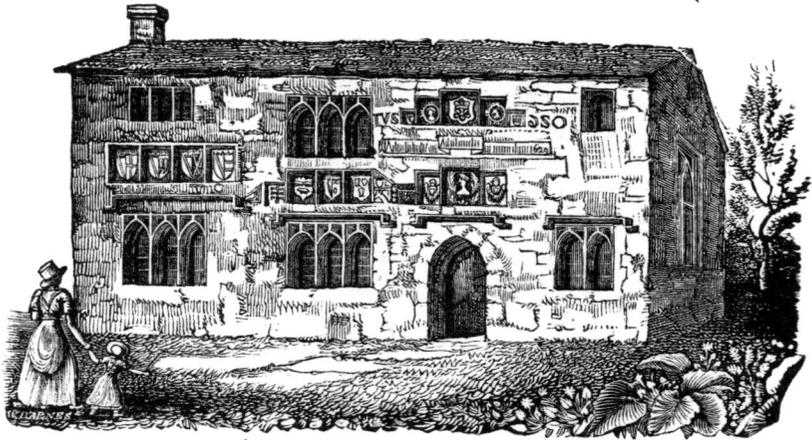

Ancient Parsonage House at Chew Stoke.

CHAP. IX.

Road from Cheddar to Bristol, Charter House.—East Harp-
tree, Richmont Castle, Coley, East Harptree Church, Charitable
Bequests, Lamb-Cavern—West Harptree, Gourney or Prince's
Manor, Tilly Manor, Manor Houses, Church, Charitable Be-
quests.—Compton Martin, Bigfield Court, Manor of Moreton,
Church.—Nempnet.—Chew Stoke, Church, Charitable Be-
quests.—Chew Magna, Manor of Chew, Court Houses, Sutton
Court, Church, Charitable Bequests, Bow Ditch.—Stanton
Drew, Manor, Church, Charitable Bequests, the Temple at
Stanton Drew, Description, more ancient than Stonehenge, vari-
ous conjectures.—Maes Knoll, Bulleton.—Dundry, Church,
View from the Tower, Charitable Bequests.—Winford, Tith-
ings, Church.—Bishopworth, Inyn's Court.—Bedminster,
St. Catherine's Hospital, Church, Inquisition, Survey.

THE road from Cheddar to Bristol may be varied, by
passing through the Cliffs and over the Downs into the

turnpike road from Wells. A little beyond the Cliffs, on the left of the road, is

CHARTER HOUSE.

This was a Roman Station of considerable extent, situated on the line of the Roman Road from Old Sarum to Uphill. The remaining vestiges chiefly consist of a small amphitheatre, with a considerable space covered with squares, circles, and some irregular earth-works. The soil is remarkably rich and black, and is mixed with fragments of ancient pottery, and occasionally with coins of the lower empire.*

At Temple Down the road crosses the Roman Road before mentioned, which may, at this point, be most distinctly traced in a direct line to the small inn called the Castle of Comfort, and in an opposite direction to the station at Charter House. A little beyond, on the right, is

EAST HARPTREE,

a considerable village pleasantly situated on the northern side of the Mendip Hills. It is remarkable for a sort of breccia, or pudding stone, formed by silicious pebbles, varying from the size of a pea, to that of an orange, firmly cemented together. About half a mile north-westward from the church, are the few remaining vestiges of

RICHMONT CASTLE,

once the noble baronial residence of that branch of the Harptrees who assumed the name of Gourney, and who were ennobled by the same title. † It was afterwards possessed by the Newtons, of whom, Sir John Newton, lies in effigy, clothed in armour, above a stately monument in East Harptree church, with figures of his eight sons and twelve daughters ; and no less than twenty coats of arms.

* See the Appendix for a detailed account of this Roman Road and Station.

† See West Harptree for a full account of this family.

The site of Richmont Castle is on the eastern side of an eminence looking over a deep romantic glen, the sides of which are richly wooded. In 1138, this castle was garrisoned by Sir William de Harptre in aid of the Empress Maud, against King Stephen; who, after the reduction of Bristol, prepared to lay siege to it, but the garrison making an imprudent sally to attack the rear of his army, he cut off their retreat by means of his cavalry, set fire to the gates. and placing scaling ladders against the walls, made himself master of the place. This ancient castle was not entirely demolished until some centuries afterwards, when Sir John Newton erected another mansion at Eastwood, in the reign of Henry VIII. The only parts now left, are the foundations of a large circular building, probably the keep or donjon.

THE MANOR OF EAST HARPTREE

is now in the possession of Earl Waldegrave, whose ancestor, Sir Edward Waldegrave, knt. was M. P. for Somersetshire in the reign of Queen Mary. His grandson. Edward, distinguished himself as an adherent to Charles I. who knighted him in 1607, and created him a baronet in 1643. His grandson, Sir Charles, was created Baron Waldegrave of Chewton, in the county of Somerset, by James II. in 1685. James, his eldest son, was ambassador at several foreign courts, in the reigns of George I. and II. the latter of whom created him Viscount Chewton and Earl of Waldegrave. East Harptree court house is pleasantly situated within an enclosed park, and is at present occupied by Captain Waldegrave, R. N. the Earl's brother.

COLEY.

About a mile to the east, is Coley, a small retired hamlet within the manor of East Harptree, through which runs the river Chew. It consists of a mansion with two or three other respectable residences, and five or six labourer's

cottages. The former belonged to the family of Bowcher, one of whose ancestors was imprisoned during the rebellion of the Duke of Monmouth, for his supposed adherence to that party, and died during confinement, thereby happily escaping the vindictive barbarity of the arbitrary Judge Jeffreys. The property continues to be held by a descendant from this family through the female line.

EAST HARPTREE CHURCH

is a respectable building, with a nave, aisle, and chancel, of different eras, the latter being by far the most ancient. The windows also vary, from the early lancet form to that of the perpendicular style; in some of them are a few panes of stained glass. The northern porch has been converted into a vestry room, the inner door-way of which is of a peculiar character, of Norman construction. The font is circular, massive, and capacious, and had an inscription around the upper edge, now rendered illegible by whitewash.

In the church-yard is an unusually large " pay table," ornamented with tracery on the sides, which, most probably, was originally a tomb.

CHARITABLE BEQUEST.—WILLIAM PLUMLEY, gent. in 1615, left by will, all his land, &c. in Glastonbury and Catcott, for the use of the poor of East Harptree. This property amounts to about 47 acres, which were lately let for 58*l*. per annum. Of this sum 7*l*. 10*s*. is paid yearly to the parish schoolmaster, and the remainder mostly distributed amongst the second poor on the 21st of December, either in money or clothing, as the case may require.

PUBLIC SCHOOL HOUSE.

There is a school house in this parish, stated by Collinson to have been founded by Sir John Newton, knt. about the year 1560, and endowed by him with 10*l*. per annum, for teaching ten poor children to read. This statement does

not, however, correspond with the inscription over the school house door, which is as follows:

" HOC ÆDIFICIUM EDUCANDÆ JUVENTUTIS GRATIA
FUNDATUM, ET EXTRUCTUM, INDULSIT NOBIS PIA
BENIGNITAS UNI VERE GENEROSI JOHANNIS NEW-
TONI, ARMIGERI. ANO. DOM. 1653.

"NULLUM TUTIUS REIPUB: AFFERE MAJUS MELIUSVE
POSSUMUS, QUAM UT DOCEAMUS ATQ. ERUDIAMUS JU-
VENTUTEM."

Over this inscription is a coat of arms, stated by the same authority to be those of Newton. It is probable, the erector was a descendant of Sir John Newton, but it does not appear that this school was ever endowed. At all events, no records of any endowment remain, and the education of the ten poor children, supposed to be alluded to by Collinson, do not appear to be in any way connected with Sir John Newton, but are paid for out of the rents arising from Plumley's Charity, at the sole discretion of the minister and church-wardens, for the time being.

East Harptree contains 130 houses, 139 families, and 627 inhabitants. The living is a vicarage and a peculiar, in the deanery of Frome, belonging to the prebendary.— Rev. John Parsons, incumbent.

Above the village of East Harptree, on the Mendip Range, is a very extensive cave, called

LAMB CAVERN.

The descent to it is by a steep shaft, about 40 feet deep, at the bottom of which is a large vaulted apartment, about 240 feet in length, 20 feet wide, and nearly 40 feet in height. The floor is covered with loose fragments of rock, but the roof is firmly arched by nature, and thickly hung with stalactites of various forms. From this cavern numerous openings lead to other vaulted caves, of a similar character, but of greater dimensions.

WEST HARPTREE

is a large and respectable village, on the north side of the
Mendip Hills, in a valley well wooded, and watered by an
excellent spring, called *Pileswell*. This parish has been
divided into two principal manors from the earliest times,
and is noted as such in the Domesday Record; one was
formerly called the Gourney, now the Prince's Manor; the
other, Tilly Manor.

GOURNAY, OR PRINCE'S MANOR,

was held, soon after the Conquest, by Azelin, or Ascelin,
surnamed Gouel de Percheval, who came over with William
of Normandy. He died in 1120, leaving several sons, of
whom, John, the youngest, inherited the manor of Harp-
tree, and assumed the name. He left a son, William,
afterwards created baron of Harptree, who, in 1138, united
with other barons against King Stephen, and erected strong
fortifications at Harptree; as did his uncle, William de
Perceval, at Castle Carey. This manor regularly descended
to Lord Thomas de Harptree, whose wife, Eva de Gour-
nay, was heiress to the families of Fitzharding, Gournay,
Gaunt, and Pagenel. Their son, Robert de Harptree,
assumed his mother's name of Gournay, and was Lord of
East and West Harptree, Farrington, Inglishcombe, and
of Over and Nether Weare. He was founder of the hospi-
tal of Gaunt, or Belleswicke, near Bristol, and died in
1268, in the 53rd of Henry III. This manor descended to his
youngest grandson, Thomas de Gournay, and from him to
his son, Sir Thomas de Gournay. He was one of the parties
to whom was committed the custody of Edward II. in
Berkeley Castle, and in consequence of his being accessary
to the murder of that prince, was, by order of Edward III.
privately executed at sea. His estates were confiscated to
the crown, and annexed to the dutchy of Cornwall, by
which the manors of West Harptree, Farrington Gournay,

o

Inglishcombe, Widcombe, Curry Mallet, Shepton Mallet, Stoke-under-Hamden, Midsummer Norton, Stratton-on-the-Foss, Laverton, and Milton Falconbridge, all of which belonged to the Gournays, and became vested in the King, as Duke of Cornwall.

WEST HARPTREE TILLY MANOR

was possessed, soon after the Conquest, by an ancient family named Tilly; one of whom held it in 1194, sixth of Richard I. William Tilly was lord of this manor in the time of Edward III. and is recorded as a benefactor to the Abbey of Glastonbury. The last of this family who possessed the manor, appears to have been Lionel Tilly, lord of Salthay, in this county, in the reign of Henry VI. for in 1476, 16th of Edward IV. it was held by Walter Rodney, son of Sir Walter Rodney, knt. and in 1543, 35th of Henry VIII. it was vested in the crown, and granted to John Lord Russel, who sold it to John Buckland, whose descendants resided here so late as 1696. One of this family, named Ralph Buckland, was a celebrated puritan in the time of James I. He afterwards became a Roman Catholic priest, and wrote and translated many religious treatises. The present lord of Tilly Manor, is Colonel Cooper.

THE PRINCE'S AND TILLY MANOR HOUSES

are both standing, in which Court Leets for each manor, are still held. The former stands on the site of the mansion which was inhabited by the Gournay family, for many generations. The present building was originally a large mansion in the best style of the Elizabethan era. The front is remaining, with a square portico, carried up to the third story, where it terminates with an open balcony. Over the entrance are two shields, one charged with three lions rampant, and the other with two chevrons between three roses.

The TILLY MANOR HOUSE, stands near the church, on the opposite side of the road; part of the centre only of

the original mansion remains, the two wings having been demolished. The front still retains tokens of its former respectability, having coats of arms over each of the lower tier of windows. It is now used as a farm house; but one of the drawing rooms remains almost entire, with gilt edged oak paneling, and a curious ceiling, having in the centre, a deep projecting oval wreath of fruit and flowers. In the parlour is an antique mantel-piece, carved in oak; and a cornice, ornamented with the Tilly arms.

WEST HARPTREE CHURCH

is a small, plain building, of some antiquity, with a low tower surmounted by a leaded spire. The ancient character of this edifice has been injured by injudicious repairs, and is retained only in the chancel, tower, and north entrance. In the chancel are a few monuments to the Bucklands, who came from Lewes in Sussex; but there are none of the Harptree family, either in this church or that of East Harptree. On the north side of the chancel, is a large monument to the memory of William Erle, sergeant at law, and several of his family, dated 1703 to 1739.

CHARITABLE BEQUESTS.—JOHN BUCKLAND, in 1673, gave by will, a close of land, containing three acres, called Cholwell, for the benefit of the poor, and apprenticing poor children of West Harptree. This land, with two other pieces, called Syme's Close and Cockwell, left by MARY. BUCKLAND, are let for 17l. per annum, which is entirely applied in apprenticing poor children of both sexes.

JOHN PLUMMER, in 1729, gave by will, about twenty acres of land in this parish, now let for about 45l. per annum, a moiety for the poor of West Harptree, and the remainder for the poor of the adjoining parish of Priddy.

SAMUEL LOCKIER, in 1817, gave by will, certain premises to be sold, and the net produce to be invested, and the income applied to instructing poor children of West

Harptree, in reading, writing, and arithmetic. The sum invested is 300*l.* the interest of which, about 15*l.* is applied in paying the school house rent of 10*l.* and a salary to the schoolmaster, who instructs ten poor children in the church catechism, in writing, and the rudiments of arithmetic. A copy-hold estate now held on lives, will hereafter belong to this charity.

WILLIAM ERLE, sergeant at law, left by will, 50*l.* the interest to be applied to the use of the poor of this parish.

West Harptree contains 98 houses, 109 families, and 529 inhabitants. The living is a vicarage * in the deanery of Bedminster. The King is patron as Prince of Wales.— Rev. James Rouquett, incumbent.

COMPTON MARTIN

is nearly a mile west of the Harptrees, and consists of one street, half a mile long, in a delightful wooded vale, gradually sloping towards the heights of Mendip. It derived its additional name from a family of great eminence, originally from Normandy. One of them named Martin de Tours, possessed the territory of Kemeys in Pembrokeshire, where he founded the monastery of St. Dogmaels; and where his grandson, William Fitz-Martin, had the strong castle of Lanhever, which, in the reign of Henry II. was stormed and taken by Rhese ap Griffith, prince of South Wales, whose daughter he had married. It was afterwards held by the family of Wake, under that of Martin, as superior lords, until in the reign of Edward III. when John Wake contrived to secure it to himself. It was ultimately possessed by the Chandos family, who sold it in 1779.

* A curious document is preserved, by which it appears, that in 1344, 18th of Edward III. it was ordained that the vicar should have a house nearer the church, separate from the parsonage, to be built within six months, at the expense of the Abbot of Keynsham, consisting of a hall, two sitting rooms, two cellars, kitchen, granary, stable for three horses, a pigeon house, and seven acres of land, with other appendages.

About a mile north of the village, and within the parish of Compton Martin, is an ancient mansion, called

BIGFIELD COURT.

Its original name was Bykeford, which it imparted to a family who held it ; but it afterwards was possessed by the Martins, and now belongs to Mr. Smyth of Keynsham. The building is of great antiquity, and its style of architecture curious. It was surrounded by a moat, great part of which remains full of water to the present time. It is supposed to have belonged to some religious order.

About a mile to the north-east, is the still more ancient

MANOR OF MORETON,

which is mentioned in Domesday Survey as having been held previously by three Saxon thanes. It was at that time of considerable extent, and subsequently of increased importance, and gave name to the family of De Morton, who flourished here for several generations; as did another branch of the same family at Milborn St. Andrew, in Dorsetshire. This family possessed the manor of Moreton in the time of Edward II. but it subsequently passed through various families of note, until it was again recovered, in 1596, 39th of Elizabeth, by Sir George Morton, knt. of Clenston, in Dorsetshire, who was descended from its early possessors of the same name.

COMPTON MARTIN CHURCH

is situated on elevated ground, has a handsome tower, which was once ornamented with flying buttresses and three canopied niches, containing figures. The interior is remarkably interesting, presenting specimens of the various eras, from the early Norman to that of the latest perpendicular style. The arches in the nave are Norman, with massive circular shafts, all plain except one, which is deeply cabled, but whose lower part has been unfortunately cut away for private accommodation. On one side of the clerestory, are four small lancet windows o

early date, and opposite to them were four others to corres-
pond, but now walled up. The roof of the chancel is a
fine specimen of Norman architecture, being divided into
two compartments, by a broad ornamented arch, with deep
massive groins from each angle of the roof, crossing in the
centre. At the eastern end of the south aisle is a chapel
enclosed by a carved oak screen.

Compton Martin contains 88 houses, 103 families, and
534 inhabitants. The living is a rectory in the deanery of
Redcliff.—The Rev. John Royle, incumbent.

NEMPNET

is an ancient village, and is deserving of notice on account
of its containing a large old manorial mansion, called
REGILBURY HOUSE, for some time the residence of Sir
William Wyndham, on his retirement from the cares of
state; and also from its vicinity to the remarkable tumulus,
or cemetery, called " Butcombe Barrow," described at
length in a former chapter.

This manor was held by the families of Martin and
Perceval, for several generations, of the Abbot of Flaxley,
as chief lord of the manor. Subsequently to the dissolution,
it was possessed by the Baber family, from whom it de-
scended to the Tyntes of Halswell, the present possessors.

NEMPNET CHURCH,

is a chapelry to Compton Martin ; it is a small structure,
with a newly built tower.

CHEW STOKE

is pleasantly situated on the river Chew, seven miles from
Bristol on the direct road from that city to Wells. It is
remarkable for its lime-stone and red sand-stone quarries,
the latter abounding in fossil remains. The manor was
held at the time of the Conquest, by Gilbert Fitz-Turold,
who, conspiring with Robert Duke of Normandy, against
William Rufus, suffered confiscation of all his estates ; it

was afterwards possessed by the Lords Beauchamp, of
Hatch, and subsequently by the St. Loes, who also held
the

MANOR OF ST. CROSS,

on which are the foundations of an ancient cell for four
nuns, founded by Elizabeth de Sancta Cruce, or St.
Cross, from whom its name was derived.

CHEW STOKE CHURCH

is a handsome edifice dedicated to St. Andrew, with a good
spire, and a turret at the east angle, surmounted by a
light and elegant pinnacle. The upper division of this tower
has four windows, containing excellent pierced tracery, of
an unusual character; the parapet is also pierced and has
a small figure in an ornamented niche, in the centre of
each side. The east window is of the decorative era, and
in good taste. Great part of this church was built by one
of the St. Loes, whose arms are sculptured in stone on
the exterior of the wall, together with those of Fitz-James.

THE PARSONAGE

is a curious, ancient building, contiguous to the church,
and is just 300 years old. It is now used as a poor house,
but is richly decorated on the exterior with numerous
coats of arms, sculptured in stone, of the families of St.
Loe, Fitz-Payne, Ansell, Rivers, Ragland, Malet, and
others. Over the door is this inscription:

A. dno factu est istud quod barry in Anno dni
MDxxix.

Laus Deo. Laus Deo.

CHARITABLE BEQUESTS.—In 1718 a public subscription
was made for the purpose of establishing a Charity or
Free School at Chew Stoke. The total amount was

2221. 12s. 6d. Part of this sum was laid out in the purchase of lands at Oldfield and other places, and the whole property vested in trustees. The income is now as follows : 38l. from twelve acres in Oldfield; 28l. from about ten acres, called Crockard's or Well Close; 5l. rent charge; 8l. 5s. interest for 165l. lent in 1808, on a note of hand; and 10l. from 200l. lent on the Wesleyan chapel at Nailsea, making a total of 91l. 7s. out of which, some payments are made for the use of the poor, leaving 87l. 7s. to be applied to the support of the school.

The premises belonging to this charity, consist of a dwelling house, and a school room annexed, capable of accommodating fifty or sixty children. At present twenty boys are taught reading, writing, and arithmetic, twelve of whom receive annually a suit of clothes, at the expence nearly of 28l.

A girls' school is also supported out of the income; eight of whom are clothed at an annual expence of about 8l. 12s. 8d. The school master has the use of the house and garden, with a salary of 20l. The mistress receives 18l. per annum, with 20s. yearly for coal.

Amongst the other bequests to the poor of this parish, is one by Sir Abraham Elton, bart. in Bank Stock, which produces 21l. 1s. 9d. annually.

Chew Stoke contains 108 houses, 126 families, and 681 inhabitants. The benefice is a rectory in the deanery of Redcliff.—The Rev. W. P. Wait, incumbent.

CHEW MAGNA

was formerly a large market town and a borough; which, together with the manor, belonged to Gyso Bishop of Bath and Wells. This prelate stood high in the favour of Edward the Confessor, on whose death, he fled the country; but after the Conquest, he returned, and was restored by William to all his former honours and possessions. Subsequent kings greatly enriched the borough of

Chew Magna, and granted it important privileges; all of which are become obsolete. The town is still of considerable extent, though with some appearance of decay, and is pleasantly situated on the north side of the river Chew, over which there is a bridge called Tun or Town bridge.

Manor House at Chew Magna.

THE MANOR OF CHEW,

including the borough and adjacent vills, continued to be possessed by the See of Bath and Wells, from the time of Gyso, until the second year of Edward VI. 1548, a period of upwards of five centuries. In that year it was alienated by Bishop Barlow, under royal licence, to the Duke of Somerset; upon whose attainder it was escheated to the crown, and granted to Lord Plumley, who sold

the royalty, leet, and the tithed lands to Sir Francis Pop-
ham, and the bishop's house and demesne, to Edward Baber,
esq. The manor continued in the Popham family until
they sold it, in 1766, to Richard Summers, in whose family
it continues. Baber's portion of the manor continued in
that family for several generations, and is now possessed
by the Harfords of Bristol, some of whom reside here.

CHEW MAGNA COURT HOUSE

stood contiguous to the church. Its remains are remarka-
ble for two small octagon towers of an unusual character.
Near the south entrance to the church-yard, is another
ancient building, formerly

THE CHURCH MANOR HOUSE,

which, though used as the parish poor house, is still re-
tained as the legal place for holding the court leet and
court baron of James Harford, esq. the present lord of the
manor. This is an interesting old building, with an arched
door-way crochetted and finealed, of the perpendicular era,
and a window above. It is supposed to have been built by
one of the St. Loes, whose arms, impaling those of Fitz-
paine, surmounted by a labelled motto, are cut in stone
over the door; above the window is a figure of St.
George and the dragon.

SUTTON COURT

is a large ancient manor house, within the parish of Chew
Magna. It was originally inhabited by a family of the
same name, from whom it came into the family of St. Loe,
about 1646. The celebrated topographer and antiquary,
John Leland, took up his abode here for some time, whilst
making his well known Itinerary of the country; it was
then inhabited by Sir John St. Loe, and was, even then,
denominated by Leland, an " old manor place." Within
the house are the arms of St. Loe, quartered with Ragland,
Irwood, Pointz, Acton, Fitz-Paine, Ancel, Rivers, Malet,
and Fitz-Nichols, all of which originally stood in a large

parlour, built in 1558, by Elizabeth, the wife of Sir William St. Loe, captain of Queen Elizabeth's guards, and chief butler of England, who settled this manor upon her.

In 1428, seventh of Henry VI. the MANOR OF SUTTON belonged to Sir John St. Loe, who married Eleanor, the daughter of Sir Thomas Arundell, knt. of Wardour Castle and Shaftesbury, by Catherine, daughter and co-heiress of John Chydiock, esq. From the St. Loes, this manor was given, by the widow of the before mentioned Sir William St. Loe, to her son by her second husband, Charles Cavendish, father to the Duke of Newcastle, who also possessed it ; but adhering to the cause of Charles I. he lost his estates by confiscation, and the manor was sold to Elizabeth, wife of Samuel Baber, who settled it on her son, by a second marriage, John Strachey ; his descendant, Sir Henry Strachey, now lives at Sutton Court, and possesses the manor.

STOWEY MEAD.

This delightful residence lies about a mile south of Sutton Court, on the opposite side of the turnpike road from Harptree to Bath. It is a small elegant cottage, surrounded by grounds tastefully designed, and is screened from view by a belt of timber and plantations. It has been for many years the occasional residence of Captain Sandford, who has lately succeeded to the Irish title of Lord Mount Sandford.

About half a mile to the north-east of Stowey Mead and Sutton Court, is Stowey House, belonging to W. J. Burdett, esq.

CHEW MAGNA CHURCH

is a large ancient building 106 feet in length, by 60 in width. It consists of a nave, side aisles with chapels at their eastern ends, a chancel, two porches, and a well built tower 103 feet high, surmounted by an open battlement with one turret. The prevailing style is that of the perpendicular era, and it is said that the north aisle was built by Sir John St. Loe, about the year 1420 ; which is probable, from the circumstance of his arms being emblazoned on its roof, and

his chapel which is attached being of a similar character; but some parts of the church are of a much more ancient date. A carved screen, of some antiquity, separates the chancel and chapels from the body of the church; the pulpit and reading desk are of the same character, and over the former, is a curiously sculptured sounding board to correspond.

The font is old and capacious, but modernised; and " Bishop Jewell's Defence of the Church," is still chained to a small reading desk, for the edification of those who have not the opportunity of reading it at home.

Within this church are numerous monuments of members of families, connected, at different times, with this place and its several manors. Amongst the most remarkable, is a large old tomb in the Sutton Court chapel, at the end of the north aisle; it is of the age of Henry VI. and is surmounted by the gigantic figure of Sir John St. Loe, clothed in armour, cross-legged, with his head resting on his head-piece, and measuring seven feet four inches in length, and two feet four across the shoulders. At his side is the figure of his lady, much defaced, but probably of a later date. In this part of the church are also several monuments of the Strachey family.

In the opposite chapel, which belonged to the Baber manor house, are monumental effigies of Edward Baber, and Catherine his wife, dated 1578 and 1601; near which are several mural tablets commemorative of that family.

On the cill of a window lies the antique and curious figure of Sir John Hautville, knt. carved out of a solid piece of oak; he is clothed in armour, with a loose cloak over it, bound round the waist by a girdle. This figure was originally in Norton Hautville church, over the knight's tomb, from whence it was removed on the destruction of that building. This Sir John Hautville lived in the thirteenth century, in the reign of Henry III. The fame of his personal strength and prowess is still cherished by the country people; among them, there is a tradition,

that he threw the stone called Hautville's coit, part of which now lies near the road to Stanton Drew, from his supposed residence at Maes Knoll, a mile distant.

CHARITABLE BEQUESTS.—JOHN CURTIS, and AGNES his wife, in 1607, gave 40*s.* annually for three sermons, and 20*s.* for schooling one poor boy of the parish of Chew Magna for ever; the latter is paid to the schoolmaster at the poor house, where a school has been held from time immemorial.

JOHN TEGG of Stowey, in 1684, gave all his lands in Moorton, after two lives, for the education of poor children of Chew Magna. The parish holds two pieces of land in Moor, a hamlet in the parish of Compton Martin, the rent of which being 12*l.* is paid to the master of the charity school.

MADAM BABER gave 100*l.* the interest to be employed in binding out poor children apprentices. The parish holds four acres of land in Compton Martin, the average rent of 5*l.* is so applied. There are several other bequests for the benefit of the poor of this parish.

Chew Magna contains 5000 acres of land, 368 houses, 403 families, and 1884 inhabitants. Bishop Ralph de Salopia appropriated the church *mensæ episcopalia*, and reserving the tithes of the demesne lands, endowed the vicar with the residue. The living is a vicarage, and is held by one presentation with Dundry.—Rev. John Hall, incumbent.

The name of *Chew* is supposed to be a corruption of *Teuw*, and thence was derived *Chew Magna*, or the " *Great Chew*."

BOW DITCH

is an ancient encampment of a circular form, with triple ramparts, on the hill above the town of Chew Magna. Its site is commanding, and has a fine view of the surrounding country and of the Bristol Channel.

STANTON DREW,

the Stone Town of the Druids, where was one of the sacred temples of their god *Teut* or *Teutates*, from whom it probably derived its name.

THE MANOR OF STANTON

formed part of the immense lordship of Keynsham, at the time of the Conquest, soon after which, it was possessed by a family who derived their name from it; where his descendants continued, until the estate came to John de Montacute, Earl of Salisbury.

This manor was afterwards possessed by the family of Choke, and was held by Lord Chief Justice Choke, who resided at Ashton Court; it was subsequently held by Anthony Ashley Cooper, esq. of the Shaftesbury family. He sold it to P. Coates, esq. the present proprietor, who lives at the manor house, STANTON COURT. This mansion has a venerable appearance, and was originally possessed by Edward St. Loe, esq. at which time it was an embattled castle, with towers at the angles, and was regularly fortified. At the back of Mr. Fowler's house, near the church, is an ancient looking building, with small pointed windows, having much the appearance of a chapel. The PARSONAGE HOUSE is also an interesting relict of antiquity. On a blocked window, which has grotesque masques at the corners, are two armorial shields cut in the stone; one of them charged with three garbs within a bordure engrailed; the other, on a fesse, a mitre, with labels expanded between three bucks' heads cabossed in chief, and in base as many pheons; the latter being the arms of Bishop Thomas Beckington. Mr. Willis has lately erected a picturesque residence at this place.

STANTON DREW CHURCH

is not only contiguous to the Druidical Temple, but evidently within its original range, being situated a little

south-west of the great circle, between those stones called lower Tyning and the Cove. The parts of this edifice are arranged in an unusual manner, consisting of a nave and aisle, with a low tower on the north side; the lower story forms the entrance porch, in which is a pointed arch with florid tracery, and a small saint's niche of good workmanship. Attached to the eastern side of the tower, is an ancient chapel, now used as a vestry-room, in which are four handsome monuments of the Lyde family; originally from Bristol, who possessed an estate in this parish for many years. Also one to Sir Michael Foster, a Judge who married a Lyde. There are also several monuments of the Adams's, who owned the manor of Bulleton or Belgetone, within this parish. The others chiefly belong to the families of Hopkins, Sellick, Hippisley, Bull, Coates, and others. On the floors are several ancient stones, some of them having vestiges of effigies and inscriptions. The font is plain, circular, and massive.

CHARITABLE BEQUESTS.—RICHARD JONES of Stowey, in 1688, gave by will, 3000*l.* to be invested by his executors for charitable purposes. 1600*l.* of this amount was expended in the purchase of an estate called Bere Farm, in the parish of Higham. This estate was let for 248*l.* but it was subsequently reduced to 148*l.* One-fifth of this income is paid to the parishes of Chew Magna and Stowey; one-fifth to the master of a school at Newton St. Loe; and one-fifth to the minister of that parish for the purpose of binding out apprentices. Stanton Drew has the benefit of the remaining two-fifths; one moiety of which is paid to the school master, who teaches from 20 to 30 poor children of that parish; the other moiety is reserved by the acting trustee, Mr. Coates, for the purpose of apprenticing poor boys from Stanton Drew.

ELIZABETH LYDE, relict of James Lyde, jun. esq. in 1772, gave 100*l.* out of the interest of which, three guineas

is paid as rent of a school room, and the remainder to a school mistress, who teaches six poor girls to read and sew.

WILLIAM SAGE, CHARLES CHANCELLOR, JOHN ADAMS, and ROBERT HODGES, left various small sums for the benefit of the poor of this parish ; the income produces from 5l. to 6l. and is mostly distributed in bread.

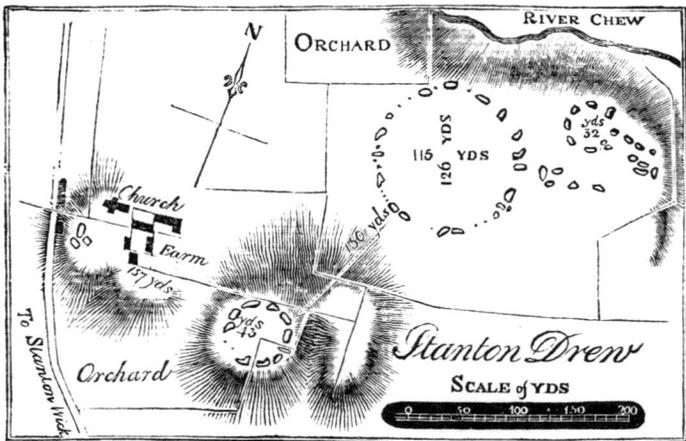

DRUIDICAL TEMPLE AT STANTON DREW.

The principal remains of this remarkable monument of ancient times, are to the eastward of the church, and consist of an assemblage of ponderous stones, originally composing three circles, together with some detached masses, difficult to account for, of magnesian lime-stone, of red sand-stone, and of a breccia composed of pebbles and grit, firmly cemented together. The largest and smallest circles stand within a field called Stone Close, adjoining the dwelling house of Mr. Coates.

The largest circle is an ellipsis, measuring 126 by 115 yards in diameter, situated in a vale about 100 yards south of the river Chew, from which it is separated by some rising ground, forming a sort of rough amphitheatre. Fourteen stones only are now apparent; five of which stand erect in their places, eight others are evidently buried just below the surface; whilst the position of five more is indicated in dry summers by the withering of the turf over them. How many stones originally formed the circle, cannot now be ascertained. Seyer makes the number twenty-seven, but acknowledges that there were probably more ; Dr. Musgrave, who wrote in 1718, supposes them to have amounted to thirty-two, but they were not perfect, even then.

The most rational conjecture, strengthened by a comparison of the relative position of the remaining stones, appears to be, that their original number was thirty, corresponding with the days of the calendar month. They are of various sizes, the largest measuring nine feet in height, and twenty-two in circumference. The entrance to this circle, was, probably, on the eastern side, where lie two stones eighteen feet asunder from centre to centre, but appearing comparatively small, from being either buried in the ground, or broken off; opposite to these, are five stones, placed in two rows, which are the only remaining ones that formed the entrance into the larger temple.

At the distance of about forty yards to the north-east, is another circle of eight stones, but most likely originally of seven. It is thirty-two yards in diameter, the stones forming its circumference being very large, and of far superior workmanship to the others ; half of these retain their erect position, the others lie high above the ground.

Adjoining to this second circle, on its eastern side, is a confused mass of seven stones, which either originally composed another circle, or otherwise formed part of an avenue leading to the one above described.

P

In an orchard, at the distance of 150 yards south-west of the largest and centrical circle, is a third, rather less perfect, called by Stukely, the Lunar Temple, probably because it consisted of twelve stones, all of which are rude and irregular. The circle is forty yards in diameter, and occupies the summit of a low hill or knoll, raised above the level of the other circles; around the edges of this, the stones were placed; portions of ten are remaining, some lying prostrate, others standing erect, and a few buried at a considerable depth below the surface.

At the distance of 157 yards north-west from the last circle, and near the church, are three other stones, placed in a triangular form, on another low eminence. These stones form what is called the Cove, a space measuring about ten feet wide by eight deep, enclosed by these three flat stones; supposed to be erected for judicial purposes, where the Druids sat and administered justice to the neighbouring tribes.

North-west from this cove, are two large stones lying flat, in a field called Lower Tyning; and north-east from the great circle, beyond the brook, by the side of the road to Chew Magna, is the huge stone now called Hackvell's Quoit; a name corrupted from Hautville, the formidable warrior previously mentioned.

The remains at Stanton Drew may certainly be classed with those at Carnac in Britany, and at Avebury in Wiltshire, though by no means equal to either of them in extent or grandeur.

Stanton Drew and Avebury were, probably, built prior to Stonehenge, as is evident from their greater roughness and more irregular form; Stonehenge being comparatively an elegant structure, formed of stones hewn into regular shapes, and perhaps, one of the latest specimens of that peculiar style of architecture.

The Rev. W. L. Bowles, in a recent publication, states as his opinion, that Stanton Drew, like Avebury, was a tem-

ple of the Druids, dedicated to the *greatest* Teacher, the one god, the knowledge of whom was brought to Britain by the Phenicians; this great Teacher being Thoth, the Egyptian Taxut, the Phenician god, from whom came the Celtic name, *Teut*, latinized by Lucan into *Teutates*. According to Cæsar, this was the greatest god of the Celts, and he enumerates these deities; first, Mercury, (Teut); after him, the god of medical springs, of light and of heat, the *Sun*; in Celtic, *Bel*, from the Phenician and Chaldean, latinized into *Belenus*, and the same as Apollo; Mercury being the same as Thoth, Taut, Teut, &c.

Thoth was an astronomer, and the grandson of Ham, the son of Noah. His ideas of the one god were derived, according to the same hypothesis, from patriarchal tradition; from his various knowledge of natural phenomena, and from the instructions which he gave his people in religious matters, his memory was venerated, as if he were more than mortal. By the Egyptians, the Phenicians, and the Druids, he was worshipped under the several names of Thoth, Taxut, and Teut.

It is further supposed that the circle of thirty stones, has reference to the days of the month, Thoth having first divided the year into 365 days; the odd days were afterwards intercalated, but Thoth was the discoverer of 365 days to complete the solar year; and in the tomb of Ozymandias, the seventh king of Egypt from Hdor, was preserved the *Golden Circle*, or the Zodiac, divided into 365 portions, corresponding with the days of the year. To this, the author adds, that the first representation of Thoth, was invariably by a " stone," on a mound; and fourteen miles from the Druid's Stone-Town, now Stanton Drew, stands this very representation of *Thoth*, or the Celtic *Teut*, on a vast natural mound, called to this day, Cleeve Teut or Tout.* It is also probable that the

* See the Rev. W. L. Bowles's " *Hermes Britannicus*," and the third chap. of these " Delineations. "

circle of twelve stones, had reference to the months of the
year; and that of seven, to the days of the week.

Seyer conjectures that these stones at Stanton Drew,
were erected by the Druids for the united purposes of
religion, law, and government. They were not raised
without a prodigious expence of labour, and must therefore
have been erected for some purpose interesting to the whole
tribe; and such, religion, law, and government, have always
been. There is good authority for believing that such
circles of stones were built for temples; that sacred rites
were performed within them; and that the civil assemblies
and proceedings of the Druids were accompanied and
sanctioned by religious ceremonies.

That the Druids were connected with them is plain, even
from the name of Stanton Drew; they were the priests, the
legislators, and the judges of the nation, and controuled
even kings. It is therefore almost certain, that the village
of Stanton Drew was, in some sense, a metropolis, or seat of
government of the Hædui, and that this, with perhaps others
in its immediate neighbourhood, was inhabited exclusively
by Druids; some of whom went daily and sat in the cove,
or justice seat, or within the circles, to decide suits and
complaints brought before them; others, probably, in-
structed the youth; whilst others offered up daily sacrifices.

Probably also, continues Seyer, there was an assembly
within the circles, of all the men of property belonging to
the tribe, (the Hædui,) where peace and war, taxation,
succession to the lands, and even to the throne, and other
national offices, were settled, still under the superintend-
ance of the Druids; and the circles being placed on an
easy and pleasant knoll, in a valley surrounded by hills,
whatever was done might be seen by the whole assembled
tribe.

Sir Richard Hoare, in his "Ancient Wiltshire," considers
the Druids to have been the priests who officiated within
the circles, but not those who raised them. The Druidical

priests are described by Cæsar in his Commentaries, as presiding in matters of religion, and as having the care of public and private sacrifices. They also interpreted the will of the gods; they had the direction and education of youth; and in all cases, whether public or private, their decision was final. In other instances they were the supreme judges, whose opinions and decrees were all important, and likely to have been accompanied by all these exterior means of impressing the common people with awe and veneration for their character, and with willing obedience to their edicts.

MAES KNOLL

is an extensive fortress on the eastern extremity of Dundry Hill, overlooking the village of Whitchurch, and distant from Bristol five miles. The northern side is defended by the natural form of the hill; on the top is a dry wall, about two feet high; this was probably continued round the station. At the western extremity, the hill closes on both sides, making a narrow isthmus, which is crossed by an immense tumulus, called Maes Knoll Tump. This barrow is 390 feet long, 84 feet broad, and about 45 feet high, above the level of the camp on the inside; but on the western side of the Knoll, there is a deep ditch, from the bottom of which, to the top of the Knoll by one continued acclivity, cannot be less than 60 feet; the ground being so wrought as to admit an entrance into the camp at each end of the mound. The camp itself is bounded on the west by the Knoll; on the north and south by the natural fall of the hill, aided by art; on the east, where the access is more easy, the place is defended by a ditch about ten feet deep and very perfect; with a similar one not so perfect, about forty or fifty yards lower down the hill, probably constructed as an outwork, and for the purpose of enclosing an additional space. On the south is a space of sloping ground taken in and guarded by two ditches at its extremity;

the steep declivity forming of itself a tolerable defence to the east and west.

Seyer considers Maes Knoll Tump as the most interesting part of the station; he says it is usually considered to be a mere military agger or rampart, but that in his opinion it is of much more ancient date, and is a sepulchral barrow, of an oblong shape, and of the same kind as Silbury Hill, Fairy's Toot, and others. Its mere appearance, he says, especially on the approach from the east, is sufficient to prove so. For these reasons he has no doubt that it was raised in the ordinary way, as a barrow for some deceased chieftain; having, perhaps, some reference to Stanton Drew, which it overlooks at the direct distance of about a mile.

BELLUTON.

It is a curious coincidence, that within the parish, and between the circles at Stanton Drew and Maes Knoll, is an ancient village, now called Belluton, but formerly Belgetone, or the town of the Belgæ; and it was, probably, connected with their boundary line of Wansdike, formed by that warlike people previous to the Roman invasion, to defend their territory from the excursions of the aboriginal Britons, who were equally fierce and warlike, and tenacious of their territory.

DUNDRY

is a small village, situated on a lofty hill, 790 feet above the level of the sea; and the elevated and finely ornamented tower of its church, is visible from a great distance. Its name is derived from two Erse words, *Dun* and *Draegh*, signifying a hill of oaks, which no doubt was a correct designation of its ancient appearance, though there is little ground for such an appellation at present.

THE MANOR OF DUNDRY

was anciently united with that of Chew Magna, and held by the Bishops of Bath and Wells, for upwards of five

hundred years, until the time of Edward **VI.** when it was alienated from the church, and given to the Duke of Somerset, on whose attainder, it reverted to the crown ; and passed through several hands, until it came from the Popham family to the Summers who are its present possessors.

DUNDRY CHURCH

is celebrated only for its magnificent tower of the age of Edward IV. (1461 to 1483) and was probably intended for a land mark by its founder ; since the character, neither of the body of the church, nor the village itself, seems to call for a tower on so splendid a scale. It is supported by buttresses of eight gradations, at three of the angles, and by a turret at the other. Four horizontal tablets separate the height into four stories, each of which, contains pointed windows with perpendicular mullions. The upper cornice has heads of animals projecting at the angles, as water spouts, which are repeated over each window. The whole is surmounted by four richly pierced square turrets, supported by flying buttresses, and connected by battlements of the same elegant character. *

From the summit of this tower, is a fine view of Bristol, with its numerous spires, contrasted with the more solid tower of the cathedral ; more to the left, are the crescents at Clifton, almost overhanging the Hot Wells ; and below the picturesque rocks of St. Vincent, are occasional views of the Avon, bounded by the hanging woods of Stokeleigh. Rather more to the west is Sir John Smyth's elegant seat at Long Ashton, over which are seen the waters of the Severn, bounded by the Welsh coast. To the south, the eye ranges over a rich and varied country, including Alfred's Tower, the luxuriant woods rising above Sir R. C. Hoare's

* The south-west or weather sides of this fine tower, have recently been thoroughly and judiciously repaired, by the substitution of sound stones for those which were decayed.

seat at Stourhead ; also Knoll Hill near Warminster, with the noble plantations at Long-leat, and the Duke of Somerset's ; beyond which are the high downs of Wilts and Dorset.

The body of Dundry church is of more than ancient date the tower; the columns of the arches are plain and massive, and at the west end of the nave, is a small lancet window of the early English era. The font is octagonal with a large recess, and is enriched with sculpture of an early age.

There are a few monumental tablets, one in memory of William Symes, gent. and several of his successors, with their arms; *Or*, two lions passant, langued, *Sable*. There are also memorials of the families of Tibbot, Haythorne, and Baker's, of Alwick Court, and one of William Jones, of Bishport, of whom it asserts, " that his natural abilities, unaided by academical education, enabled him to refute, with uncommon sagacity, the slavish systems of usurped authority over the rights, the consciences, or the reason, of mankind."

In the church yard is a handsome old cross, with a tall shaft having an ornamented head, nearly perfect, fixed on a high pedestal, on five rows of steps. Near it originally stood an immense stone, of about five feet cubic measure, which has been removed to the southern side of the church ; it is called the money stone, and on it the poor have been paid for time immemorial. North of the church are the mutilated remains of an ancient stone coffin ; and contiguous is an antique house, built by the bishops of Bath and Wells for the residence of the officiating curate, but now converted into the parish poors' house.

CHARITABLE BEQUESTS.—BENJAMIN SYMES, in 1778, gave 300*l.* in trust, from which, 2*l.* 16*s.* a year is paid to a schoolmaster at Winford, for teaching two boys of Dundry parish ; 2*l.* 3*s.* 2*d.* is paid to a tailor for clothing them ; 4*l.* 19*s.* 2*d.* is allotted to the poor of Dundry ;

2*l.* 7*s.* 4½*d.* to the poor of Nailsea, and 2*l.* 7*s.* 4½*d.* to the poor of Chew Magna.

HESTER SYMES, in 1782, gave 50*l.* The income of 2*l.* 10*s.* is paid to the schoolmaster at Winford, before mentioned, for teaching two additional boys in the same way.

JAMES HELLIAR, in 1779, gave 100*l.* The interest of 5*l.* is paid to a school mistress in the parish of Dundry, for teaching seven poor girls. There are several other gifts for the benefit of the poor of Dundry.

Dundry contains 2800 acres of land, 82 houses, 92 families, and 454 inhabitants. The living is a curacy annexed to Chew Magna.

A short distance south of Dundry, is the parish of

WINFORD,

divided into three tithings, of Winford, Regil, and Fenton, which were anciently surrounded by a forest, and situated in a deep narrow vale, bounded by high hills, well cultivated and richly wooded. The MANOR of WINFORD is mentioned at length in the Norman survey; at which time it was held by the Bishop of Coutances; having previously been possessed by a Saxon thane named Alwold. It subsequently belonged to the families of D'Amorie, Bayouse, and Sor; after which, both the hamlets of Winford and Fenton were added to the manor of Backwell, and, together with the advowson of the church of Winford, were held by the Rodney family; and now by that of Elton. The parish of Winford contains 3000 acres of land.

Regil is also mentioned in the Domesday Record. Subsequently it became a cell to the Cistertian Abbey of Flaxley in Gloucestershire, which appears to have held large possessions, mostly in demesne, in Winford, Nempnet, Butcombe, and Stoke.

WINFORD CHURCH

is a handsome structure, with a stately tower of excellent masonry, surmounted by battlements. In the windows

are a few remains of painted glass, and in that of the chancel, the following coat of arms: *Gules*, a saltier, *or*, between four faces resembling moons. At the north-east corner of the south aisle, formerly stood a monument, whereon lay the effigy of John Cottrell in armour, dated 1612, with these arms: *Argent*, a bend between six escallops, *sable*.

BISHOPWORTH

is situated in the port-way from the city of Wells to that of Bristol, from which circumstance it is also called Buishport. This manor was formerly the property of a branch of the family of Arthurs, of Clapton. Thomas Arthur, esq. was lord of it in 1312, sixth of Edward II. and it continued in the same family, until 1558, first of Elizabeth, when John Arthur, esq. dying without issue, it descended to his nearest heirs, who sold it to Hugh Smyth, esq. of Long Ashton. An ancient house in this manor was originally a chapel, built by John Arthur, esq. lord of the manor, on the waste lands of the village; the licence for this purpose having been granted by Gilbert de Dunster, canon of Salisbury, and prebendary of Bedminster: "*Datum quinto die Maij, anno regni regis Henrici quinto.*"

Within this manor is another ancient house, called

INYNS' COURT,

from Sir John Inyn or Onewyn, to whom it belonged, together with a secondary manor, in 1439; from this family it descended, by an heiress, to the Pauletts. In one of the windows was the following coat of arms in painted glass: A fesse *azure*, between four unicorns' heads, impaling, *azure*, a chevron ermined, between three lions rampant, *argent*.

BEDMINSTER

is a populous and extensive village; the great western road from the city of Bristol passing through the main street. This MANOR belonged to the Crown, until William Rufus bestowed it, together with nearly the whole hundred,

and many other large possessions, on Robert Fitz-Hamon, when he created him Earl of Gloucester. Under his successors, Bedminster was held by Robert Fitz-Harding, son of the famous governor of Bristol, who was the progenitor of the Berkeley family. His grandson founded an hospital in this village for a master, warden, and several poor brothers, and a chantry in his manor house, within the parish. One of his successors, Thomas de Berkeley, greatly enlarged this hospital, embattled the manor house, and converted it into a fortified residence; no vestiges of this now remain. There still exist considerable portions of

ST. CATHARINE'S HOSPITAL,

founded by Robert de Berkeley. It stood on the west side of the street, near Brightbow Bridge, and part of the eastern end of the chapel, with a pointed window now filled up, is still existing, after a lapse of six centuries. The original foundation was charitable, rather than religious. The members were a master or warden, with three or four brethren, who wore the secular habit of priests, with a cope or mantle of black, decorated with a St. Catharine's wheel on the left breast.

The last of the Berkeley family who possessed the manor of Bedminster, was Thomas, the fourth lord; by the marriage of whose only daughter and heiress, it devolved in 1416, to Richard Beauchamp, Earl of Warwick, and by the marriage of one of his co-heiresses, it came successively to Humphrey, Henry, and Edward, Dukes of Buckingham; but by the attainder of the latter, it reverted to the Crown, 13th of Henry VIII. It was afterwards possessed by Henry Bourchier, Earl of Essex, and subsequently by the Nevils, one of whom sold it to the Smyths of Ashton Court.

BEDMINSTER CHURCH

stands a little southward from the village, and consists of a nave, chancel, and north aisle, with a large square tower at the west end, surmounted by open battlements, and for-

merly crowned with a steeple, which was thrown down in 1563. The population of this parish has increased from 2278 in 1801, to 7979 in 1821, having nearly quadrupled in twenty years; since which it has, probably, doubled; the church is therefore totally inadequate to the present number of the parishioners, and a spacious new church is about to be erected in a central situation. In the interior of the church are several modern monuments and inscriptions. The only ancient one is on a flat stone in the chancel, commemorative of the family of Grinfield, whereon it is said they settled in this parish in the second year of Edward I. 1273. The arms on the stone are, quarterly, 1. A sword in pale. 2. Two spurs leathered. 3. Two escallops in chief. 4. A fess lozengey.

This church has been richly endowed from the early days of the Saxons, and at the time of the Conquest, the officiating priest held an estate of about 120 acres, besides tithes. The living is a vicarage, with the chapels of St. Mary Redcliff and Abbott's Leigh annexed. It is also a prebend in the cathedral church of Salisbury, and a court baron is held here for the same. The prebendal manor is held for lives by the college of Winchester.—The Rev. R. Martin Whish is the prebendary, and also incumbent of the vicarage.

In 1317, the eleventh of Edward II. an inquisition was taken on the goods of foreigners possessed of benefices, within this diocese, and the following goods and chattels were found in the Parsonage house of Bedminster, belonging to Master Gerald de Tylleto, rector of the prebendal church of that place.

IN PRIMIS.

					£.	s.	d.			£.	s.	d.
30	Quarters of	WHEAT, at	-	6s. 8d. per qr.	10	0	0	worth in 1829	70s.	105	0	0
20	Do.	BEANS -	-	3s. 3d. - - -	3	5	0	- - - - - -	34s.	34	0	0
10	Do.	BARLEY -	-	4s. 0d. - - -	2	0	0	- - - - - -	34s.	17	0	0
15	Do.	OATS -	- -	2s. 0d. - - -	1	10	0	- - - - - -	22s.	16	10	0
					16	15	0			172	10	0

Besides a numerous list of " Rentes of assize due at Bedmynstre and at Redclyve," amounting to what would now be a very large sum, " out of which, Henry de Ashton, rector of the church of Heie-risynden, in the diocese of Worcester, farmer of the said church of Bedminster, received 18*l.* 7*s.* 8*d.* equal to about 200*l.* now ; and 100*s.* equal to 55*l.* now, was paid to the vicar of Redclyve, for his pension."

At the time of the Reformation, commissioners were sent into Somersetshire by Edward VI. to survey "all and singular colliges, chauntryes, free chappels, guyldes, fraternityes, brotherydes, and anniversaries whatsoever within the sayde countie." The report of this commission is a curious document and is headed :—

" Decanatus de Bedmystre. "

" The free chappell or hospital of St. Katerine there, is yerely worth in landes, &c. 21*l.* 15*s.* 4*d.* A chalice of silver waying viij *oz.* ornaments praysed at iiij*s.* vj*d.* Bell metal c*lbs.* William Clerke, gent. maister of the same hospital by the King's *tres* patent not yet shewn. There be no poor people maynteyned, savynge that the sayd maister Clerke assigneth iij cottages parcel of the same hospitall, worth yerely xx*s.* not charged in this value to the poor men, to dwell in, and other relief they have none, but as God sendeth."

Similar particulars are also enumerated of " The Free Chappell of Knoll."—" The Chappell scituate within the parish church-yerde ther."—" The chappell of St. Peter at Bysporte."—And the " Lights founded within the parishe church ther."—" Mem. p'takers of the Lord's Holy Soup ther, cccxx. p'sones."

Bedminster is connected with the city of Bristol by a handsome cast-iron bridge, thrown over the New-Cut, through which the waters of the Avon flow, instead of through its natural channel, which now forms the Floating Harbour of the city.

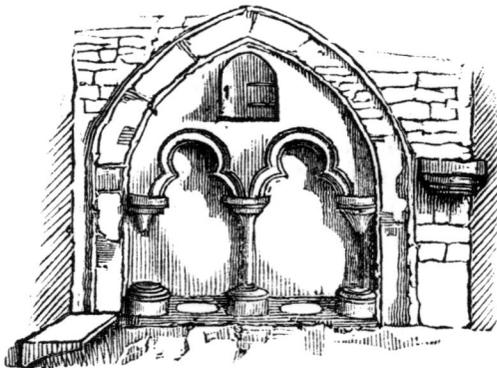

CONSECRATED WATER DRAINS IN COMPTON BISHOP CHURCH.

Arches formed of Oak in Clapton Manor House.

CHAP. X.

WRAXALL

was formerly a considerable town, the buildings of which extended as far southward towards Nailsea, as the river which separates the parishes. It is situated in a hollow,

formed by the sweep of a lofty range of hills, commanding a varied prospect, peculiar to these extraordinary acclivities, scarcely to be exceeded, in softness and variety, by any scenery in the kingdom; and is said by travellers, to vie even with that of the more favoured climate of Italy. On the south-west are the Mendip heights, whose sides are ornamented with masses of wood of luxuriant growth; on the west, a view of the Channel is obtained, with the Steep and Flat Holms, and the coast of Cardiff; and towards the south, a wide expanse of country is opened to the view, scattered over with no less than fourteen distant villages.

THE MANOR OF WRAXALL

was formerly extensive, including those of Bourton and Nailsea. At the time of the Norman Survey it was held by the Bishop of Coutances, soon after which, it came to the family of De Wrokeshale, in whose possession it continued until the time of King John, when it came, by the marriage of an heiress of that family, to the De Morevilles; from whom it passed, by marriage, to Ralph de Gorges, a knight and warrior. He was one of those who, in 1236, were blocked up with Henry the III. in the city of Bristol, by the disaffected citizens; after which he attended Prince Edward to the Holy Land.

The present manor of Wraxall descended in this family of Gorges for several generations. In 1651, Samuel Gorges, who was then living at Wraxall Lodge, appears to have taken some part in the political troubles of that time, for he paid 582l. composition money for the preservation of his estate. The last male heir of this respectable family, died in 1699, leaving an only daughter and heiress, by whose marriage it came to John Codrington, esq. His only daughter, Jane, in 1742, married Sir Richard Warwick Bampfylde, bart. It now belongs to Sir John Smyth, bart. of Ashton Court.

WRAXALL COURT

was a fine old manor house, situated north-west from the church, with a park adjoining on the side of the hill; but every part has been greatly modernized, excepting the porch; which remains in its original state, with the date of 1658, and the initials S. G. viz. of Samuel Gorges, who probably built it, and who died in 1671.

WRAXALL CHURCH

is a handsome edifice, consisting of a nave, chancel, north aisle, and south transept, with a good tower at the west end, supported by well built buttresses, and surmounted by light and elegant pinnacles. In the eastern wall of the ornamented porch, on the south side of the church, is a door-way, leading up a narrow flight of steps, to a small opening, from which an acolyte, or clerk of inferior order, used formerly to address the people with some preparatory admonitions, previous to their entering the church.

Within this church are a considerable number of handsome monuments. In the chancel is a large altar tomb, surmounted by the figures of Sir Edmund Gorges and Anne his wife, the daughter of John Howard, Duke of Norfolk. He is represented in armour, with a golden chain round his neck; and his wife in a loose robe, with a hood turned back. Around this tomb are numerous well sculptured coats of arms relating to the family of Gorges, quartered with Russel, Mowbray, and Englowes.

Against the wall of a small chapel, forming a recess at the end of the south transept, is a handsome marble monument, to the memory of Margaretta, wife of the Rev. Sam. Coopey, and daughter of the Rev. Charles Brent, of the South Brent family, who died in 1774.

There is a brass plate against the wall, near the entrance to the pulpit, with a Latin inscription, in commemoration of John Tynte, of the Chelvy family, obit. 1616.

Q

The decorative English style prevails in this church, which was probably erected in the fourteenth century. Two of the northern windows retain their painted glass. The font is octagonal, with trefoiled panelling, of the early part of the fifteenth century, corresponding with that on the exterior of some of the seats.

In the church-yard is an unusually high cross, with a portion of the shaft, on a massive pedestal, elevated on four rows of deep octagonal steps; and in the south-west corner, Mr. Vaughan, the rector, has built a nealty designed house for the master of the Sunday school.

ON WRAXALL HILL,

which overlooks the parsonage house, some Roman coins were found, within a circle of 300 feet in diameter, scattered near the surface, and mostly in a patch of black earth. This elevated spot was, probably, used as a beacon station. The coins were chiefly of Constantine, with some of Claudius and Crispus.

A short distance north of Wraxall, is

CHARLTON HOUSE,

a large handsome mansion, in a retired and pleasing situation, successively the seat of the Berkeleys, Gorges, Yates, and Muggleworths, and now the manorial residence of Thomas Kington, esq.

CHARITABLE BEQUESTS.—RICHARD VAUGHAN, esq. of Wraxall Lodge, erected the school-house in the church-yard, in 1809, and gave it in trust; in 1811, he also gave 300*l.* to be invested, and the income to be appropriated, partly for the repair of the school-house, and the remainder to be expended in the religious education of the poor of Wraxall, for ever.

THE MARCHIONESS OF NORTHAMPTON, relict of Sir Thomas Gorges, gave 100*l.* with which, about sixteen acres of land, called Firth, were purchased, now let for 30*l.* This sum, with 3*l.* 4*s.* derived from the produce of

timber cut upon it, is distributed annually amongst the second poor of **Wraxall**.

HENRY MUGGLEWORTH and ANN NEWMAN, in 1782–3, left monies, applied by the parish officers in rebuilding the poors' house, for which 5*l.* 10*s.* 6*d.* is raised out of the poors' rates, and distributed annually in bread. The sum of 21*l.* 1*s.* 10*d.* derived from Sir Abraham Elton's legacy, is annually distributed amongst the poor of this parish.

MRS. ELIZABETH MARTINDALE, about the year 1791, gave by will 195*l.* in the Old South Sea Annuities; the dividend of 5*l.* 17*s.* is regularly paid to the master and mistress of a school in the parish, who educate six poor girls, according to the testator's direction.

FAYLAND

is about a mile to the eastward of **Wraxall**; it was once a considerable village, the residence of several respectable families, including De Failands, who derived their name from it, the Meades of Meade's Place, the Jubbes of Jubbe's Court, and others.

On Leigh Down, about a mile below Fayland's Inn, close to the horse-way which leads to that place from Rownham Ferry, is a small

INTRENCHMENT

containing about two thirds of an acre, of an irregular shape, and enclosed by a rampart, rising from five to nine feet above the bottom of the ditch. About half a mile from this, is another similar enclosure, called

OLD FORT

lying towards the edge of the hill, which overlooks the vale of Ashton. It is of a circular form, about sixteen yards in diameter, having no apparent entrance, and is enclosed by a rampart composed of loose stones, now overgrown with turf.

Q 2

On the same down, about fifty yards from Old Fort, was a tumulus of stones, four feet high and four yards in diameter. It was removed in 1815, for the purpose of using its materials, when several hundred Roman coins of the Lower Empire were discovered, together with more ancient fragments of earthen jars or urns, some apparently hardened in the sun, and black and red in colour.

On the same hill, about 200 yards distant, towards Ashton church, is another of these ancient enclosures, having the form of a parallelogram, with one of its corners rounded; and being 35 yards long by 25 wide. These works are of too insignificant a character to allow the supposition, of their having been formed for military purposes, either by the Britons or Romans; it is more probable they were originally constructed by the early inhabitants of the country, to serve as secure holds for protecting their cattle; though the many Roman coins discovered in their vicinity, shew that they were frequented either by Romans or Romanized Britons.

Towards the north, between Wraxall and Tickenham, is

CLAPTON,

situated on the northern acclivity of the hill, with two rivulets running through the village, towards the Severn and Portishead Point. This manor was held of the Honour of Gloucester, for several generations, by a family who derived their name from the place; one of whom assumed the name of Arthur, whose descendants of that name, and of Winter, lived here for a long series of years, from the reign of King Stephen in 1140, to that of Charles II. in 1685.

CLAPTON MANOR HOUSE,

is contiguous to the church. It is an ancient mansion, built by one of the Arthurs, whose arms, impaling that of Berkeley, are placed over the entrance porch. It was probably erected originally by Richard Arthur, who lived

in the reign of Henry VI. (1422 to 1461) and who married
Alice, daughter of James, Lord Berkeley. In front of the
remaining part of this edifice, is a square projecting tower,
embattled; the lower story forms the porch, with pointed
arch door ways. On the left hand of the entrance, is an
ancient moulded arch, carved in oak. This double arch
way, together with corresponding ones, now filled up, in
the outer wall, communicated with an extensive eastern
wing, once enclosing a large baronial hall, but no part
of this now remains.

On the brow of the hill, to the west of Clapton, over-
looking the vale towards Portishead, is

NAISH HOUSE,

the seat of James Adam Gordon, esq. the proprietor of
several adjoining manors. His residence is a substantial
mansion, delightfully situated, and commands extensive
views of the surrounding country, Kingroad anchorage,
and the Bristol Channel. It is surrounded on all sides,
except the south, with extensive woods and flourishing
plantations; and in the interior are some good paintings,
particularly a series of portraits of the Stuarts.

CLAPTON CHURCH

is situated on an eminence near the manor house, with an
extensive view of the natural amphitheatre, formed by the
hills to the south and west, pleasingly interspersed with
villages, gentlemen's seats, woods, hills, knolls, and mea-
dows. This edifice is ancient, its tower is low, and sur-
mounted by an ancient carved cornice or parapet, of the
era of Edward I. having the shark-toothed label over one
of the windows; the arch opening into the nave, being
a fine one of the lancet form. The roof is a good specimen
of the open-ribbed arch style, having carved bosses and a
sculptured cornice. The chancel is somewhat more mo-
dern; and the windows, in which a few fragments of
painted glass still remain, are ornamented with perpendicu-
lar mullions. It has a consecrated-water drain, beneath an

equilateral niche; and at the eastern end is a curious and unusual ledge, extending the whole width, and supported by small circular columns, with sculptured bases and capitals; on the summit of this, are still remaining two old immense brass candlesticks, which once held the large wax tapers, that were kept burning on each side of the altar.

The capitals of the columns, of the chancel arch, have been sculptured with the Arthur arms, surrounded by foliage. The font is of early date, and of peculiar character; it is quatrefoil in shape, but has been much disfigured by modern faces.

On the north side of the chancel, is an ancient chapel or chantry, with the plain tomb of William Winter, and his wife Mary, daughter and heiress of Edward Arthur, dated 1632.

Several of the Arthurs, Winters, and Southcotes lie buried in this church. The manorial vault is below the north aisle, which was probably the family chapel; and against the wall is the curious and stately monument of Henry Winter, who died in 1672. On the top is his effigy, clothed in armour, with that of his wife in a close bodied vest, both kneeling, and a child between them seated in a canopied chair, holding a skull in his lap, and a bird in his left hand. Above are the arms of Winter, impaling Southcote.*

TICKENHAM

stands on the south side of the high range of hills, extending from Leigh Down, nearly to Clevedon, and which in this vicinity, is rendered beautiful by patches of flourishing plantations and woods. The village is built at the foot of the hill, on the immediate edge of the moor, which divides this parish from that of Nailsea. This moor was

* This monument has received considerable injury from the defective state of the roof above it; which, with the rest of the church, needs the attention of the church wardens, or of the rural deans.

a few centuries since, a deep impassable morass, but is now intersected by a raised causeway, probably upon more ancient foundations.

A branch of the Berkeley family resided for many generations in this village, and adopted it as a surname. One of them named Nicholas de Tickenham, in the reign of Henry III. " for the health of his own soul, and the souls of Sybil and Wentlyen, his two wives, granted to the hospital of Billeswick in Bristol, the privilege of digging turf in his moor of Tickenham." His grandson confirmed this grant, who is certified in an old deed dated 1304, to have held part of the manor of Tickenham, of Roger Bigod, Earl of Norfolk and Marshal of England, by the service of keeping the gate of the castle of Chepstow in Monmouthshire, for forty days in the time of war. The manor is now possessed by Sir John Smyth, bart. of Ashton Court.

In Limebridge Wood, near Tickenham, and in the vicinity, grows the *Fly-Orchis*, and other species of that genus of plants.

Near the church-yard stand the venerable remains of an ancient manorial mansion, called

TICKENHAM COURT HOUSE,

part of which is in a sufficient state of repair to be used as a farm house. It was originally built in the form of a Roman H, and its style may be cited as a model of the architecture which prevailed at the date of its erection, which was early in the fifteenth century. The old with-drawing room remains nearly entire, and measures $30\frac{1}{2}$ feet by $16\frac{1}{2}$. Modern refinement might be well satisfied with its proportions, decorations, and windows; those facing the southeast were of grand dimensions; the two towards the west were narrower, but of the same pattern, and were formerly filled with painted glass, a few fragments of which remain. The walls and ceiling were panelled with oak, and beautifully ornamented. Over the mantel-piece, were three

shields carved in oak, the first is taken away; the second is charged, quarterly, first and fourth, a griffin segreant, for *Davis ;* second and third, a chevron between three spears' heads, for *Rice,* impaling two lions passant ; the third coat impales three eagles displayed, for *Rodney.*— These arms belonged to Rice Davis, esq. who resided here, and who married a Rodney.

In another apartment, the ascent to which is by a winding flight of stone steps in an octagonal turret, still remains a portion of an ornamented ceiling, divided into shallow compartments, of an unusually rich circular pattern.

The shell of the great hall is also in a tolerably perfect state, and is used as a brew house, &c.* It was detached from the mansion, and is contiguous to the church; the arched oak roof remains entire; at the western end was a finely arched window, with tracery; and on each side of the hall, between the windows, is a stone bracket of elegant workmanship, for the purpose of sustaining the military trophies, which were amongst the most admired decorations of these stately apartments.

TICKENHAM CHURCH

stands on rising ground near the edge of the moor, and is an ancient building, consisting of a nave, chancel, north and south aisles, with a tower at the west end. The patronage was anciently vested in the abbot of the convent of St. Augustine in Bristol ; after the dissolution of that monastery, it was granted to the Bishop of Bristol, whose successors continue to possess it.

The building is of various dates, some of the windows being of the lancet form, and others of the perpendicular era. The west window is a good specimen of the latter

* This fine building may be restored at a comparatively trifling expense, and would make an excellent parish school-house. It is locally denominated " The Chapel," probably because it contains the remains of a tomb, on which one of the figures of the knight templars, now lying in the north aisle of the church, is supposed to have been originally placed.

style, and was open to the nave by a lofty arch, but is now hid by a gallery for the Sunday school. There is a stoup in the porch, and a consecrated-water drain in the chancel, where is a modern painting over the communion table, of Moses and the burning bush, by an amateur artist. The font is very ancient, being a square stone cistern of ample dimensions, resting on four small round pillars, one at each angle, with a large one in the centre.

The southern aisle is more modern than the tower; its exterior wall is ornamented with a band of rich trefoiled panelling. In this aisle is an ancient flat stone, in which is cut a large cross flory, voided, but without any inscription. The interior door-way of the porch is trefoiled, with circular columns of an ancient character. Against the wall of the north aisle, on a long raised stone bench, are the figures of two cross-legged knights, in armour, with that of a female in a long robe between them; supposed to represent some of the De Tickenham family.

In a window above these figures, are two coats of arms in painted glass: first, *or*, three pallets, *gules*, within a bordure, *azure*, bezantie, for Basset; second, quarterly, *gules* and *or*, a bend, *argent*, for Fitz-Nicholas. In the chancel window, are four other coats of arms.

CADBURY OR TICKENHAM CAMP

is on the same ridge of hill as the camps in Leigh Wood, about seven miles distant from them, immediately above the village of Tickenham, in a commanding situation on the narrowest and most insulated part of the ridge, overlooking the vale of Portbury on one side, and that of Nailsea on the other. It is an area of about seven acres, in form nearly approaching a square, the sides of which are about 190 yards, having the corners rounded, and the sides curved. It is defended by two ditches and three ramparts, the perpendicular height of the latter, is nearly twenty feet at the lowest part of the ditch. The tops of the ramparts are about forty-five feet distance from each other.

It has one main entrance near the north-east corner, and two or three others of small size ; the main entrance having an additional defence of a singular kind; the interior rampart being prolonged about twenty feet and curved, so as to flank the immediate entrance into the area. Its summit commands a view of most of the military stations in the vicinity. It was evidently connected with extensive lines of entrenchment on the opposite summit of the hill to the north-west. These out-works are remarkably well constructed for defence, and as commanding the contiguous defiles to the east and west, appear to have been essential to the security of the original fortress.*

Cadbury was evidently an important station, that completely commanded the military road, which ran from Bower Walls on the Avon, to the termination of the heights of Clevedon ; and also the approaches from the Mendip Hills and the country to the south, to the port of Portishead, and the northern coast; thus were the occupiers of Cadbury enabled to hold all the district in subjection.

About half a mile from Cadbury Camp, under the same ridge of hills, numerous Roman coins were found in a ditch by the side of Lime-brook Lane, contiguous to the spot where many old foundations of buildings have at different times been discovered. These coins were all of the lower empire, as were those found about fifty years previously on the same piece of ground, enclosed in three Roman urns, and which were chiefly of the time of Constantine with others of different ages. Many silver coins have also been discovered within the last ten years, in a copse at the eastern base of Cadbury Hill.

The ride from Wraxall to Clevedon is a continued terrace, commanding almost unrivalled scenery, and the approach to the village is remarkably picturesque, its effect being heightened by oak trees, whose branches, by constant

* Vide " Seyer's Bristol."

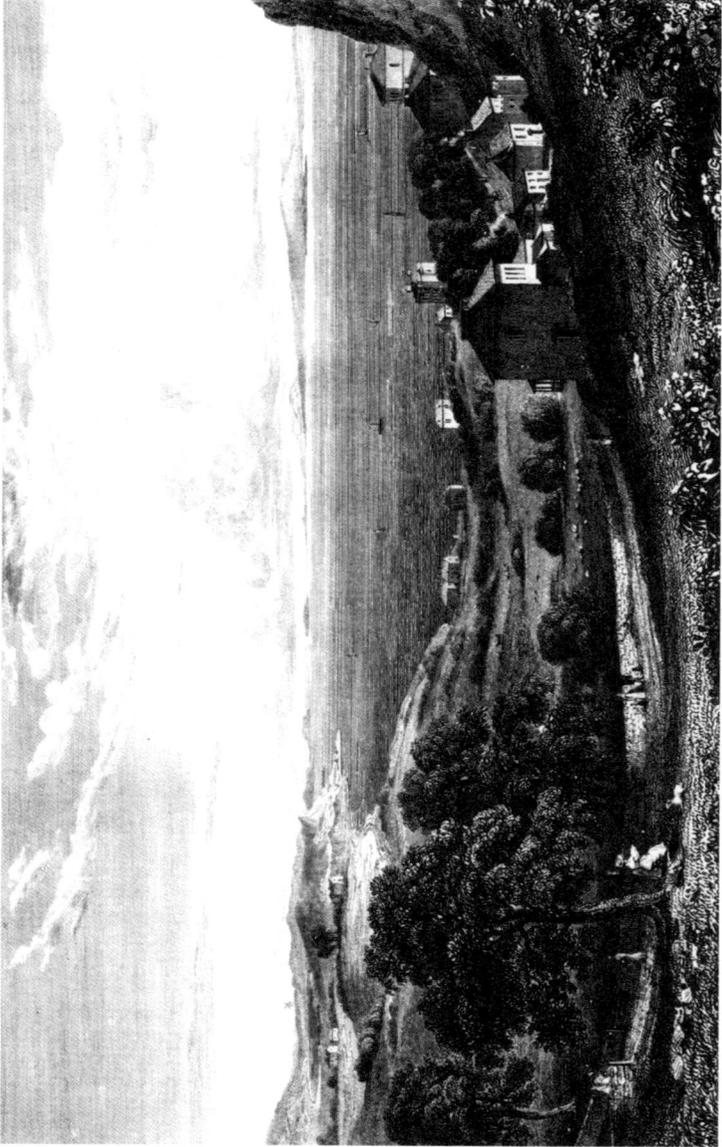

VIEW OF CLEVEDON & ITS BAY

To Lady Elton, this Plate is respectfully inscribed.

exposure to the south-west wind, form a canopy over the road.

CLEVEDON

stands on the extremity of the hill westward of Tickenham, and is so denominated, because the cliff or clive here ceasing, a dun or valley is formed, declining to the Bristol Channel. The rocks rise to a majestic height, and on one of them, overlooking a vast extent of land and water, a tower formerly stood, called " *Wake's Tower*," from the family of Wake, who were lords of the manor, and who erected it as a place of observation. This tower has long since been demolished, and on its site a summer house was erected in 1738, which is now also in ruins. The beauty of the prospect from this spot, seems a strong inducement to rebuild it.

This manor is mentioned in Domesday Book as being held under the king, by Matthew de Moretaine, but as having previously belonged to John the Dane, in the time of Edward the Confessor. From this survey it appears to have been a valuable lordship, consisting of extensive tracts of arable and meadow land, with pasture a mile and a half square.

Soon after the Norman Conquest, the possessors of this manor assumed the name of Clivedon ; one of whom, in 1296, was summoned to attend King Edward I. at London, with horse and arms, ready to sail into foreign parts. It remained in this family, who resided at the manor house, until 1409, when it came by marriage to Edmund Hogshaw, and passed from him to his sister's husband, John Bluet. He conveyed it to Sir Thomas Lovel, whose heiress married Sir Thomas Wake, knt. This gentleman's son, Sir Roger Wake, was sheriff of Northamptonshire in 1484, and who having espoused the cause of Richard III. at the battle of Bosworth, was attainted and his lands seized by Henry VII. who granted the manor of Clevedon to four of his friends, to hold on the service of a red rose, payable

yearly at the feast of the nativity of St. John the Baptist. But Sir Roger Wake shortly afterwards obtained a pardon, and the restitution of this and most of his other manors.

The family of Wake lived at the court house for many generations; the estate afterwards came into the possession of John Digby, Earl of Bristol; from his family it was purchased by Sir Abraham Elton, the first baronet of that name, who, in 1727, left five pounds yearly, clear of all charges, for teaching poor children, inhabiting this parish, to read. His successor is the present lord of the manor, and resides at Clevedon Court.

Clevedon being only thirteen miles distant from the populous city of Bristol, has acquired comparative importance as a bathing place. It is situated on the coast of the Severn, a few miles south-west of the mouth of the Avon. It may in some measure be considered as the rival of Weston, over which it has the advantage of more varied and picturesque scenery; but in the important point of an extensive sandy beach, Weston possesses decided superiority.

A handsome hotel has been recently erected in a situation of delightful scenery, where comfortable accommodations are combined with reasonable charges. Numerous detached villas, have also been raised on the slope of the hill towards the water, commanding the whole bay and the Steep and Flat Holms. About forty new houses have been already built, and as many more are in progress, under the southern rocky slope, and facing the bay. These residences now building, command a very pleasing view of the coast; in the foreground are fertile fields, interspersed with coppices, extending to the sea, with the village church agreably situated on the romantic promontory forming the southern side of the bay.

There are some delightful walks in the vicinity of Clevedon; one of the pleasantest is to the ruins of Walton church and Walton castle. Path-ways have been formed

along the edge of the cliffs, that gradually ascend to the
summit of the Down, which forms a delightful range,
and commands a beautiful prospect of the Channel, whence
a path-way leads through the fields to the ruins.*

Lady Elton has caused several other walks to be opened
through the different woods and plantations, one of which
especially deserves notice. It commences at the south
western point of Clevedon Bay, and is carried through
varied enclosures towards the hills, contiguous to Clevedon
Court; these hills also being intersected by foot-paths in
every direction, commanding extensive prospects.†

Another favourite walk is along the edge of the beach to
the church, which is situated on Clevedon Point, a mile
distant from the hotel. On the shore are three bathing
machines which are let down and drawn up by windlasses.
Above the beach is a new road beautifully undulating
along the limestone ridge, and leading to several pleasantly
situated lodging houses, recently erected; near these, some
hot baths have been built by an industrious speculator,
who intends also to erect some lodging houses in connection
with them.

The air is mild, and myrtles and other delicate shrubs
flourish in the gardens; timber trees of all kinds grow
luxuriantly, and fruit trees would thrive and bear well, in
the lower parts towards the church. On the whole, Cleve-

* It is much to be regretted that the lessee of the surrounding farm, feels
so little disposition to afford accommodation to those who are inclined to
explore these interesting ruins.

† There are three pleasant ways to Clevedon; one over Leigh Down from
Long Ashton, by Fayland's Inn to Tickenham and Clevedon Court; returning
by Tickenham and Wraxall, and so by Belmont Lodge into the turnpike-road,
about five miles and a half from Bristol, passing through the delightful village
of Long Ashton: the first 13 miles, the second 14½; but there is another equally
pleasant, if not more so, by Leigh, Portishead, and Walton, making it about
16 miles.

The only deficiency is its want of a fishery, and the present bad state of
the roads; but the latter are greatly improving. A new road, fifty feet wide,
is in progress from the hotel to the church, which, when finished, will open a
circular drive of four miles, in connection with the cross roads from Bristol
over High-dale Hill. A pier had also been decided upon, the design by Messrs.
Wallis and Miles having been approved and adopted, with a view to its im-
mediate execution.

don is a picturesque place, well calculated for the residence of invalids who require a pure air, and the opportunity of taking moderate exercise in a variety of pleasing and sheltered walks.

CLEVEDON CHURCH

stands at the western extremity of the village, on Clevedon Point, at a small distance from the edge of the steep and precipitous cliffs, whose height secures it from the waves, which sometimes beat with terrific violence below, when the wind sets in strong from the west. This church was appropriated to the Abbey of St. Augustine in Bristol, and the patronage continues to be vested in the Bishop of that city. It is a cruciform building, with a tower in the centre, and is 104 feet long, by 56 in width.

The tower is old, with a more modern upper story, and though low, must serve, from its elevated situation, as a conspicuous land mark. The chancel is ancient, and its roof is externally supported by projecting corbels, having their extremities carved into grotesque masks.

The south transept is the manorial chapel, with the vault beneath. On one side is the figure of Sir Thomas Clevedon, in armour, with his sword by his side, and his feet resting against a bull; but the arms and inscription are entirely obliterated.

Against the north wall of the chancel is a large stone tomb, with this inscription :

Here resteth the bodye of
John Kenn, of Clyvedon, the sonne of John Kenn, of Kenn, esquire, who deceased the twelfth day of Aprill, in the yeare of our Lord God.
M. cccc° xc iij°.

ARMS.— *Ermine*, three crescents, *gules*, a mullet for distinction.

CHARITABLE BEQUESTS.—THOMAS GWILLIAMS, alias
PHILLIPS, gent. in 1650, gave six acres of land, in the
parish of Kingston Seymour, the profits thereof to be em-
ployed, yearly, for ever, in placing out poor men's sons,
natives of this parish, apprentices. This land is let for
11l. 1s. per annum, which sum is expended by the parish
officers, as directed by the testator.

JOHN, EARL OF BRISTOL, in 1687, gave 5l. per annum,
to the poor of this parish; and SIR ABRAHAM ELTON,
bart. settled 5l. per annum, for ever, for teaching poor
children to read. Both these sums are paid by Sir Abraham
Elton, bart. of Clevedon Court, to a schoolmistress, who
teaches from twelve to twenty poor children of this parish.

CLEVEDON COURT.

This seat of Sir Abraham Elton, bart. is very pleasantly
situated south-east of the village, and two miles from the
church. It faces Nailsea, and is built on the southern slope
of the hill, which is composed of craggy rocks, intermingled
with timber trees and herbage. It is a large building of
various ages, exhibiting noble simplicity and correctness
of design; and is considered by Buckler, as one of the most
valuable relics of early domestic architecture in England.
The great hall was built in the reign of Edward II. and is
remarkable for the breadth and boldness of its porch and
large window, between which is the only other window
that admits light on the south side. The interior of the
hall has been modernized, excepting the space under the
gallery; which, with the arches of entrance, retains the
original triple door-ways leading to the kitchen and its
offices. On the northern side of the hall is the fire place,
with a window immediately above it. These are lined
with ancient carved oak, the panes being filled with the
royal arms of England, from King Egbert to George IV.
On the western side of the hall, is the old carved stone door-
way, leading to the apartments on that side of the mansion,

through a wall of immense thickness. The ancient chim-
neys and turrets on the outside, are interesting specimens
of their age. The kitchen was rebuilt in the reign of
Elizabeth, and possesses considerable merit ; its prevailing
ornaments are imitated from an older style ; an example
which was neglected by the architect who was afterwards
employed on the other side of the hall.*

* Vide H. Buckler's " Eltham Palace."

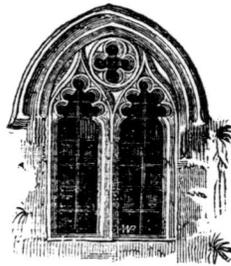

Window in Tickenham Court House.

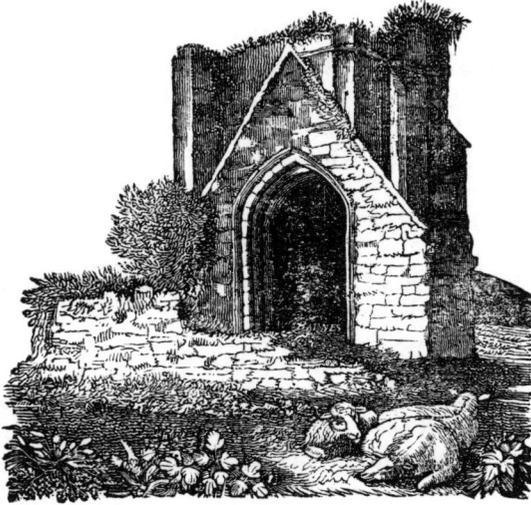

Ruins of Walton old Church.

CHAP. XI.

Walton in *Gordano, Walton Castle, Ancient Church, Modern Church.—Weston* in *Gordano, Manor House, Church.—Portishead, Manor House, Church, Charitable Bequest, Kingroad, Portishead Fort, Capenor Court, The Wansdike.—Portbury, Manor, Portbury Priors, Church, Charitable Bequests, Portbury Camp.—Easton* in *Gordano, Manor, Church, Pill, Ham Green.*

WALTON IN GORDANO,

a village lying to the northeast of Clevedon, is delightfully situated, facing the well wooded range of hills, called Clapton and Tickenham heights. Its name is derived from the

Saxon, and signifies a *wild town,* a term remarkably applicable to its original situation, on the north-western declivity of the hill towards the sea, where now stand the ruins of the ancient parish church.

The manor of Walton was the only one in the county of Somerset possessed by Ralph de Mortimer, a kinsman of William the Conqueror, some of whose posterity were Earls of March. Under this family, the manor was held by Richard de Walton, whose descendants possessed it for several generations ; it was subsequently held by the families of Berkeley, Cheddar, Newton, Seymour, and Paulett.

The present lord of the manor is Philip John Miles, esq. who is also the proprietor of

WALTON CASTLE,

built on the highest part of the hill, but now in ruins. Its site is greatly exposed, and it has a most desolate appearance in rough weather, the sea beating against its rocky foundation on one side, whilst a tract of marshy land extends on the other. It commands an extensive prospect, both by sea and land. It was originally erected for a hunting seat, and is of an octangular shape, having a low round tower at each angle, with an embattled wall between them. In the centre of the area, stands the keep or citadel, also octangular ; with a small turret of the same shape, on the south-east side, rising above the rest of the structure ; the roof and floors are fallen in, and no use is made of any part of the castle, excepting a small portion of the ballium, which serves as a dairy house, for the tenant of the neighbouring farm.

The entrance is through an embattled gateway, eastward, which leads to a portal opening into the keep. Over the door-way of one of the round towers, is a shield bearing three swords in pile, the arms of Paulett, who were the former lords of the adjacent manor.

On the hill near the castle, are evident traces of an ancient ditch and bank, enclosing a considerable space; and below the south-west brow, are other considerable vestiges of earth-works, though no account of any fortification or settlement near this spot is extant.

North-west of this castle, are the ruins of the

ANCIENT PARISH CHURCH,

at the upper part of the ravine, leading immediately to the beach. It consists of a single aisle, with a tower at the west end, which, excepting the roof and crown of the parapet, was until very recently, almost entire. At the north-east angle is a winding stone stair-case leading to the summit of the building. A large fine mitred arch opens to the nave, some of the walls of which are standing, and in that at the east-end are two niches, and the remains of a third for images; there is in the south wall the fragment of a benetoire.

The tracery of the west window must have been rich, and the door-way below it, has a deeply moulded arch of the age of Richard II. with emblazoned shields on the angles of the label. These interesting ruins are rapidly falling into still greater decay. The churchyard is surrounded by a wall, and though much neglected, is still used as a place of sepulture. Within it stands part of the shaft of an ancient cross, surmounting a pedestal on three rows of steps.

THE MODERN CHURCH

is a plain and simple edifice near the centre of the village, on the south side of the hill, and is destitute of a single monument or ornament, excepting a curious stone figure in the interior of the western wall, probably removed from the old church, as well as the font, which is of a plain octagonal form. Near the church is a national school house, erected in 1816; and a little to the west, is the present MANOR HOUSE, a large, respectable modern edifice.

WESTON IN GORDANO

is a small compact village, with an air of antiquity, situated below the hill, one mile from Walton. It derives its distinctive appellation from the ancient family of De Gordano, who had large possessions in this vicinity.

This manor was held under the Bishop of Coutances, by Ascelin de Perceval, from whom, by the Lovels and St. Maurs, it came to Sir Richard de Perceval, knt. who attended Richard I. in his expedition to the Holy Land, in 1190, and who, being a person of great strength and valour, greatly distinguished himself. It is related of him, that in one engagement he continued on horseback, after he had lost an arm, holding the bridle in his teeth, and dealing slaughter around him, until he fell from loss of blood; from this circumstance, the family are supposed to have derived their crest of a man on horseback, with one leg couped. He, however, lived to return home, and was buried in Weston church, under a superb monument of curious workmanship; but the indiscriminate zeal of the parliamentary forces, in the civil wars of the seventeeth century, utterly destroyed this beautiful memorial of departed valour.

This gallant knight's descendant, James Perceval, lived here in 1554, and married five wives, all from the vicinity; by the first four of whom he had no offspring, but his fifth bore him ten children.

Thomas, the son of this James Perceval, was a firm royalist, and his property was consequently much injured by the parliamentary forces; by whom he was obliged to pay 250l. as a composition for the preservation of his estates.

In the vicinity of Weston in Gordano, grows the *trifolium stellatum*, or starry trefoil.

THE MANOR HOUSE

stood south-west from the church, near the moor, but only a few ruinous walls and arches remain of this once magnificent mansion. It was built in 1430, by Sir Richard

Perceval. It was a large handsome structure, having in
the windows, painted on glass, the arms of the different
branches of the family, and of their connections by mar-
riage, for several centuries; these, with the house itself,
suffered much injury in the civil wars. We learn, however,
that Thomas Perceval twice entertained King Charles II.
after the restoration, in this mansion.

WESTON CHURCH

is a small ancient structure, consisting of a nave, chancel,
and chapel on the south side, adjoining which is the belfry,
and a low tower, which was rebuilt a few years since, in a
very inferior manner to its former state, and to the general
architecture of the church.

Over the inner door in the porch, is a gallery or loft, to
which there is access by a very narrow flight of stone steps
in the side wall. Immediately over the centre of this
gallery stood a figure of St. Paul, the patron saint, whose
bell still hangs in an arched turret on the apex of the roof
of the nave.

On the south side of the nave is a stone oratory, near
which is a consecrated-water drain, and in the south-east
corner of the nave, stands, much elevated, an unusual kind
of reading loft, with an access from the belfry, by a small
arch-way through the massy wall.

The roofs are formed of arched ribs of oak open to the
tiling; a screen separates the chancel, in which are four
old semicircular oak stalls, with two smaller ones on each
side of the entrance through the screen; and on the right
is a water course beneath a lancet arch. The eastern
window is a fine one, with mullions of the perpendicular
era; in the upper compartments a few figures of painted
glass remain, but obscured by white-wash.

There is only one monument remaining of the long line
of Percevals, who were lords of this manor for many
generations, and that one is going rapidly to decay. It is
against the north wall of the nave, and underneath, are the

remains of Richard Perceval, who died in 1482, and of Catharine his wife; having the arms of Perceval, Hampton, Ballowe, and Cheddar, around it.

PORTISHEAD,

or the head of the port, was so called from being one of the horns of the port of Kingroad. It is an extensive parish, containing 2050 acres, pleasantly situated on the north side of a finely wooded ridge of hills, rising boldly from the coast of the Bristol Channel, and sheltering the vale from every wind but the east. About 180 years since, a fort was erected on Portishead Point, which is supposed to have been anciently a Roman guard station. It commanded this straight of the Channel, but has since been demolished, and its foundations only remain. During the late war, a small battery was erected, a few yards from the ancient fort; the remaining walls of which were then demolished. The battery belongs to James Adam Gordon, esq. the lord of the manor, but is now dismantled and unoccupied. The whole property of this parish anciently belonged to the Berkeleys, having been sold, with large contiguous possessions, to Ransom Maurice, Lord Berkeley, who was taken prisoner at the battle of Poictiers.

A few fishing smacks belong to this place; and flat fish, sprats, herrings, and shrimps, are taken in great abundance on its beach; market boats are employed in carrying grain, cider, and other produce to Bristol.

The corporation of Bristol, being secondary lords of the manor and patrons of the living, have, with the liberal accompaniment of the lord of the manor, expended large sums in the repairs of the church; the former particularly, in the formation of delightful drives over the hills and through the woods; some parts of these command fine views of Kingroad, and the contiguous country. Near the head, they have also erected a cottage for a boatman, who affords passengers by the steam or other packets, an opportunity to land, or to embark for Bristol, or the coast on

either side of the Channel. It has been in contemplation
to form a landing pier for the delivery of the Irish mails at
this spot, in connection with the long talked of chain
bridge across the river Avon at St. Vincent's rocks.

At one side of the church-yard, is the ancient

MANOR HOUSE,

the property of the corporation of Bristol, having a curious
hexagonal tower attached to its south-west corner, proba-
bly built for obtaining a prospect of Kingroad. In the hall,
now used as a cider cellar, is an antique mantel-piece of
carved oak; and at the south-east end, is the approach to
the old oak staircase, which leads to the rooms in the up-
per stories of the house.

PORTISHEAD CHURCH,

the interior of which is in very good keeping, is a handsome
building, with a lofty tower of excellent masonry, sur-
mounted by light and elegantly ornamented pinnacles.

The prevailing character of this church, is the perpen-
dicular English; but some of the arches and windows are
of the decorative order; and in the upper centre of the
east window of the chancel, the mouldings form a Catharine
wheel. A new vestry room, quite in character with the
architecture of the church, has been built at the east end
of the north aisle. The font is massive Norman, and has
characteristic ornaments, executed in a very bold, but
rough style.

The upper end of the north aisle has been screened off
by a broad arch, having the appearance of a flying buttress,
below which was a screen, forming a chapel, over the vault
of the Mohun and Fust families, who formerly possessed
Capenor Court, within this manor. Over the vault were
banners, with the arms of Sir Edward Fust, baronet, and
on a hatchment, those of Mohun, impaling Morgan of
Easton; but three spear-headed staffs alone remain.

There are few or no monuments within this church; and
although Sir Edward Fust, bart. was buried in the family

vault so late as the year 1727, yet no monument to his me-
mory has hitherto been erected. The register of this parish
goes back to the year 1542, and is a curious relique. The
rectory house is ancient, and still retains a window of the
age of Edward I. The contiguous barn is also a fine old
building, supported by massive buttresses.

In the church-yard is a cross of five rows of steps, sur-
mounted by a shaft of a single stone, twelve feet high, and
almost perfect, with the exception of its terminating cross
flory.

In the woods in the vicinity of Portishead, the *rubia
peregrina*, or Wild Madder, grows abundantly.

CHARITABLE BEQUEST.—CATHARINE CHAPPELL, in
1693, gave certain lands for the benefit of poor house-
keepers of Portishead parish. These lands have since
been exchanged by act of parliament, for two pieces, called
Fore Hill, one measuring about twelve acres, and the
other about one, lately let for 5*l.* 3*s.* 4½*d.* per annum, which
is distributed as directed; although the original trust deed
has not been renewed.

KINGROAD

is immediately opposite to Portishead, and is a well known
anchorage or road stead, formed by a sweep of the coast;
but the number of vessels frequenting it, has somewhat de-
creased, since the formation of the floating harbour at
Bristol. On that part of the shore immediately opposite
Kingroad, are the remains of a landing place or slip, which
ran into the Severn at Kingroad, and is, probably, an
ancient landing-place of the Romans. In a line from thence
to Portbury, is a spot called Chapel Pill, from a small
Roman Catholic chapel, which stood in a field surrounded
by elm trees; some vestiges of which still remain.

On the hills to the west, are several enclosures, which
retain the name of " the Danes," though locally pro-
nounced " Deans ; " and on that part of the hill above the

village, about half a mile south of the point, are evident
traces of considerable embankments and ditches.

PORTISHEAD CAMP.

This interesting encampment has been lately thrown open
to the researches of the antiquary, by the removal of much
of the underwood, which hid it from observation, probably
for centuries past. It is situated on the northern side of
the elevated hill, which forms the Point of Portishead, and
encloses a considerable space of ground, sloping from the
summit of the hill to the shore. Its form approaches to that
of an irregular rhomboid, its longest diameter being about
400 yards, and its shortest about 200. The south-western
angle is at the commanding point, and is resorted to by
pilots, as the look-out for vessels coming up the channel.
The upper and longest side is formed by the narrow ridge
of the hill, and is continued for about 400 yards eastward
of this point. From this upper line the hill falls consider-
ably to the north and south, as well as to the east, at the
extremity of the high ridge in that direction. The eastern
and western sides of the enclosure consist of embankments
formed of loose stones, and are of considerable height,
being continued down the declivity of the hill to the sea,
with traces of a ditch on the outsides. The shore forms the
northern defence, being formed of cliffs varying from 15 to
30 feet high, on which no landing could be effected with-
out much difficulty ; but there is a convenient access be-
yond the point to the eastward.

The scenery in the vicinity of Portishead is truly de-
lightful, especially on the side of the hill towards the
Bristol Channel, where the houses are rapidly increasing,
with a view of accommodating the visitors from Bristol,
who frequent this secluded spot during the summer months.

The following interesting particulars of the

SIEGE OF PORTISHEAD FORT,

are extracted from the Parliamentary Records of the times,

and were communicated by the worthy rector of that parish.

FIRST.—" Perfect passages of each day's proceedings in parliament, from Wednesday, August 27th to Wednesday, September 3rd 1645.

Monday, September 1st.—" There came letters from Sir Thomas Fairfax, his quarters, which certify, that 200 clubmen having put themselves under the command of his excellency, who set officers over them, and with some of his own men, sent them to take Portishead Point; a garrison of the enemy about six miles from Bristol, which is a strong garrison, and stops the passage of Kingroad ; a place to be kept against a great strength, and of such consequence, that it is worth their lying down, ever since their being before Bristol; and when the enemy heard that a party was coming to besiege them, they were much perplexed ; divers of them left the garrison and went home ; and when they came before it, they sent from the fort for a parley, which was granted; and Wednesday, the 27th of August, 1645, it was agreed :

I.—" That within forty-eight hours they should deliver up the garrison and fort of Portishead, to Sir Thomas Fairfax, for the use and service of the parliament.

II.—" That they should all take an oath never to take up arms against the parliament hereafter, but every man go home to his own dwelling, and there remain.

III.—" That they should have all quarter for their lives.

IV.—" That they shall leave the fort, with all the ordnance, arms, and ammunition, to Sir Thomas Fairfax, undemolished or hurt.

" All of which was accordingly performed, on Thursday, the 28th of August, and we took in the fort, six pieces of ordnance, 200 arms, all their powder, one pullet, match, ammunition, bag and baggage ; and his excellency hath put into it 400 men, well armed, to keep it for the parliament, with eight pieces of ordnance more, and so hath made Bristol an in-land town ; and the ship that was

coming with ammunition to relieve Bristol, is, by this means, kept back, and some of our ships are putting out toward her, to do what they can for the taking of her."

SECOND.—"A perfect diurnal of some passages in parliament, and from other parts of this kingdom, from Monday, September 1st to Monday, September 8th 1645."

This account is similar in substance to the before mentioned, with the addition, " that this fort commands all the ships and boats, so that now our ships may come freely into Severn. Our forces have also seized upon a ship in Avon, with twelve pieces of ordnance, and fifty prisoners, with store of provisions."

In Sprigge's " England's Recovery," it is also stated, " that the fort at Portishead Point, which had been four days besieged by Lieutenant Colonel Kempson, of Colonel Welden's regiment, with a party of foot, was, with six pieces of ordnance, this day, August 28th 1645, surrendered unto him, who managed that business with much judgment and resolution ; by the taking whereof the passage of Kingroad with our ships was made open."

CAPENOR COURT

is now almost in ruins, but many of the luxuriant elms which once formed a noble avenue leading to the west front, still remain. This mansion stands in a sequestered situation, on the western side of Portishead hill, and was occasionally inhabited by some of the family of Fusts, of Hill Court, Gloucestershire, until within the last fifty years; part of it is now used as a farm house, and the remainder is rapidly going to ruin. Capenor Court originally belonged to a family of that name, under the Percevals of Weston, as superior lord. It afterwards came to the Mohuns of Fleet, in the county of Dorset ; and from them, by marriage of an heiress, it passed to Sir Edward Fust, bart. and is now the property of Miss Fust, the niece of his great grandson, Sir John Fust, bart. On her decease, it descends to H. Jenner, esq. of Wenboe Castle, in the county of Glamorgan.

That remarkable military boundary, called

THE WANSDIKE,

is supposed, by Collinson and other antiquaries, to have been brought through this remote corner of the country, and to have terminated at the ancient sea-port of Portishead. It was originally constructed by the Belgæ, a German nation, who invaded England some centuries previous to the Romans. They landed on the southern coast, and gradually drove the aboriginal Britons further inland, until they found it either imprudent or impossible to extend their conquests to the north. They are therefore supposed to have constructed this formidable line of fortified boundary, to protect the extent of country they had conquered, from the attempts of the previous race of inhabitants to recover it. Its western extremity commenced on the coast of the Bristol Channel at Portishead, and taking a south-eastern course, nearly parallel to the river Avon, it was carried almost direct to that remarkable hill and fortification, called Maes Knoll; thence forming a considerable angle towards the south, it proceeded west to Bath Hampton, and over the Wiltshire downs; where the principal labour and attention appears to have been bestowed upon it, and where its remains are in a state of preservation, until it terminated at the river Thames, in Berkshire.

PORTBURY

is an ancient town, and gives name to the hundred. * It was formerly of much greater extent than at present. It is situated in an insulated district, at the northern extremity of the county, being bounded on three sides by the river Avon and the Bristol Channel, and by a lofty mountainous ridge of hills on the south, extending from the heights above Rownham Ferry at Clifton, to the coast at Clevedon;

* Throughout this hundred, the vine flourishes most luxuriantly; a strong proof of the mildness of its climate.

which also separates it from the broad levels of Somerset-
shire, over which the waters of the Channel formerly
flowed.

This district, thus strong by nature, was judiciously
selected by the Romans, as possessing many advantages
for establishing an extensive colony, connected with the
fortified town of Portbury, and its adjacent harbour of
Portishead.

The name of Portbury is derived from the Saxon, and
implies that its importance was not unnoticed by its for-
mer possessors. Massy foundations of walls and buildings
have been occasionally discovered, as well as coins of the
Lower Roman Empire; besides which, a Roman vicinal
road, which continues, in many parts, comparatively per-
fect, and easy to be traced, came from the forest of Exmoor,
over the Poulden Hills, near Bridgewater, through the
towns of Axbridge and Portbury, to their harbour at Portis-
head; where there was a much frequented passage or tra-
jectus, across the Bristol Channel, to the important station
at Caerleon in Monmouthshire, called *Isca - Silurum.* *
Another Roman road ran on the south side of the Avon,
nearly parallel, and in some places on the same course as
Wansdike, from Bath to Portbury.

THE MANOR OF PORTBURY

was granted by the Conqueror, to Geoffry, bishop of Cou-
tances, by whose death, in 1093, it reverted to the crown,
and was given to Harding, father of Fitz-Harding, the
noted merchant and governor of Bristol, who occasionally
resided at Portbury. His son, marrying the daughter of
Roger, Lord Berkeley, became a progenitor of the noble
family of Berkeley, of Berkeley Castle; who continued to
possess this manor for many generations, until it passed, by

* A few years since, the foundations of an ancient pier, or projecting landing
place, about nine feet wide, were dug up near the Creach, at Portishead; and
a lane leading from Clapton to Portishead, still retains the name of Silver
Street.

marriage, to the family of Coke of Holkham, in Norfolk, one of whom sold it, in 1784, to James Gordon, esq. the grandfather of the present lord of the manor.

Within this parish is a farm called

PORTBURY PRIORS,

having been the site of a cell, connected with the Augustine Priory of Bromere, in Hampshire, to whom the land was granted, in early ages, by one of the Berkeleys. The ruins of this priory are considerable, and have been recently restored with great judgment and taste, by James Adam Gordon, esq. of Naish House, the lord of the manor, who has erected a large handsome apartment, over the old vaulted rooms or cells, with characteristic windows, having borders of coloured glass; the old walls have been re-faced with free-stone, with an ornamental turret, chimney, and octagonal summits. The other parts of this interesting ruin are extensive, and intended to be restored upon a corresponding plan, by the enlightened and liberal proprietor.

PORTBURY CHURCH

consists of a nave, chancel, north and south aisles, a chapel, and a good tower at the west end; which, together with the walls of the side aisles, 'is surmounted by an embattled parapet. The small saints' bell remains, and in the south wall of the chancel are three large niches or stalls; with a smaller one which formed the consecrated-water drain. There are also three similar arched recesses in the wall of the south aisle.

The interior of this church has an antique and venerable air, which is somewhat increased by the gloom arising from the immense thickness of the walls. It has evidently undergone repeated alterations, but its original Norman character is apparent in several instances; the finest portion is the semicircular arched doorway leading from the porch, which is a good specimen of the class. The small apartment over the porch is still in existence. The font is

a ponderous one of the Norman character. The nave has an arched roof open to the tiles, formed of oak ribs, as are also those of the side aisles, where they spring from corbels, carved with antique heads or masks. This church is far too large for the population of the parish; in consequence of which, a very small portion of it is provided with seats, mostly of ancient oak and of a singular character.

Attached to the chancel, is an ancient chapel, which was a chantry, originally founded by Thomas Lord Berkeley in 1337, who endowed it with fifty acres of land, and certain rents in Portbury, for prayers, saying mass, and singing in the lady chapel, " for the souls of all his ancestors, his own, his successors, and of all faithful deceased."

Many of the Berkeleys were buried in this church, but have no monument remaining. On the wall of the north aisle is a small, but perfect, brass plate, with the portrait of Sarah, wife of Walter Kemish, kneeling at a desk, two children behind her also kneeling, and two infants below. The date is 1621. Some painted glass remained until lately, in two windows of this aisle, chiefly the arms of Berkeley.

In the churchyard are three venerable yew trees, two of immense size, and are supposed to be 500 years old. North-west of the church, is a large old rectorial barn, apparently going fast to decay.

CHARITABLE BEQUESTS. — JAMES SELBY, HENRY MUGGLEWORTH, and JOHN CONANT, respectively gave charitable bequests to this parish; the income from these, amounts to about 10l. 8s. 6d. which with the exception of 20s. paid for two sermons, is annually given in bread to the poor.

PORTBURY CAMP

is a small rude entrenchment, apparently constructed by the early Britons, on the edge of the hill which overhangs the village. The hill is insulated, and the whole summit

occupied by the fortress, the area of which is about one acre and a half. A small rampart about three feet high, appears to have surrounded the area, and is still visible in many places; the natural strength of the position having been improved artificially, as to have made it sufficiently strong. This and other similar small forts, are conjectured by Seyer, to have been formed by the early inhabitants of the country, for the purpose of a temporary retreat during an invasion from any neighbouring tribe.*

EASTON IN GORDANO,
OR EASTON ST. GEORGE.

lies eastward from Portbury, deriving the distinctive appellation of *in Gordano,* from the family of that name; and that of *St. George,* from the dedication of the church. The village is pleasantly situated, on rising ground, five miles from Bristol, commanding a fine view of Kingroad.

On the death of the Bishop of Coutances, William Rufus gave it to Robert Fitz-Hamon, Earl of Gloucester. He built the castle of Bristol with stone, which he brought from Normandy, giving every tenth stone towards building the chapel of St. Mary, in the priory of St. James, which he had founded in that city. He also built Cardiff Castle, founded the abbey of Margam, in Glamorganshire, and was a benefactor to the monasteries of Neath, Tewkesbury, and Gloucester. This powerful baron died in 1147, and was buried beneath a green jasper stone, in the priory of St. James.

EASTON MANOR

has been possessed by a succession of noble families, of whom many were renowned as warriors and statesmen. William, Earl of Gloucester, son of Robert the Consul, was a brave warrior, and a liberal benefactor to religious

* In the year 1827, the foundations of a fort, or other military work, were dug up on the vicarage glebe; also several small cannon shot, and a curious ancient clock.

establishments, having founded the monastery of Keyn-sham. He resided chiefly at Cardiff Castle, being lord of
the surrounding territory, then called *Gwladvorgan,* or the
Land of Morgan. In an insurrection, headed by one of
his vassals, named *Yvor,* the castle was stormed, though
well garrisoned; the earl, his countess, and their young son,
carried off to *Yvor's* fastnesses in the woods, where they
were detained, until they made terms with him. From
William Earl of Gloucester, this manor came by descent
to De Clares, Earls of Hertford ; to De Burghs, Earls of
Ulster ; to Lionel Plantagenet, Duke of Clarence, to the
Earls of March; and to Richard of York, Earl of Cam-bridge. On the death of his son, Richard Duke of York,
at the battle of Wakefield, in 1460, his estates were con-fiscated, and this manor granted to John Yonge, a native
of Bristol, who was knighted by Edward IV. By the
marriage of his great grand-daughter, an heiress, this
manor came to the Malets of Enmore ; they sold it to the
Morgans, whose successors have recently sold it, together
with the hamlet of Pill, to James Adam Gordon, esq. of
Naish House.

The manor house is a large old building, in the Eliza-bethan style, not far from the church, and is occupied by
John Gardner, esq.

EASTON CHURCH

is a respectable building, consisting of a large nave, chancel,
and vestry room, with a handsome tower at the west end,
containing six bells, the tenor one having this legend :

"𝕮𝖔𝖒𝖊 𝖜𝖍𝖊𝖓 𝕴 𝖈𝖆𝖑𝖑 𝖙𝖔 𝖘𝖊𝖗𝖛𝖊 𝕲𝖔𝖉 𝖆𝖑𝖑."

The whole of this edifice has been rebuilt, with the ex-ception of the tower ; the interior is fitted up in a plain,
but appropriate manner, so as to contain six hundred free
seats for the lower classes, who are extremely numerous.

The tower is ancient, and is surmounted by battlements, which must have been originally rich and ornamental; in the centre, is a curious figure, apparently representing the patron, S.t George, destroying the dragon. The staircase turret, at the angle of the tower, is continued up to its summit, where it terminates in a light spire.

In the south wall of the chancel, were the remains of three tabernacles. Beneath the upper end of the south side, is the family vault of the Morgans, many of whose monuments are in this church. In the chancel is a small elegant marble monument, to the memory of Cordelia, wife of Richard Wilkins, vicar of this place, and daughter of Conyers Place, A. M. of Marnhull, in the county of Dorset, dated 1774.

Against the north wall of the old nave, was a curious old tablet, dated 1669. At the top, was the portrait of Captain Samuel Sturmy, of this parish, who published a mathematical treatise, in folio, entitled " The Mariner's or Artisan's Magazine ; " a copy of which he gave to the parish, to be chained and locked in the desk, until any ingenious person should borrow it, leaving 3l. as a security, in the hands of trustees, against damage, &c.

Dr. George Bull, afterwards Bishop of St. David's, who ranks as a learned divine, was a short time resident vicar of this parish.

Easton in Gordano is a vicarage; the present vicar is Henry Mirehouse. The rectory is inappropriate, and belongs to a prebendal stall in Wells Cathedral. Mr. G. Wilkins holds it on lives from the prebendary.

North-east from the village of Easton, is the hamlet of

CROCKERNE-PILL, OR PILL,

inhahited chiefly by mariners, who pilot vessels to and from Bristol, as low down the Channel as the island of Lundy. In this way a considerable number of boats and yawls are employed, some of which are constantly plying in the channel, waiting to take charge of vessels.

HAM GREEN,

near Easton in Gordano, is the residence of Richard Bright, esq. father of one of the present members for Bristol. The house is substantial and handsome. The south front has a more ancient appearance than the other, and probably, belonged to the original edifice, to which the more modern structure, fronting the east, has been added. It is surrounded by a pleasant lawn, screened by trees and shrubberies, having a delightful opening towards Leigh Court.

Font in Wraxall Church.

s 2

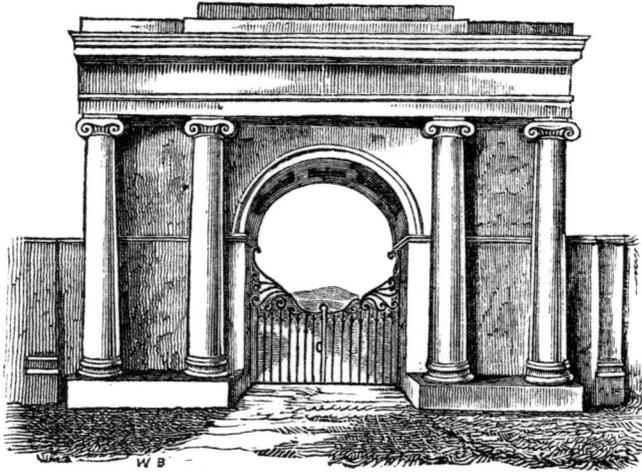

Leigh Court Gateway and Lodge.

CHAP. XII.

ABBOTS' LEIGH,

derives its name from the manor, having formerly belonged to the Abbots of St. Augustine in Bristol. The village is situated on the brow of the hill, which, for a considerable distance, is called Leigh Down; an uncultivated plain, partially covered with a thin stratum of soil, but with projecting rocks in many places.

The river Avon bounds this parish on the north, above which, the lime-stone rocks form a high and continued ridge, beautifully covered with underwood and timber.

LEIGH CHURCH

is a plain building, situated on an eminence, commanding a view of the Severn, with the intermediate country. It is composed of a nave, south aisle, chancel, and tower, with a modern vestry room, attached to the north wall of the nave, but at total variance with the style of the church, and consequently out of all taste, as appendage to an edifice of that description. The chancel has been judiciously restored, especially the ceiling. The font is massive and ancient, but has been remounted, and ornamented with angelic busts of modern date.

Beneath the chancel is the family vault of the Nortons and Trenchards, to whose memory several monuments are erected in the church. The mass of white-wash has been removed from one of them in the chancel, and the face of the stone restored to view. The canopy is supported by six Corinthian columns, with the arms and crest of the Nortons, but neither figures nor inscription remain. There is another monument of marble, with the busts of Sir George Norton, and Dame Frances his wife, dated 1715. This knight was son of Sir George Norton of Abbots' Leigh, whose eminent loyalty induced him to conceal King Charles II. in his house, at the hazard of life and fortune, until he had provided means for his escape into France. On the opposite wall are marble tablets to the memory of John Trenchard, esq. who died in 1723, and Robert Hippesley Trenchard, dated 1787.

The church-yard is very pleasantly situated, overlooking the house and domain of Abbots' Leigh; it contains the pedestal and steps of an old cross, and an ancient yew tree.

THE MANOR OF LEIGH

originally formed a part of the immense lordship of Bedminster, and was held by the Bishop of Coutances. It

afterwards fell into the hands of Robert Fitz-Harding, who gave it to the canons of St. Augustine, founded by him in the city of Bristol, in 1148. King John confirmed the grant, and the manor continued in their possession until the dissolution by Henry VIII. who gave it to Paul Bush, the first Bishop of Bristol. The bishop afterwards resigned the manor to Edward VI. and this King granted it to Sir George Norton, knt. whose son George, succeeding him, resided on the manor, and was greatly attached to the Stuart family, as before related. His descendants having no issue, the manor came to William Trenchard of Cutteridge, in Wilts, by right of his wife, a collateral heiress of the Nortons. The Trenchards subsequently sold this manor to Philip John Miles, esq. the present proprietor, who has lately erected a magnificent mansion, called

LEIGH COURT.

The former court house was a large ancient building, situated on the brow of the hill. In this house lived Thomas Gordon, the celebrated translator of Tacitus, who, with his friend and patron, Mr. Trenchard, wrote and published " Cato," and the " Independent Whig ; " two political publications much noticed at that period.

Leigh Court is also remarkable as one of the places which contributed to the concealment of Charles II. after the battle of Worcester, he having remained there several days in the disguise of a servant, and keeping his room under the plea of illness.*

The noble mansion now known by the name of LEIGH COURT, was commenced by Philip John Miles, esq. about the year 1814.† It is situated a quarter of a mile northeast from the former Court House, on a gentle ascent,

* Vide " Clarendon's History of the Rebellion."

† The designs for this magnificent residence were furnished by Mr. Hopper, to whose talent as an architect, it is highly creditable.

which commands most luxuriant prospects of the surrounding country, and the Bristol Channel.

About one mile from Rownham Ferry, a chaste Ionic gateway and lodge form the entrance into the demesne. On entering the inner park, the scenery is luxuriant, and the prospects delightfully varied. On the right is a deep and well-wooded glen, beyond which rise the heights of Clifton, the tower of Cook's Folly, and those of Blaze Castle, with occasional views of the Avon.

Immediately around the house is a thriving plantation of ever-greens, intermingled with trees of great size and beauty; some of which overhang a narrow romantic glen, which separates the pleasure grounds and lawn from the park, to which the deer are confined by an iron fence scarcely perceptible.

The south, as the principal entrance, has an Ionic portico, supported by four massive columns; there is a similar portico on the north front, and a colonade to the east. The mansion is surrounded by an extensive lawn, bounded by shrubberies, intersected by winding foot-paths. The principal apartments are, a vestibule on the south side; on the left a billiard room and study; on the opposite side a music room, which leads into the library facing the east; beyond this is the drawing room, which opens into the saloon; on the other side of which is the dining room. In the centre of the building is the great hall, with which all the apartments on the principal story communicate. The stair case leads to an open gallery, in connection with the sleeping apartments, which occupy the first story.

The rooms are elegantly furnished, and those on the principal story contain a very extensive collection of paintings, mostly by foreign masters of eminence. These were selected principally by Richard Hart Davis, esq. M. P. for Bristol, and afford a convincing proof of his refined taste and judgment. Many of them originally adorned the magnificent palaces of Italy, previous to its invasion by the French army during the consular dynasty.

The most celebrated of them are some fine specimens of Titian, Rubens, Claude, and Poussin; and especially a pair of Claude's, which are considered equal to any of that artist's best productions.

Mr. Miles purchased the collection in 1816, and transferred them to his magnificent mansion; in the spacious apartments of which, the different specimens are seen to great advantage.*

The entrance from the portico on the south side, opens into the vestibule, which is enclosed by a circle of eight marble columns, with Ionic capitals. The floor is formed of alternate radiating circles of black and white marble, and opens into

THE GREAT HALL.

This apartment possesses singular architectural beauty, and attracts universal admiration. A double flight of steps leads to a peristyle of the Ionic order; around which are twenty appropriate marble columns, supporting a lofty dome, lighted by painted glass, and adorned with highly enriched panels. The floor is of chequered marble, on which are four magnificent vases, that were brought from Wanstead House. One pair from the antique, by Delveaux, representing an heroic subject, and a sacrifice to Apollo. The second pair are sculptured by Scheemaker, on one of them, a bacchanalian subject, and on the other, the sacrifice of Iphigenia, from the Medicean vase. At the north end is a magnificent organ.

The BILLIARD ROOM is plain and simple in its architecture, but richly onamented with paintings.

* See " Young's characteristic Etchings" of the whole of this collection; part of which has been removed to Mr. Miles's London residence.

NOTE.—Every facility of introduction is afforded by the proprietor, to those whose taste may induce them to visit Leigh Court. The day set apart for admission is Thursday, by previous application for a ticket at No. 61, Queen's Square, Bristol.

1 The Conversion of St. Paul *Rubens*

This Painting belonged to M. De Montesquieu, and was thought worthy of being placed in the National Museum of France; but being restored to his family after the Revolution, it was sent to England and purchased by R. Hart Davis, esq. for 4000*L* who transferred it to the present proprietor.— The subject of this painting is taken from the following text. " And as Saul came near to Damascus, suddenly there shined round about him, a light from Heaven, and he fell to the Earth, and heard a voice, saying unto him, Saul, Saul, why persecutest thou me. I am Jesus."

2 A Holy Family *Carlo Maratti*

This celebrated Painter began his early career by drawing on the walls of his father's house, with the juice of flowers; and afterwards by his excellent copies from Raphael; whose works in the Farnese gallery, he repaired and preserved.

3 The Graces *Titian*
4 Virgin and Infant Christ *Sasso Ferrato*
5 William Tell *Holbein*

This Patriotic Hero of Switzerland, has been alike celebrated by the historian, the painter, and the poet, who have been justly desirous of associating their labours with the lustre of his name.

The Music Room is beautifully finished, the decorations are in an elegant style, and somewhat richer than the billiard room. The views from the windows of this apartment are extensive and delightful, commanding the woods at King-weston above Lord de Clifford's; Blaze Castle with its beautiful glen; Cook's Folly over Leigh Wood, and many other interesting objects.

6 The Cascatelle of Tivoli . . . *Gaspar Poussin*
7 The Companion *Gaspar Poussin*

These companion Pictures were purchased at Paris by William Beckford, esq. and by him sold to Richard Hart Davis, esq. The composition of one of them is formed from the beautiful scenery of the valley of the Cascatellas adjoining Tivoli. The artist has selected the most striking features of that classical and enchanting spot, and embodying them into one view, has produced a picture, which for effect of light and shadow, and general arrangement, has seldom been equalled even by his own pencil. The other represents the Cascade formed by the Anio, at Tivoli, immediately below the grand fall. The rocks on the foreground are contiguous to the Grotto of the Syrens, into which the river precipitates itself "

8 Pope Julius II. *Raphael*
9 Head of the Virgin *Correggio*
10 Christ entering Jerusalem . . . *Paolo Veronese*

" And they brought the colt to Jesus, and cast their garments on him, and he sat upon him; and many spread their garments in the way," &c.

11 The Vision of St. Jerome *Parmigiano*

This very interesting Cabinet Picture, has been considered as a small model
for this Master's celebrated picture in the collection of George Watson Taylor,
esq. It was sent from Leghorn to be deposited in the French Museum, but
the vessel being captured by an English cruizer, the Picture was sold, and
became the property of Henry Hope, esq. at whose sale it was purchased by
Mr. Miles.

12 Ecce Homo *Carlo Dolci*
13 The Virgin and Child *Carracci*
14 The Adoration of St. Bernard *Mengs*
15 Joseph and the Angel *Guercino*
16 St. John *Leonardo da Vinci*
17 The " Wise Men's Offering " . . *Giovanni Bellini*
18 St. Peter *Guido*
19 The Virgin and Child *Vandyke*

A beautiful Painting.

20 The Entombment *Carracci*
21 A Landscape *Gasper Poussin*
22 Grace Triumphing over Sin *Parmigiano*
23 Head of St. John the Baptist *Murillo*
24 A Sea Port *Claude*
25 A Fog *Vernet*
26 The Virgin with the Infant Jesus . . . *Raphael*

From the same subject in the Church of Loretto.

THE LIBRARY is a mangificent apartment, fitted up
with mahogany book-cases, enriched with or-molu mould-
ings. It is lighted by five large windows, with plate glass,
overlooking the same delightful scenery as the music room.
The collection of books is not very large at present, but
every opportunity is embraced of adding choice and valua-
ble works : considerable purchases were made at the Font-
hill sale. At one end is a curious pedestal clock, once the
property of Napoleon ; and at the other, is an excellent
bust of the proprietor, by Chantry. The two marble
mantel-pieces are particularly fine, and the ceiling is ex-
tremely rich, with a deeply moulded cornice.

27 Saint John writing the Revelation . . . *Murillo*

This animated and expressive representation of the " Beloved Apostle," was
formerly in the collection of M. Robit, at Paris ; it was afterwards sold to H.
Hope, esq. for five hundred guineas.

28 Saint John *Correggio*

The Saloon occupies the centre of the north front, and
commands a most extensive prospect over Shirehampton
and Penpole Point to the Severn, and the hills on its op-
posite shore. In this apartment are two handsome china
vases, and a circular slab of *verde antique*, mounted on
gilt dolphins, from Fonthill ; but its chief ornaments are
the pair of Altieri Claude's :—

29 The Landing of Æneas *Claude*
30 The Sacrifice of Apollo *Claude*

These celebrated Pictures, known by the name of the Altieri Claudes, were
purchased from that prince by J. Fagan, an English artist, afterwards British
Consul for Sicily, during the military occupation of Rome. They were con-
sidered as the greatest ornaments of the Altieri Palace ; and to save them
from the French, Fagan took the precaution to secrete them within a wall,
and for refusing to deliver them up he was imprisoned ; but he afterwards
found means to convey them to Naples. When the French took possession
of that city in 1790, whilst attempting to escape to Nelson's fleet, he was ar-
rested, with the pictures in his possession, but through the interference of a
friend, he escaped with them to Palermo, from whence he consigned them to
a merchant in England, where he arrived just in time to save them from sale.
They were subsequently sold to W. Beckford, esq. for 7000*l.* and purchased
from him, by R. H. Davis, for 12000*l.* by whom they were transferred, with
many others, to the present proprietor.

31 Holy Family *Rubens*
32 Woman taken in Adultery *Rubens*

The latter of these magnificent paintings was painted for the family of Knyf,
of Antwerp, from whom it was purchased by H. Hope, esq. Two of the
accusers are said to be portraits of the celebrated reformers, Calvin and
Luther ; the former being distinguished by a black beard, and a phylactery,
with an inscription on his head. The second is without a beard, and his head
covered with a quoif ; the third, between the woman and Christ, is Van Oort,
the early master of Rubens ; and the young man bending over the woman's
shoulder, was taken from Vandyke ; the head of Christ being obviously a
portrait of the artist.

33 Venus and Adonis *Titian*

This picture, of which there are many representations, was in the possession of
Benjamin West, who considered it as one of the most perfect and beautiful
works of the master. A fine repetition is in the Angerstein Collection.

34 Saint John *Domenichino*

This picture formed one of the principal ornaments of the Gistiniani Gallery
at Rome, and is allowed to be the finest single figure painted by this distin-
guished artist.

The DRAWING ROOM is a splendid apartment, furnished with rose-wood, mounted on richly gilt carved pedestals, with crimson silk damask hangings. The pier mirrors and window frames are also richly gilt and sculptured, and the whole style of the fittings of this room, particularly the ceiling, are magnificent.

35 Virgin with the Infant Jesus *Raphael*
36 Creator Mundi *Leonardo da Vinci*

> This picture is an evidence of the elevated genius of the illustrious painter. The figure is strictly ideal; the expression sublime and superhuman. It has usually been denominated, " Salvator Mundi;" but it evidently represents the Son of God as creator of the world. The globe which he holds in one hand, in the centre of which a bright light is sparkling, and the raised arm and uplifted finger of the other hand, appear to allude to the omnific mandate, " Let there be light, and there was light."

37 The Procession of Chaucer's Pilgrims to Canterbury
Stothard

> The landscape of this picture has a deep-toned brightness that accords most admirably with the figures, who are supposed to have just escaped from the bustling environs of the metropolis. They are collected together by Harry Baillie, their guide and host, who is represented standing in his stirrups, exulting in the plan he has formed for their entertainment. This intelligent group is rendered still more interesting by the charm of colouring, which, though simple, is strong, and most harmoniously distributed throughout the picture.

38 Magdalene *Guercino*
39 Landscape *Salvator Rosa*
40 Christ bearing his Cross *Raphael*

> " And they took Jesus, and led him away. And he bearing his cross, went forth into a place called, in Hebrew, Golgotha, where they crucified him." This unquestionable Picture of Raphael, is in his early manner, and was purchased at the sale of the Orlean's Pictures, in February, 1800.

41 Virgin and Child *Bartolomeo*
42 Passing the Ford *Claude*

> This Picture is esteemed to be one of the best specimens of Claude's elaborate finishing.

43 Christ Preaching in the Temple . . . *Compana*

> In this Picture the Painter has introduced the portraits of Solyman the Magnificent, Francis I. Charles V. Cardinal Bembo, Titian, Giorgione, Bellini, Henry VIII. Anna Boleyn, and Queen Elizabeth when a little girl.

44 Cleopatra *Guido*
45 Portrait of Philip IV. of Spain . . . *Velasquez*

46 The Crucifixion *Michael Angelo*
47 The Water Doctor *Gerhard Douw*
48 Virgin and Child *Murillo*
49 The Death of St. Francis *Correggio*

This celebrated Picture was esteemed so fine a one by Carracci, that he actually copied it.

50 The Death of St. Francis *Carracci, after Correggio*

In this fine copy of 49, the elevated expression of the saint, the beauty of form, and magical tone of colour in the original, are imitated to perfection.

51 Cows *Potter*

The animals and landscapes by this artist, are of great value, not only for their peculiar excellence, but from their scarcity.

.The Dining Room has a handsome mantel-piece and a rich ceiling.

52 The Virgin in Adoration *Velasquez*
53 St. John *Carracci*
54 Virgin and Child *Andrea del Sarto*
55 A Storm ; the Calling of Abraham *Gasper Poussin*

This picture is esteemed to be one of the finest specimens of the Master. It formerly belonged to the Colonna Palace at Rome, and subsequently became the property of W. Beckford, esq. by whom it was transferred to R. H. Davis, esq.

56 The Martyrdom of St. Andrew *Murillo*
57 The Flight into Egypt *Murillo*
58 Figure of Music *Romonelli*
59 A Nymph Sleeping *Domenichino*
60 A Jew Rabbi *Rembrandt*
61 A Landscape *Salvator Rosa*
62 A Sea Port *Claude*
63 Diana and Actæon *Annibal Carracci*

This Picture is considered to be one of the finest works of Annibal; it was purchased by Henry Hope esq. and subsequently by the present proprietor.

64 Susanna and the Elders *Guido Cagnacci*

This fine Painting is also from the collection of Henry Hope, esq. at Haerlem.

65 The Plague of Athens *Nichola Poussin*

The Picture is a most striking representation of that dreadful calamity which broke out in Athens during the Peloponnesian war, 430 years before the Christian æra. This contagious disorder, affected equally the strong and the weak; on its first attack, the mind sunk into dejection and despair. The miserable victims lay together in the streets, or near the fountains where they were left to perish without assistance from the few whose constitutions had resisted the malady.

LEIGH DOWN

was a Roman station, and Barret remarks, that several ancient roads, originally constructed by that nation, might be traced; especially one skirting the hills from the Severn near Clevedon, and over the high ridge of the downs to Cadbury Camp, which it intersected; from thence it was continued towards the stations near Fayland, from whence a broad high bank, probably the remains of a prætentura, or strong fence, passed over the down to the camps of Bower Wall and Stokeleigh, overhanging the Avon opposite Clifton. From these, another old road might be traced through an orchard at the village of Leigh, and through Leigh Wood, down to the river Avon at Sea Mills, the site of the Roman town of Abona.*

These roads are now nearly obliterated, but several discoveries of Roman coins have been made within these few years; especially in 1817, when full 500 were brought to light, by a workman accidentally turning them up when enclosing a small portion of Leigh Down, in Ashton parish. They were all of silver, with a very few exceptions, and about the size of denarii. A list of many of these coins is given in Seyer's Bristol, vol. i. p. 69, which occupies ten pages of small print, in 4to. He supposes them to have

* Tacitus, speaking of Ostorius, the Roman general in Britain, has a remarkable paragraph, which Seyer has rendered thus: " Lest the enemy should again collect themselves (after having been dispersed by light armed troops) and by a dangerous and faithless peace give no repose, either to the general or his army, he (Ostorius) began to disarm the inhabitants of those towns and districts whom he suspected, and to secure the banks of the Severn and the Antona, either by constructing new fortresses, or by occupying the ancient ones of the natives."

been buried in, or soon after, the reign of Constantius II. A. D. 240, about one hundred years before the Romans quitted this country. They varied much, both in the heads and legends, and no two pieces were exactly alike, having evidently been cast in different moulds. Out of 239 coins, 100 belonged to Severus and his empress, who both resided for a considerable period in Great Britain.

The BRITISH STATION on the AVON

consisted of three separate camps,* of which Seyer gives an interesting plate, tending to prove them to be originally of British workmanship, and not formed by the Romans; although their armies might subsequently have occupied them. On Leigh Down is a deep ravine, the mouth of which, opening to the river, is formed by two precipitous rocks, overlooking the Avon and Hotwells. These heights with the glen below, are interspersed with trees and forest shrubs, springing from amidst the crags, which are in some places almost perpendicular, and in others entirely so; having here and there a cavern, hollowed out by the hand of nature, and exhibiting a very romantic and wild appearance. On the summits of these cliffs, are two large camps, exactly similar to the one on Clifton Hill, which rises perpendicularly on the opposite side of the river. The one on the eastern side of Stokeleigh Slade, is called

BOWER WALLS CAMP.

Its side towards the river Avon, is bounded by a precipice of moderate height, which rendered all artificial de-

* Seyer justly remarks, that these remains of British settlements or stations, are generally called Camps; but their warfare being tumultuary, and their campaigns of short duration, they did not fortify the temporary stations of their armies; but soon after the Roman invasion, they, according to Cæsar, first began to fortify their camps. What are erroneously called British Camps, were probably fortified towns, or hill forts, where the chief, with his immediate attendants, and their families, resided; and into which the inhabitants of the neighbourhood retreated, with their flocks and cattle, when attacked, and within the ramparts of which, they defended themselves with advantage.

fence unnecessary; at the foot of which, the descent to the river is steep, and covered with wood. Nearly in the centre of this side, where it projects towards the camps at Clifton, is a small circular mound, probably once higher, and used as a signal station. On the north-west side, the camp is bounded by another precipice of great depth, over-hanging the combe. The third side of the camp, being level with the down, is guarded by three ramparts, drawn nearly in a quarter-circle, so as to connect the two pre-cipitous sides, the whole form being the segment of a circle. The ramparts are composed of loose stones, nearly covered with turf, the innermost being eighteen feet perpendicular above the area, which, contains about seven acres, now overgrown with forest trees. Seyer considers the two inner ramparts to have been crowned with walls, built of stone and mortar; the latter covering the rampart in great abundance. The area is crossed in various places by stony ridges, which were probably the foundations of long walls or ranks of houses; the whole appearance of the place would induce the conjecture, that it was destroyed by violence. Its name of BOWER WALLS, is synonimous with Borough Walls, and is derived from the Saxon.

STOKELEIGH CAMP

is on the opposite height, to the west of the former, from which it is divided by the deep combe, now thickly co-vered with wood. Its general form towards the down, is also that of a segment of a circle; its two straight sides being guarded by the precipices, connected by a rampart, drawn in a curved line, and enclosing an area of about eight acres. The top of the rampart is from ten to four-teen feet above the level of the camp, and as much as twenty-five to thirty feet above the bottom of the ditch on its exterior side. It was surmounted by a stone wall, four feet thick, but without mortar, the ruins of which are evi-dent through the whole length, being in some places, from two to three feet high. At the distance of forty-two feet

from the ditch, is another low rampart. At each end was an entrance; close to one of them, are the ruins, probably of a gatehouse; and near the other, the ruins of a building of greater size and superior importance, but now overgrown with shrubs and brambles.

At the angular point which projects over the river, is a mound, corresponding with the one in Ashley or Bower-Walls Camp, which was, probably, a station for signals. Considerably beyond the outer rampart, is another ditch, and also a small area, enclosed by a rampart and ditch; the latter within the former, and consequently not intended for defence.

These two camps overhang the deep glen called

STOKELEIGH SLADE,

through the centre of which are the remains of an ancient road, about three feet high and eighteen feet broad; which probably formed the line of communication between these two camps, on the Somersetshire side of the river, and a third, which crowns the heights of St. Vincent's Rocks, on the Clifton side. As this road approaches the river, it can be distinctly traced for upwards of fifty feet, apparently leading to the

ANCIENT FORD ACROSS THE AVON,

where the water at low tides, even now ripples over a strong bar, and where the river may be passed on foot, the water not being deeper than from twelve to eighteen inches. This bar appears to be the remains of an artificial ford, formed on a natural ledge of the rock, and intended to keep up a communication between the camps on each side of the river. It might have allowed the passage of men and horses for an hour or two every ebb of the tide, and even so late as 1480, it was a dangerous reef for boats and ships. Nearly opposite, on the Clifton side, is a broad way, now covered with turf and fern, leading from the river to the top of the hill, by an ascent so regular, that nature has

T

probably been seconded by art in its construction. From
the bottom of this slope, a foot path branches off and in-
clines upwards towards the western corner of the

CLIFTON CAMP,

which is placed on the highest point of St. Vincent's Rock,
where it rises 285 feet perpendicularly above the river at
high tides. Its area contains between three and four acres,
surrounded by two ditches, which form three aggeres, or
ramparts. The inner rampart, in its present state, rises
not more than three, four, or five feet above the level of
the area ; but there was, probably, once a wall upon it.
The entrance is on the north-eastern side, not in the mid-
dle, but where the hill is of easiest ascent ; the ditches
being broken off, so as to leave a kind of causeway on the
natural hill ; there are also two other narrow entrances,
one at the western, and one at the southern point.

Seyer considers these three camps to have been con-
nected by the ford across the Avon, and to have unitedly
formed a British station of great extent, and of immense
defensive strength ; which was subsequently occupied by
the Romans. The camp on the Clifton side, he considers
to have been the site of the original British town of *Caer-
Odor*, a name derived from the Welch *Godor*, a chasm ; the
G being mute, as was usual, formed *Caer-Odor*, the city
of the chasm, afterwards translated by the Saxons into
Clifton, or the *Cliff-town ;* names equally appropriate for
a fortress standing on the very edge of that prodigious
chasm through which the Avon flows. From this fortified
settlement, the city of Bristol probably sprang ; the more
sheltered situation and local conveniences of which, gradu-
ally occasioned the entire abandonment of the original
settlement.

APPENDIX.

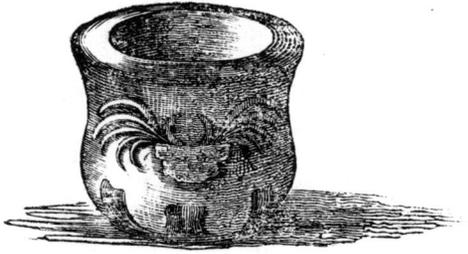

APPENDIX A.

GEOLOGICAL SKETCH,*

ILLUSTRATED WITH A MAP COLOURED GEOLOGICALLY.

GENERAL FEATURES of the DISTRICT. — Series of Stratified Rocks within the District. — FIRST SERIES of ROCKS. Old Red Sandstone, Carboniferous or Mountain Limestone. Mendip Mines in the Carboniferous Limestone. Caverns in ditto.—COAL MEASURES. Millstone Grit. Lower Coal Shale. Pennant Grit. Upper Coal Shale. Collieries. Sections of the Coal Measures.— SECOND SERIES of ROCKS. New Red Sandstone formation. Magnesian Limestone. Red Sandstone. Red and Variegated Marl. Lias. Inferior Oolite. Diluvial Deposits. Alluvial Deposits. Deposits of Tufa.

GENERAL FEATURES OF THE DISTRICT.

THE north-western district of Somersetshire may be said to be principally included within the following boundaries : viz. the river Avon on the north, the turnpike road from

* This sketch has been chiefly extracted from Buckland's and Conybeare's " Observations on the south-western coal district of England," and Weaver's " Geological Observations on part of Gloucestershire and Somersetshire," printed in the Transactions of the Geological Society. Reference has also been made to Phillips' and Conybeare's " Outlines of the Geology of England and Wales," Ure's " New System of Geology," Townsend's " Character of Moses Established," and Pinkerton's ' Treatise on Rocks."

Bristol to Wells on the east, the river Axe and a portion
of the Mendip Hills on the south, and the Bristol Chan-
nel on the west.

This expanded area displays scenes of beauty and variety,
well calculated to gratify a taste for the picturesque. It
also claims peculiar notice from geologists, as serving, in
a striking degree, to elucidate and establish the relative
character and affinities of some of the most remarkable of
the British rocks. It possesses interest also with the
practical miner, as containing numerous strata of coal-
shale and iron ore, which, with the lime-stone beds border-
ing on the coal, form an opportune and highly useful
association. Mines of calamine and lead ore add to its
mineral riches; these in some places are partially worked;
but not being engaged in with sufficient energy, are not
very productive.

This district is composed of three principal ranges of
hills, separated from each other by extensive tracts of level
surface, and diversified in themselves by numerous inter-
secting vallies. The most prominent and remarkable of
these ranges is that of Mendip, which extends nearly across
the southern portion of the district from east to west.
The second in the scale of magnitude is that of Broadfield
and Dundry Downs, occupying nearly the central portion,
and divided from the former by the vale of the Yeo, &c.
The other division comprises the lesser range of Leigh
Down, forming the most northern part of the district;
Kenn Moor, and the vales of Nailsea and Ashton limiting
the tract of separation from the middle range. On the
south of the Mendip chain are the extensive plains, through
which flow the Axe, the Brue, and the Parret.

This general outline of the surface has a near connection
with its geological structure, which presents three great
undulations from north to south, though much modified
and interrupted by abruption, the super-position of newer
formations, and partial denudation.

The highest portion of the Mendip range, including Black Dwon, presents a smooth and uninterrupted surface for a considerable distance towards the north and south; its aspect then changes, and ravines, expanding in their descent, begin to appear. The Cheddar Cliffs, in particular, intersect the range on the southern side, branching in their northern ascent into those sinuous dells and combes, which give so beautiful and sublime a character to the face of Mendip. On the north, the two combes of Burrington and Doleberry enter Mendip at right angles with the vale of Yeo, pursuing a course subsequently to the south-east, nearly parallel to the range, exhibiting a broken escarp_ment to the south; but in their ascent to the north they merge into the general surface.

To the west of Burrington the face of Mendip is again varied; presenting a continuous ridge, projecting to the westward, towards Sidcot, where the two corresponding dells, merge in the valley, which declines to the south-west, between Crook Peak and Loxton Hill. On each side of this valley are two ridges, whose broken escarpments face the north and south, while Bleadon Hill bounds the vale to the west, immediately connected with the northern ridge.

The Mendip Hills form the southern boundary of the Gloucester and Somersetshire coal basin, and at this extremity in particular, the lowest stratum composing the basin, viz. the old red sand-stone, appears over a considerable tract of surface, though in insulated portions. This basin occupies an irregular triangular space, the northern apex of which extends across the Avon into Gloucestershire, terminating at the village of Tortworth; the eastern frontier is comprised within that point and the neighbourhood of Wells; Mendip forms the base of the triangle; and its western boundary is the Bristol Channel and Severn; though the stratum is evidently continued beyond the shore, and has connection, in a degree, with the opposite Welsh

Coast. This coal field, though apparently separated from the other coal basins of England, is evidently formed by a similar agency, and no doubt at the same era, and has been also subject, at later periods, to the same revolutions. Similar to the others, it rests on a common base of old red sand stone, and is covered with the same irregular overlying deposits, forming the supermedial series.

GENERAL VIEW OF THE SERIES OF STRATA WITHIN THE DISTRICT.

Before entering into a minute description of the structure and appearances of the strata and soils which comprise the superficies of the district, it may be proper to notice generally the arrangement preserved through the sketch; which will be the means of more readily shewing the singular character and connection of the different beds which repose on, and lie beneath the coal formation.

As in this district there are scarcely any appearances of the rocks forming the transition series, this sketch will be confined to the investigation of the medial, or carboniferous strata, and the supermedial series reposing immediately on the coal basins. Of the former, the following grand divisions form the series, and compose, in a greater or less degree, a large superficial portion of the district, viz.

I.—Old red sand-stone, which occurs in large tracts on the Mendip Hills, on the western portion of Leigh Down, and also forms an extensive though narrow tract on the western flank of Walton and Weston Downs.

II.—The mountain or carboniferous lime-stone, which occupies an extensive portion of the district, is the most predominant feature of the Mendip Hills, Broadfield Down, and Leigh Down, and occurs in smaller tracts in other situations.

III.—Mill-stone grit, of which but a small portion appears; it forms the south-eastern escarpment of Leigh Down, immediately adjoining and between the mountain lime-stone, and new red sand-stone.

IV.—The coal-shale and pennant; a considerable tract of which occupies the neighbourhood of Pensford, Clutton, Farmborough, Nailsea, and the north-western declivity of Leigh Down.

The supermedial strata form the following divisions above the coal, viz.

I.—New red sand-stone, which may be sub-divided into magnesian or dolomitic lime-stone, red sand-stone, and red marl. These strata occupy a very large tract, principally in the middle of the district.

II.—Lias, which covers the greater part of Brent Knoll, the escarpments and intermediate bases of Dundry Down, and in many other places composes the high ground rising above the new red sand-stone.

III.—Inferior oolite, of which the superior range of Dundry Down is almost the only instance.* Extensive tracts of level country in the western portion of the district, present the principal remaining features, and are composed generally of diluvial and alluvial deposits.

These two grand divisions or series of strata, differ much in the degree of inclination to the horizon. The lower series generally present a greater appearance of disturbance, their inclination is more broken, and they exhibit peculiar marks of violence in the varied form of their features and irregular position. The Mendip Hills in particular possess this character in a remarkable degree. The Cheddar Cliffs, Burrington, Doleberry, and Brockley Combes, are striking instances. These subversions frequently cause members of the different series to come in contact and overlie each other in every varied position, whilst the absence of some of the members produce an anomaly in their arrangement. Those of the second series, on the contrary,

* This stone is extensively quarried at the highest point of the down, called Dundry Hill, and at the villages of Felton and Broadfield. The hard bed of the extensive quarries at Felton, supplied the stone of Bristol Bridge, and of the splendid churches at Wrington, Yatton, Backwell, Congresbury, Churchill, Banwell, Hutton, and other places throughout the North Marsh.

are either perfectly level, or inclined almost imperceptibly
to the horizon ; they seldom shew traces of internal de-
rangement, and they rest transversely on the truncated
edges of the strata of the former series.

In that part of the great escarpment of the supermedial
series which lies to the east of the coal district, the over-
lying strata, from the conglomerate series upwards, are
usually entire, and in regular order, the lowest being rarely
wanted. But in some instances the red marl, lias, or oolite,
are placed immediately in contact with the older rocks.
The prevailing surfaces of the red marl and lias, generally
form moderate acclivities within and without the coal basin,
and are rarely found investing the highest crusts of the
older chains; but the oolite mountans are on a higher level,
and forms the natural exterior boundary of the coal district
to the east. Many insulated masses project themselves
to the west, of which Dundry Hill, 790 feet above the sea,
Glastonbury Tor, and Brent Knoll, are striking instances.

FIRST SERIES OF ROCKS.

As there is little or no appearance of any of the strata
composing the transition series of rocks, it will not be
necessary to advert to it in this sketch; the old red sand-
stone therefore being the lowest formation which exhibits
its surface in the district, it will be our first object to em-
brace its details.

OLD RED SAND-STONE.

This formation consists of various alternating beds of
sand-stone, quartzose, conglomerate, and slaty marl, usu-
ally much indurated. These are generally of a brick-red
colour, often flecked with streaks, or mottled with spots
of a yellowish green colour ; and sometimes with entire
beds of that, or a greenish gray colour. It is usually com-
posed of fine grains of quartzose sand, mixt in variable
proportions, with red clay and mica ; white streaks of fels-
par being frequently disseminated through it.

The conglomerate contains pebbles of milky quartz; occasionally of red and black jasper, and more rarely of slate. These are imbedded in a matrix of sharp, glossy, quartzose sand, firmly cemented by red oxide of iron.

The sandy stratum of the Mendip Range is of a sterile character, which is increased by its high elevation and exposure; the change of stratum from lime-stone to sand-stone, is immediately indicated throughout the chain, by a change of herbage; the surface generally exhibiting a swampy appearance, even in the steepest slopes, where the sand-stone begins to prevail.

In the lowest visible portions of the old red sand-stone of Mendip, occur some beds of sand-stone conglomerate, which present the usual characteristics, with the exception that clayey, marly, or corn-stone beds, are no where exposed to view; but layers of reddish slate-clay, from six inches to one foot thick, are partially interstratified with old red sand stone, in which, organic remains are rarely, if ever, found.

The sand-stone, where adjacent to the superincumbent slate-clay, is sometimes traversed by numerous small filamentous veins of calcareous spar, and in some places it contains portions of carbonate of lime; as in the Rowber-row ravine, and in the road east of Winscombe church.

The nucleus of Mendip consists of the old red sand stone, and occupies the highest elevations of the range, though not in a continuous line; these principal summits are Black-down, Nine-barrow Down, Penhill, and Maesbury Beacon; the two latter of which, being without the bounds of the district, will not be particularly described. Blackdown, the highest point of all, being 1092 feet above the level of the sea, forms the most conspicuous tract of old red sand-stone; it extends from the meridian of Blagdon on the east, to that of Rowberrow, whence, forming a distinct ridge, it gradually descends to the vale at Sidcot, and terminates at Winscombe church, at which place it is partially

concealed by conglomerated deposits of the sand-stone and mountain lime-stone.

To the east of the road from Bristol to Cross, the sand-stone rises into a bold hill, distinguished by a clump of firs on its summit; and soon afterwards, near Shipham, swells into the ridge of Black Down, which extends about four miles in length, from Shipham eastward, to near Ubley Hill farm; and is about one mile in breadth. In the Rowberrow defile, the conglomerate rises high up the northern slope of Black Down, and resting on the edges of the sand-stone, presents a bold range of crags on the western side of the ravine.

The sand-stone of the Black Down range, supports on its northern and southern flanks, a body of slate-clay, which is succeeded by continuous carboniferous lime-stone, all in a conformable position. It is distinctly arched from the south-west to the north-east, being nearly flat on the crown of the arch. The sand-stone strata dip, on the northern side, at angles gradually increasing from 7° to 40° and where in contact with the slate-clay, to 47°; but on the southern side they support the clay, under an angle of from 20° to 40°; these dispositions may also be observed in the Combes of Burrington and Doleberry, and in the ravines on the southern side of Mendip.

This elliptical tract of red sand-stone is encircled by a zone of mountain lime-stone, except at a lateral opening near Loxton; the streams which descend to the Axe, from the western portion of the range, flow through it.

Nine Barrow Hill, so called from the group of tumuli on the surface, forms another nucleus of old red sand-stone; its summit is the most elevated at its western point, on the north of the village of Priddy. This ridge bends in an eastward direction from North-hill; following a curve for about three miles, which is concave towards the north. The zone of mountain lime-stone, lying on its northern flank, is much concealed by overlying deposits, and a tract

of conglomerate intervenes between them. The escarp-
ment of this hill above the valleys of Chewton Mendip and
the Harptrees, exhibits a species of conglomerate called
shelly chert, of which singular formation, is the elevated
platform, immediately north of the Castle of Comfort, ex-
extending irregularly in a longitudinal direction about two
miles, and nearly one in breadth.

The mountain lime-stone bounds this belt of old red
sand-stone on the south, in the same manner as that of
Black Down.

There is a slight appearance of the old red sand-stone
on the Mendip chain, in a valley at the head of Emborrow
Mere, though of so limited an extent as not to merit par-
ticular notice.

A considerable tract of this formation, appears along the
northern escarpment of Leigh Down, emerging from be-
neath the lime-stone, and extending from Charlton House
to the Avon opposite Cook's Folly, where the range again
shews itself on the north side of the Avon defile. This
tract at its western end is nearly a mile in width; and, at
its northern base, are several abrupt and finely wooded
valleys. Towards the Avon its width decreases, the dolo-
mitic conglomerate and the mountain lime-stone, approach-
ing so near to each other, as to leave but a narrow neck
of its surface exposed.

To the south of the confluence of the Avon with the
Severn at Portishead Point, is the northern extremity of
another extensive, though rather narrow tract of old red
sand-stone, reaching from that point where a small belt
of lime-stone mantles round it, to Clevedon ; it forms the
western escarpment of Walton and Weston Downs, a
similar range of mountain lime-stone forming its eastern
frontier. Along the coast, particularly near Portishead
Point, a deposit of dolomitic conglomerate greatly conceals
the inclined strata, which are exhibited occasionally only,
on the low cliffs. At low water, there is some appearance

of the pennant coal grit, reposing on the calcareous chain, which may be traced for some way from Portishead Point, to the Fort; and in a cove, midway between the northern cape and the fort, the crop of a bed of coal may be seen, having a covering of pennant abounding in vegetable remains. These strata are highly elevated, and sometimes vertical or reversed in their dip.

There is rarely found any appearance of organic remains in this formation.

CARBONIFEROUS OR MOUNTAIN LIME-STONE.

The mountain lime-stone of this district agrees in mineralogical character, organic remains, and geological position, with that of Derbyshire, and the great central ridge of the north of England. It is in no part of the district so completely displayed, as in the defile of the Avon, which has been described by Dr. Bright, Mr. Cumberland, and Dr. Buckland, in the fourth and fifth volumes of the Geological Transactions; to which papers the reader is referred for more detailed particulars.

This formation derives its name from the great elevations which it attains, and is composed of a numerous series of beds; one of the lowest of which, denominated the black rock, from its deep colour, abounds with encrinites, presenting the most striking features. Some of the beds are often dolomitic, and the calcareous beds are preceded below, and succeeded above, by argillaceous strata, which may be termed the lower and upper lime-stone shales. The former of these occupies the interval between the old red sand-stone, and the calcareous beds of the mountain lime-stone; the latter lies between the mountain lime-stone and the incumbent mill-stone grit.

The lower lime-stone shale consists of a soft argillaceous slate, with a few subordinate calcareous beds. It forms an important feature in the constitution of the Mendips, where its extent is usually indicated by a low narrow tract of stiff wet clay land, immediately encircling the base of

the old red sand-stone, and extending from that base to the dry surface of the lime-stone.

The contact of the shale with the lime-stone, is marked in some places by the sudden engulfment of streams, which, rising on the old red sand-stone, maintain their course above ground, while flowing on that rock, or on the retentive beds of shale, but no sooner come into contact with encircling zones of lime-stone, than they suddenly disappear in its numerous fissures and caverns, termed swalletholes. One instance of this has been already mentioned at Charter House, on the south-east flank of Black Down, whose exit, increased by other collected waters, may probably be traced to the foot of Cheddar Cliffs.

The aggregate thickness of the beds belonging to the formation of mountain lime-stone, determined by comparing their horizontal breadth with their inclination on either side of the Mendips, is from 500 to 700 feet.

The texture of the carboniferous lime-stone is generally crystalline, though in an imperfect degree, and is so hard and close grained, as to be susceptible of a durable polish. Gray is the prevailing colour, but it often exhibits other shades, yellow, blue, black, &c. Carbonate of lime sometimes exists in some of its beds in a very great proportion, even as much as 96 per cent; but by admixtures it often passes into magnesian, ferruginous, bituminous, and fetid lime-stone.

The lime-stone on the north and south of the elevated part of Mendip, called Black Down, forms a continuous body, which sweeps round the eastern extremity of the high sand-stone ridge, being in that quarter, in close contact with it. The lime-stone is thus spread over Mendip, in a space of three miles in breadth, as far as the road that traverses the range, south of West Harptree.

The continuous lime-stone on the southern side of Mendip, is generally disposed in strata varying from six inches to five feet in thickness, and on the northern side, in strata

from six inches to three feet. It is commonly of a bluish
gray colour, sometimes tinged with black, and more rarely
mottled with red; and has often a fetid odour. It con-
tains incidentally, slight layers and masses of horn-stone
and lydian-stone; and also beds of magnesian lime-stone,
of variable thickness. The lime-stone of the northern
range, as traversed by Burrington Combe, and the ravines
connected with it, appears to be about 600 fathoms wide.

The calcareous zone surrounding the sand-stone of Black
Down, though of inferior height to that elevation, is, how-
ever, very prominent. The northern and southern lime-
stone ridges are traversed by numerous vallies, which
being deep and precipitous, afford great strength of po-
sition, in a military point of view, to those insular summits
which they surround, as is exemplified by the fortified
camps of Banwell and Doleberry. On the southern side of
the chain, appears the conical summit of Crook Peak,
which, yielding but little in height to Black Down, and
much exceeding it in the mountainous character of its out-
line, forms one of the most striking features in the western
portion of Mendip. From Cross to Cheddar, the southern
declivity of the chain towards the valley of the Axe, is
unusually abrupt, and the transverse vallies which pene-
trate into it, are distinguished by a wild and rocky cha-
racter. Here also we have two striking ravines; Tinning's
Gate, and the yet more stupendous chasm of Cheddar Cliff,
which rivals the wildest defiles in the British Islands.

The two bands of mountain lime-stone, which are sepa-
rated by the red sand-stone of Black Down, and the con-
glomerate, which covers the vale from thence to Loxton,
approach each other at the latter place; the confluence of
the above tract with the southern escarpment of the Men-
dip Range, forming the line of division between Crook
Peak and the eastern point of Bleadon Hill; the ridge at
the latter expands, and is continued to the extreme western
point of Uphill Hill, near the mouth of the Axe, where

the chain sinks to a level with the sea. On the other side of the mouth of the Axe, is the insulated hill of Brean Down, composed of mountain lime-stone, dipping to the north, conformably to the northern flank of the Loxton chain, of which it is the continuation; and on the same line, at a short distance from the shore, is the Steep Holm, consisting of mountain lime-stone, presenting at its extremity, a remarkable undulation of the strata, in the form of an arch.

On the western boundary of the district are the two lime-stone ridges of Worleberry and Woodspring, which are probably detached appendages to the western and northern ranges of that formation, perhaps from Broadfield Down on the west, and Weston Down on the north. They lie considerably to the north of the western extremity of the Mendip Chain, and run from east to west, nearly parallel to that chain, and to each other.

Worleberry Hill is crowned with an extensive encampment at its western extremity. The ridge is about 400 feet high, and nearly three miles in length. On the east, at the village of Worle, the strata rise abruptly from beneath horizontal beds of conglomerate and lias; and terminate on the west in a precipitous cliff, facing the sea. On this side, is the low island of Birnbeck, which appears to have been originally a continuation of the western extremity of Worleberry Ridge, as does also the Flat Holm, being in the same line of bearing. This islet consists entirely of mountain lime-stone, with a small bay on the north-east side, covered with shingle, in which are pebbles of chalk-flint, red sand-stone, quartz, flinty-slate, and porphyry.

The ridge of Woodspring is about one hundred feet in height. It is flanked on the south-east by a bed of lias, probably connected with a similar bed at Worle, and thence, by an overlying alluvial deposit, with another bed, south-east of Worle, which bends round westward to Locking,

v

and where, as far as Uphill, it makes its appearance along
the edge of the marsh.

On approaching the western foot of Broadfield Down,
the lime-stone is skirted by a plain of red marl and newer
red sand-stone. Along the southern hangings of this down,
the dolomitic conglomerate, or magnesian lime-stone, ap-
pears ; and in some instances, as at Red Hill, near Wring-
ton, ascends its flank nearly to the summit, and forms a
belt, continued at intervals from Yatton to the north of
Wrington and to Chew Magna. Detached summits of
lias also appear in this vicinity, south of Butcombe, and
west of Nempnet.

The mountain lime-stone of Broadfield Down, the loftiest
of the south-eastern frontier of the Nailsea coal tract, oc-
cupies a triangular space of considerable extent, of which,
the three angles, on the north, the south-west, and the
south-east, are marked by the villages of Backwell, Yatton,
and Butcombe ; its southern base skirting the village of
Wrington.

The apex of the south-eastern angle of this ridge, is at
a point called Heath Hill, about one mile north of But-
combe. This hill is composed of mill-stone grit, resem-
bling that of Brandon Hill, above the town of Bristol ; it
rests upon mountain lime-stone, dipping to the south ; and
if a trial for coal was made about a quarter of a mile to the
south of this point, it is probable that it would penetrate
to the lowest of the coal seams. On the further side of the
valley, extending immediately to the west, are situated the
ruddle pits, for which this district is famous, and from
which the mineral called spanish brown, is conveyed to all
parts of England. It is a highly ferruginous red ochre ; is
very abundant, and seems to occur in one of the lowest beds
of the new red sand-stone.

Near Felton the lias sweeps over the intervening beds,
and comes into immediate contact with the mountain lime-
stone. It occupies nearly the whole extent of a long nar-

row valley, which is overhung at the eastern extremity by picturesque and precipitous lime-stone craggs, called Hart-cliff Rocks,* and thence extends westward to the head of Brockley Combe.

This picturesque defile has been already fully described in the second chapter. It extends nearly a mile from east to west, and exhibits, especially on its northern side, abrupt precipices, towering above luxuriant forest trees. About a mile and a half to the east, is another of these fine gorges, in which the north-western side of Broadfield Down terminates, called Goblin Combe, near the village of Cleeve. The mouth of this richly wooded defile is marked by a very striking conical hill, bearing on its summit a huge calcareous tor, resembling Thorpe Cloud, at the entrance of Dove-dale, in Derbyshire.

Another calcareous ridge, belonging to the northern portion of the district, is well known under the name of Leigh Down, and is continued across the narrow defile of the Avon, to Durdham Down, and King's Weston Down. They are parts of a calcareous zone, encircling a nucleus of old red sand-stone.

Leigh Down is that part of the zone which extends from Clevedon on the coast, to the defile of the Avon at Clifton. It is not continuous with Broadfield Down, but is separated from it by the valley of Nailsea; an undulation in the lime-stone strata contains a small coal basin. The upper part of this valley, near Kencot Cross, so called from an ancient stone cross fixed in a most romantic situation north-east of Flax Bourton, is contracted to a narrow space, only three quarters of a mile broad, the sub-strata being concealed in that interval by over-lying beds of red marl and lias.

Leigh Down is about eleven miles long; its general bearing is from south-west to north-east. Its breadth,

* Miscalled Hartley Rocks, in the "Ordnance Survey." They give name to the hundred; the ascent from the north, is by an easy acclivity; and on the summit, the hundred courts were formerly held.

from being half a mile near Clevedon, increases to one mile and a half at the defile of the Avon.

This ridge of lime-stone commences with the detached hillock, on which Clevedon church is built, and presenting a low cliff towards the sea. To this hillock succeeds a narrow flat, to the north of which the hills rise to the height of about 300 feet, and soon separate into two branches. That, diverging to the north and skirting the coast, is called Walton Down, distinguished by the castle built on its highest point; the more northerly portion is called Weston Down, from the village of Weston in Gordano. The other range, to the eastward, is the chain of Leigh Down. Near the diverging point, the ridge is completely broken through by a defile, along the eastern brow of which, the park of Sir Abraham Elton extends. From this point to Wraxall, the ridge is narrow, and the dip of the lime-stone regular, being a little to the east of south, at an angle of 60°. Two deep gullies traverse this ridge, a little further to the north-east, winding across it, and including between them the insulated summit of Cadbury Castle, crowned by an entrenchment.

From this point the chain continues gradually widening to the Avon, its most elevated portion being near its centre at Failand's Inn, where it is about 500 feet above the sea.

The western half of the lime-stone range from Clevedon towards Portbury, presents remarkable anomalies along its northern escarpment. The local phenomena clearly indicate, that a great fault ranges along the edge of this part of the escarpment, effecting a very considerable subsidence of the strata; so that the coal measures, depressed to the level of the old red sand-stone, appear to occupy its place, and seem to dip beneath the mountain lime-stone, on which, in fact, they repose. The lime-stone beneath the coal measures having subsided, together with the coal measures, form, on re-emerging, the second calcareous ridge already mentioned, called Walton and Weston Downs.

These downs, formed by the subsided mass of lime-stone, are divided along the summit, by a longitudinal valley, into two parallel crests, the southern consisting of mountain lime-stone, the northern of old red sand-stone; an intermediate valley marking the shale that divides the two formations. The continuation of the lime-stone ridge is concealed, a little to the north of Weston in Gordano, by overlying masses of magnesian lime-stone; but the ridge of sand-stone extends about a mile further, until it reaches the southern extremity of Portishead Bay, where it terminates at the fault already mentioned, and where the lime-stone again appears, mantling round the nucleus of sand-stone. From this point southward to Clevedon, the coast is skirted by magnesian lime-stone, which here forms a talus, at the base of the hills of old red sand-stone.

A remarkable feature in the mountain lime-stone, is its intersection by narrow precipitous mural chasms, which lie transversely to the calcareous chains, which they intersect, and to the contiguous low-land vallies. These often form the gorges, by which the upland vallies descend into the neighbouring plains; they are then simply excavations in the lime-stone, produced, apparently, by the furrowing action of some violent cause acting from without. At other times these ravines completely intersect the calcareous ridges to a depth beneath the level of the contiguous longitudinal vallies, and they then turn the rivers aside from pursuing those vallies in their course. In this latter case they are often the result of internal derangements of the highest antiquity. Cheddar Cliff is cited by Dr. Buckland as an instance of the former kind; and the defile of the Avon, which turns that river aside from the valley leading through Long Ashton and Nailsea to the Bristol Channel, and conducts it through the lime-stone chain of Leigh Down, into the Severn, is a magnificent example of the latter.

The ORGANIC REMAINS preserved in the carboniferous lime-stone, are strongly distinguished from those in the

superior lime-stones, the oolitic and the lias, and belong in
a majority of instances to entire distinct families; but its
alliance is much more close to the older, than to the more
recent formations. Vertebral animals are extremely rare,
but there are many species of *testacca*, or shell-fish, all
belonging to a very few genera; while the zoophytal
families, *(polyparies,)* particularly encrinites and coral-
lites, exist in great profusion.* Some vertebræ of fish,
shark's teeth, palatal tritores, and a radius of a balistes have
been found. Of the crustaceous tribe, a few trilobites occur
in this formation; and among the univalve shells, the fol-
lowing genera may be noticed—ammonites, nautilites, or-
thoceratites, euomphalus, cirrus, nerita, helix, and turbo;
among bivalves, modiola, mya, terebratula, spirifer, pro-
ducti, and a few echini; and among encrinites—posterio-
crinites, platycrinites, cyathocrinites, actinocrinites, and
rhedocrinites; all of which latter are distinguished from
those occuring in the lias and more recent beds, by the
thinness of the ossicula forming the cup, which contains
the viscera.†

MENDIP MINES IN THE CARBONIFEROUS LIMESTONE.

The Mendip Hills were formerly celebrated for mines,
which are now comparatively of small importance, either
as objects of mineralogical, or of commercial attention.
The mines of calamine, which are the principal ones now
worked, do not occur in the inclined strata, but in the
overlying conglomerate. The lead mines are almost en-

* Mr. G. Cumberland and Mr. J. S. Miller, have both published works on
encrinites, or crinoidea, in which, numerous species are discriminated.

† Mr. Parkinson remarks, that the shells in the mountain lime-stone, are of
the earliest formation, yet exceed, in complexity of structure, the shells which
have been discovered, either in any subsequent formation, or living in our present
seas. It is in this early creation that those shells are found, which possess that
complicated structure that enabled their inhabitants to rise and sink with them
in the water. Not only the many chambered univalves, but the bivalves and
multivalves of that era, also seem to have been endued with a similar property.

tirely abandoned, but have been worked principally in the mountain lime-stone.

Galena is the only ore. The gangue is calcareous spar, mixed occasionally with a little sulphate of barytes. The veins are thin, and not certain in their direction. Though the principal mining district is that around Shipham and Rowberrow, yet there is scarcely any part of the calcareous ridges of Mendip in which shafts have not formerly been opened. The workings are unusually shallow, being generally undertaken by the mining peasantry of the neighbourhood, with the rudest machinery, and most limited capitals; and the water no sooner flowed in, than the works were necessarily abandoned.

Manganese is dug about East Harptree, and was formerly, in a small degree, from a vein on the summit of the lime-stone ridge, about a mile east of Shute-shelf Hill.

. CAVERNS IN THE MOUNTAIN LIME-STONE.

The mountain lime-stone, as well as all the great calcareous formations, are often cavernous, and intersected by fissures, several of which have been fully described in the foregoing chapters. The caverns consist generally of a series of vaulted chambers, connected by narrower passages; and sometimes traversed by streams derived from swallet-holes, but are more frequently destitute of any water, except such as percolates through their sides and roof. Many of them are much admired on account of their sparry concretions and stalactitic projections; but their greatest interest is derived from the circumstance of their occasionally containing antediluvian remains of animals which no longer exist in these latitudes, if at all upon the face of the globe. These deposits of the bones of animals upon the floor and within the recesses of the caverns, form one of the most remarkable phenomena which the fossil or geological kingdom can present; more especially when we consider that they occur in a great many localities, and under similar aspects, in countries very remote from each

other ; those in Germany and England having been the most carefully examined and described.*

The hills containing the caverns in this district, are all of analogous composition, being calcareous, very productive of stalactite and stalagmite, which, under a thousand varied forms, lines the roofs and walls. The bones are found nearly in a corresponding condition with those in other caves; detached, dispersed, partially broken, intermingled with diluvial detritus, but never themselves rolled, and consequently not drifted from a distance by water. They are a little lighter, and less solid in Banwell Cave, than recent bones, yet as regards their true animal nature, are very little decomposed, still combined with gelatine, and not at all fossilized.

A mass of earth, occasionally impregnated with animal matter, wherever it occurs, both in Germany and England, envelopes the bones, with the exception of a few found occasionally on the surface of the floor, which have accumulated there at much later periods, and generally belong to species now living.

The most interesting part of the phenomenon is, that the more remarkable species of the bones yet discovered, are identical over an immense space of territory. The largest proportion belongs to an extinct species of the bear, *(ursus spelæus,)* whose remains, though plentiful, do not however predominate in the Cavern at Banwell. This species is calculated by Cuvier, to have been one-fourth larger than the existing race of bears; and their teeth being found in a more perfect state, the summits less worn, and the enamel and prominences more entire, indicate that the extinct species were more exclusively carnivorous.

The genera so common here in the diluvial detritus, namely, the elephant, the rhinoceros, the horse, and the ox, or bison, are very rare in the caverns of Germany ; but

* See Professor Buckland's " Reliquiæ Diluvianæ," and Ure's " New System of Geology."

in the one at Banwell, the ox bones predominate in an immense proportion, whilst it is devoid of the others. In Hutton Cave, on the contrary, no bones of the ox tribe have been found, but a large number of those of the horse, together with remains of other great and small herbiverous animals, such as the elephant, wild boar, hare, and rabbit; combined with bones of carnivora, including tiger, hyæna, bear, wolf, and fox, together with bones of the rat, mouse, bat, and of birds.

In the Uphill Cavern, the bones and teeth of the hyæna, were abundant, intermingled with those of the rhinoceros, bear, ox, horse, polecat, &c.* The bones of the larger animals, including those of the hyæna, were no less broken and gnawed, than those discovered at Kirkdale, and in other caverns, where hyæna's bones and teeth predominated; and it is generally admitted, that the Uphill Cave, together with those at Kirkdale and Torquay, have been dens occupied by hyænas, previously to the deluge. The one at Banwell was, probably, tenanted in the same manner by bears and wolves in succession; and that on Hutton Hill was, perhaps, a common sepulchre for the animals whose remains have been found there.

M. Cuvier and Dr. Buckland have pursued the study of these animal phenomena with unrivalled zeal and intelligence. From their elaborate comparisons and researches, they appear to have drawn the following conclusions :—

I.—That England has been inhabited by the different animals, whose remains have been discovered in the caverns, at a time when a far higher temperature prevailed in these regions, and that they lived together in the same country, and belonged to the same general epocha, though possibly not to the same precise era of that epocha.

II.—That the establishment of these animals, or of their remains, in the caverns, is long posterior to the epocha, at

* See Mr. Williams's Letter to Mr. Patteson.

which the extensive mineral strata were deposited, not only of the mountains that contain the caverns, but even those of much more modern formations.

III.—That the bear and hyæna of all these caverns, as well as the elephant and rhinoceros, belong to the same extinct species that occur in the diluvial gravel; whence it follows that the period in which they inhabited these regions, was that immediately preceding the formation of this gravel, by that transient and universal inundation which has left traces of its ravages, committed at no very distant period over the whole surface of the globe, and since which no important or general physical changes appear to have been effected.

THE COAL MEASURES.

Dr. Buckland and Mr. Coneybeare divide the south-western coal district of England into the *northern*, the *central*, the *southern*, the *eastern*, and the *western*, coal-tracts. The *northern* comprehends the collieries of Iron Acton, Sodbury, and Kingswood. The *central* coal-tract commences on the south-east of Dundry Hill, and on the table-land of lias, which supports its loftier summit of oolite, and extends as far south as Temple Cloud. The *southern* tract begins near Emborrow, on the west, and extends to Mells near Frome, on the east. The *eastern* one is in the Golden Valley, a little to the north of midway between Bristol and Bath. The *western* coal-tract lies at the south-eastern foot of Leigh Down, including the coal field of Nailsea, and those of Clapton, Long Ashton, and Bedminster. This last being the only coal-tract within the north-western portion of Somersetshire, is that to which this Geological Sketch will be confined.

The coal measures in the western coal-tract of the Bristol basin, are bounded on the east by overlying beds of red marl, which form the upper strata in the shafts of all the coal-pits between Long Ashton and Bedminster.

The fragments of Strata of newer red sand-stone that hang on the slopes of Leigh and Broadfield Downs, to the

north-west and south-east of the Nailsea basin, shew that the exposure of the coal measures is here the result of denudation.

The coal measures may be subdivided into—1. The *millstone-grit.*—2. The *lower coal-shale.*—3. The *pennant-grit.*—4. The *upper coal-shale.*

MILLSTONE-GRIT.

The *millstone-grit* * is the lowest coal measure ; it agrees in position, and seems to be of cotemporaneous origin, with the millstone-grit of Derbyshire. It differs, however, from the grit of the north of England, in being charged with red oxide of iron, and so compact, as often to assume the character of a close-grained cherty quartz rock. The character of this grit is well exhibited in Brandon Hill, near Bristol.

Associated with the compact and cherty beds of this grit, there often occurs a silicious conglomerate, containing large quartzose pebbles, which might be applied to the fabrication of millstones. The beds of grit are divided by waybands, and often by thick seams of red ferruginous clay.

The lower beds of grit contain impressions of shells, the the *anomia producta*, for instance, which occurs in the mountain lime-stone, and also impressions of those vegetables which are commonly found in the coal measures.

The millstone-grit appears as a quartzose conglomerate, between the coal and lime-stone, along the northern frontier of the Nailsea coal basin, and may be traced over Nailsea heath ; it is much more visible at Long Ashton, where it skirts the northern side of the village, reaching down to the road, and forming the subsoil of the park of Ashton Court ; the Avon divides it from the continuous range of the same formation which reaches over Brandon Hill. This is the only tract in the district where the millstone-grit appears above the surface.

* The term "Millstone" is also locally applied by the miners to the dolomitic conglomerate.

LOWER COAL-SHALE.

This measure reposes on the millstone-grit, and consists principally of argillaceous strata ; even the grit, which alternates with the shale, contains much clay, and occasionally resembles some of the varieties of grey-wacké. Slate-clay predominates, and imparts its character to the whole series. Iron-stone occurs in some of the lower beds of shale, and also vegetable remains, particularly those of long-fluted reeds, and of trunks, marked on their exterior by lozenge-shaped impressions, are common ; but those of the ferns are less so than in the upper shale.

The collieries of Bedminster are obviously referable to the lower coal-shale. The Ashton seams, now out of working, lie below those of Bedminster ; but they both rise conformably against the millstone-grit of Leigh Down. In the coal-field of Nailsea, the lower seams, alternating with shale, are interposed between the millstone and pennant-grits.

In the Clapton coal-field it is difficult to pronounce decisively to which division of the coal measures the seams of the subsided mass belong, the working having been long disused. Dr. Buckland, however, refers them to the lower coal-shale.

PENNANT GRIT.

This coal measure consists of thick stratified masses of very fissiler sand-stone, having mica, decayed felspar, and carbonaceous vegetable fragments abundantly disseminated through it, and varying in colour from greenish gray to dark brick-red. The thick beds of grit alternate with thin strata of shale and coal. It is known by the name of pennant stone, and is quarried largely for paving and building throughout the district. The total thickness of this series, is not less than four or five hundred feet.

In the coal basin of Nailsea, the pennant covers an area about a mile and a quarter broad on Nailsea Heath, and

the upper seams of coal worked in that field, appear to be subordinate to this rock. In the Clapton coal field the pennant, along the line of the fault, abuts against the mountain lime-stone. This rock also occurs on the coast at Portishead, as already noticed.

THE UPPER COAL SHALE.

This consists principally of slaty-clay, alternating with some thin beds of grit, called *greys*, a word, perhaps of the same origin, with the French *grés*. Impressions of ferns are very abundant in this shale, and some lepidodendra occur.

The upper shale does not properly belong to the western coal district ; its border does not extend further to the west than Stanton Drew, which belongs to the central district, where these seams lie almost immediately on the pennant rock. Some of the collieries worked in the upper shale, are subject to the fire-damp, which is hardly known in those of the lower shale.

COLLIERIES.

The number of collieries in work, was probably greater formerly than at present, though the total produce of the mines is certainly much greater now than at any former period. The traces of ancient workings are to be found over several parishes, in which no pits are now in use.

The seams of coal throughout this district, are comparatively very thin, and their aggregate thickness in any single coal-pit, scarcely exceeds that of one of the ordinary seams in the principal coal fields in England.

The district may, however, be considered rich in this valuable mineral, and as able to answer largely the future demand. Many of the ancient pits may be drained and worked to advantage on the present improved system ; and much of the area is still untouched. There is every reason to believe, that the coal measures of the central coal district, extend beneath the valley of Wrington, between the

Mendips and Broadfield Down ; and it has already been
stated as probable, that the lower coal-shale would be
found a little to the south-east of Winford, where the mill-
stone grit rests against the lime-stone of Broadfield Down.
No coal has been found south of the Mendip Range ; but
since the mountain lime-stone dips beneath the marshes in
that direction, and re-emerges on the north of the Quantock
Hills, it seems probable that there exists an intermediate
basin beneath the red marl, which forms the uppermost
sub-stratum in this alluvial tract *

SECTIONS OF THE COAL MEASURES.

SECTION I.

In the lower coal-shale at BEDMINSTER, in the western
coal-tract.—Dip S. S. E. 1 *in 3.*

DESCENDING ORDER.

	Fath.	ft.	in.
Alluvial blue clay, with trunks of trees	4	0	0
Red Ground	6	0	0
Cliffs or Duns	20	0	0
Grays, a compact gray grit-stone, with argillaceous mixture	3	0	0
1. *Hard seam*, not worked	0	1	0
Under-earth, a friable grit	6	0	0
2. *Top seam*	0	2	6
Under-earth	1	0	0
3. *Little seam*, not worked	0	1	2
Cliff and stone	10	0	0
4. *Coal*, not worked	0	1	0
Cliff and stone	9	0	0
5. *Great seam*	0	3	4
Cliff and stone	14	0	0
6. *Thin seam*, occasionally worked	0	1	8
Total depth of workings	74	4	8

* Coneybeare and Phillips have expressed an opinion, that there are upper
coal seams beneath the hill of Dundry, which they have indicated in their
section. This surmise is, probably, correct, but if so, it must, on account of
the obstacles to working it at present with profit, be regarded as a treasure for
future ages.

The top seam lies 40 fathoms deep in the northernmost pit, called Mash Pit, and 116 fathoms deep in the southernmost pit, about 1000 yards distant from the former. All the seams consist of caking coal. Many impressions of lepido-dendra and syringo-dendra occur above the great seam. The greatest fault throws up the beds 19 fathoms on the north side.

SECTION II.

In the lower coal-shale at LONG ASHTON, in the western coal-tract. Mr. Gore's coal-work.—DIP *northerly.*

DESCENDING ORDER.

	Fath.	ft.	in.
Vegetable mould	0	1	0
Stiff light-coloured clay	0	0	6
Red gritty clay ,	4	3	0
Duns, with vegetable impressions	3	0	0
Hard gray stone	0	4	0
Duns	0	2	0
1. *Flaky bad coal*	0	1	0
Flaky, black substance, (shale, with coal intermingled)	0	1	6
2. *Coal*	0	3	6
Total depth of workings .	9	4	6

A fault runs north-west and south-west, near to which the beds are vertical. In another pit twenty yards to the south of the former, the dip is to the south. Another fault, perpendicular to the former one, runs, probably, between the two works.

SECTION III.

In pennant rock and lower coal shale, at NAILSEA.

DESCENDING ORDER.

	Fath.	ft.	in.	
Rubble	1	0	0	Worked in the pit nearest the church.
1. *Withey seam*	0	4	0	
Rock... a few fathoms				DIP S. 2 in 9.

	Fath.	ft.	in.	
2. *Seam* mentioned in the Phil. Mag. 1811, as No. 3	0	2	0	
2. *King's-hill seam*	0	1	4	Worked in White's Collieries, immediately west of the Glass House.
Pennant		a few fathoms		
4. *Rock seam*, not mentioned in Phil. Mag.	0	1	4	
Duns	3	0	0	
Rock	3	0	0	
Duns	3	0	0	
5. *White's, or main coal.* There is no pennant below this seam	0	3	6	Dip from S. to S. W. 2 in 9.
Cliff		a few fathoms		
7. *Little seam*, not mentioned in Phil. Mag.	0	1	4	
Cliff		a few fathoms		
8. *Violet seam*	0	0	10	

An interval follows which has not been thoroughly examined. The new pit at Backwell, which is said to be sunk in this interval, exhibits, beneath overlying red marl, the following beds :

DESCENDING ORDER.

	Fath.	ft.	in.	
Rubbly rock	3	0	0	New pit of Backwell.
Duns	10	0	0	
9. *Little rock seam*, good coal	0	1	8	Dip N. N. W. 1 in 4.
Duns not sunk through	4	0	0	
Duns and stone	10	0	0	
10. *Smith's seam*, variable in thickness	0	5	0	
Duns, &c.	13	0	0	
11. *Dog coal*; a good fine coal. It has a thin argillaceous parting, and swells into large irregular masses	0	3	0	Old Pits of Backwell, called Teague's Colliery, in Phil. Mag.
Duns	1	3	0	
12. *Spider delf coal*; good coal	0	2	0	Dip N. N. W. 1 in 4.
Duns	10	0	0	
13. *Crow seam*; good coal	0	3	0	

Below this, two other thin seams have been proved, viz.

14. *Milway seam*

15. *Rock seam*

The faults in the Nailsea coal-field are few and inconsiderable.

SECTION IV.

In the northernmost pits formerly worked in the parish of STANTON DREW.—DIP *nearly east.*

DESCENDING ORDER.

		Fath.	ft.	in.
Lias Formation.	Stony arable, mixed with spongy yellow earth or clay	0	2	0
	Lias lime-stone	1	4	0
	Yellow loam	1	0	0
	Blue clay, inclining to marl	0	3	0
	Whitish loam	0	3	0
	Deep blue marl, soft, fat, and soapy	0	2	0
	Iron pyrites	0	0	6
	Deep blue marl	0	3	0
	Depth of Lias Formation .	4	5	6
New Red Sand-stone.	Red earth, becoming a malm at the surface ..	10	0	0
	Reddish fire-stone from 4 to	5	0	0
	Greyish millstone, (dolomitic conglomerate) 3 feet at Sutton, at Stanton Drew	1	4	0
	Depth of New Red Sand-stone .	16	4	0
Coal Measures.	Coal clives	6	0	0
	1. *Stinking seam,* hard and sulphureous	0	2	0
	Cliffs and duns, fram 5½ to	7	0	0
	2. *Cat-head seam,* (from lumps of stone called cats' heads)	0	2	6
	Cliff and duns, from 5½ to	7	0	0
	3. *Three-coal seam* {coal stone 1 to 2 feet, parting the coal...}	0	3	0
	Hard cliff, subject to water, and containing cockles and ferns, from 8 to	10	0	0
	4. *Peaw, i. e.* Peacock *seam,* irridescent coal	0	2	0
	Cliff	6	0	0
	5. *Smith's coal*	0	3	0
	Cliff .	6	0	0
	6. *Shelly, i. e.* Shaly *seam*	0	2	6
	Cliff	6	0	0
	7. *Ten-inch seam*	0	0	10
	Depth of Coal Measures .	50	3	10
	Total depth of workings .	82	1	4

w

These coal pits are not sunk through the lias, which is found on the hills, but through the red marl in the vallies. There is but little red marl on the surface in some parts of the parish of Stanton Drew, where you arrive almost immediately at the coal measures.

SECTION V.

Seams worked in the parish of STANTON DREW, to the east of those mentioned in section 4, also in Phil. Trans. for 1719.—DIP. E. by N. 1 *in* 3.

DESCENDING ORDER.

	Fath.	ft.	in.
Greys and Cliff	0	0	0
1. *Small lime coal*	0	3	0
Cliff	3	0	0
2. *Coal* fit for culinary purposes	0	2	6
Cliff	3	0	0
3. *Good hard coal*	0	2	10
Total depth of workings	7	2	4

At Clutton, south-east of Stanton Drew, there are 10 to 14 fathoms of red earth; at Stanton Drew the coal measures rise to the surface.

SECOND SERIES OF ROCKS.

This series, by some geologists called the super-medial series, repose on the coal basin of the district in a similar manner with the other coal basins of England. The members of the strata consist of, 1. *New Red Sand-Stone*, divided into the minor formation of dolomite or magnesian limestone, red sand-stone, and red marl.—2. *Lias.*—3. *Inferior Oolite.*

THE NEW RED SAND-STONE FORMATION average a total thickness of about 200 feet, in the south-western coal district; which is little more than one fourth of the depth it attains in the north-eastern parts of England.

THE MAGNESIAN LIME STONE

is the lowest member of this formation, and reposes immediately on the coal measure. This conglomerate consists of fragments of the older rocks, cemented together with a dolomite, blended with carbonate of lime, clay, and fine iron-shot sand. These fragments vary from the finest grains to bowlders of three feet in diameter, which are mostly rounded, though when the parent rock is near, but slightly so. The fragments are mostly those of the inclined strata nearest at hand. The conglomerate has evidently existed in the state of loose gravel, but occasionally the grain is so fine, and it is so charged with the matter of cement, that it becomes compact, and bears no traces of mechanical origin ; in this state it closely agrees in character with the magnesian lime-stone of the north of England, under which name it is represented on the geological map which accompanies this sketch.

The yellow magnesian lime-stone, thus strongly characterised, prevails over tracts of considerable extent ; at Portishead Point, it forms a ridge, which gradually becomes narrower, till it terminates a little north of Clevedon. It is particularly visible beneath Walton old church, on the coast of the Bristol Channel.

This formation is remarkable for the occurrence of small irregular cavities, from an inch to a foot in diameter, which are lined, and sometimes filled, with concentric plates, resembling in their structure those of an agate ; and consisting of calcareous spar, coarse chalcedony, and crystals of quartz. These geodes are called from their shape, *potatoe stones*, and are found near Wraxall, Winscombe, Compton Bishop, Clevedon and other parts of the district, where the compact magnesian lime-stone abounds.

The effects of a destructive power, are shewn in the abruption of escarpments, and the excavation of vallies in the Mendip range, though manifestly followed by reproduction from their debris. The flanks of Mendip also testify

the same destructive agency. On the southern side, the calcareous conglomerate forms an exterior border of low hills, ranging along its foot, the extended strata of which gently inclining towards the south, descend low into the plain, as may be observed near Axbridge. To the southward, the conglomerate is succeeded by new red clay marl, which supports lias in the form of truncated cones, as in the knolls of Cheddar and Brent, the latter surmounted by a cap of oolite; or in narrow extended ridges, as in those of Weare and Badgworth.

The magnesian lime-stone formation varies greatly in thickness, sometimes forming a thick bank or talus near the base of those hills, from whose debris it has been derived; while at a distance from them, it grows thinner, and at length wholly disappears. Sometimes it hangs on the sides of the mountains, at considerable elevations; and in narrow vallies, it occasionally fills the intervals between the ridges, and conceals, with its horizontal beds, the fundamental rock; striking examples of which may be seen in the vallies of Shipham on Mendip.

Associated with magnesian lime-stone, there often occurs a fine and compact sand-stone, which assumes the character of chert. It is found on the elevated platform above East Harptree, and consists of fragments of old red sandstone imbedded in a cherty cement.* It abounds with heavy spar, is sometimes very calcareous, and contains shells belonging to the genera ammonites, modiola, pecten, tellina, and plagiostoma, which are in general reduced to the state of hollow crusts; the shell itself is sometimes chalcedonized.

This conglomerate skirts the northern and southern sides of the Mendip chain, spreading itself in the neighbourhood of Wells, but forming a narrow band from thence

* Most of the Druidical Stones forming the circles at Stanton Drew, are composed of this cherty sand-stone.

by Cheddar and Axbridge to Bleadon, where it forms a beautiful breccia, called *wonder-stone*, consisting of yellow transparent crystals of carbonate of lime, disseminated through a dark red earthy dolomite.

At East and West Harptree, the magnesian lime-stone lies in banks of enormous thickness, and has formerly been extremely productive of calamine. From West Harptree it continues to maintain a considerable thickness along the whole base of Mendip, by Burrington and Banwell, to Uphill on the Bristol Channel. It is strikingly displayed to the east of Butcombe, at the bottom of the deep vallies, which there cut through hills of lias. It skirts the valley of Nailsea, along the north western base of Broadfield Down, and occurs less abundantly along the opposite slope of Leigh Down. It has been previously mentioned as lining the coast from Clevedon to Portishead and Portbury; and in the interval between these villages, it partially conceals the subjacent old red sand-stone. It crosses the Avon to the west of Cook's Folly, and constitutes the upfilling of the vale of Westbury, between the opposite ridges of Durdham and King's Weston Downs.

This rock is often metalliferous, yielding occasionally galena, a small quantity of blue and green carbonate of copper, and more frequently calamine; sulphate of strontia abounds in it, and has of late been much used for making nitrate of strontia.*

It has consequently been extensively subjected to mining operations, principally in the parishes of Shipham and Rowberrow, and also near Rickford. The metalliferous portions of this formation are traversed by veins in all directions, which observe no regular dip. They vary in width from one to six inches, but are occasionally enlarged to the breadth of one to three feet. Few workings have

* A chemical substance extensively used for producing a red flame in fire-works.

gone to a greater depth than twenty to thirty fathoms, depending, probably, upon the thickness of the magnesian lime-stone bed.

The magnesian lime-stone contains but few fossils, but at Clevedon four species of encrinites occur in it. Silicious coryophylia have been found under Cadbury Camp, which Mr. Cumberland has described as resembling bamboo and sugar cane; they probably belong to this, or to the upper mountain lime-stone beds.

RED SAND STONE.

This member of the newer red sand-stone formation, immediately reposes upon the magnesian lime-stone, and consists of a friable red, white, or yellow sand-stone, which sometimes is abundantly charged with dolomite. It is seldom hard, tough, and fissile enough for tile or flag stones. It is now rarely employed for architectural purposes, but was used for the walls of the Bristol cathedral, and more recently in the construction of the docks. This rock may be advantageously studied in the vicinity of Chew Stoke and Chew Magna; in the New Cut at Bristol, where it contains cells filled with strontia, or in a labyrinth of excavations beneath Redcliffe Parade.

The absence of distinct lines of stratification forms its general character; another feature is the appearance of irregular openings and lines of deceptive strata, which run obliquely over beds, affording massive blocks of free-stone.

In the sand-stone above East Harptree, casts and impressions of shells occur, which, though often obscure, are referable to the following genera:—a species of ammonite, a turbinated shell, the pecten quinquecostatus, a modiola, a pinna, an astarte or venus, and one or two species of ostrea. Crinoidal remains occasionally appear; and a species of bivalve is particularly abundant, apparently a tellina or a donax.

Mining operations have been conducted in the new red sand-stone formation, in that part which skirts the eastern

borders of the Broadfield Down Range. The mineral consists of a clay iron-stone, called ruddle, which varies in thickness, but in some places extends to five or six feet. To this bed pits are sunk, which are wrought in the dry season only. The ruddle thus obtained, is applied to various purposes, and particularly in the preparation of the pigment, called spanish brown.

RED AND VARIEGATED MARL

reposes on the sand-stone, and is not laminar, like that of the old red sand-stone, but globular in structure. The marl in the upper part of the series becomes green, and contains subordinate layers of red and green marl stone, approaching in character to lias, and gradually passing into it.

The two preceding members of the new red sand-stone formation, the red sand-stone and the red marl, are of inferior interest to magnesian lime-stone; but are of importance as affording, in many instances, distinct marks between the newer sand-stone and the old.

The beds of red marl form an extremely rich soil, and it appears peculiarly congenial to the growth of the apple and pear; as may be observed also in Monmouthshire and Herefordshire.

This, and the sand-stone member of the formation, are extensively distributed over the Bristol coal field, appearing along the boundaries of the several exposed coal tracts; they are seen in the vallies of the Fensford coal basin, emerging from the high table-lands of lias and oolite. The shafts, which are here pierced to the coal, exhibit sections of the highest geological importance, displaying the relation between the new red sand-stone and coal measures, establishing beyond doubt, the distinctive character between the new red sand-stone and the old, which, from their similar ingredients and appearance, are liable to be confounded together.

LIAS.

The lias consists of strata of blue slaty clay, which, in the lower part of the formation, alternate with the beds of lime-stone.

The aggregate thickness of the formation, within the limits of this district, may be fairly estimated at fifty fathoms, but this is frequently much less. Beneath the clay lie the beds of lias, properly so called, which consist of compact lime-stone, having an earthy aspect, and smooth conchoidal fracture, and these are separated by thin partings of blue slaty clay. The thickness of its strata varies from four to twelve inches, and renders its stony beds suitable for extensive use as flag-stone.

Beneath the lime-stone beds, a third and lower formation is sometimes found, which is characterized by the presence of black shale; which occasionally attains a thickness of from 15 to 20 feet. This shale contains thin beds of greenish silicious grit, highly charged with mica, and loaded with scales, teeth, palates and bones of fishes, and the bones of many gigantic reptiles.*

The lias of this district contains similar organic remains to those found in other parts of England; including the ichthyosaurus and plesiosaurus,† large compressed fishes, crustacea of the crab and lobster kind, and the beaks of sepiæ. Also large tuberculated bodies, extremely compact, and probably connected with the palates of some large cartilaginous fish, or possibly of the turtle. It also affords all the testacea common to the formation, especially gryphites, the gigantic plagiostoma, and enormous ammonites, with several species of pentacrinites.

* Robert Anstice, esq. of Bridgewater discovered, a few years since, a bone bed of this silicious grit, at Watchet, from which he extracted a great variety of animal remains.

† For detailed particulars of the great antediluvian amphibia, see Ure's "Geology," p. 202 to 247, and particularly p. 226; also Mr. Coneybeare's papers in the "Geological Transactions."

In tracing the topographical extent of this formation, it is found to the south of the Mendips, reposing on the newer red sand-stone, which extends beneath the marsh-lands of Somersetshire. Occasionally it emerges above them, and then composes the summit, or in some cases, the entire mass of insulated hills ; the most remarkable of which is Brent Knoll, which, rising to the height of near 500 feet above the sea, and standing quite alone amid the flats, presents a very conspicuous land-mark. On its summit is a detached nodule of inferior oolite.

The lias not unfrequently constitutes extensive, and sometimes elevated platforms, crowning the acclivities formed by the newer red sand-stone, and sometimes supporting higher platforms of oolite. Many of these hills, as before remarked, stand completely insulated from one another by numerous intervening vallies, and exhibit, on their sides, the same series of strata.

INFERIOR OOLITE.

This formation forms the boundary of the Bristol coal basins generally, rather than a constituent part of the district, but the detached outliers, from the general boundary, forming the crest or summit of Brent Knoll, and of Dundry Hill, requires some notice.

The inferior oolite here crowns the platforms of lias, and rises on Dundry, 700 feet above the sea, and at Brent, 500 feet. These beds consist of a coarsely crystalline and loosely compacted oolitic lime-stone, forming a durable free-stone. It is extensively quarried, and has been formerly used for building in Bristol and its vicinity to a great extent ; though now superseded by the Bath oolite.

The organic remains of vertebral animals are scarce in this formation. Fragments of the claws of marine crustacea, of the crab or lobster families, have occurred in the beds at Dundry. The *chambered univalves* consist of ammonites, nautilites, belemnites, turbo rostellaria, melanea, trochus, &c. The *equivalved bivalves* of trigonia, cardita,

lutraria, astarte, unio, mya, mytilus, modiola, pinna, tere-
bratula, ostrea, pecten, lima, perna, and plagiostoma. It
also contains echini, several genera of the corals, and some
alcyonia.*

The inferior oolite is the highest member of the super-
medial series which occurs in this district; therefore the
diluvial and alluvial deposits which cover the remaining
portion of the district, and now coming under review, not
forming any distinct connection with either of the rock for-
mations, will be treated, as separate and insulated por-
tions of geological interest.

DILUVIAL DEPOSITS.

The accumulations of diluvial debris, are neither strik-
ing nor extensive in this district. The valley of the
Severn seems to have formed their great receptacle, and it
is probable that the extensive marsh lands or flats, conceal
deposits of the same kind. Near the mouth of the Avon
are rolled fragments of all the rocks in the vicinity, from
the old red sand-stone to the chalk, forming considerable
heaps, though covered by peat at the surface. These de-
posits contain the remains of quadrupeds peculiar to di-
luvian beds; but the most striking illustrations of the
diluvian theory, are afforded on the summits of some of the
eminences belonging to Mendip.

In several of the hills towards the western extremity of
this chain, many fissures in the mountain lime-stone are
filled with stalactites mixed with ochre, enveloping, and
sometimes cementing fragments of the adjacent lime-stone;
and in these, masses of bones have occasionally been found.

One of the most remarkable instances of this, occurs in
the caverns which the Rev. D. Williams has re-opened at
Hutton, the details of which have been already given.
Diluvial remains have also been discovered in the caverns

* For the various species of these genera, see Coneybeare and Phillips's
" Outline," p. 239.

on Banwell Hill, at Uphill, and at Burrington. Elephants'
bones have been discovered in loose rubble, at the depth of
four fathoms, on the summit of Sandford Hill, and large
molares of this animal have been found in the beds of di-
luvial gravel near Shirehampton, on the coast.

ALLUVIAL DEPOSITS.

The marshes or flats which skirt our district on the south
and west, have evidently, at a period comparatively recent,
formed estuaries, which have gradually been filled up, by
sediments of mud from the Severn, and other tide rivers
flowing into them, and by the growth of zostera marina, and
such other plants as concur to produce peat on the sea-
coast, and in salt marshes.

These estuaries have finally been rescued from the sea
by artificial embankments, the position of which have often
been determined by that of elevated natural banks of muddy
sediment, or by the high beaches of shingle which the tides
have in some places thrown up. Were these barriers re-
moved, the sea would, at spring-tides, reclaim its former
territory, and, washing the base of Glastonbury Hill, show
the propriety of its ancient appellation, the " Isle of Ava-
lon." It would also again overflow the vales to the north
and south of Broadfield Downs, some of the lands, especially
south of Congresbury, being from eight to ten feet below
high water mark.

The extent of the alluvial soil may be readily traced by re-
ference to the map which accompanies this sketch. In the
original state of estuaries, it appears to have been shallow,
the natural bed being lias or red marl, covered by diluvial
gravel. On this base reposes a bed of blue clay, being the
mud, apparently once forming the bottom of the estuaries,
and extending beneath the peat, which forms the greater
part of the present surface of the marshes.

The silty bottom occasionally passes into sand, which,
from its natural tendency to drift, has either been heaped
into thick banks in the interior of the marshes, or mixed

with shingle, has formed lines of beach at the foot of the higher grounds. Such lines called batches, may be traced in many places, especially along the border of King's Sedgemoor, the southern exterior boundary of our district. The remarkable batch in the parish of Yatton, has been already noticed, which place, like many others, retains in the etymology of its name, the evidence of its former maritime position.

The peat which fills these estuaries, is in many places, fourteen or fifteen feet thick, and is sometimes separated into two or more strata, by partings of clay. The common sedge, whence Sedgmoor derives its name, enters largely into the composition of the peat. Trees of considerable dimensions, both of oak, fir, and willow, have been discovered in these marshes, at the depth of ten to twenty feet, sometimes standing in the same upright condition in which they grew, but frequently with the trunks lying prostrate; and together with them occur furze bushes and hazel trees with their nuts. Reeds, and other palustrine plants appear to have grown among them. These remains are not confined to the low-lands, but occasionally occur on higher ground; an instance of which may be observed on the hill above East Harptree, where is a small peat-bog, in which are found the stems of oak trees, in an upright position.

The peat does not appear over the whole surface of the marshes; but in the more inland parts, it is sometimes covered with the alluvium of land floods; and near the mouths of the rivers, traversing the màrshes, it is concealed by deposits of marine silt of considerable depth, and of extraordinary fertility, producing, as already mentioned, crops of wheat of forty bushels per acre, for twenty years in succession without manure.

In a small peat bog near the hot-wells, horns of the deer, the head of an ox, nuts, and blue earthy phosphate of iron, have been found. The peat consisted chiefly of decayed

sphagnum palustre, which in some instances, was suffi-
ciently preserved to be identified. In a semi-decayed state,
it resembled oak saw-dust, and gave the origin to the
story, that a Roman timber yard once existed here.

The ancient estuaries, now forming the marshes, pro-
vincially termed " flats," have evidently been the recepta-
cles of the diluvian debris of the surrounding districts.
The clay has been observed not to contain shells ; the sand
affords them abundantly, identically with the recent Eng-
lish species, and most of them marine; though, like the
recent shells on the shore, they are in some instances
mixed with those of the land and fresh water.

The following is a tolerably correct list of the recent
shells found on the coast of our district :

LIST OF SHELLS.

Balanus.............. Balanoides
 And one or two other species.
Lepas Anatifera

 Washed ashore on pieces of wreck.

Pholas.. Crispata
 Candida
 Dactylus
 Parva

 These live in the soft beds of Lias, on
 the beach.

Mya................. Truncata
Tellina............. Solidula
Cardium Edule
Arca Nucleus
Ostrea.............. Edulis

 And a small species with the beak much
 produced.

Mytilus......... ... Edulis
 Rugosus
Bulla.........Retusa

 This and Turbo Ulvæ, are the most
 numerous.

Buccinum....... ...Undatum
 Lapillus
 Reticulatum
Murex..Erinaceus
 Reticulatus
Trochus.Magnus
TurboLittoreus
 Pullus
 Ulvæ
Nerita........Littoralis
PatellaVulgata
 Fissura

Roman coins, pottery, and moulds of Roman coins are
occasionally discovered on the peat in various places below

the covering of alluvium.* Hence it is evident that at the
time of the Roman occupation, the surface of the peat was
more generally exposed, and protected from inundation,
either by its own natural level, or more probably by arti-
ficial embankments, which there is historical authority for
ascribing to Roman power and ingenuity in many other
parts of England.

DEPOSITS OF TUFA.

One more recent change of the earth's surface, may be
noticed within our district, the deposition of tufa from
springs charged with calcareous matter. The best example
of this occurs on its eastern boundary, at the foot of Men-
dip. On the side of the hill above Sutton, is a spring
called the " petrifying spring," which has formed consi-
derable masses of rock, that prove on examination to
consist of an indurated tufaceous mass, containing land-
shells, and impressions of blades of grass and other vege-
table matter.

* A large quantity of Roman coins, chiefly of the Emperor Constantine,
have been recently discovered near Congresbury, a considerable distance from
the base of the hills, on the borders of the marsh, which must have been
formerly a morass.

APPENDIX B.

BOTANICAL MEMORANDA.

MONANDRIA MONOGYNIA.

Hippuris vulgaris Common mare's tail { Ditches at Weston-su-
per-mare

DIANDRIA MONOGYNIA.

Veronica spicata Spiked speedwell.......... Hotwell rocks
———— montana Mountain speedwell E. Harptree Combe
Utricularia vulgaris........ Greater bladderwort Moor Dit. Wedmore
Lycopus europæus Common gipsy-wort Ditches, Uphill, &c.
Salvia verbenaca Wild English clary Worle-Hill

TRIANDRIA MONOGYNIA.

Valeriana rubra Red valerian { On the rocky hill at
Weston-super-Mare
Eriophorum vaginatum Hare's tail cotton-grass Bogs on Mendip Hills

TETRANDRIA MONOGYNIA.

Dipsacus pilosus Shepherd's staff E. Harptree Combe
Scabiosa columbaria Small scabious Hotwell Rocks
Rubia peregrina Wild madder,.... Rickford Combe
Plantago coronopus........ Buck's horn plantain Uphill, and Weston
———— maritima Sea plantain.............. Uphill, and Weston

PENTANDRIA MONOGYNIA.

Lithospermum purp. cœrul. Purple gromwell........ { Woods between Ched-
 dar and Axbridge
Lycopsis arvensisSmall buglossWeston-super-mare
Menyanthes trifoliata......Common buckbean.........Bogs on Mendip
Hottonia palustrisFeather-foilMoor Ditches
Anagallis tenella..........Bog pimpernel............Bogs on Mendip
Campanula patula.........Spreading bell-flowerE. Harptree Combe
Viola hirtaHairy violet..............East Harptree
Verbascum lychnitisWhite mulleinWorle
Hyoscyamus nigerCommon henbaneWeston-super-mare
Atropa belladonnaDeadly nightshadeWeston-super-mare
Erythræa pulchella........Dwarf branched centaury...Sandy ground, Uphill
Glaux maritimaBlack salt-wortUphill
Vinca minor..............Lesser periwinckle........Ubley

PENTANDRIA DIGYNIA.

Salsola fruticosaShrubby salt-wortSteep Holm
Eryngium maritimum......Sea eryngoSands, Weston
————— campestreField eryngoWaste places, Do.
Crithmum maritimum......Sea samphireB. Down and S. Holm
Phellandrium aquaticum.....Water drop-wort.........Ditches, at Weston
Pimpinella dioicaDwarf burnet saxifrage.....Rocks, Weston

PENTANDRIA PENTAGYNIA.

Statice armeriaCommon thriftRocks, Weston
——— limoniumCommon sea lavender......Uphill

HEXANDRIA MONOGYNIA.

Allium ampeloprasum Great round-headed garlick. Steep Holm

From its great abundance in this Island, Ray gives it the specific name of
"Allium Holmense Spherico Capite," the Great Round-Headed Garlick of
the Holm Islands.

Fritillaria meleagrisCommon fritillaryCompton Martin
Anthericum ossifragumLancashire bog asphodel....Bogs on Mendip
Convallaria multiflora......Solomon's sealHarptree Combe

HEXANDRIA TRIGYNIA.

Rumex pulcher............Fiddle dockUphill
Colchicum autumnaleMeadow saffronPastures, C. Martin

OCTANDRIA MONOGYNIA.

Epilobium angustifolium ...Rose grey willow herbMoors, Cheddar
Vaccinium vitis idæaRed whortle berryAbove Weston
Daphne mezereumCommon mezereonC. Martin Wood

OCTANDRIA TETRAGYNIA.

Paris quadrifolia.Herb parisC. Martin Wood

ENNEANDRIA HEXAGYNIA.

Butomus umbellatusFlowering rushMoor Ditches

DECANDRIA MONOGYNIA.

Andromeda polifoliaMarsh andromeda..........Peat Bogs, Wedmore

DECANDRIA DIGYNIA.

Chrysosplenium alternifol...Alternate-leavd. golden sax. Near the Mill, Coley
Saxifraga hypnoides.......Mossy saxifrageCheddar Cliffs
Dianthus cæsiusMountain Pink Cheddar Cliffs
——— arenarius........Stone Pink. Cheddar Cliffs

> These beautiful plants grow luxuriantly on Cheddar Cliffs. They differ considerably; the latter being narrower in the leaf, and not so sea-green in colour; the flower is larger, more jagged, and with seldom more than one on a stalk, and it is more fragrant, particularly in the evening. Sir J. E. Smith considers the Stone Pink a variety of the Dianthus Caryophyllus or Clove Pink.

DECANDRIA TRIGYNIA.

Arenaria vernaVernal sand wort { Among the refuse of lead mines, Mendip

DECANDRIA PENTAGYNIA.

Sedum rupestreStone crop...... { Cheddar Cliffs St. Vincent's rock

DODECANDRIA DIGYNIA.

Euphorbia paralias........Sea spurgeSands, Berrow

ICOSANDRIA PENTAGYNIA.

Pyrus ariaWhite beam tree..........Cheddar Cliffs

ICOSANDRIA POLYGYNIA.

Geum rivaleWater avensEast Harptree
Comarum palustrePurple marsh cinque-foil ...Near Axbridge

POLYANDRIA MONOGYNIA.

Papaver cambricumYellow poppy............Cheddar Cliffs
Cistus polifoliusWhite mountain cistusBrean Down

> This remarkable indigenous plant may be found about the middle of the southern side, towards Berrow; but the increasing cultivation of the Down, will probably, extirpate it ere long. Ray terms it the "Dwarf Cistus, with poley-mountain leaves," and states it to be an efficacious styptic.

X

POLYANDRIA PENTAGYNIA.

Paeonia corallinaEntire-leaved peonySteep Holm

> Indigenous on this solitary rock, having been found there by Dr. Wright and others ; it is admitted by Dr. Smith in his " English Flora," and figured in English Botany. It is not known elsewhere in England.

POLYANDRIA POLYGYNIA.

Thalictrum minusLesser meadow-rue........Cheddar Cliffs

DIDYNAMIA GYMNOSPERMIA.

Ballota nigraBlack horehound..Weston-super-mare
Leonurus cardiacaCommon motherwortWorle

DIDYNAMIA ANGIOSPERMIA.

Lathræa squamaria........Tooth wortC. Martin Wood
Antirrhinum cymbalariaIvy-leaved snap dragonWalls at Clifton
————— LinariaYellow toad-flax........ {Birnbeck, & Weston-super-mare

TETRADYNAMIA SILICULOSA.

Draba muralis............Speedwell leavd. whit. grass E. Harptree Combe
Lepidium ruderaleNarrow leavd. pepper-wort Hotwells
————— petræumMountain pepper-wortSt. Vincent's rocks

MONADELPHIA PENTANDRIA.

Erodium moschatumMusky stork's billCheddar
————— cicutariumHemlock stork's billCheddar Cliffs
————— maritimumSea stork's billUphill, &c.

MONADELPHIA DECANDRIA.

Geranium sanguineum......Bloody crane's billSt. Vincent's Rocks
————— rotundifoliumRound-leaved crane's bill ..Near Bristol

MONADELPHIA POLYANDRIA.

Lavatera arborea.........Sea-tree mallowSteep Holm

DIADELPHIA HEXANDRIA.

Fumaria capreolataRamping fumitoryFlat Holm

DIADELPHIA DECANDRIA.

Lathyrus Aphaca..........Yellow vetchling..........Weston-super-mare
Vicia sylvaticaWood vetchCompton Martin
Hippocrepis comosaTufted horse-shoe vetchWeston-super-mare
Medicago maculataSpotted medickHotwells

SYNGENESIA POLYGAMIA ÆQUALIS.

Hieracium murorum.......Broad-leaved hawkweed...Cheddar Cliffs
Carduus tenuiflorusSlender-leaved thistle......Uphill

APPENDIX C.

LIST OF SOME OF THE SEA BIRDS.

Common Curlew	Numenius Arquata
Whimbrel	Numenius Phæopus
Grey Plover	Tringa Squatarola
Knot	——— Cinerea
Purre	——— Cinclus
Golden Plover	Charadrius Pluvialis
Ring Dotterel	Charadrius Hiaticula
Oyster Catcher	Hæmatopus Ostralegus
Grey Phalarope	Phalaropus Lobatus
Puffin	Alca Arctica
Guillemot, different species	Uria
Gull, different species	Larus
Grey-leg Goose	Anas Anser
Wild Duck	—— Borchas
Sheldrake	—— Tadorna
Scaupduck	—— Marila
Blue-winged Shoveller	—— Clypeata
Widgeon	—— Penelops
Golden-eye Duck	—— Clangula
Tufted Duck	—— Fuligula
Teal	—— Crecca
Cormorant	Pelecanus Corbo
Shag	——— Graculus

NOTE.—The Birds inland are nearly the same throughout the West of England. The Herons at Brockley are the common species of ARDEA CINEREA. There is another Heronry at Margam near Neath, and in Lord Darnley's Park near Rochester. Herons are birds of migration, and they observe a remarkable accuracy in the time of their return. They are powerful birds, and when attacked, strike at the eye of their assailant.

APPENDIX D.

THE WANSDIKE.

A more detailed description of this curious and extra-ordinary work of ancient times, may not be unacceptable, as being connected at one of its extremities, with the north-western part of the district, embraced by these DE-LINEATIONS. It derives its Saxon appellation, *Waden-erdic* or *Woden Dike*, from the principal object of Saxon worship, WODEN or MERCURY.

Few subjects of antiquarian research, have given rise to more speculation, than this gigantic work; which has been successively attributed to the Britons, Romans, and Sax-ons.—The Rev. W. L. Bowles, in his recent "History of Bremhill," gives what appears to be the most rational account of it, "that it was the last frontier boundary of the encroachments of the Belgæ northward; that on this rampart, a stand was made between the contending bar-barians, the Belgians and the aboriginal Britons; and that many of the numerous encampments in the western counties, especially in Wilts and Somerset, were occupied as advantageous positions in the obstinate wars between the Britons and their continental invaders.

The Belgæ were a brave people, of Celtic origin, who passed over the narrow sea from Gaul into Britain, about 313 years before the Christian æra, and therefore pre-viously to the Roman invasion. They landed on the southern coast, where they chiefly settled, gradually driv-ing the aboriginal Britons further inland. Many years after

their first settlement in this country, one of the most powerful princes of Gaul, named Divitiacus, King of the Suessones, brought over a large army of continental Belgæ to assist their countrymen in extending the boundaries of their settlements.

But the original British possessors having been already driven back upon their strong holds, and especially those in the vicinity of their sacred temples on the Wiltshire Downs, and at Stanton Drew, collected their forces and vigorously repelled the attacks of their enemies. From their different encampments they harrassed their invaders, who finding it impracticable either to dislodge them, or to extend their conquests further north, to secure themselves, they threw up the large deep fosse and dike, called Wansdike, as the exterior line of defence to the northward of their conquests, and to serve as a boundary line between the two rival nations; many parts of this immense work remain perfect to this day, though nearly two thousand years have elapsed since its construction.

The Wansdike formed a line of protection to the country between the rivers Thames and Severn, each of which afforded a natural defence to the inhabitants on both sides of them. Extending in nearly a direct line from the Thames, it enters the boundary of Wiltshire, near Great Bedwin, and crosses that county through the forest of Savernake, and over the Marlborough Downs. In this part it appears almost in its original state, being extremely deep, and protected by a lofty mound. This is evidently the strongest part of the whole line; which is accounted for by its being immediately opposite to the British strong holds at Oldbury, and around their sacred temples at Avebury, Silbury, &c.*

* It is a remarkable fact noticed by the Rev. W. L. Bowles, that the line of Wansdike immediately opposite to the Temples at Avebury, is double the height of any other part of this entrenchment, being, both here, and opposite to Oldbury Castle, forty feet from the lowest part of the trench, to the summit of the bank; plainly evincing the necessity of more than ordinary precaution, in the neighbourhood of places held sacred by the Britons, and which they doubtless protected by strong garrisons, in the fortified stations erected near them.

Quitting these downs, the Wansdike passes by Calstone,
Heddington and Spye Park, and crossing the river Avon
near Benacre, traverses the fields, where it is now oblite-
rated, until it again meets with the Avon at Bath-Hamp-
ton ; it there enters the county of Somerset, and continues
its course over Claverton Down to Prior Park and Inglish
Combe, and is very conspicuous in the fields westward of
the church, with a high ridge on its *southern* side. It
has its direction clearly marked by a deep lane leading
to Stantonbury Camp, of which it formed the northern
boundary ; thence it proceeded by Publow and Bulleton,
near which the name of Wansdike is still continued, to the
ancient fortification of Maes Knoll, whose lofty and pe-
culiar western terrace, between the outer and inner ram-
parts, seems to have been a post of observation. The
course of this extraordinary barrier has been thus far as-
certained with some degree of certainty,* but antiquaries
are by no means decided in opinion that it proceeded further
west than Maes Knoll ; as, however, Collinson, whose re-
sidence at Long Ashton, gave him an advantage in personal
examination, has described its continued course towards
the Severn, we will trace, with him, its supposed western
continuation in the hundred of Portbury. On descending
from the lofty eminence of Maes Knoll, the Wansdike
crosses Highbridge Common, where its track is still visible,
and intersects the turnpike road from Bristol to Wells ; a
few years since it formed a deep narrow lane overhung with
briers, leading to Yanley Street, in Long Ashton parish,
and now called Deep Combe Lane. Thence it traversed
the meadows to a lane anciently called Wondesditch Lane,
near which it crosses the Ashton road at Rayener's Cross,
and ascending the hill, enters the hundred of Portbury, in

* The course of Wansdike has been traced from Maes Knoll in Somerset-
shire to near Hungerford in Berkshire, by Sir R. C. Hoare, who had this
portion accurately surveyed, and engraved in his " Ancient Wiltshire."

the parish of **Wraxall,** and pursuing its course over Clapton Hill, terminates at the ancient port of Portishead.

The many camps, ramparts, and military relics which are found throughout the course of the Wansdike, from its entrance into Somersetshire, to its termination at Portishead on the Bristol Channel, indicate its former importance as a military boundary, and the fierce spirit of contention with which it was attacked and defended by the British and Belgic tribes.

The name of HAMPTON on the Avon, signifies the old fortified town, and on the hill above it are several encampments. The barracks or barrows beyond Lynscombe, are very ancient places of sepulture; and Barrow Hill, between these and Inglishcombe, is, perhaps, the largest tumulus in the world. At Inglishcombe is a castle of very remote antiquity. The camp at Stanton Bury Hill, was, probably, an important fortress to protect the pass, long before the arrival of the Romans, though afterwards adopted by them. Publow or Publawe, signifies a hill of sepulture, synonymous to the Latin *tumulus,* and these were raised over the bodies of chiefs, who lost their lives, either on attacking or defending this military boundary; the monument of Stanton Drew is a remarkable remnant of antiquity near the same line. Harelane, signifying the military road, leads to Maes Knoll, another very ancient fortification; and Hareclive, near Broadfield Down, is the military rock, where, probably, a battle was fought in defending the pass into the neighbouring valley; southward, at Butcombe, is a most ancient and remarkable stone sepulchre, beneath an insulated barrow, where, possibly, might have been interred some of the Druidical priests who officiated at their contiguous temple at Stanton Drew.*

* See Sir R. C. Hoare's " Ancient Wiltshire," " Collinson's Somersetshire," the Rev. W. L. Bowles's " Bremhill."

APPENDIX E.

ROMAN ROAD FROM UPHILL TO OLD SARUM.

This ancient road appears to have escaped the notice of our earlier antiquaries, as we do not find it mentioned in the ancient Itineraries, nor is it noticed either by Stukeley or Horseley.

Sir Richard Colt Hoare, to whom the public are indebted for the accurate and complete investigation of this road, had the whole line surveyed and engraved for his splendid work on " Ancient Wiltshire."

On the summit of Uphill, at a short distance south-east from the church, and contiguous to two British tumuli, are evident vestiges of a square circumvallation, where fragments of Samian, and other antique pottery, have been found ; all plainly indicating the site of a Roman station connected with the sea-port on the river Axe, below the hill ; where are still retained the names of Borough Walls and Cold Harbour, both of Roman derivation, and often occurring in the vicinity of their roads and stations. From this port was a passage across the Channel to a station on the opposite coast of Wales at the mouth of the river Taaf, near Cardiff; which continued to be a much frequented passage into Wales, even down to modern times.

From the Roman station on the summit of Uphill, a straight line of road leads directly to the ancient village of Oldmixon, but from thence the traces of the causeway become very indistinct over Bleadon Down, and on the south side of Went Hill, until it crosses the turnpike road from Bristol to Bridgewater, at the fourteenth mile-stone between Churchill and Cross, passed beneath Banwell

Hill, with its large British earth-work; and still nearer to a small square enclosure on the same ridge, but rather closer to the village of Banwell. It is not easy to conjecture the intent of this work, which measures nearly 230 yards in circumference, occupying an area of not less than an acre. From this point the road is continued direct to the modern village of Shipham, leaving Doleberry and Dinhurst camps to the left, and shortly after, it arrives at a spot, where a narrow pass has been cut through the rocky stratum to admit its passage. It then intersects a small square earth-work or camp, and traversing a valley, is carried along the side of the Black Down ridge. Having reached the summit, it proceeds to

CHARTER HOUSE,
twelve miles from Uphill, where was formerly a small religious establishment, a cell to the celebrated Carthusian monastery at Witham, in Somersetshire. On this spot are evident vestiges of a very extensive

ROMAN SETTLEMENT AND STATION.
A considerable tract of ground, first noticed by the Rev. John Skinner of Camerton, covered with squares, circles, and other irregular earth-works; and in turning up the soil, Sir Richard Hoare discovered abundance of pottery, from the finest Samian to the coarsest description, as well as iron, glass, scoriæ of iron, &c. On Charter House Green, numerous small coins of the Lower Roman Empire have been found, and in an adjoining field are the remains of a small Roman amphitheatre.

From this interesting station a very perfect fragment of the Roman road makes an angle rather more towards the south, and passing by a considerable number of tumuli, many of which occur throughout its whole course, leads directly to a solitary inn, called the CASTLE OF COMFORT, in the vicinity of which are four large British circles, one group of nine barrows, and another of eight, with two other large single ones between the groups. Some of these barrows were opened in 1825, by order of the present

Bishop of the diocese, and were found generally to contain a small circular hole, eighteen inches wide, and the same in depth, filled with burnt bones; in one of these holes, however, were contained a few beads, exactly similar to those found with most of the Egyptian mummies.*

The Roman road then crosses the road from Wells to Bristol at GREEN ORE FARM, and thence by Maesbury Camp, until it crosses the fosse road from Ilchester to Bath, on the commanding eminence called BEACON HILL. Thence it traverses a succession of pasture land, until it ascends by the present turnpike road from Bruton to Frome, to a small ROMAN STATION on GEAR HILL. From this point the traces of the road become very indistinct for a considerable distance, but it is conjectured to have pursued nearly a straight line through Maiden Bradley, near which it passed out of Somerset into Wilts; thence near Kington and through Monkton Deveril, it pursued its course over the downs until it crossed the road from Shaftesbury to Warminster, near the sixth mile stone from the latter place.

Contiguous to this spot, to the north of Lower Pert Wood Farm, the Romans seem to have paid a mark of reverence to the sepulchral mound of some native Britons, by not cutting through, but by passing *round* it; a remarkable circumstance, as near Woodyates Inn, in Dorsetshire, a Roman road passes directly *through* a British tumulus.

At a short distance from Pertwood, fifteen miles from Old Sarum, the Roman road is still remarkably perfect; it passes through an extensive range of wood, called Great Ridge, abounding in remains of British settlements, near to a small earth-work opposite to the village of Chicklade. On emerging from this woody ridge, it crosses the western road between Deptford Inn and Chicklade, about the ninetieth mile-stone from London, near some very ancient

* This interesting information was given to the author by the Rev. F. Blackburn, rector of Weston, who was present during the discovery, and who compared the beads; and who was also present when some very rude urns were discovered on Beacon Hill near Maesbury Castle, on which an attempt at ornament had been made by indenting figures with the thumb nail.

and extensive earth-works at Stockton Wood Corner. This, Sir Richard Hoare imagines to have been the Roman station nearest to Old Sarum, which is at ten miles distance; and it probably may have been previously occupied, both by the Britons, and by their invaders, the Belgæ; an opinion, which is strengthened by the frequent discovery of fragments of pottery, coins, &c.

From Stockton works the Roman road may be traced without interruption, in a very perfect state, through GROVELY WOOD, on the north side of which are no less than five extensive earth-works and camps, exclusive of Hamshill Ditches to the south; *viz.* Bedbury Rings, Hanging Longford, East Castle, Grovely Castle, and Grovely Works. Leaving the wood, the road crosses the river Wiley, and the turnpike road from Salisbury to Warminster; it then passes through the village of Chilhampton, and over its down, until it crosses the river Avon, and traversing the village of Stratford, enters the fortress of OLD SARUM by its western portal.

The line of road which we have thus traced from the port at the mouth of the river Axe, to the strong, and in those days, impregnable fortress of Sorbiodunum, is interesting to the antiquary, from the numerous British settlements, earth-works, sepulchral barrows, and ancient camps, on each side, throughout its course; and likewise for two considerable Roman stations, doubtless established to ensure a free communication by this road, not only to the port at Uphill, but to the mines opened on the Mendip Range; from which, the ancient Britons and the Belgæ, and subsequently the Romans also, procured supplies of the different metals which are found there. And still further to secure this important line of communication, they terminated its course at the important fortress of Old Sarum, and protected its opposite extremity on the summit of Uphill, together with the harbour below, by strongly fortifying the insulated ridge of Brean Down, which to this day, is covered over with vestiges of defensive works, bearing the evident stamp of remote antiquity.

APPENDIX F.

ROMAN AND BRITISH STATIONS AND ANTIQUITIES, WITHIN THE DISTRICT.

ASHTON CAMP *British Station.*

AVON RIVER near Clifton *British Station of three Camps.*

AXBRIDGE { *Roman Town, through which passed several of their Roads.*

BANWELL HILL { *British and Roman Encampment; Roman Road.*

BELLUTON *A Town of the Belgæ.*

BLEADON HILL *British and Roman Station.*

BOW DITCH, near Chew Magna } *Ancient Encampment.*

BREAN DOWN *British, Saxon, & Roman Station.*

BRENT KNOLL *British & Roman fortified Station.*

BURRINGTON COMBE*Ancient Sepulchre.*

BUTCOMBE BARROW*British Sepulchre.*

CADBURY, near Yatton ..*British Station.*

CADBURY, on the brow of the hill to the east } *Roman Antiquities.*

CASTLE OF COMFORT ...*British Circles and Tumuli.*

CLEVEDON*Roman Guard Station.*

CLEEVE TOOT { *Small Danish Encampment and Roman Coins.*

CHARTER HOUSE { *British Antiquities and Roman Station.*

CHEDDAR MOOR *British Tumuli.*

DOLEBERRY { *British, Danish, and Roman Encampment.*

FAYLAND { *British and Roman Enclosures and Roman Coins.*

KINGSTON SEYMOUR ... *Ancient Pottery.*

LEIGH DOWN { *British Encampments, Roman Roads, Entrenchments, and Coins.*

MAES KNOLL { *British and Roman Encampment, and a British Tumulus.*

PORTBURY { *Western termination of the Wansdike, British Encampment, and a Roman Fortified Town.*

PORTISHEAD { *British and Roman Coast Station, and termination of two Roman Roads.*

PORTISHEAD HILL ... { *British, Danish, and Roman Encampments.*

PORTISHEAD POINT*Roman Guard Station.*

SLOUGH PITS, S. E. of Banwell } *British Station.*

STANTON DREW *Druidical Temple.*

TICKENHAM, on the Hill above the Village.... { *British and Roman Entrenchment and Roman Coins.*

TYNTE'S PLACE *British Station.*

UPHILL DOWN *Roman Station & British Tumuli*

WALTON, near the Castle *Ancient Earth Works.*

WORLE HILL *British & Roman Encampments.*

WRAXALL HILL *Roman Beacon Station.*

WYCK ST. LAWRENCE .. *Roman Guard Station.*

INDEX

TO THE PRINCIPAL PLACES, ETC. MENTIONED IN THE WORK.